The Flowering of the Renaissance

THE
FLOWERING OF
THE RENAISSANCE

Vincent Cronin

COLLINS/FONTANA

First published by Collins 1969
First issued in Fontana 1972
© Vincent Cronin, 1969

Printed in Great Britain by
Richard Clay (The Chaucer Press) Ltd,
Bungay, Suffolk

Contents

Colour Illustrations

Black and White Illustrations

ILLUSTRATIONS

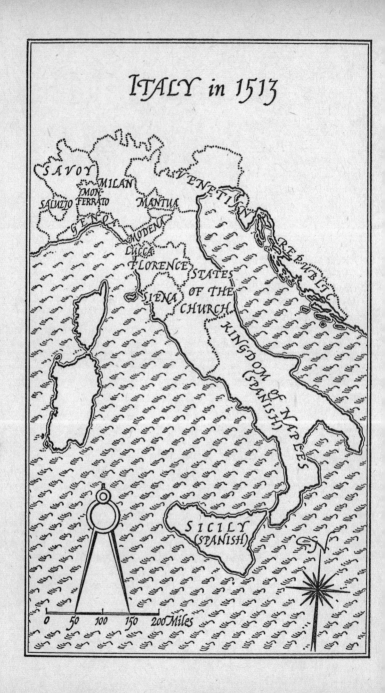

ITALY in 1513

SAVOY

VENETIAN

MILAN

SALUZIO

MON-
FERRATO

MANTUA

GENOA

MODENA

LUCCA

FLORENCE

SIENA

STATES
OF THE
CHURCH

REPUBLIC

KINGDOM OF NAPLES
(SPANISH)

SICILY
(SPANISH)

0 50 100 150 200 Miles

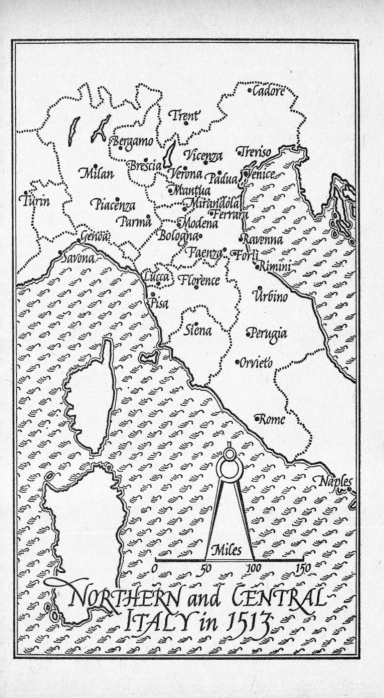

NORTHERN and CENTRAL ITALY in 1513

Prologue

DURING the fifteenth century, in Florence, a small group of laymen cross-bred Christianity with the best elements of classical Greece and Rome to produce a new way of life which may be termed Christian humanism. This set high value on political freedom, public-spiritedness and free enquiry, on man's will and imagination, on the beauty and power of the human body which, like all created things, was conceived not as God's enemy but as His ally, and as an expression of His love. The Christian humanists took a new interest in man as a whole and, as a means of fathoming man's nature, in literature and the arts, in history and in science. They viewed life no longer as a vale of tears, but as a quest for enlarging man's powers, and so his awareness of God. They adopted a generous attitude to the views of pagan antiquity and to unorthodox thinkers such as Origen; they even drew near to tolerance in matters of conscience.

The Christian faith still came first with these early humanists, and in the most famous library of the day the Bible was bound in gold brocade, classical writers in silver. But inevitably there was tension. The pagan lion and Christian lamb do not lie down easily together, and though Plato and the Gospels may be made to harmonize, the balance is delicate. At the end of the fifteenth century Christian

humanism came under attack from within, when Savonarola denounced it as a pagan way of life, a travesty of the Gospels, and from without, when the French invasion of Italy, culminating in their victory at Fornovo in 1495, showed up the political and military weakness of Florence.

Rome succeeded Florence as the political and intellectual leader of Italy, a development symbolized shortly before 1500 when, at the Pope's bidding, Lorenzo de' Medici's favourite artist, Antonio Pollaiuolo of Florence, added figures of Romulus and Remus to the ancient bronze statue of the suckling *She-Wolf*. Julius II and Leo X, two of the most powerful and interesting of the Renaissance popes, sought to put into practice a modified version of Christian humanism. They strengthened Rome politically and made it the most civilized city in Europe.

What the popes did was disliked by many, particularly in Germany. When Luther attacked the notion of merit and rejected the popes' teaching authority, Germans rallied to him; in 1527 a largely German army sacked Rome. These events brought to a head earlier doubts and plunged Italy into a crisis: intellectual, theological, moral and artistic. A period of heart-searching began. Could Italians summon up an adequate answer to the Lutherans? And could they, in face of so widespread a threat, save the principles of Christian humanism?

The answers lie in the texture of Italian life and civilization during the *cinquecento*. This is surveyed, with a particular eye to the crisis, first in Northern Italy generally, then more specifically in Venice which, after the Sack of Rome, emerged as the chief centre of Christian humanism. All the trends apparent in Venice and elsewhere found expression at the Council of Trent, the Church's galvanic attempt to find an answer to the crisis posed not only by Lutheranism but in the very fruits of the Italian Renaissance itself. It is the tragedy of Trent that the Church, despite much goodwill on both sides, ultimately came down against the main principles of Christian humanism. The effects of this decision on Italian civilization and the resultant 'conformism' offer a striking parallel with events in the Communist world today. Venice alone preserved a measure of independence and artistic vigour and held alight the torch of free-

dom; her example was to prove an inspiration to those men of the nineteenth century who succeeded in liberating Italy and establishing once again the principles of Christian humanism.

CHAPTER I

The Awakening of Rome

A PILGRIM arriving in Rome in the jubilee year of 1500 would have
been surprised by the city's appearance. Instead of close-knit streets
and stone houses tightly belted by a powerful wall, he would have
found a patchwork of fields, vineyards, gardens, marshes and ponds
interspersed with clusters of wooden, single-storey houses with
outside staircases and balconies, the whole lying loosely within a
huge circuit of wall so broken-down that it was easier to pass
through the gaps than the gates. This remains of a wall, fourteen
miles long, had been built by Aurelian for a city of one million
inhabitants; now there were only 40,000, less than in Florence or
Venice or Naples. Cattle grazed among the four upright columns of
the Forum, hence its name of Campo Vaccino, and the aqueducts
had been so shattered by ten sets of invaders during the Dark Ages
that even their purpose was forgotten by many: one pilgrim, a
Douai draper, was told that 'the aqueducts were used formerly to
bring oil, wine and water from Naples.'

This city-amid-fields offered no arresting landmark: no cathedral,
no town hall, no castellated palace. St Peter's was merely one large
church among 280 others, their shabby, often crumbling exteriors
giving no hint of the gleaming mosaics within. Seven of them, the
Stational churches, had to be visited by pilgrims claiming a plenary
indulgence—remission of punishment due to past sins: according to
Dom Edme, Abbot of Clairvaux, who went round them in 1521,
the visit took eight hours, on poor tracks, sometimes through
marshes 'where the mules sank up to their tails.'

Whereas most Italian cities were famous for this or that product—
Lucca for silk, Venice for ships, Milan for steel—Rome produced
nothing at all. She had no industries, no raw materials. In 1500 she

just about met her needs in corn, grown in the Campagna's black, difficult soil, but as the century progressed, most of her bread was baked from imported grain. Romans disliked the flat wine of Latium, and so wine had to be imported too, mainly from Corsica, Crete and Naples. Cloth came in from Florence, paper from Fabriano, soap from Genoa, knives and swords from Milan, carpets from Turkey.

To meet the cost of these goods Rome had only her pilgrim trade. The town where St Peter had been crucified and St Paul beheaded attracted 50,000 pilgrims annually. According to the census of 1527, Rome had 236 inns, lodging houses and taverns, one to every 288 inhabitants, compared with one per 1488 inhabitants in Florence. The best of them, the Bear, Sun, Ship, Crown, Camel and Angel, stood close to the Pantheon, and their landlords would send boys to the city gates in order to solicit customers among the pilgrims, most of whom arrived in Lent, a third of them on their own horses. In order to gain the plenary indulgence Italians had to spend fifteen days in Rome, non-Italians eight. During this time they lived well—consumption of meat was extremely high—and they bought guide-books and souvenirs. To the Romans they were an indispensable source of income.

Even without foreign pilgrims, Rome was a cosmopolitan place. Most of its inhabitants had been born outside Rome, 20% were non-Italians, chiefly Spaniards and Germans, while only 16% or 6,400 were Roman born. Of these a handful possessed citizenship and though they claimed the right to rule their city, in practice it was the Pope who ruled, for not only was he by far the largest employer, but he collected and spent the revenue. It was the Pope who chose the Governor—a cleric—and he who paid all the magistrates. True, an ordinary Council met regularly, composed of the various municipal magistrates, and also less often a Great Council, which included the same persons and selected civic notables. The Councils sometimes passed bold decrees against the Pope's will, but hardly ever dared put them to the test. A popular rising in 1143 had instituted 56 senators, but the Popes had whittled them down to one. This last senator dressed in fine sunset colours—crimson gown, brocade cloak and fur cap—he had the right to a page

and four servants, he carried an ivory sceptre, but his power was nil. There was also a Colonel of the Militia of the Roman People—but no militia.

The Romans accepted this. There was no powerful leaven of craftsmen as in Florence, and therefore little republican feeling. Roman citizens were usually of noble or gentle birth and content with trappings of power that vaguely recalled imperial splendour. Yet what privileges they did possess—be it only the Conservators' right to music at meals—they clung to tenaciously, and on tiny points of protocol they made many a petition to the popes.

The Romans of 1500 retained certain characteristics of their forebears. They loved ceremonies and spectacles. They responded to fine phrases and rolling sentences. They expected of their ruler dignity and largesse, and if they did not get it abused him with satirical and licentious songs. They had a cosmopolitan outlook, though this did not necessarily imply breadth of vision. But they were not grave like the classical Romans. They were turbulent, rowdy and changeable as their weather. When a new pope was elected, they looted, as though by right, his old palace, and when he died, the interregnum was bloodied with murder.

This unproductive half-decrepit city, swept in winter by the icy *tramontana* and in autumn by a sultry miasmal breeze that caused tertian fever, might long ago have been abandoned to wolves, nettles and ivy but for the fact that it was the see of St Peter, and therefore the seat of government of Catholic Christendom. Here the Curia kept archives and registers of appointments; here they administered justice and held final courts of appeal; it was here that a Flemish burgher applied if he wished to drink milk in Lent, here that a Spaniard who had traded with the Turk sought absolution. But behind the bustle of day-to-day business, much of it petty, lay a central, crucial fact: it was here in Rome that the man who claimed to be the Vicar of Christ sought to preserve and interpret to the world Christ's message.

In order to accomplish this task the Bishop of Rome decided at a very early date that he required to be independent. It was perhaps the most far-reaching decision ever taken in the Church when the Bishop of Rome, like the bishops of other cities, agreed to accept

estates bequeathed to him in the wills of fervent Christians. From being a property-owner, the Bishop of Rome gradually became a lord of towns and cities, and finally, through the Donation of Pepin, the lord of whole provinces. By 1500 the Pope ruled the largest part of Italy after the King of Naples. It comprised Latium, Umbria, Bologna, Romagna and the March of Ancona, with a population of over one million.

The Papal States provided the Pope with political independence, but not with economic independence. The States were in fact as much of an economic burden as Rome, which produced nothing and consumed much. Around 1500 Rome, through customs and excise, and the Papal States, through taxes, which were kept low, provided the Pope with 144,400 gold ducats, at a time when the purchasing power of the ducat was approximately that of one pound sterling today.[1] Out of this the Pope had to pay costs of administration, as well as troops required to defend the States against other Italian powers, and to coerce any feudal prince who declined to pay his taxes.

It was his need to achieve economic independence that turned the Pope to tax Church property outside Italy. This happened in the reign of John XXII, when the Popes were living in Avignon and the Papal States were in revolt. In 1318 John decreed that in future the holder of a benefice must pay to Rome annates—his first year's revenue—in order to defray costs of the Church's administration. Annates and similar taxes provided the Pope with a 'spiritual revenue' equal in amount to the 'temporal revenue' from Rome and the Papal States. So the Pope achieved his goal of economic independence.

But this independence was constantly jeopardized. The French King, by the Pragmatic Sanction of 1438, reduced annates from France by four-fifths, and then played on the Pope's need to get the Sanction lifted. A famous example occurred when Louis XI asked Pius II to give the red hat to his favourite, Jouffroy Bishop of Arras. Arras was a tall, handsome, ruddy-cheeked courtier described by the women of Rome, who had good cause to know, as Venus's Achilles. The sacred college informed Pius that Arras was quite unsuitable, a

[1] The *ducato di camera* and other Italian currencies are discussed in Appendix A.

know-all and a boaster, yet 'influenced as easily as a child', while the holy German cardinal, Nicholas of Cusa, actually burst into tears at the proposal. Pius pointed out that Arras, who was Legate to France, had promised to get the Pragmatic Sanction lifted and, if rejected, 'he will rage like a serpent and spit out all his venom on us.' Pius was the most eloquent man of his day—eloquence he defined as saying the same thing three times over—and he finally convinced the sacred college. But not content with his red hat, Arras next asked for Besançon and Albi, two very rich sees. Pius said he could have one, but not both, for that would be a grave abuse. Arras flew into a rage, hurled insults and threats at the Pope and finally tried to bribe him, offering 12,000 ducats for both sees. Pius's patience gave way. 'Go to the devil,' he said, and in a sense Arras did. He scandalized Rome with his debauchery and scenes of violence, hurling silver dishes at his servants and even overturning his dining-room table. The Pragmatic Sanction was, however, lifted. Such was the price Popes sometimes had to pay for economic independence. No wonder Pius's dearest ambition was to see himself at the head of a crusading army, kings as his lieutenants, renewing papal authority with victories over the Turk. Pius's crusade came to nothing but the economic problem for long continued to bedevil the Papacy.

In 1447 Tommaso Parentucelli, the son of a poor Tuscan physician, was elected Pope with the title Nicholas V. It is an important date because Nicholas was the first Pope for 150 years to spend his whole reign in Rome. During centuries of war with the Emperor and his Ghibelline allies, the Popes could seldom reside for long in so vulnerable a city, and since 1100 they had spent more time outside Rome than in it. But with Nicholas V there began that continual residence which was to make Rome and the Papacy almost interchangeable terms.

The physical return of the Popes coincided with the return to the past we call the classical revival. Nicholas, a modest, peaceable man, had spent much of his earlier life in Florence. He was a close friend of Cosimo de' Medici, and had been commissioned by him to catalogue Niccolò Niccoli's library for the Convent of S. Marco. In Florence Nicholas read the newly discovered classical authors. Many

priests condemned this 'pagan' learning and said it was a mortal sin to read books by adorers of false gods. But Nicholas, like his Florentine friends, welcomed it and recognized at how many points the ancient Greeks and Romans had surpassed the Italians of his day. He saw Ghiberti and Donatello making sculpture according to classical models and Brunelleschi building the soaring dome of Florence cathedral.

Nicholas was the first Pope to patronize the new learning. He invited scholars to Rome to translate into Latin such newly dis-covered Greek authors as Herodotus, Xenophon, Polybius, Dio-dorus and Appian. Though Lorenzo Valla had written a treatise discrediting the Donation of Constantine, Nicholas tolerantly made him a papal secretary and commissioned him to translate Thucydides at the handsome fee of 500 ducats. He paid 1000 ducats for the first ten books of Strabo and offered 10,000 for a translation of Homer. If an author showed scruples, the Pope would say kindly, 'Don't refuse: you may not find another Nicholas.' He realized that he was breaking new ground and that later Popes might be less large-minded.

The city of Rome imposed a heavy burden on Nicholas, as on his predecessors. He had to patch up its seemingly endless wall, its old bridges and dozens of medieval churches. So it took an act of courage to decide to stretch already slender resources by beautifying the city. Nicholas called Fra Angelico from Florence to fresco his private chapel in rose and blue with scenes from the lives of St Stephen and St Laurence. He brought Renaud de Maincourt from Paris to found Rome's first tapestry workshop. He planned to place the Egyptian obelisk near St Peter's on four colossal figures of the Evangelists, as a spectacular symbol of the harmony between Christian and pagan thought. But his most ambitious plan concerned St Peter's. The basilica was then 1100 years old, and its southern wall leaned outward to the extent of 3 *braccia*—4 feet 9 inches. After discussing the matter with the Florentine architect Leon Battista Alberti, Nicholas decided completely to rebuild St Peter's as a domed basilica with nave and double aisles. He got work started at once on foundations for a new choir, using 2500 cartloads of stone from the Colosseum, and although the foundations rose only six feet

in his pontificate, a beginning had been made to a new conception of Rome. As Nicholas explained on his deathbed: If the faith of ordinary men is to be strong, 'they must have something that appeals to the eye . . . majestic buildings, imperishable memorials and witnesses seemingly planted by the hand of God.'

Sixtus IV continued Nicholas's work with all the determination of a Ligurian. He opened, straightened or paved many streets between the new papal residence in the Vatican and the civic centre on the Capitoline Hill. He built the bridge across the Tiber that still bears his name. He built the Sistine Chapel and decorated it with frescoes, notably Perugino's *Giving of the Keys to Peter*, and Botticelli's Old Testament scenes, chosen to show that the Pope was the successor of the priest-kings of Israel. He re-established the Sapienza, as the university of Rome was called, though the professors' pay several times had to go to soldiers defending the Papal States. One of the professors was Pomponius Laetus, who had learned from Lorenzo Valla the importance of philology in reconstructing history; he made a large collection of Roman inscriptions—only a single Christian example was considered polished enough for inclusion.

Sixtus added 1000 manuscripts to the collection begun by Nicholas, mostly works of theology, philosophy and patristic literature. To house them he also built a splendid library in the new classical style, with round-headed arches on Corinthian columns; its walls were marble, and decorations included Sixtus's family device, the oak-leaf and acorn. The library was heated in winter—an innovation at that time—and anyone might borrow books on deposit of a small sum. Sixtus got Melozzo da Forlì to paint a commemorative picture of himself in the new library, attended by the first librarian, Platina, and his nephew, Giuliano della Rovere, the future Julius II. Its inscription states that before Sixtus built the library, books had been stacked away 'in squalor'.

The forty-odd cardinals whose role it was to help the Pope govern the Church also began to build. Raffaello Riario, another of Sixtus's nephews, was lucky enough to win, in a single night's gambling, the huge sum of 60,000 ducats, and sensible enough to spend it on what is perhaps the most beautiful of all Roman houses, later to be known as the Palazzo della Cancelleria. Though sparsely furnished, the

cardinals' new dwellings were hung with brocade draperies and their tables gleamed with heavy silver. Profiting from the recent improvement in textiles, the cardinals dressed in fine robes of red watered silk, adding for the street a red hood and their red tasselled hat; in Advent and Lent they wore violet. An innovation in the second half of the century was their right to a silk mitre and red biretta, as well as red caparisons and gilded stirrups for their genets and mules. With a retinue of between 80 and 100 servants each, the cardinals did on a smaller scale what the Popes were doing: built and stocked libraries, commissioned pictures embodying the recent discovery of perspective and took an interest in the city's classical remains.

In the *City of God* St Augustine had described the sack of Rome by Alaric in 410 as a punishment for sin, in particular for the continuance of pagan practices and, ever since, classical remains had been viewed with awesome guilt. But with the discovery of Latin texts and inscriptions, scholars began to take a closer interest in ancient history and to study the ruins of Rome for their own sake. The first man to do so seriously is known as Flavio Biondo—inexactly as it happens, because Flavio is just an Italian form of Flavus, which in turn is a Latin form of Biondo. He usually signed Blondus Forliviensis, being a native of Forlì in the Papal States, and is best called simply Biondo. Born in 1392, he received a good education and trained as a notary. In 1420 he began a close friendship with Guarino of Verona, a pioneer humanist schoolteacher, and in 1423 married Paola Michelini, a noble lady of Forlì, who bore him ten sons. In 1433 he moved to Rome, and the following year was named apostolic secretary. As well as being a scholar Biondo evidently possessed presence and initiative, for he was sent on diplomatic missions to Venice and to Francesco Sforza, then just an ambitious *condottiere*. Biondo loved Rome with all the passion of a provincial. In his spare time he measured old buildings and tracked down faded streets until he was able to reconstruct the topography of ancient Rome, publishing his results in 1444–6 in three books entitled *Roma instaurata*. During the pontificate of Nicholas V he travelled the length and breadth of Italy in order to compile a historical and geographical survey of the peninsula, *Italia illustrata*,

the first of its kind since antiquity. He also sought to interest various rulers, notably the King of Naples, in uniting Italy against the Turk. He returned to Rome and in 1459, four years before his death, published his masterpiece, *Roma triumphans*.

Biondo's idea, like all revolutionary ideas, was very simple. His aim was to explain how pagan Rome became triumphant, in the hope that the Pope by emulating Rome's methods might himself become triumphant. He ascribed the greatness of ancient Rome to her administration, military discipline, customs and institutions, and, above all, to her religion. He began Book I with a quotation from Cicero: 'Other nations may surpass the Romans in numbers, in the arts, in practical skills, but in religion, piety and theology we leave the rest of the world a long way behind.' He also quoted Livy's story about the praetor Gn. Cornelius who was heavily fined for daring to upbraid M. Emilius Lepidus, the Chief Pontiff: 'the Romans,' commented Biondo, 'wished religion to rank above secular affairs.'

Biondo then sought to show that the Papacy, in structure, institutions and customs, was a continuation of the Roman Republic and Empire. Such Christian practices as virginity, fasting, vows, the placing of flowers on a grave had their origin in pagan Rome. After his death a Pope lay in state on a dais, just like the Emperors of old. But Biondo thought the Pope corresponded more to a Consul than to an Emperor, and the cardinals to Senators. Cicero had claimed that Rome was 'the rock of all the world and all nations', and that the world found joy and glory in being subject to her. This claim was still valid, but the aims of Christian Rome were higher: she 'prepares souls for eternal glory as once the pagan Republic pursued ephemeral glory.' However, in dedicating his book to Pius II Biondo dropped to a lower conception of glory: he expressed the hope that Pius would soon be celebrating 'a most brilliant and glorious triumph' over the Turk.

Biondo's book was to prove enormously influential. His declaration that the Church of Rome was the natural successor of ancient Rome was basically a half-truth, but he accumulated such a wealth of illustrative detail that he made it seem convincing. The abiding effect of the book was to make Romans aware of their past no longer as a remote relic, but as a living presence interwoven in the

fabric of daily life, not something to be guilty of but something to love. Just as Leonardo Bruni had awoken patriotism in Florence in 1400 with a panegyric praising his city as the successor of ancient republics, so Biondo awoke Roman patriotism and a healthy ambition to emulate the past. From now on classical Rome was to be an abiding influence.

Biondo's book was not, however, without dangers. It played down the unique character of Christianity, which at times seems to be merely one more manifestation of the eternal city, and by ignoring the part played by Greek ideas and techniques in Roman civilization, it diverted attention from Greek authors, the study of which had proved so fruitful in Florence.

Biondo, as we have seen, compared the Popes to Consuls, and the cardinals to Senators. That is to say, he thought that the Church resembled and should continue to resemble the Roman Republic. However, since the Republic had given way to the Empire before becoming, in Biondo's eyes, the Church of Rome, it was natural for any reader who believed in unlimited papal power to assume that the Church was the new Empire, the Pope the new Emperor. This in fact is what usually happened, and the effect of this kind of interpretation can be seen in the following incident, recounted by Pius II in his *Commentaries*, a book whose title and third-person style is modelled on the *Commentaries* of Julius Caesar.

One hot summer's day Pius was travelling from Santa Fiora to Rome. Because of gout, he was carried on a gilded litter, accompanied by a colourful suite of courtiers and horsemen. Pius's stern nature relaxed on such journeys. He noted the blue of flax fields, the scarlet of wild strawberries, the orange of beeches in autumn, and he liked picnics, especially if a fresh-caught trout was served. As the procession wound over the hills they came on a cowherd tending his beasts. The cowherd realized that some great lord was approaching, and thinking the dust and heat might have made him thirsty, he took out his gourd, squatted beside one of the cows and filled the gourd with milk. Then, excited but hesitant, he offered it to the man who sat in the gilded litter. Pius looked fastidiously at the gourd, which was very dirty and covered with grease. It would be easy to hand it to one of his cardinals or simply to order the procession forward.

But suddenly there came to his mind a passage from Plutarch's *Life of Artaxerxes*. Travelling in a distant land, Artaxerxes arrived at a stream where a peasant offered him water in his cupped hands, and Artaxerxes gratefully quenched his thirst. So finally Pius accepted the gourd and, to the cowherd's great satisfaction, drank the milk.

This small event has a triple interest: it shows how men steeped in classical literature tended to see life as a palimpsest; it shows a humanist acting graciously in imitation not of Christ but of a pagan; and it shows the Pope to whom Biondo had dedicated his book identifying himself with an absolute monarch whose nod, like that of the Roman Emperors, could signify life or death.

If Biondo's book awoke Rome to a sense of her own great past, it also therefore provided a new notion of the Papacy. Henceforth, and throughout the sixteenth century, the Pope was to see himself as in some sense the successor not only of Peter but also of the Roman Emperors. The medieval concept of the Pope as 'priest-king' no longer carried much weight, whereas this 'historical' theory of the Pope's temporal power made an appeal to men enamoured of the classical world, though it was not calculated to please the Germans, who considered their own Holy Roman Emperor to be the lawful successor of the Caesars. The theory was further enhanced by the publication in 1470 of Suetonius's *Lives of the Caesars*. This provided portraits of Julius Caesar and eleven Emperors in unforgettable detail. The book was widely read and constantly reprinted. It was complemented by the publication of Tacitus's *Histories* and books 11–16 of the *Annals*, the three works between them providing a picture of the early Empire much more vivid than any available picture of the Republic in its prime. It was probably Suetonius's work that gave Sixtus IV the idea of commissioning from Platina the *Lives of the Popes*, in which Christ is referred to as 'Emperor of the Christians'.

The new ideal had much in it of good. The early Roman Emperors helped to spread civilization throughout Europe, and Rome's proudest title had been not Conqueror of Nations but *caput mundi*, Head of the World. Used with discretion and in the spiritual sense specified by Biondo, it could lead to a new sense of unity within Christendom.

But the ideal was also open to grave abuse, for the Emperors had tried and often succeeded in setting themselves above the law. The first to abuse the ideal was Roderigo Borgia. Elected Pope in 1492, he chose for himself the name of Alexander the Great, having already chosen for his son the name of Caesar. Pope Alexander VI seems to have considered himself, like a new Tiberius, wholly above the moral law. He kept a mistress, he decorated his apartments with such scenes as *The Bath of Susannah*, he entertained mixed company with the spectacle of stallions suddenly let loose among a herd of mares. His nepotism savoured more of the Caesars than of earlier Popes. On two occasions he handed over control of the Vatican palace to his daughter Lucrezia during his absence, with power to open his correspondence. For his son Juan he carved the dukedom of Nepi out of possessions of Roman barons, and to Caesar he made over much of the Papal States. There had been popes more depraved during the tenth century, but coming at a time of serious intellectual self-searching, Alexander's behaviour caused general disgust and strengthened the hand of all who desired reform.

In Alexander's pontificate occurred the decisive event that divides the fifteenth from the sixteenth centuries: the invasion of Italy by King Charles VIII of France—and the Pope's meeting with Charles in 1495 aptly symbolizes the reaction of Italy as a whole to the French. Alexander was by no means a physically weak man; he liked bull-fights, and seems to have seen himself as a bull-like figure, the family blazon being a bull; yet when he met the tiny myopic youth of twenty-four Alexander quite literally collapsed. He fell into one of those deep faints to which he was subject, and had to be helped out of the garden. It was as though he foresaw, behind the youth with the nervous tic, his tough Breton, German and Scots mercenaries, the whole huge army of 60,000 which was soon to occupy Naples and defeat the combined Italian forces at Fornovo, as though he foresaw the four other invasions within his lifetime which were to divide Italy like surgeons dissecting a leg.

There in the Vatican garden the venerable papal ideal of a *respublica christiana*, of collaboration between royal sword and papal crozier, was seen to be defunct. Europe had now fragmented into tough nation states bent on expansion. It was for Alexander's

successors, if they could, to keep the Papacy independent, politically as well as economically, in face of this new threat. It was for them to show whether, with tact and without hubris, they could make good their claim to be heirs of the Roman Emperors. It was for them to try and rally the hundred and one lordships of Italy to a common purpose. Only they now had the requisite authority for, by the first few years of the new century, Milan was occupied by the French, Naples by the Spaniards; Florence, impoverished, was still vainly trying to recapture her port at Pisa, stolen by the French. What power and hope that remained were centred in the city of Rome.

CHAPTER 2

Julius II

ON THE LAST DAY of October 1503 thirty-eight cardinals entered the Vatican Palace in order to choose a new pope. It was the second conclave that year, for Pius III, the successor of Alexander VI, had died after a pontificate of only one month. Each cardinal had one servant and was allotted a cubicle containing a bed, hung with silk curtains and marked with his coat of arms. The windows of the hall had been bricked up and when the cardinals were inside the doors were locked. One of their number went round after dark with a torch in order to ensure that no unauthorized person had slipped through the three rows of guards who ringed the hall. At dinner-time servants placed food in special wooden containers: a senior official cut open the bread, carved the chickens, prodded the joints of meat and held the decanters of wine to the light before sending them in to the cardinals through a revolving hatch. Even so, messages sometimes passed in or out: at the conclave of 1513 the Englishman Bainbridge made known the name of the cardinal then in the lead by scratching it on the base of a silver platter.

The cardinals were obliged to elect one of their own number—that had been the rule since 769—and must do so by a two-thirds majority. Three-fifths of the cardinals were Italian, but so disunited that Louis XII, who held the Duchy of Milan and the Kingdom of Naples, was convinced he could secure the election of Georges d'Amboise. The energetic Giuliano della Rovere argued that a French pope would move the Papacy back to Avignon. Rovere entered the conclave a firm favourite with the Romans, who betted heavily on papal elections, and he took a leading part in the discussions, arguments and bargaining that ensued. Later that night the cardinals sat down at the conclave table, on which lay paper, ink,

reed and quill pens. Each cardinal wrote on a slip of paper one name only, then went to the altar on which stood a golden chalice. Removing the paten, he placed his slip in the chalice, then re-covered it with the paten. When the slips were counted, it was found that all but three cardinals—Amboise, the Neapolitan Carafa and Casanova, a Spaniard—had voted for Rovere. According to custom, Rovere then signed a document promising to hold a Council within two years. After that and homage by the cardinals the conclave ended. It had been the shortest in history.

The new Pope, who took the name Julius II, had been born in Albissola, near Savona, on 5 December 1443, his father, Raffaello della Rovere, being a brother of Sixtus IV, his mother, Teodora Manerola, of Greek origin. As a boy he was very poor and used to earn a little money by sailing onions in a small boat down to Genoa. He joined the Franciscans and took a law degree in Perugia. In 1471, when his uncle became Pope, he was made Bishop and Cardinal. He successfully administered and quelled rebellions in the Papal States and later, as Legate to France, got to know French ambitions first-hand.

Julius was a fine-looking man. He had a big head, straight nose, powerful jaw and deep-set eyes with an awe-inspiring expression which Italians call *terribile*. His nervous energy was such that he was seldom still for a minute, and he said exactly what he thought—'It will kill me if I don't let it out.' He had a quick temper and carried a stick with which he would beat those who incurred his anger. When annoying documents were submitted, he would throw his spectacles and the documents too at whoever had brought them. He was also a man who liked to do everything himself. When ill, he ignored his doctors and, to their horror, treated a high fever by chewing, without swallowing, quantities of plums, strawberries and small onions.

Julius kept a good table, his favourite dishes being chicken, game and sucking pig, while his Lenten fare consisted of prawns, tunny, lampreys from Flanders and caviar. He also enjoyed a good wine, especially those of Samos and Corsica. Though as a cardinal he had had three daughters, women no longer played any part in his life. He was essentially a serious person and had so loathed Alexander VI

that he spent part of the Borgia's reign in self-imposed exile in France. Only once was he heard to make a joke. Proto da Lucca, a member of his suite and an incessant chatterer, asked him for the bishopric of Cagli. 'Impossible,' said Julius. 'In Spanish *caglio* means "I'm silent".'

The new Pope found a very grave situation in Italy. His independence was threatened from three different quarters. Profiting from disorders under Cesare Borgia, the key cities of Bologna and Perugia had rebelled against papal suzerainty, while the Venetian Republic had seized two more papal cities, Faenza, the majolica centre, and Rimini. Even graver was the French threat. In December 1503 the French lost the Kingdom of Naples to the Spaniards, but it soon became clear that they intended to make good that loss by expanding in northern Italy. Installed in the Duchy of Milan and controlling the politics of Florence, they were busy wooing Mantua from its suzerain the Emperor and Ferrara from its suzerain the Pope.

Julius decided to try and regain the papal cities first. In 1506 he ordered his vassal Guidobaldo of Urbino to raise 500 cavalry, but instead of entrusting them to a general Julius took command of them himself. It was a bold and startling step but, he believed, the only way to get results. Never before had a Pope ridden out of Rome at the head of an army in order to crush a rebellious city, and amid the general amazement none was greater than Gianpaolo Baglione's, leader of the rebellion in Perugia. Though he was tough and unscrupulous—Machiavelli accuses him of parricide and incest—Baglione lost his nerve and rode forward to Orvieto, where he knelt before Julius, made his submission and offered a levy of troops. Julius forgave him: 'But do it again and I'll hang you.'

Julius then pressed over the Apennines for Bologna. It was bitter cold. As his mule-drivers stumbled through patches of snow, they swore and cursed; after each lapse Julius, who liked an oath himself, gruffly absolved them. The sixty-two-year-old Pope crossed torrents swollen by floods and clambered on foot over rocky slopes, but he would get up at dawn to lead the next day's march. His energy was such that even the French king responded to his curt call for help against a rebel. Giovanni Bentivoglio, the rebel in question, reviewed his 6000 troops in the main square of Bologna and

promised to fight to the death. But steadily the warrior Pope advanced, with his 500 cavalry and the aura of success at Perugia. It was too much for Bentivoglio. On 1 November 1506 he secretly slipped away, and ten days later Julius entered Bologna amid wildly cheering crowds. The following Palm Sunday the Pope returned to Rome, where he was welcomed by arches modelled on that of Constantine, decorated with statues and pictures. True, the arches were only of wood, but their inscriptions left nothing to be desired: '*Tyrannorum expulsori*', '*Custodi quietis*' and '*Veni, vidi, vici*.'

Julius next turned to Faenza and Rimini. First he tried diplomacy, but when he asked to see Venice's title deeds to the two Adriatic cities, the Venetian ambassador replied with cool insolence: 'Your holiness will find them written on the back of Constantine's donation to Pope Sylvester of the city of Rome and the Papal State.' Julius was furious and confided to Machiavelli, 'To ruin the Venetians, I'll join with France, with the Emperor, with anyone.' This in fact is what he did. In December 1508 he united France, Germany and Spain in the League of Cambrai, ostensibly against the Turk, in fact against Venice, and on 14 May 1509 a powerful French army routed the Venetians near Cremona. Venice immediately handed over Faenza and Rimini to Julius.

The hardest part of Julius's task now remained: to expel the French. Julius would repeatedly say how he longed for 'Italy to be freed from the barbarians.' If the term 'barbarians' savours more of the Roman Emperors than of a Pope, the concept of freeing Italy as a whole—not only the Papal States—was large-minded, and well in advance of most political thinking of the day.

Julius decided to join with Venice and attack the French through their main ally, Ferrara. He saw the war as a personal trial of strength between himself and Louis XII, 'a cock who wants all the hens'. After wintering in Bologna, where he was struck down by serious illness and for a time lay delirious, Julius rose from his sickbed, mounted his horse and on 2 January 1511 rode out of the town in high spirits: 'Let's see who has the bigger testicles, the King of France or I.'

In a heavy snowstorm Julius joined his mainly Venetian army outside Mirandola, a key town of 5000 inhabitants 30 miles west of

Ferrara, and defended by powerful walls, a moat and 900 troops, part French, part Ferrarese. Julius took command. Wearing armour under a white cloak with a fur collar, his head muffled in a sheepskin hood—'he looks like a bear,' wrote the Mantuan ambassador—Julius toured the lines in snow 'half as high as a horse', set up his nine cannon, and cursed the enemy: 'Rebels! Robbers! That swine of a duke!' He talked of nothing but capturing the town. Returning to his billet in a convent kitchen near the front line, he would chant over and over, 'Mirandola! Mirandola!', bringing a smile of admiration even to his half-frozen aides.

Twelve days later Julius was lying asleep when the convent kitchen received a direct hit from an iron cannon-ball ten inches in diameter. Two of his grooms were wounded but Julius was unhurt. He calmly changed his billet and sent the cannon-ball to the sanctuary of Loreto, where it is still preserved. When the second billet also came under fire, he moved back to the first. Meanwhile the English ambassador arrived and with all the innocence of a newcomer asked why Julius was fighting his compatriots and not the Turk. 'We'll talk about the Turk,' Julius replied, 'when we've taken Mirandola.'

Everything had to bend to the Pope's iron will, even his gout-weakened body. In weather so cold that the Po had frozen hard, he was everywhere at once, cheering on his men, directing the cannon. At last the thick walls were breached. On 20 January the commander of Mirandola surrendered to Julius and was obliged to pay 6000 ducats for exemption from pillage. Not waiting to have the gates unbarred, Julius eagerly clambered in through the breach on a wooden ladder.

Julius's success at Mirandola had a symbolic value out of all importance to the strategic value of the town. It showed that he was in deadly earnest about driving the French from Italy. He was thus able to secure allies. The end came in 1513, when 18,000 Swiss pikemen routed the French at the battle of Novara. The remnants of Louis's army straggled home, while papal troops swept up the Po valley.

Julius had cleared Italy of the French and re-established his authority over the Papal States—two very important achievements. Further-

more, among the city-states abandoned earlier by the French were Parma and Piacenza, both rich, flourishing and strategically placed. Taking the measure of this new Pope who always seemed to win, they declared their wish to become papal cities. The Parmese ambassador addressed a speech to the consistory in which, with more emotion than logic, he recalled that Parma had originally been named Julia Augusta by Julius Caesar, and so ought to belong to the Pope, while a Parmese poet, Francesco Maria Grapaldi, made the same point hexametrically:

> Te Regem, dominum volumus, dulcissime Juli:
> Templa Deis, leges populis, das ocia ferro:
> Es Cato, Pompilius, Cesar, sic Cesare major,
> Sit qualis quantusque velit . . .
> Julia Parma tua est merito, quae Julia Juli
> Nomen habet, sed re nunc Julia Parma . . .

> Sweet Julius, we want you for our king,
> Instead of war you bring peace, religion and law:
> Cato you are, Pompilius, a greater than Caesar,
> Be whatever you choose to be . . .
> Parma which once bore the name of Julius
> Justly belongs to Julius the second . . .

—verses which won Grapaldi a laurel wreath from the Pope.

By annexing Parma and Piacenza Julius considerably strengthened the Papal States, while by expelling the French he brought a glow of pride to all Italians and especially to the Romans. On the evening of 27 June 1512 they celebrated the liberation of Genoa from French rule. The whole city burst into a flood of light. Fireworks shot up and cannon thundered from S. Angelo. The warrior Pope returned to the Vatican amid a procession of torches, while crowds shouted 'Julius! Julius!' 'Never,' said the Venetian envoy, 'was any Emperor or victorious general so honoured on entering Rome as the Pope has been today.'

There were some, however, who refrained from cheering. They believed that by strengthening the Papacy in the things that are Caesar's, Julius had weakened it in the things that are God's. Michelangelo wrote a sonnet lamenting that 'Chalices are turned

into helmets and swords, Christ's cross and thorns to spears and shields', while Erasmus of Rotterdam, studying Greek in Bologna, had watched Julius's triumphal entry in 1506 and described his feelings in *The Praise of Folly*, a book which was to be widely read in Germany:

> Although in the Gospel the apostle Peter says to his divine Master: 'We have forsaken all to follow you,' the Popes claim that they possess a patrimony consisting of estates, towns, taxes, lordships; and when, driven by truly Christian zeal, they use fire and sword to hold on to this dear patrimony, when their holy, fatherly arm sheds Christian blood on all sides, then, elated at having humbled these wretches whom they call enemies of the Church, they boast of fighting for that same Church and defending the bride of Christ with apostolic courage.

The question was as old as the Papacy itself—should the Bishop of Rome imitate the lamb or the lion? If the former, he endangered the truth he had been commissioned to preserve; if the latter, he endangered Christian charity. Julius considered it imperative to preserve his political and economic independence, even by force of arms; others, like Erasmus, considered that the real challenge to the Papacy came over things that are God's, and that the Pope should shame aggressive princes by turning the other cheek.

This, however, was not the only grievance to arise from Julius's temporal and spiritual roles. Shortly after the Pope's capture of Mirandola five of his cardinals—two Spaniards and three Frenchmen—rode away to join the French king. The fruits of their defection appeared on 28 May 1511, when Julius found a summons affixed to the door of the church of S. Francesco, near his lodgings in Rimini. Delegates of the German Emperor and the most Christian King summoned a Council of the Church, to be held on 1 September, an action which had become necessary, they said, in order to comply with the decree *Frequens* published by the Council of Constance in 1417, and neglected by the Pope, who had also failed to keep the solemn promise made in conclave.

The decree *Frequens* had indeed laid down that a Council should be held every ten years; there had been none since 1439. And Julius had indeed sworn to hold a Council by 1505; it was now 1511. Why

had none been held? Why did the summons plunge Julius into gloom? Why was a Council anathema to him, as it had been to all Popes for seventy years? The answer lay in another decree, *Sacrosancta*, passed by that same Council of Constance, to the effect that the General Council, representing as it did all Christendom, derived its authority directly from Christ, hence everyone, the Pope included, was bound to obey it in all that concerns the faith.

This decree had given rise to two conflicting interpretations, both with honourable antecedents as far back as the twelfth century. One held that a Council was 'above' a Pope, while the other—the Curia's view—argued that *Sacrosancta* had possessed merely an interim validity, from 1415 to 1417, when there had been either a doubtful Pope or no Pope at all.

The first interpretation was held by many men of goodwill who genuinely wished to reform the Church and believed that such reform could be achieved only by limiting the Pope's absolute power. Unfortunately for the reformers, the same interpretation was also upheld by any and every prince at odds or at war with Rome, and their lawyers used it as ammunition to bombard the Popes politically. The political conciliarists outnumbered the genuine conciliarists and had, by their unscrupulousness, ruined the latter's case with Rome. Indeed, while French lawyers were even now evolving a view of the Church little short of Gallicanism, the Papacy, in self-defence, had been hardening interpretation of *Sacrosancta* to the point where Pius II had actually excommunicated in advance anyone who dared to call a Council.

For two months Julius pondered how to deal with the summons. He thought of declaring the throne of France vacant and transferring it to Henry VIII of England, but this plan never went beyond the draft stage. Finally he decided on a much more effective measure. He himself summoned a Council, one he believed he could control, to assemble the following spring in Rome.

The pro-French cardinals duly met in November, at Pisa, supported by a special issue of French coins inscribed *Perdam Babylonis nomen* and, as expected, they declared Julius suspended. But their assembly was now no more than an 'anti-Council', and when Emperor Maximilian withdrew his support from it, no one took its

activities seriously, since it was obviously just an instrument of French policy.

Julius's Council, which assembled in the Lateran in April 1512, was attended mainly by Italian bishops, others being deterred by the war in north Italy. This strengthened Julius's already strong hand still further. Indeed, like the Roman Emperors, he now had a personal bodyguard consisting of 200 Swiss soldiers, the Swiss being recognized as the best fighting men of the day. Julius completely controlled the Fifth Lateran Council to a degree hitherto unknown. Foreign ambassadors might address the bishops only with the Pope's permission, and the Council was forbidden to issue decrees in its own name. All decrees took the form of papal bulls, signed by Julius.

To Julius himself and to the Curia this kind of Council seemed a victory, but like his victories on the battlefield, this too had a dark side. By his very strength Julius defrauded the Council of its rightful and necessary role. Instead of acting as a restraining influence on the Pope and voicing the anxieties of Christendom, it merely acted as the Pope's instrument. This was to anger genuine conciliarists, notably in Germany. Furthermore, Julius left in abeyance the burning question of how *Sacrosancta* should be interpreted, so that in France, Germany and England many continued to believe that a Council was the Church's final court of appeal. As late as 1534 Sir Thomas More, no mean scholar, could write to Thomas Cromwell that, while firmly believing the primacy of Rome to have been instituted by God, 'yet never thought I the Pope above the general council.'

Julius was a successful soldier and a successful politician. But he was not only these things. At heart he seems to have been a man of peace, a member of the Order of St Francis of Assisi whom circumstances obliged to wage war. It is significant that his favourite pastimes were fishing and sailing, and that he liked gardens. Behind the Vatican he laid out the first considerable Roman garden since ancient times, in which aviaries and ponds were shaded by laurels and orange and pomegranate trees. He liked Dante and, lying ill in Bologna, listened to his architect friend Bramante read the *Comedy* aloud. He was very fond also of classical sculpture, his purchases including the *Apollo*

Belvedere, the *Tiber* and the *Torso del Belvedere*. When the *Laocoön* was discovered on 14 January 1506 by a man digging in his vineyard near the Baths of Trajan, Julius bought it for 4140 ducats and had it conveyed on a cart to the Vatican along flower-strewn roads to the pealing of church bells.

Julius's patronage of the arts has left a lasting mark on our civilization. It is intimately linked to his political activity, not only because his political successes kept Rome independent and provided money for the arts but because both express the Pope's determination to assert his authority as an essential condition for preserving and proclaiming Christ's message.

When he had been Pope for barely eighteen months and all his successes lay in the future, Julius conceived the idea of ordering his own tomb. It would be no ordinary resting-place but a colossal marble edifice decorated with many statues as fine as those in his own collection, a statement in contemporary terms of papal authority. But was there an artist to realize a work so grandiose? Julius, who had seen the *Pietà* in St Peter's and certainly heard about the *David*, called on Michelangelo.

The former protégé of Lorenzo de' Medici was then aged twenty-nine. Stocky, with a broken nose and curly hair, he was a man who spoke little, worked much and lived simply. He was generous to the poor and needy, and possessed of a strong trust in Providence: 'God did not create us to abandon us.' But towards his fellow-men he showed less trust. He was secretive and liked to work in a locked room. His sturdy Florentine independence tended to defiance, so that some found him 'frightening' and 'impossible to deal with'.

Michelangelo at once answered the Pope's summons. He possessed the largeness of vision to enter into Julius's idea of a vast tomb, and drew a sketch of a free-standing rectangular monument, some 30 feet long and 20 wide, adorned with statues and rising in three zones to a catafalque. Julius liked the sketch, gave Michelangelo a contract at a salary of 100 ducats a month and sent him off to Carrara to obtain 100 tons of snow-white marble.

After eight months' gruelling labour in the Carrara quarries Michelangelo set up a workshop in front of St Peter's and prepared to begin the tomb. Julius however had meanwhile conceived an even

more ambitious plan—the rebuilding of St Peter's—and his passion for the tomb had cooled. In April he told a goldsmith and his master of ceremonies that he would not give another penny for stones, whether large or small. Michelangelo, worried, asked several times for an audience, but Julius, who was preparing to lay the foundation stone of the new St Peter's, was too busy to see him. Finally, on 17 April 1506, Michelangelo was turned out of the palace.

This rebuff both angered and alarmed him. He sensed secret enemies: 'I believed, if I stayed, that the city would be my own tomb before it was the Pope's.' In 1494 at the time of the French invasion he had fled Florence, and now once again he took flight, selling his scanty possessions and galloping full speed for Florence, pursued by five of the Pope's horsemen. Once safe on Florentine soil, he wrote to Julius: 'Since your Holiness no longer requires the monument, I am freed from my contract, and I will not sign a new one.'

In November 1506 Julius entered Bologna in triumph and, not for the first time, invited Michelangelo to re-enter his service. Persuaded by the Florentine Government that it would be patriotic to do so, Michelangelo swallowed his pride and rode to the brown-brick papal city. No sooner had he pulled off his riding-boots than he was escorted to the Palace of the Sixteen, a rope round his neck as a symbol of repentance. Here Julius eyed him sternly. 'It was your business to come to seek us, whereas you have waited till we came to seek you,' alluding to his march north.

Michelangelo fell on his knees. He had left Rome, he said, in a fit of rage, and now asked pardon. Julius made no answer, but sat with his head down, frowning. Finally the grim silence was broken by a courtier-bishop.

'Your Holiness should not be so hard on this fault of Michelangelo; he is a man who has never been taught good manners. These artists do not know how to behave, they understand nothing but their art.'

In a fury Julius turned on the bishop. 'You venture,' he roared, 'to say to this man things that I should never have dreamed of saying. It is you who have no manners. Get out of my sight, you miserable, ignorant clown.' He struck the bishop with the stick he always carried, and to Michelangelo reached out his hand in forgiveness.

Julius then explained that he wanted a statue of himself in bronze: no ordinary statue, but one 14 feet high—twice the height of the *David* in Florence. How much would it cost?

'I think the mould could be made for 1000 ducats, but foundry is not my trade, and therefore I cannot bind myself.'

'Set to work at once,' said Julius.

Michelangelo lodged in a poor room, where he slept in the same bed with three helpers for casting the statue. At the end of June they began the bronze-pouring. Technically so large a work presented many problems, and only the bust came out, the lower part sticking to the wax mould. Michelangelo started again and in February 1508 succeeded in delivering a perfect statue weighing six tons. It depicted Julius in full pontificals, the tiara on his head, the keys in one hand, the other raised in blessing. The huge bronze admirably typified the more-than-lifesize Pope, but its dimensions are probably to be explained by Julius's interest in the Emperors, so many of whom had erected colossal statues of themselves: Nero's had been 150 feet high. Doubtless Michelangelo was struck by the difference between Julius's concept of a ruler and that of his former patron, Lorenzo de' Medici, always shunning the limelight and insisting that he was merely one citizen among many; yet both concepts came from classical antiquity.

The statue caused wonder among the people of Bologna. One man asked Michelangelo which he thought was bigger, the statue or a pair of oxen, to which the sculptor, who did not suffer fools gladly, replied: 'It depends on the oxen. You see, an ox from Florence isn't as big as one from Bologna.' Set in position above the door of the church of S. Petronio, the statue of Julius did not remain there long. During a revolution in December 1511 it was toppled down, broken amid gibes and, save for the head, recast as a culverin by Alfonso, Duke of Ferrara, who called it *La Giulia*. So the statue intended to honour Julius ended up as a gun pointed against him.

A friendship was ripening between the Pope and Michelangelo. Though the Pope was twice the sculptor's age, both were virile, serious, energetic and possessed of breadth of vision. Back in Rome at the beginning of 1508, Julius conceived the plan of getting Michelangelo to decorate the ceiling of the Sistine Chapel with

designs, and the lunettes with large figures: at present the ceiling was painted blue with gold stars. Michelangelo protested that he was a sculptor, not a painter, and would prefer to start carving the Pope's tomb. But finally he consented.

Michelangelo found himself to some extent limited by the existing decoration. The side walls depicted scenes from the life of Moses facing comparable scenes in the life of Christ: the history of man under the Law, then under Grace. Michelangelo's first idea was to take man's history a stage further by painting the Apostles in the lunettes. After making several sketches, he decided that this decoration would be 'poor'. 'Why poor?' asked Julius. 'Because the apostles were very poor.' Evidently Michelangelo meant austere and humble, whereas his own particular gift, as he knew by now, was for celebrating the power and beauty of the human body.

Julius and Michelangelo then looked for another subject. Now Lorenzo de' Medici's circle in Florence had claimed that there exists an underlying harmony between Hebrew, pagan and Christian thought, and this view was widely held by humanist scholars in Rome. Julius was sympathetic to it, and Michelangelo had been brought up in it. According to this view, the world of Greece and Rome which was being rediscovered in all its splendour was not a rival but an ally of truth. Just as the Prophets of Israel and the Sibyls from pagan darkness could speak of the true God, so did the nudes of Polyclitus make an authentic statement about beauty, therefore about God. Michelangelo had already hinted at such an approach in his Doni *Holy Family*, where the Christ-child is portrayed against a background of nude youths in the classical style, thus suggesting that Christianity fulfils the beauty and promise of antiquity. This was evidently the thinking that led Julius and Michelangelo to agree on a new subject: Scenes from *Genesis*, that is, the history of man before the giving of the Law; treated, however, prophetically. The Scenes would look forward, through Prophets, Sibyls, the ancestors of Mary and nude figures in the classical style symbolizing natural man, to the Incarnation of Christ. But instead of confining these scenes to the lunettes and painting the ceiling with 'the usual adornments', Michelangelo offered to paint the whole surface with figures, more than 10,000 square feet.

This was seven times the area Giotto had painted in the Scrovegni Chapel and it was, as contemporaries recognized, a superhuman task. But here precisely lay its appeal for Julius, who delighted in campaigns that daunted his closest advisers, and for Michelangelo, who had learned from Ficino's neo-Platonism that an artist receives guidance from God to organize and complete His universe. That summer Julius gave Michelangelo a contract for the ceiling at a fee of 6000 ducats, all paints chargeable to the artist.

Now Michelangelo had never painted a fresco in his life. So while completing the first cartoons and supervising the erection of wooden scaffolding, he sent to Florence for his young studio assistants, hoping that their technical knowledge would help him. But their designs failed to satisfy him. One morning he made up his mind to scrap everything they had done. He shut himself up in the chapel and refused to let them in again.

He was alone with the immense bare vault. Climbing the ladders to the top of the scaffolding, he began work on the first scene, *The Flood*. He smeared the ceiling above him with a fine layer of *intonaco*—a plaster composed of two parts volcanic tufa and one part lime, stirred together with a little water. He chose tufa instead of the usual beach sand because it gave a rougher, less white surface. On this layer of *intonaco* he placed the appropriate piece of the cartoon, smoothing it quite flat and fastening it with small nails. He then dusted powdered charcoal over it. The charcoal passed through holes in the cartoon pricked beforehand and adhered to the moist *intonaco*, leaving the outlines of the figures. Later he was to omit the charcoal dusting and prick the outlines directly on to the plaster with an awl. He then unfastened the cartoon and began to paint. He had to be quick, especially in summer, when plaster dried in a couple of hours, and accurate too, because mistakes could not be rectified.

In summer the air immediately under the vault was suffocating and the plaster dust irritated his skin. Watercolours dripped on to his face and even into his eyes. He worked standing, looking upwards. In a burlesque sonnet illustrated with a sketch he says that the skin on his throat became so distended it looked like a bird's crop. The strain was such that after a day's work he could not read a letter unless he held it above him and tilted his head backwards.

When he had finished *The Flood*, Michelangelo dismantled that part of the scaffolding and looked at it from below. He saw that the figures were too small and determined to continue on a broader scale, converting the form, mass and stresses of the vault into artistic values. But would he be able to continue? 'It has been a year since I got a penny from this Pope,' he wrote on 27 January 1509, 'and I don't ask him for any, because my work isn't going ahead well enough for me to feel I deserve it. That's the trouble—also that painting is not my profession.'

Payments however did begin, and when Julius left on his Ferrara campaign again abruptly stopped. At the end of September 1510 Michelangelo found he had no money to buy pigments, so laying his brushes aside he rode the 250 miles to Bologna and persuaded Julius to resume payments. In October he was paid 500 ducats in Rome. But presently money again dried up, and with it his paints. Michelangelo rode a second time to Bologna, and again a hard-pressed Julius decided that the ceiling must come before everything else. In January 1511 Michelangelo had been paid and was back on his scaffolding.

When Julius returned to Rome he naturally wanted to see how work was progressing. Several times he climbed up, with Michelangelo's strong hand supporting him on the highest ladder, to study the latest scenes, and each time he would ask, 'When will you finish?' Michelangelo would reply, 'When I can.' He had become more assured now and was painting figures in the lunettes without any cartoon. But when Julius received that answer for the third time, in autumn 1512, he exploded into one of his furies. 'Do you want me to have you thrown off the scaffolding?' Though he would have liked to add some touches of gold and ultramarine, Michelangelo saw that the Pope would not wait any longer. So he signed the work, but instead of putting his name he painted the Greek letters Alpha and Omega near the prophet Jeremiah, thus attributing any merit in the ceiling to God, through whose assistance it had been begun and ended. Evidently Michelangelo saw himself in Platonic terms, like the Sibyls and Prophets, as an instrument through whom God made manifest His beauty.

The scaffolding was dismantled and without even waiting for the

dust to settle Julius hurried to gaze on the finished whole. The expectations of three and a half years were not disappointed. Julius liked the ceiling very much indeed, as Michelangelo wrote to his father, and ordered it to be shown to the public on 31 October 1512, the Vigil of All Saints, the feast which celebrates the human race glorified in heaven. All Rome flocked to see it, says Vasari, and one can imagine the effect on them of so vast a work, containing 343 figures, some of them as much as eighteen feet high, in its pristine colours of rose, lilac, green and grey.

At a literal level the ceiling is straightforward enough. Five scenes of Creation are followed by the Fall and Expulsion, the Sacrifice of Noah, the Flood, and Noah's Drunkenness, that darkening of the spirit which was later to be righted when God gave the Ten Commandments to Moses: since that event was already depicted on the wall below, the ceiling dovetailed into the rest of the chapel. Below the Scenes from *Genesis* are twelve Prophets and Sibyls, who by their utterances look forward to the Incarnation; while in the spandrels and lunettes are the ancestors of Christ.

In depicting these events, Michelangelo makes man the hero. In the centre of the ceiling and dominating the whole is the figure of Adam. Medieval mosaicists had shown God bending over him and breathing into his body a soul, either as rays or as a little Psyche with butterfly wings, *psyche* being Greek for both soul and butterfly. Breaking with these and other traditions, in an image of genius Michelangelo shows God imparting life through his own and Adam's outstretched fingers. And this Adam is an image of the God who is creating him, a perfect being unflawed by sin. His body is beautiful and unblemished. It is just such a body as Christ will assume, and which we shall have in heaven. Even after the Fall, it is the most perfect of created things. It is also the most versatile. In the rest of the ceiling Michelangelo celebrates the power and beauty of the human body in a wide variety of actions. He depicts titanic, muscular figures engaged in tasks that test them to the limit. He shows them exercising not faith, hope and charity which have not yet arrived in the world, but classical *virtus*, virility. They impose their will on events through bodies that drive like tornados, torrents or avalanches. Even as Prophets and Sibyls they are not passive, they

strain and twist and writhe in order to glimpse the hidden mystery, then to express it. As the ancestors of Mary, they struggle to protect their children, that long stream of expectant humanity flowing from Adam to Christ.

Michelangelo's titanic grand design is enriched by innumerable perceptive details. The Ignudi, the nude male figures who represent man in classical times, carry festoons of oak leaves and acorns, as a sign of the golden age in which they lived, and also in allusion to Julius whose family blazon was the oak tree and who was hailed by many as a restorer of the golden age. Again, the Brazen Serpent erected by Moses to heal the people of Israel harks back ironically to the serpent coiled round the Tree of Life. Classical borrowings too add to the theme of harmony between pagan and Christian thought. In the Expulsion, for example, Adam raises his hands in a gesture of defence from the chastising angel and this is a mirror image of Orestes pursued by the Furies in an antique bas-relief. These and many other details give the ceiling an incomparable imaginative richness.

When the Sistine ceiling was finished, Julius, who the previous year had suffered an almost fatal illness, began to take a renewed interest in his tomb. Michelangelo's design called for three tiers, the lowest where Julius's body would lie, a middle part decorated with seated figures of Moses and St Paul, and an uppermost part on which two angels would support a figure of the Pope sleeping. Julius now set Michelangelo to work on the statue of Moses, whom the Popes considered a prototype of themselves.

Michelangelo's *Moses* is close to the Sistine figures both in time and spirit. He is an incarnation of man's driving will, and since his own will was immensely powerful so must be his body. Whereas in the *David* Michelangelo had exaggerated the size of the head, to signify that the young warrior's triumph had not been one of mere strength, here he exaggerates the size of the arms, boldly marking their veins and sinews. The bearded prophet holds the tablets of the Law in his muscular hands and his gaze, defiant and terrible, was perhaps suggested by Julius in anger. The two horns on his head are explained by the Vulgate's mistranslation of a passage from *Exodus*:

'his brow became horned while he spoke to God', whereas the Hebrew has 'radiant'. The horns were a traditional way of designating Moses in art and even in mystery plays. A last curious point is that in the beard Michelangelo has carved small portraits of Julius and himself in profile, evidently to commemorate their collaboration in the tomb.

During 1513 Michelangelo also made two statues for the lowest part of Julius's tomb. It is uncertain what they represent. Vasari says 'provinces subjugated by the Pope and made obedient to the Apostolic Church'; Condivi says they are two of the three arts, Painting, Sculpture and Architecture, 'made prisoners of death with their patron, since they would never find another Pope to encourage them as he had done.' The two youths, one resigned, the other struggling vainly to free himself, transcend any particular allegory to become symbols of human captivity and, as such, they reveal another side of Michelangelo's character. The body he exalted in the *Moses* and the Sistine ceiling was also the body that held him personally captive, for Michelangelo instinctively preferred the love of men to the love of women. Theoretically man's body was one with the cosmos, in fact it was not.

Michelangelo left the two prisoners unfinished. Several explanations present themselves. He may have left them thus because the relief is more pronounced in unfinished work, or because there is a sense of movement, as though the form were striving to free itself from the block. Or he may have wished them to resemble certain antique statues, such as the *Torso del Belvedere*, which are more expressive when worn and truncated, or he may have intended to associate his figures, through the rough stone, with the cosmos. But if the prisoners are understood to express a temperamental dilemma that never was and never could be resolved, that perhaps provides the most satisfactory explanation of why they were left unfinished.

The tomb too was left unfinished, at least in the form Julius intended, so that later, after the Pope's death, when lesser men whittled away the grand design, these prisoners were allowed no part in it and, like Julius himself in earlier life, went into exile in France. It was Julius however who commissioned them; they belong beside the

Moses, and they remain the most moving testimony of all to the collaboration of a great artist and a great patron.

On 26 November 1507 Julius made one of his lightning pronouncements. He could not bear to live in the Appartamento Borgia any longer, continually reminded of 'those Spaniards of cursed memory' by Pinturicchio's frescoes of Alexander VI, Lucrezia and the rest. He decided to move to four rooms on the second floor. At once he called in Perugino, Lorenzo Lotto and others to begin decorating the first of the *Stanze*, as they are called, and Raphael too when he arrived in Rome at the end of 1508. Perceiving the young man's genius, Julius dismissed the other painters and entrusted the frescoes to Raphael alone.

Raffaello Sanzio was then aged just twenty-six, a slim man with a thin face, dark eyes, slender neck and delicate, probably consumptive, appearance. His sweet, equable character won him everyone's affection. For many years he was in love with *La Fornarina*, the baker's daughter whose large dark eyes and rather round face appear in many of his works, notably the *Sistine Madonna*, in which Julius is also portrayed; it was perhaps for love of her that he put off marriage to Cardinal da Bibbiena's wealthy niece.

Julius imparted to Raphael his plan for the *Stanze*. He wished them to proclaim the absolute power of the Pope, spiritual as well as temporal, the spiritual power being exemplified in the doctrine of the real presence of God in the Blessed Sacrament. Julius had a particular devotion to the Eucharist—in 1508 he took the unusual step of joining the Confraternity of the Blessed Sacrament, a group of Romans who wished to honour God in the Eucharist by providing a torch-carrying escort whenever viaticum was carried to the sick. The Real Presence had been denied by the Bohemians when they separated themselves from Rome and by their theologians was currently under attack.

The Sistine Chapel had proclaimed the Incarnation as the fulfilment of pre-Christian striving, and the most important of the *Stanze*, the library, proclaims the Real Presence as the fulfilment or culmination of other kinds of truth. First, there is the truth of law, symbolized by the *Pandects* and the *Decretals*; second, poetic truth, depicted

under the form of Apollo and the Muses; third, philosophic truth, depicted in a fresco larger than the preceding two, known as *The School of Athens*. In a hall dominated by statues of Apollo and Pallas, symbolizing Reason, the philosophers of antiquity ponder, dispute and finally, in the persons of Plato and Aristotle, reach heights where agreement is possible. Opposite this fresco is one depicting the revealed truth of the Real Presence. Doctors of the Church, saints and popes down the centuries, even Julius's favourite Dante, are shown paying tribute to the Blessed Sacrament exposed in a monstrance, above and converging on which are the Three Persons of the Trinity attended by the Blessed and by angels.

In the next room, his bedroom, Julius chose to state the truth of the Real Presence in terms of an actual historical incident. A certain Bohemian priest had doubts about transubstantiation; in order to try and overcome them he made a pilgrimage to Rome. On the way, at Bolsena, while celebrating Mass, he saw the host in his hand oozing blood. He tried to hide it in the corporal, but the blood seeped through, leaving a cross-shaped mark on the linen. Following on this miracle, the feast of Corpus Christi had been instituted, and the blood-stained corporal was preserved in Orvieto, where Julius had seen and venerated it.

In Raphael's rendering of this dramatic scene a hundred years are bridged in order to show Julius at a prie-dieu watching the miracle take place. He is attended by Swiss guards in the handsome striped blue and orange uniforms he had commissioned Michelangelo to design for them. The mural is not only a beautiful and original composition: it is a notable attempt to arrest heresy with paint.

Raphael had arrived in Rome a somewhat languorous artist, and when he attempted to depict people in action as in the *Deposition* of 1507 he lapsed into a lymphatic formalism. But Julius's *Stanze* are robust and vigorous. *The School of Athens*, in particular, is crowded with energetic figures, notably the portrait of Leonardo da Vinci as Plato. The aging Pope seems to have imparted to the younger man not only his vision of the underlying harmony of classical and Christian truth, but also some of his own unflagging energy.

Julius's patronage extended also to architecture. In this field the

Roman Emperors had been pre-eminent, and it was natural for a Pope who in some degree saw himself as their successor to engage as his architect an expert on the imperial style. This man—the third artist of genius employed by Julius—was Donato d'Angelo Lazzari, known as Bramante from his eagerness in seeking out commissions, *bramare* meaning to solicit. Born in Lombardy in 1444, Bramante was built like a wrestler, with a forceful muscular head and curly hair. Two little facts are known about him: he had a passion for pears and he liked giving supper parties at which he would entertain his friends by improvising on the lyre. However, like many a convivial Italian, Bramante saw himself as essentially sad and solitary, and wrote sonnets to proclaim the fact. He was a friend of Raphael, but did not get on with Michelangelo.

Julius commissioned Bramante to lay out the great garden mentioned earlier, which stretched from the Vatican proper to the thirteenth-century Belvedere villa 300 yards north, to enclose the garden with two long straight galleries, and to reconstruct the villa along the lines of the imperial Temple of Fortune at Palestrina. This reconstruction called for a two-storeyed façade, having for its centre a vast semi-circular niche with flanking walls of blind arcades, the whole being approached by a double ramp ascending in terraces. Although the full plan was never realized, enough was built to set a classical mark on the largely medieval Vatican Palace. The façade of the Belvedere villa was remodelled, and the gallery on the east side built—the other had to wait fifty years. Julius decorated the gallery's open colonnades with frescoes representing the chief Italian cities— another example of his feeling for Italy as a whole—and in the courtyard of the Belvedere villa displayed his *Apollo*, the *Laocoön* and other works of classical sculpture.

The culmination of Julius's life both as Pope and patron was the rebuilding of St Peter's. The idea of a great new basilica, which had been shelved since the death of Nicholas V, naturally appealed to Julius. Not only was the old basilica decrepit, but on men who had come to appreciate the best imperial monuments, its style jarred, notably the vast atrium separating the entrance from the basilica proper, and the crude roof of open timber. Julius wanted a building which would, as he worded it in a bull, 'embody the

greatness of the present and the future'. This could be achieved of course only by turning to the greatness of the past.

'The dome of the Pantheon over the vault of the Temple of Peace', is how Bramante described his concept of the new St Peter's. Like the humanists of Florence, Bramante considered a centrally-planned church most suited to express the perfection of God, and his first design took the form of a Greek cross. However, in order to retain the tomb of St Peter under the dome—Julius would not hear of it being moved—he found that the arms of the cross would have to be shortened unduly. He then submitted a quite different project. Inside, it called for a traditional nave and aisles, outside for a portico entrance derived from the Pantheon, a dome marked with concentric rings like those on the Pantheon also, and four secondary domes at the intersection of the arms. While numerous towers gave the impression of complexity, unity was maintained by heavy cornices extending throughout on the same level.

Julius was not easy to please. He had already turned down plans by Sangallo and Rossellino. But he liked Bramante's new design, approved it in October 1505, commissioned Caradosso to strike a medal depicting its elevation, and ordered work to begin. The soil was marshy, and workmen had to dig down 25 feet before striking solid tufa. On Low Sunday 1506 Julius climbed down to that level to bless and set in place the white marble foundation stone—twelve inches by six by one and a half—inscribed: 'Pope Julius II of Liguria in the year 1506 restored this basilica, which had fallen into decay.'

Thereafter not a moment was lost. Julius proclaimed an indulgence within Italy in order to raise money for the cartloads of honey-coloured travertine which workmen carted from the Tivoli region, marble from Carrara, puzzolane from around Rome, lime from Montecello. Henry VIII sent tin for the roof and Julius, who knew his man, thanked him with barrels of wine and hundreds of Parmesan cheeses. Costabili of Ferrara wrote on 12 April 1507: 'Today the Pope went to St Peter's to inspect work. I was there too. The Pope brought Bramante with him, and said smilingly to me, "Bramante tells me that he has 2500 men on the job; one might hold a review of such an army."'

A single misjudgment marred the great undertaking. Bramante

was so fervent a classicist that he found no beauty in Constantine's basilica. He had the medieval candelabra, icons and mosaics destroyed, though fortunately Giotto's *Navicella* escaped his workmen's hammers. He earned the title of '*il Ruinante*', and a lampoon pictures the architect arriving at the gates of heaven, where St Peter reproaches him with destroying his church and tells him to wait outside until it is rebuilt; Bramante coolly replies that he intends to spend his time replacing the narrow path to heaven by a well-paved Roman highway.

By the end of his reign Julius had spent 70,653 ducats on St Peter's. Four great piers rose to the level of the dome and the arcades which were to bear the dome were partly finished. The walls of the projecting choir were also complete, and vaulting begun on the south transept. Building would continue through many reigns, and modifications would be made to Bramante's designs, but to Julius must go the honour of having chosen so grand a plan and in a mere seven years carried the work so far.

It is difficult to believe that Julius crowded so much action and activity into a pontificate of less than ten years. It was exhausting work for a man in his late sixties to launch out into so many new schemes, and in Raphael's portrait, probably of 1512, the Pope's eyes are downcast and tired, and his powers seem beginning to fail. In the following February he was prevented by illness from attending the fifth session of the Lateran Council. He lay in the room Raphael had decorated for him, close to the new Belvedere, close also to the Sistine Chapel. He could claim to have fulfilled his task of reasserting papal authority and proclaiming Christianity in contemporary terms through the techniques that had most advanced in his day: sculpture, painting and architecture. Indeed the new Christian Rome could now compare favourably with the classical, hence the title of Albertini's little book, published in 1510: *The Marvels of Modern and Ancient Rome*. Only the great tomb was not ready. Julius left 10,000 ducats for its completion, and finally, thirty-one years later, in a much reduced form, it was to hold his mortal remains, not, as he would have liked, in St Peter's, but in S. Pietro in Vincoli.

On 20 February 1513 Julius II died. He was described by the

Florentine historian Guicciardini, no lover of the Papacy, as 'worthier than any of his predecessors to be honoured and held in illustrious remembrance.' The Romans agreed. 'I have lived forty years in this city,' wrote Paris de Grassis, his master of ceremonies, 'but never yet have I seen such a vast throng at a Pope's funeral. The guards could not control the crowds as they forced their way through to kiss the dead man's feet. . . . Many even to whom the death of Julius might have been supposed welcome for various reasons burst into tears, declaring that this Pope had delivered them and Italy and Christendom from the yoke of the French barbarians.'

After Caesar, Augustus

I HAVE THREE SONS,' Lorenzo de' Medici used to say, 'one foolish, one good and one clever.' The clever son was born in the Palazzo Medici on 11 December 1475 and christened Giovanni Romolo Damaso. He was 'brought up in a library'—the phrase is his own—learning Latin and Greek from Poliziano, imbibing the broad-minded philosophical ideas of Pico and Ficino, laughing at Pulci's burlesque *Morgante*, watching Michelangelo shape a block of marble in the Palazzo garden. Destined by Lorenzo for a career that would bring Florentine principles to the capital of Christendom, at seven he received minor orders, at twelve the abbey of Monte Cassino, at seventeen a Cardinal's hat. He studied canon law at the University of Pisa but before he could graduate or learn theology Charles VIII rode in. With his 'foolish' brother Piero he was driven from Florence and spent an unhappy period wandering in Germany and France. In 1497 he returned to Rome and three times served as Legate, on the last occasion being captured by the French at the Battle of Ravenna. He was imprisoned in a pigeon-cote from which, however, he escaped hidden in a basket. He attended the conclave on a litter, suffering from an anal fistula, which between scrutinies his doctor lanced. In a long, commendably unsimoniacal election, during which the sacred college was reduced to a vegetable diet, he was chosen in preference to Raffaello Riario—whom Lorenzo had saved from lynching at the time of the Pazzi plot—mainly by the younger cardinals, who did not want a second nephew of Sixtus IV. He took his name in evident allusion to Leo the Great, who had kept the Hun from Rome—but by diplomacy, not arms. He was still in minor orders and was ordained priest four days after his election.

The new Pope was above middle height, broad-shouldered and

portly. His head was set on a short neck, and the cheeks were puffy. He was short-sighted—hence the magnifying-glass in Raphael's portrait, and his enemies' quip: 'Blind cardinals have chosen a blind Pope.' He had shapely white hands and liked to show them off, as the fashion was, with diamond rings. He perspired easily and during long ceremonies would be seen mopping his face and hands. He also suffered from the cold, and in severe weather would wear gloves, even to say Mass.

Though he was not robust, Leo was a happy man who liked to make others happy. He was generous to a fault and whenever he could grant a favour did so. He had inherited Lorenzo's easy, tactful manner, but not his daring. In politics, for instance, Leo moved cautiously—hence the nickname given him by Julius: 'Your Circumspection'; and once when fire broke out in the Vatican his alarm was judged excessive. Otherwise he had plenty of self-control. He fasted twice a week, and his name was never associated with any woman. He took his religious duties seriously, said his office every day, and once, on ascending the Scala Sancta, was heard to beg God's indulgence for not climbing it on bended knee like the poor women of Rome. As his papal motto he chose the first verse of Psalm 119: 'Happy those who are irreproachable in their life, who walk in the way of the Lord.' The linking of happiness and virtue is typical of the man.

Soon after his election Leo is reported to have said to his brother, 'Let us enjoy the Papacy since God has given it to us.' Though first recorded by a Venetian two years after the event, the *mot* may well be authentic; if so, it is much less ingenuous than it sounds. Leo had been raised in a civic-minded and civilized Republican family, and enjoyment for him meant extending through patronage the principles of Christian humanism. His ambition as Pope was to renew Christianity through learning, literature and the arts. Rome in particular he intended to become a great civilized city, a worthy successor to the Rome of Virgil and Horace. The humanists understood this when they hailed Leo on the morrow of his election with the phrase: 'After Caesar, Augustus.'

To civilize Rome was no small ambition. Despite Julius's building, the city was still an inhumane and bloodthirsty place.

Within memory a Pope's son had been stabbed to death, and when someone who had seen the body being thrown into the Tiber was asked by the magistrates why he had not revealed the fact, he replied that murder was an everyday occurrence and it had never dawned on him to go to the authorities. With advances in medicine poison was now being increasingly and more subtly used; indeed it was a Florentine cardinal, Ferdinando Ponzetti, who in 1521 published the first handbook on poisons. Leo himself was to be the object of a plot headed by Alfonso Petrucci, who disapproved of papal policy in Siena, and five other cardinals. They planned that Leo's fistula should be treated with ointment containing poison. Through an intercepted letter the plot was discovered and quashed, but the incident puts into relief the ambitious nature of Leo's programme.

As an essential condition for civilizing Rome, Leo had to preserve the peace won for Italy by Julius II's wars. Under their ambitious young king, François I, the French again crossed the Alps in 1515, while the election of Charles V as Emperor in 1519 united in a formidable coalition Spanish with German strength. Applying Lorenzo's principle of the balance of power, Leo skilfully got the Emperor to expel François from Milan and thereafter played off the two rulers against each other. He also forestalled any future French schism by the Concordat of 1516. This laid down that the Pope and the King of France were jointly to appoint bishops; it made the King to a certain extent overlord of the French Church, but also at the same time its natural protector. For three hundred years Leo's Concordat was to ensure that French kings would, if only from self-interest, remain loyal to Rome.

Leo began his work of civilizing Rome by refounding the Sapienza, which because of war had been inoperative for thirty years. He did so on a lavish scale. He appointed no less than 88 professors at salaries totalling 14,490 ducats, part of which, in case of sickness, was payable to their dependants. With his usual broad-mindedness he increased the range of faculties: civil law was the largest—Leo lifted the ban on clerics studying this subject—then came rhetoric, philosophy and theology, medicine, canon law, Greek, mathematics, astronomy and botany. Leo rejected the chau-

vinism implicit in Pomponius Laetus's boast that he declined to learn Greek for fear of spoiling his Latin accent; the new Pope summoned Giovanni Lascaris, Lorenzo's former librarian, to strengthen the Greek faculty, and subsidized Varino Favorino, who had once taught him Greek, in his task of composing an important Greek lexicon. Leo also founded a Greek press, attached to the Sapienza, which published scholarly editions of Didymus's *Commentaries on Homer*, Porphyry's *Homeric Questions*, and the *Scholia* of Sophocles's tragedies. He encouraged Cardinal Ximenes in his five-language edition of the Bible, and shipped to him in Toledo boxes of precious Greek manuscripts chained and padlocked. Hebrew studies Leo also promoted by founding a chair of Hebrew and a Hebrew press. When the German scholar Johann Reuchlin was denounced to Rome by the Dominicans for advocating the study of all Hebrew books, even those hostile to Christianity, Leo dropped the case, a gesture which German humanists interpreted as a blessing on free enquiry.

Leo's most imaginative scheme concerns the Latin language. In common with most of his educated contemporaries Leo had a great personal liking for classical Latin and spoke it fluently, but where others saw Latin only as a means of penetrating the admired world of Cicero and Virgil, Leo saw it as a means of attaining through a study of origins to a deeper self-consciousness. With this in mind he decreed that every meeting of the Conservators—the municipal Council of Rome—should open with a speech in Latin by a native Roman about distinguished Roman citizens of past ages. But this was only one half of Leo's plan for Latin. He wished also to make the language of Cicero the universal language of educated men, and as such, an instrument of civilization and peace. Just as the Roman Emperors used Latin to unite their Empire—Latin, claimed Valla, had more power than all the legions combined—so he would use it to unite Christendom. The very first thing Leo did on leaving the conclave was to appoint as his domestic secretaries the two most elegant Latin stylists alive—Jacopo Sadoleto of Modena and Pietro Bembo of Venice—with instructions to draft all the Pope's official correspondence, within and without Italy, in Ciceronian Latin.

With the same aim in mind Leo encouraged the writing and improvisation of Latin verse. At meals he liked to swap impromptu

repartee with Camillo Querno, a prolific versifier with long flowing hair, known as 'the archpoet':

> *Querno:* *Archipoeta facit versus pro mille poetis.*
> *Leo:* *Et pro mille aliis Archipoeta bibit.*
> *Querno:* *Porrige quod faciat mihi carmina docta Falernum.*
> *Leo:* *Hoc etiam enervat debilitatque pedes.*

> *Querno:* The archpoet turns out verses like a thousand poets.
> *Leo:* And puts away wine like a thousand more.
> *Querno:* Pass me the Falernian that inspires my witty songs.
> *Leo:* It excites you and makes you unsteady on your pins.

If Querno failed to produce a reply in perfect hexameters, Leo would add water to his wine.

Leo issued an invitation to the poets of Italy to come to Rome and write Latin verse. Nearly three hundred accepted, and most of them lived at Leo's expense. Young Ariosto was one who came for a time. He was warmly welcomed by the Pope, who kissed him on both cheeks and gave him a copyright for his verses, but finally he decided that he would rather be 'first in Italian than second in Latin.' Among those who stayed the majority produced clever occasional pieces. Biagio Palladio wrote about the passing of the most famous Roman courtesan, Imperia, who at the age of thirty-one drank poison after a lovers' quarrel: 'Mars gave imperial rule to Rome, and Venus gave us Imperia; Fortune deprived us of imperial rule, Imperia of our hearts.' In an excellent poem Sadoleto hailed the *Laocoön* as an image of *Roma rediviva* and said he could almost hear the figures groaning, whereupon Francesco Arsilli, not to be outdone, wrote a poem about Sadoleto praising the *Laocoön*: 'Never, Sadoleto, will your name be lessened by usurious Time.'

A few of the three hundred were genuine poets. They found that a classical language and the establishment of classical standards released creative energies, and they used the materials of antiquity in order to express a distinctively personal vision. Such was Marcantonio Flaminio, who arrived from a village in the Dolomites at the age of sixteen, and was hailed by Leo as a prodigy. Flaminio's pure style is revealed in the opening strophe of his *Ode to Diana*:

Virgo sylvestrum domitrix ferarum,
Quae pharetratis comitata nymphis,
Cynthium collem peragras, nigrique
Silvam Erymanthi. . . .

Maiden, tamer of the wild beasts of the woods,
Who, in the company of the quiver-bearing nymphs,
Range Cynthius's hill and the forest
Of black Erymanthus. . . .

Another remarkable poet is Zaccaria Ferreri, abbot of Monte Subasio. He had actively supported the Council of Pisa, but Leo was not one to bear a grudge, and he commissioned Ferreri to replace the medieval hymns of the Breviary, whose language and rhymes were deemed inelegant, with new ones in classical Latin. Ferreri published his versions in 1525. For the feast of Corpus Christi, instead of Thomas Aquinas's *Pange Lingua*, he offered beautiful, closely knit sapphics, of which this is the last stanza:

Zographi non ars sapientis ulla
Fingere, aut ullus penetrare vivens
Hoc valet sacrum, neque te triforme
Numen Olympi.

Artist's brush is powerless to paint
And mortal mind to probe this act,
Or to fathom you, threefold
God of Olympus.

The best of the Latin poets patronized by Leo is Marco Girolamo Vida, who was born in Cremona about 1490 and came to Rome with verses on chess and silkworms. Leo saw that the young poet was capable of more than these trifles. Wishing to be an Augustus to a new Virgil, he commissioned Vida to write a Christian *Aeneid*. He also gave Vida the necessary means, naming him prior of a quiet and beautiful monastery, S. Silvestro in Frascati. There Vida wrote his *Christias*, six books of chiselled Latin hexameters recounting the life of Christ from Bethlehem to his death on Calvary. It is a sincere work —Vida was a holy priest—with none of the pagan trappings which Erasmus thought disfigured the *De Partu Virginis* by Sannazzaro of

Naples, and it remains the finest Latin poem of the sixteenth century.

Latin prose Leo also encouraged. It was at the Pope's special request that Pietro Martire d'Anghiera, Queen Isabella's Lombard chaplain, wrote his important account of thirty-four years of ocean discovery, *Decades de orbe novo*, first published in full in 1516, and it was the Pope who urged the converted Moslem, Leo the African, to write a description of his native continent. By such activities as these, by his example and patronage Leo did more than anyone to establish the language of Cicero's Rome as a vehicle for contemporary writing. During his reign Italian poets in France, Spain and England were writing Latin verses and encouraging others to do so. There seemed a real chance that Latin-writing humanists could draw together the nations of Europe.

Leo's literary patronage extended also to the vernacular, and to a sphere which no previous Pope had entered, namely the theatre. As a boy in Florence Leo had acted in at least one St John's Day play, and his tutor Poliziano had written in *Orfeo* the first secular play in Italian ever to be performed. Ferrara had been staging Plautus and Terence since 1486, and vernacular comedy since around 1500. Mantua and Urbino also staged plays, and it was evident to Leo that if Rome were to take the intellectual lead in Italy she must do no less. When his closest friend among the Cardinals, Bernardo Dovizi da Bibbiena, wrote a comedy suggested by Plautus's *Menaechmi*, Leo decided, the year after his accession, to stage it.

The *Calandria* is set in Rome and its plot, like Shakespeare's *Comedy of Errors*, turns on identical twins. Lidio and Santilla, refugees from the Turk, arrive in Rome by different routes. Santilla, for safety, has disguised herself as a man, while Lidio, in order to visit his sweetheart, poses as Santilla, whom he believes dead. This gives rise to predictable *doubles entendres* and mistakes of identity. The play takes its name from Calandro, the gullible husband of Fulvia, with whom Lidio is in love. Fulvia asks Rufo, a wily magician, to smuggle Lidio into her room. Rufo, while pretending to agree, introduces not a man disguised as a woman but a real woman. Fulvia gives vent to her rage and bewilderment. Is Lidio a hermaphrodite, or does Rufo, as Fulvia is led to believe, possess the power to alter at will a person's sex? Finally, for a fatter fee, Rufo

succeeds in introducing Lidio, dressed in woman's clothes, to Fulvia's room, whereat the curtain falls.

The importance of his mildly amusing play lies in its tone. Sexual love is praised as the sweetest pleasure in the world, anyone who does not enjoy it is a fool, but it is constantly being thwarted as the man in question turns out to be a woman. The constant references to changes of sex and hermaphrodites point to a general truth which Bibbiena puts into the mouth of one of his characters: 'Everyone knows that women are so highly valued today that there isn't a man who does not imitate them, down to becoming a woman in body and soul.' The classical revival had titillated appetites which because of the vow of celibacy could not be satisfied, and in a predominantly masculine city this could, and often did, lead to effeminacy. Tommaso Inghirami, Vatican Librarian and one of Rome's leading orators, whose round face and upturned eyes with a cast are familiar from Raphael's portrait, was actually known by the name Phaedra, after playing that role in Seneca's *Hippolytus*.

Another comedy, Ariosto's *I Suppositi*, Leo staged in the palace of his nephew, Cardinal Cibo, in 1519. The Pope 'took his place at the door and quietly, with his blessing, gave permission to enter, as he saw fit.' Two thousand crowded in, causing such a crush that the Ferrarese ambassador almost had a leg broken. Leo took his place on a dais in the front row; his name was spelled out by candelabra on either side of the stage, and on the curtain, which Raphael had designed, Leo's favourite buffoon was depicted sporting amid devils. Fifes, bagpipes, violas and cornets provided gay music.

Ariosto's play is inspired by Terence's *Eunuch* and Plautus's *Captives*. A young couple much in love but too poor to marry contrive to thwart the advances of a rich old suitor; after much duplicity and deceit, the hero comes into money, casts off his servant's disguise and marries the girl who for two years has secretly been his mistress. In one scene a parasite named Pasifilio reads the hand of the suitor, Cleando. Here is a snatch of their dialogue translated by Gascoigne in *The Supposes* of 1566, which is sometimes described as the first English comedy worthy of the name:

Pasiphilo: O how straight and infracte is this line of life! You will live to the yeeres of Melchisedech.

Cleando: Thou wouldst say, Methusalem.
Pasiphilo: Why, is it not all one?
Cleando: I perceive you are no very good Bibler, Pasiphilo.
Pasiphilo: Yes, sir, an excellent good Bibbelere, specially in a bottle.

At these and similar jokes Leo laughed heartily, which shocked Frenchmen in the audience. They thought it unseemly that a Pope should attend so frivolous a play.

A third comedy to be staged in Rome, at Leo's special request, was Machiavelli's *Mandragola*. A Florentine youth named Callimaco falls in love with Lucrezia, the virtuous young wife of an impotent husband, Nicia. Callimaco poses as a doctor and persuades Nicia that a potion of mandrake can cure Lucrezia's childlessness. There is, however, one snag. The first to sleep with a woman who has taken such a potion, dies. So a stranger must be introduced for the night to Lucrezia's bed, and Callimaco firmly intends to be that stranger. For a fee the local priest, Fra Timoteo, persuades Lucrezia to accept the outrageous plan, and next morning, after the trick has been successfully perpetrated, takes them all to church in a general mood of self-congratulation.

Once again the play turns on sexual inadequacy, which here appears to reflect a deeper inadequacy, Florence's recent fiasco on the battlefield. For Callimaco, the potent young lover, has just returned from Paris, and it is in Paris that he has learned the reckless insolence which enables him to seduce Lucrezia. Her name, too, is significant, for the patrician girl who committed suicide had, by Botticelli and others, been made a familiar symbol of Florence in defeat.

As well as comedy, Leo also liked farce. He often summoned to Rome a famous Sienese troupe called *I Rozzi*—the Rough Ones— to perform dialect burlesques in which country bumpkins declare their love in boorish similes, play crude practical jokes and fall prey to a stereotyped villain. Sometimes pastoral and mythological elements were mixed in, and the coarse rustics would be joined by Arcadian shepherds: a happy combination which Shakespeare was later to use in *As You Like It*.

Leo's patronage of the theatre was criticized by some, and his biographer, Bishop Paolo Giovio, felt it necessary to defend the

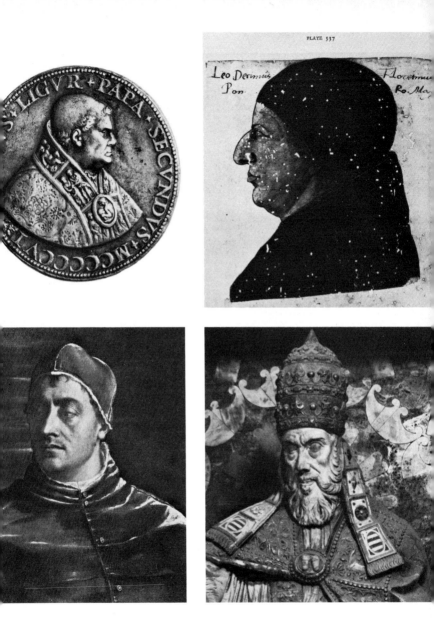

Four popes. Julius II, a Ligurian; Leo X and Clement VII, both Medici of Florence;
Paul IV, a nobleman of Naples

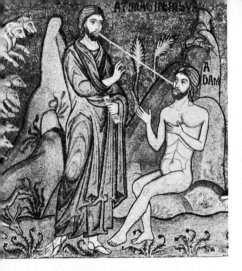
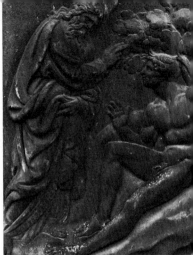
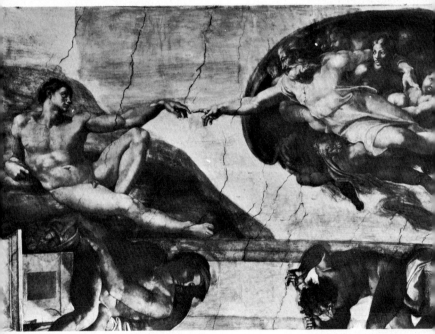

The Creation of Man. The power and invention of Michelangelo's fresco are evident when contrasted with a twelfth-century rendering in Palermo and (right) with a panel in Bologna *c.* 1430 by Jacopo della Quercia, which Michelangelo knew

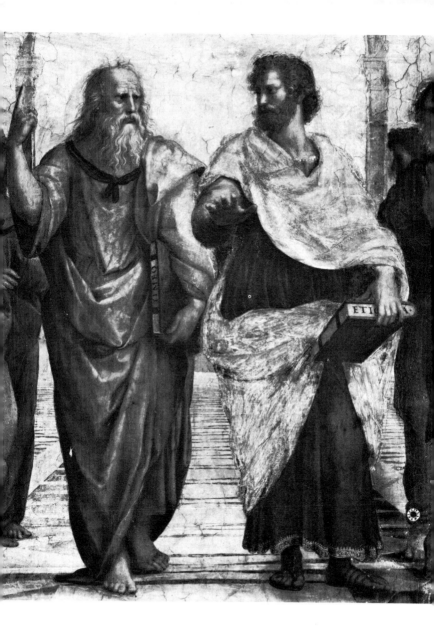

lato and Aristotle. The central figures of Raphael's *School of Athens*. Plato, for
vhom Leonardo da Vinci was probably the model, holds his *Timaeus*, Aristotle
is *Ethics*

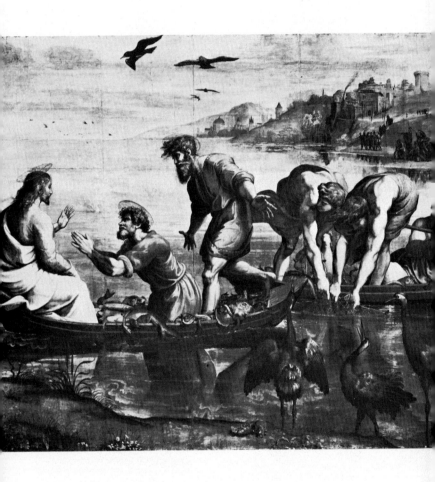

The Miraculous Draught of Fishes. In Raphael's cartoon Christ blesses with his left hand and the dramatic emphasis falls on the left side because in the tapestry for which the cartoon was intended the whole scene appears in reverse

Martin Luther with his protector, Frederick of Saxony, and friends, including (far right) the gentle scholar Philip Melanchthon

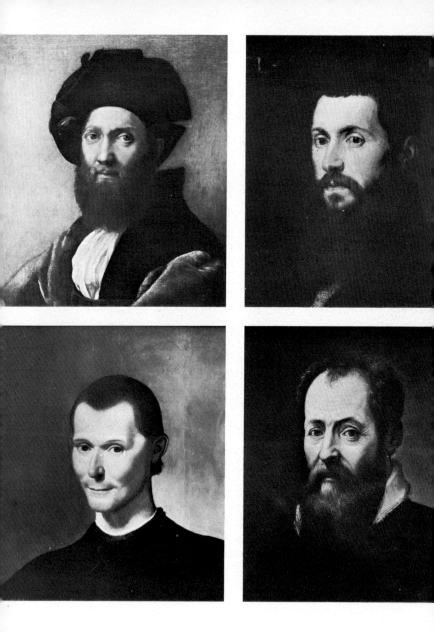

Four writers. Baldassare Castiglione was an arbiter of courtly manners; Daniele Barbaro wrote on perspective and eloquence. Niccolò Machiavelli and Giorgio Vasari in different ways advanced the art of history

Piero di Cosimo's view of primitive man. Stone-age men attack wild beasts and are themselves attacked by satyrs and centaurs. Below, bird and beast flee a forest fire, while a hut-dweller attempts to yoke oxen. The animals with human faces illustrate a classical theory that early man mated promiscuously with animals

In *The Story of Aristaeus* Niccolò dell'Abate depicts the immensity of the earth as it was being revealed by explorers. While fleeing from Aristaeus, Eurydice is bitten by a snake and dies. Beyond, her husband Orpheus seeks consolation by playing his lyre

Pope's attendance at comedies such as *Mandragola*: it is significant that he pointed as a precedent to Trajan. But Leo knew what he was about. It was proper that the head of the Church should be in touch with the body, proper that he should understand what was being said and thought by the writers of his day. And it doubtless did not escape his notice that the line, '*Homo sum: humani nihil a me alienum puto*' occurs in a play by Terence. By his tolerant attitude Leo showed that the Church had nothing to fear from the theatre; by his patronage he played an important part in encouraging Italian comedy and farce during their formative years.

Leo also continued his predecessor's patronage of Raphael. The young painter from Urbino had now become the idol of Rome and would walk the streets attended by fifty admiring artist friends. One day Michelangelo in his grim way called out: 'Where are you going, surrounded like a provost?' to which Raphael replied: 'And you, all alone like an executioner?' But despite their different temperaments, Raphael admired Michelangelo and added his portrait to *The School of Athens*, an almost Sistine figure pondering on the lowest step beside a block of stone. As commissions poured in, Raphael employed a large workshop to do the rough work and quickly amassed a fortune of 16,000 ducats, twice as much as Michelangelo would earn in a life more than twice as long. But he retained his modest amiable manner, even when he moved into a splendid new house designed by Bramante and adorned on the outside with classical columns.

Leo's most important commission to Raphael are the cartoons for ten tapestries to hang on the lower walls of the Sistine Chapel. The subject Leo chose is the very one rejected by Michelangelo, namely humble incidents in the lives of the Apostles. These include Peter's healing of the lame man and Paul's imprisonment. In his choice of two of the other subjects Leo shows the same interest as Julius and Michelangelo in the close link between early Christian and pagan thought. The first depicts the scene in Lystra when certain citizens, impressed by the Apostles' miracles, called Barnabas Jupiter, and Paul Mercury, because he was the chief speaker; 'and the priest of Jupiter, Defender of the City, brought out bulls and wreaths to the gates, eager, like the multitude, to do sacrifice,' a folly from which

the Apostles dissuaded them. The second scene shows Paul preaching in Athens, seeking to convince the Athenians by quoting not the Old Testament but their own poets—Aratus, Cleanthes and Epimenides—in support of his claim that we are all the children of God. Taken together, the two scenes amounted to a clear statement that Christianity was a fulfilment of pagan insights. This of course chimed in with the view that Christian Rome was a fulfilment of the imperial city.

The tapestries cost 16,000 ducats, of which Raphael received one thousand, and seldom has a fee been better earned. In contrast to, and complementing, Michelangelo's vault, Raphael's seven surviving cartoons are imbued with the New Testament spirit, in particular with what may be termed the grandeur of simplicity. Perhaps the best of them, *The Miraculous Draught of Fishes*, shows the apostles divided between two boats. In one John and James raise a net, their bent straining bodies clearly inspired by a figure in Michelangelo's *Battle of Cascina*. In the other Andrew recognizes the miracle with outstretched arms, while Peter kneels humbly before the seated figure of Christ, and although placed at the extreme left edge it is Christ who dominates the whole scene, partly by virtue of his calm attitude, partly because he partakes of the open sea and sky above him. Since a classical note was *de rigueur*, Raphael introduces to the foreground three cranes, a symbol of filial obedience. For all its drama, the main impression of this great drawing is one of serenity and Christian trustfulness.

As a counterpart to the tapestries Leo, who loved music, engaged the best choristers from Flanders, France, Greece and Mantua to sing divine Office in the Sistine Chapel, thus making it an artistic as well as liturgical holy of holies. Their voices must surely have gained in jubilation under Michelangelo's newly painted vault and amid Raphael's newly woven tapestries, hung at Christmas 1519. After a good performance Leo would sit enraptured, head sunk on his breast and eyes closed, lost to everything, drinking in the sweet tones and humming them softly to himself.

Leo's other big commission to Raphael was the decoration of a shady promenade alongside the papal apartments known as the *Loggie*. Excavations on the Esquiline Hill had recently revealed

certain elaborately decorated underground rooms, to visit which one had to be let down on a rope. They belonged to Nero's Golden House, of which the Emperor exclaimed, 'Good, now I can at last begin to live like a human being,' but Leo's contemporaries did not know this: they believed them to be part of the palace of Titus. They called them grottoes and the delicate architectural *trompe l'œil* framing small landscapes with figures they called '*grottesque*'. It was in this style that Leo asked Raphael to decorate the *Loggie*. The artist's gay and inventive interweaving of flowers, cupids, winged beasts and other 'grottesques' recaptures the charm of the Roman paintings and imparts to the promenade an apt note of relaxation. Leo was pleased with the work; his pleasure has a touch of irony considering its Neronian origin.

Raphael painted another masterpiece at this period, and although not commissioned by the Pope it throws considerable light on Leo's Rome. Agostino Chigi, Leo's banker, wished to decorate his new palace with the story of Amor and Psyche, and as a subordinate theme asked Raphael to fresco one of the walls with *The Triumph of Galatea*. Raphael shows Galatea driving her scallop-shell chariot and team of dolphins through the waves, while on either side Tritons carry off sea-nymphs, at whom three cupids aim their arrows. The literary sources are Virgil's *Eclogues* and Ovid's *Metamorphoses*, the iconography comes from Philostratus, while Galatea's billowing cloak and energetic movement derive from ancient bas-reliefs of Leucothea which then stood in the monastery of S. Francesco a Ripa. As for the term 'triumph', it denotes that Galatea has successfully resisted the brutal passion of Polyphemus. So the subject was vaguely moral. Raphael, however, cares more for the vitality and beauty of Galatea, whom he renders with obvious admiration. At first sight it is remarkable that the supreme painter of Madonnas should bring equally deep feeling to the portrayal of a pagan sea-nymph. But Raphael was not above using *La Fornarina* as a model for his Madonnas. He seems to have believed that all feminine beauty, whether of mistress or naiad, is an ally, not a rival of Christ's mother. '*Religio hic regnat, gloria, et alma Venus*,' wrote one of Leo's poets in praise of Rome, and the last two words are a literary equivalent of Raphael's fresco. They also express the spirit of the Leonine city.

Julius's Rome had been assertively virile; Leo introduced a gentler, more feminine note, and the *Galatea* is its image.

So much for Leo's positive achievements. They were important at the time and have left to the world a rich legacy of Christian humanism. His other activities reflect the same large-mindedness. One or two of them, however, innocent in themselves, represented tinder in regions which had already shown themselves highly critical of the Church.

The first is hunting. Leo had begun to ride to hounds at the age of nine. He liked the sport for itself and because it was good for his health and figure. He saw no reason why he should not continue to practise it as Pope. In 1516 he hunted thirty-seven days in a row. If kept in Rome by business, he would run down deer and stags in the Baths of Diocletian, but the country he preferred was the wooded hills around Viterbo, where after a hard ride he could soak in the warm baths. 'He left Rome without a stole,' lamented his master of ceremonies in January 1514, 'and, what is worse, without his rochet; and, worst of all, with boots on. That is quite incorrect, for no one can kiss his feet.' Leo just laughed at this punctiliousness. Peasants lined the road to offer presents, being rewarded so generously, says Giovio, that they saw in Leo's arrival a harvest far more productive than the best from their fields. At dawn teams of men enclosed a section of the forest with sheets of canvas, each sixty feet long and six feet high, fastened with wooden hooks and held upright by forked poles. At a signal from Leo, transmitted from glen to glen by the sound of horns, groups of archers, halberdiers, gamekeepers and beaters would drive the game forward with shouts and the beating of drums. The main sport came from deer, boar or wolf. Spectacles on his nose, Leo would dispatch these with lance or javelin. Firearms were not used, being considered unsporting.

Leo's hunts were an occasion for display. His hounds imported from France, his falcons from Crete, the Pope was attended by a suite of 140 horsemen, a body guard of 160 and the poet Guido Postumo, who put the whole colourful chase into verse. Inevitably this encouraged lavish spending among the sacred college. Cardinals began to give their hounds silver collars or gold-encrusted leashes, and in 1514 Sanseverino appeared at the papal hunt with a lion skin

round his shoulders. Galeotto della Rovere bought a string of racehorses, and Cibo opened a stud to provide fast hunters. Italians expected prelates to participate in lordly sports and to look the part, but other nationalities found these activities shocking. In Portugal, for example, clergy were forbidden to hunt; and the ban was made, at the King's request, by Leo himself.

The second activity to occasion adverse comment was Leo's attendance at banquets, his own and others'. He gave lavish dinners in the Vatican at which delicious food, including peacocks' tongues, was served on chased silver, and the best musicians in Italy sang and played. Leo himself ate moderately, though he had a penchant for lampreys cooked with cloves and nuts in a Cretan wine sauce; after dinner he joked publicly with his Dominican clown, Fra Mariano, who possessed a prodigious appetite and is said to have eaten twenty chickens at a sitting. Leo would set Mariano going by serving him a delicious-looking dish containing ravens or apes or even pieces of string, then rock with laughter as the clown champed at the tough food and tried to disguise his misery with polite smiles or expressions of bliss.

Leo enjoyed going out to banquets too. The most famous were given by Agostino Chigi. A native of Siena, for fifteen years Chigi was the leading banker in Europe. He handled Tolfa alum for the Popes and his annual income amounted to 87,000 ducats. He possessed bathroom fixtures of solid silver and an ivory and silver bed that cost 1,592 ducats. The famous Imperia had for long graced this prodigious couch, but now Chigi suffered from dropsy and took his pleasure in other ways. Once he offered dinner to the sacred college, at which every cardinal was served delicacies brought by special messenger from his own region or country, on silver engraved with his coat of arms. But Chigi's *tour de force* was a dinner for Leo, held in a loggia overlooking the Tiber. To prove to his guests that the same silver was not used twice, after each course he instructed his servants to throw the silver dishes into the river. Nets however had been laid underwater, from which the silver was later retrieved.

If Leo's presence at banquets was criticized abroad, at least he brought to these otherwise vulgar displays the Medici wit he had

inherited from Lorenzo. When the Emperor sent him fourteen hunting eagles Leo, in a letter of thanks, joked about the danger of giving away his emblem of imperial power. When he wished to give a red hat to his nephew, Innocenzo Cibo, and someone objected that he was only twenty-one, Leo remembered that he had received the cardinalate younger still from a Pope of the same name, and said with his usual smile, 'What I received from Innocent, I repay to Innocent.' When a Venetian presented him with a poem on the art of making gold, Leo sent back a richly decorated purse but, contrary to his usual practice, empty: 'since you possess the secret of filling it'. And wit led to wit. Leo gave Fra Mariano a post as *piombatore*: the work involved affixing a lead seal to papal bulls and brought in 800 ducats a year, which prompted the clown to boast that he had discovered the alchemists' secret, since now he could make gold out of lead.

Trifles such as these help to set a tone. The tone in Leo's Rome was broadminded and gay. Taken in conjunction with his patronage of learning, Latin literature, Italian comedy and the plastic arts, Leo may be said to have achieved his ambition of making Rome the most civilized city in Europe. At any rate it was now the place where everyone wanted to be. During Leo's reign more than 20,000 people came to swell the population, to savour the precious freedom and versatility of talent that Erasmus praised in a nostalgic letter, to see the fine new houses and the gardens which Julius had popularized. In one of the gardens belonging to a papal employee named Angelo Colocci writers and humanists liked to gather, and the mood of Leo's Rome is summed up in a fountain that played beside a little statue bearing the inscription: 'I am the spirit of joy, yield to my law or else go away.'

Leo himself liked to think that the spirit of his pontificate was embodied in a remarkable elephant. Captured in India, the elephant was sent as a gift to the Pope by the King of Portugal. In colour white, 'the size of three oxen, with the pace of a tortoise', it paraded through Rome carrying in a howdah jewels, brocade and pearls worth 60,000 ducats. Leo watched from a window of Castel S. Angelo; the great loping beast genuflected three times to him, bending its head low, and made a noise described as 'bar, bar, bar!'

It then plunged its trunk into a cistern and, to the crowd's delight, sent a spray of water almost up to the window.

Leo, who liked animals, was captivated by the elephant, just as Lorenzo had been by the Sultan of Egypt's giraffe. He kept it in the Belvedere, commissioned its portrait, in intarsia, for one of the doors of his private apartments, and had his poets celebrate the elephant's size, intelligence and classical associations. He decided to call it Annone, after the Carthaginian general Hanno, thus making it a symbol of Rome's glories. But this did not exhaust the beast's significance. According to Pliny, elephants are the only animals who say their prayers. They are also temperate, benign—they possess no gall—and chaste, for they can breed only after having absorbed, as an aphrodisiac, mandragora root. So Annone was an apt symbol of Christian Rome, heir to past glories.

If Leo's intentions in Rome were praiseworthy, and many of his achievements admirable, they were not without grave danger. The danger arose from the nature of the city and the nature of his court, the one inorganic and unproductive, the other without any real roots in Rome, an all-male society living away from family and place of origin, both therefore tending to artificiality and exaggeration in a way the Florentines would never have countenanced.

Let us take the matter of a pure Latin style. This demanded the use of words sanctioned by classical authors. When poets described SS. Peter and Paul as '*Dii tutelares Romae*', when they translated 'excommunicate' by 'forbid fire and water', turned 'to forgive the sins of a dying man' into 'to appease the powers of Hades and the Manes', when faith became 'persuasion', a priest 'a flamen', the Vatican 'the Capitol' and Mary a 'goddess', or even 'Diana', they were blurring the distinctiveness of Revelation. Real misunderstanding crept in when Christ was referred to as 'hero' or 'Apollo', and the Christian message transformed into a 'philosophy' compatible with the humane ethic of classical Rome. In one of his sermons Tommaso Inghirami compares the death of Jesus to the oratorical power of Cicero because he filled his disciples first with sadness and consternation, then with triumphant joy. He then likens Jesus to Curtius, Cecrops, Aristides, Epamonidas and even Iphigenia,

who were all devoted to the common good. The sermon would have horrified Savonarola, all the more since it was delivered on Good Friday, yet his audience considered that Inghirami had surpassed himself.

Closely linked with this danger was another, which Petrarch had been the first to spot. Against Cicero's statement in the *De Natura Deorum* that men are quite willing to attribute their prosperity to the gods, but not their virtue—'*virtutem autem nemo deo acceptam rettulit,*' Petrarch had written '*Cave male dicas*: Be careful what you say.' The poet's warning went unheeded among the leading spirits of Leo's Rome. Even the pious Sadoleto described wisdom as a human virtue naturally acquired, and declared that sages such as Socrates, Plato and Cicero were in every respect complete and perfect men, despite the fact that they had never received the Church's grace-giving sacraments. Formerly man was deemed to have value only in so far as he partook of heavenly grace, but now it was man who had value in himself, and Vasari could write of Raphael after his death: 'We can be sure that just as he embellished the world with his talent, so his soul now adorns heaven itself.' This exaltation of man was of course a form of osmosis in a world flooded by classical values. If there was any betrayal of Christian truth, it was quite unconscious. It was none the less dangerous for that, especially if doings or phrases were to be interpreted out of context by men living far from Rome and unfamiliar with her new, rather peculiar conventions.

Exaltation of man led to exaltation of particular men, notably the Popes. It has to be remembered that fulsome language was a feature of the age: the satirist Pietro Aretino was variously addressed as '*Precellentissimo*', '*Unichissimo*', '*Divino*', and '*Omnipotente*', but in Rome adulation went beyond bounds. Orators and poets addressed the Pope as once their forbears had addressed those Emperors who believed themselves divine. Inghirami hailed Julius as a Jupiter making the universe tremble with his frown, a Dominican poet compared Leo to the sun-god Apollo, while Giovanni Capito addressed these lines to the elephant Annone:

If you think you are serving a Libyan Lion
You err: this Leo came down from the skies.

He is your master, the world's highest glory,
Whose head is crowned with the tiara,
Holding among men a more than mortal rank:
With the right to close and open the world's frontiers.
If to serve God is truly to reign, then you,
 As Leo's servant, truly reign, Leo being God on earth.

Like every great lord, Leo had his 'taster' to sample all food for possible poison, but against this particular kind of poisonous sugar he had no one to defend him, and the tragedy is that sometimes he succumbed. When his brother Giuliano died in 1516 it was expected that Leo would order the Court into mourning and take part in the solemn funeral ceremonies. But Leo decided otherwise. A Pope, he informed his master of ceremonies, should place himself above family griefs: he should consider himself *quia ipse jam non ut homo sed ut semi deus*—not as a man, but as a demi-god.'

The final evil of Leo's reign stems jointly from the peculiar nature of Rome and from the Pope's character. Rome was not only unproductive, it had no native traditions of craftsmanship or art. So that in civilizing Rome, Leo had to bring everything from outside. The poets came from outside, so did the musicians, the painters, the architects. Of 267 artists who worked in Rome between 1503 and 1605 only seventeen were Romans, and only one—Giulio Romano —became famous. They had to be lured to Rome by high fees, they had to be well housed, and this meant that the cost of civilization was enormously increased. And the man who was paying for all this was open-handed to a fault. *Liberalitas Pontificia*' proclaimed one of Leo's medals—and the medal, like everything else commissioned by the Pope, from tiara to silver stirrups—was a beautiful object, designed at great expense. After a game of chess, win or lose, Leo would hand his opponent several gold ducats before blessing the board and leaving. He increased the papal household to 683 and spent on it twice as much as Julius. He would give 50 ducats for one bottle of amber, 500 at a time for sables and ermines, 900 for three gold chains. He gave Guido Postumo 300 ducats and a new house for versifying his hunts, 33 ducats a quarter to a favourite trombonist, a castle and the title of count to a lutenist named Giammaria Leo. He could not possibly afford to be so open-handed,

even though papal revenue had risen to 420,000 ducats. As early as 1515 he was in arrears with the pay of his 88 university professors, some of whom began to seek more stable positions elsewhere. And so the scramble for money began.

First thing when he woke, before prayers, before Mass, the datary Gianmatteo Giberti entered the Pope's bedroom—Leo liked to lie in—and there discussed who should get what benefice and for how much. Bishoprics, abbeys, even quite small parishes—all had their price, and if an applicant held one already, so much the better, because to hold a second he would have to pay. Then there were the saleable offices in the Curia and in the municipality. Leo doubled these to a total of 2150, thus raising 1,200,000 ducats, on which, however, an annual interest of 328,000 ducats had to be paid, since holders received more than 10% return on what was in effect a State investment. But the most profitable item of all was the creation of cardinals, forty-two in all, of whom at least thirty owed their red hats to money or political influence, which in the last resort also meant money: so the Church was no more independent as a result of returning to Rome, only it was now subject to money rather than to the threat of force. Ponzetti, who finally secured the cardinalate at the age of eighty, is said to have stopped a soldier in the street, and removing the soldier's cap to have measured it thoughtfully. 'Your hat is two inches bigger than mine, but yours cost one ducat, whereas mine cost 60,000.' He was not exaggerating.

Even so, income failed to match expenditure, and Leo had to borrow: 32,000 ducats from the Gaddi, with the proviso that one of the family would receive the red hat; from the Ricasoli 10,000; from the father of Cardinal Salviati 150,000. In 1521, when his overdraft reached 156,000 ducats, Leo accorded the Bini brothers, Florentine bankers, the right to sell to the highest bidder offices in the Curia, and as surety gave them Paul II's jewelled mitre, Julius II's tiara, and 'the sacred pontifical silver vessels, including those used for the celebration of divine service'.

It was under these conditions that Leo grappled with the immense task bequeathed him by Julius, the building of St Peter's. When Bramante died in 1514 he placed Raphael in charge and allocated him 60,000 ducats, whereupon Raphael remarked that the basilica

would cost a million—as it eventually did. At least 10,000 ducats a year would be required, probably much more in these early stages, and Leo looked around for ways of raising such a sum. His predecessor had issued a bull, *Liquet omnibus*, granting Christians remission of punishment due to past sins, on condition that they went to confession and contributed according to their means to the fund for building St Peter's. Living well within his income, Julius had been able to raise sufficient money by publishing the bull only in Italy. Although there were signs that indulgences were abused and resented abroad, Leo decided to extend the bull. He spoke of a basilica 'which is first among all the churches of the world and, as it were, the fixed home of Christianity'; 'since the income of the Apostolic Chamber is insufficient to meet the cost of such an incredibly vast work, the help of Christians is urgently needed.' In the fateful month of December 1514 Pope Leo X appointed commissioners—who, incidentally, were scrupulously honest—to administer the St Peter's indulgence in Avignon and the surrounding Comtat; also in Cologne, Trier, Salzburg, Bremen and other provinces of Germany.

CHAPTER 4

The Challenge from Germany

IN 1515 Giangiorgio Trissino, a highly cultivated patrician of Vicenza, visited Germany as the Pope's nuncio and was deeply struck 'by the horror of huge forests, deep marshes and barren plains. Winds and snow whip that unhappy land; the soil is like iron and encrusted with ice. . . . A barbarous people shut themselves up in warm houses and laugh at the Arctic blasts, gaming and drinking far into the night.'

Trissino is stating, rather unsympathetically perhaps, the basic truth that Italy and Germany are profoundly different lands. Wittenberg, in central Germany, lies nine degrees north of Rome, and here nature is not a friend but a wolf to be kept at bay. The people of such a region are physically robust, steeled by hard occupations like mining and forestry. They make brave soldiers. It was Germans who inflicted their most serious defeat on Augustus's legions and, first in tribes and now in innumerable principalities, they had waged war often and bitterly. They were familiar with suffering, took it indeed for granted. Fourteenth- and fifteenth-century German art abounds in Pietàs and St Sebastians dripping with blood, teeth bared in agony. But there was genuine piety as well as horror. German artists emphasized the unjust suffering of Christ because, in their harsh world of violence and torture, this allied him with them.

Where Italians suppressed or embellished the dark side of life, Germans fixed attention on it. When depicting the Trinity, Raphael showed Christ standing in triumph, but Dürer placed him agonizing on the Cross. Dürer was the first artist to depict a syphilitic. His portraits of himself and of Oswald Krell reveal men who are disturbed. Their eyes are burning, their hands, one senses, are restless. They are subject to nightmarish dreams such as one which left Dürer

76

'trembling all over'. They look inward, finding themselves 'fools', experiencing doubts as terrible as that described by Ulrich von Hutten in a youthful poem with the significant title of 'Nobody'. They find the world not tidily terraced, but craggy and baffling. In *Melencolia I* Dürer depicted a new archetype of human inadequacy: a winged female figure, hand on chin, brooding darkly amid unsolved problems. But the problems demanded solution, because over this awesome world stood a God even more awesome, severe as their climate, a God who was a Judge. This God was represented in *The Last Judgment*—a subject much commoner in Germany than in Italy—towering over the damned, who suffer torments terrible as those being inflicted in real life on German witches: whip, thumbscrew, rack and studded chair slowly heated from below.

These people were deeply religious. But they could never feel at one with nature in quite the same way as the Italians. And so their piety took a different direction. John of Wesel in Erfurt and Conrad Summenhardt in Tübingen had tended, often excessively, to depreciate the value of works and to emphasize inwardness, faith in the suffering Christ. Inwardness was fostered by the reading of spiritual books, for the Germans, leading a largely indoor life, read much more than did Italians. They were particularly devoted to the Bible: it is no accident that this was the first considerable work to issue from Gutenberg's press. The first Bible to appear in the vernacular was also a German publication, and no fewer than fourteen German Bibles appeared before 1522. In his inaugural address at Wittenberg Philip Melanchthon described his joy in the text of Scripture: how its true meaning lights up 'like the midday sun', adding ominously, 'All the countless dry glossaries, concordances, discordances and the like are only hindrances for the Spirit.'

Study of the Bible, especially of the early Church, brought into relief existing evils and intensified a desire for reform. Between 1450 and 1515 Germans held four provincial councils and no less than a hundred diocesan synods in order to try and correct abuses such as simony and appointment of unsuitable bishops, without, however, any noticeable effect. Yet there remained a thirst for reform, for a pure religion like that of the early Christians.

Differences of land and climate, of physiology and psychology, of

language and aesthetics, as well as different individual and collective experiences had created if not a radically different soul, at least radically different spiritual needs and forms from the ones obtaining in Italy. This in itself was no bad thing. The one Gospel is recorded in very different ways by the four Evangelists, and Christendom had gained not lost from being polyphonic. But such a situation clearly called for understanding, and this in turn for communication. Now, communication had seldom been worse. Fighting in Lombardy had reduced trans-Alpine travel to a trickle. Of fifty-four cardinals under Julius II and Leo X, only two were Germans, and of these the interests of one were exclusively political. Roman Legates in Germany were merely diplomats, and they seldom spoke German. If German reform plans ever reached Rome, too often they were ignored because the officials concerned had only a sketchy knowledge of actual conditions.

Desire for reform crystallized therefore in a growing antipathy to Rome. Germans disliked the fact that Alexander VI had kept a mistress, that Julius took part in battles, and that Leo attended comedies and banquets. They disliked the Pope's claim to be heir of the Roman Emperors, and the seizure of Piacenza and Parma, which since the eleventh century had owed allegiance, albeit formal, to the German Emperor. They disliked the Italian domination of the Church which followed on the Popes' return to Rome. They disliked papal domination of the Fifth Lateran Council, the petty reforms it proposed, and the loopholes therein: a cardinal's funeral must cost no more than 1500 crowns 'unless there is just cause'. Above all, they disliked the 'spiritual' taxes and dispensations, whereby, they believed, they footed the bill for Leo's poets and artists, musicians and goldsmiths—all the expensive business of this new Christian humanism. The taxes were constantly increasing—the one on briefs had risen fivefold in sixty years—and on this whole matter several diets during the fifteenth century had gone so far as to break with Rome.

Into this world and sharing many of its values Martin Luther was born on 10 November 1483. He was the son of a peasant who had risen to be a well-off mining operator in Eisleben, a town, incidentally, which lies 770 miles from Rome but only 100 miles from heretical Bohemia. Physically strong, his craggy face marked by

high cheekbones and a firm jaw, Luther described himself as 'rough, boisterous, stormy and altogether warlike, I am born to fight against innumerable monsters and devils.'

The Devil loomed large for Luther and, when he came to write his *Greater* Catechism, he was to cite the name of the Devil sixty-seven times, compared to sixty-three citations for the Saviour. As a law student he was one day caught in a thunderstorm and almost struck by lightning. This near escape from death impressed him deeply, and he vowed to enter religion. In 1505 he joined the Augustinians, two years later receiving the priesthood.

Luther attended the recently founded university in Wittenberg, a town of 2000 inhabitants, mainly brewers. Here degree requirements were lenient, and Luther took his doctorate in theology in five years instead of the usual twelve. He therefore skipped scholastic niceties and stuck to what he calls 'the kernel of the grain and the marrow of the bones', by which he meant Scripture. In 1512 he became Professor of Scripture at Wittenberg.

Luther was a deeply religious man who sought perfection in his chosen life: 'I would have martyred myself to death with fasting, prayer, reading and other good works.' But try as he might he could never attain his own ideal of goodness. This puzzled and troubled him deeply, for the whole trend of the age was to emphasize man's will, his powers of achievement. But always Luther felt his complete unworthiness before God, whom he had been brought up to believe was above all a Judge. 'We grew pale at the mention of Christ, for he was always represented to us as a severe judge, angry with us.' 'When will you do enough,' Luther asked himself, 'to win God's clemency?' And it became clear that the answer was, Never.

How then could he be saved? As a Professor of Scripture, Luther sought an answer in the New Testament, and as an Augustinian, in the commentaries of the founder of his Order. Now it so happened that a complete edition of St Augustine's works, in nine volumes, had for the first time become available in 1506. Augustine had started life as a Manichaean, and the Manichaean battle between matter which is bad and the spirit which is good marks nearly all his writings. Moreover, in a fight to the death with the heresy of Pelagius, who denied original sin, Augustine had laid a sometimes excessive emphasis on man's need for grace, and his incapacity to do

good unaided. Both characteristics appealed to something deep in the German character, and notably in Luther's. To the question, How then could he be saved? Luther found an answer in the 17th verse of the first chapter of St Paul's *Epistle to the Romans* as interpreted by St Augustine. Not efforts of will, but faith alone could justify man before God, and this faith was not something to be toiled for, not a result of *virtus*, but a free gift from above, a grace. Grace, moreover, was granted to man irrespective of his merit, and God's decision to grant or withhold it lay completely beyond the range of human understanding. This discovery comforted Luther, who believed that formerly he had been on the wrong track.

In 1510 Luther visited Rome on business for his Order. 'I fell on my knees,' he says, 'held up my hands to heaven and cried "Hail, holy Rome, sanctified by the holy martyrs and by the blood they shed here." ' Luther was not a humanist save in so far as he valued sound texts of Scripture and the Fathers, and he took no interest in the Sistine ceiling or the *Laocoön*. He was annoyed by the speed at which Roman priests said Mass: 'By the time I reached the Gospel the priest next to me had already ended and was shouting "Come on, finish, hurry up." ' But this was hardly a scandal to Luther, whose own life had become so hectic by 1516 that he wrote: 'Rarely do I have time for the prayers of the breviary or for saying Mass.'

What did profoundly shock Luther in Rome was the Renaissance itself. Aristotle's *Ethics* was a prime text in Rome and it figures in Raphael's *Stanze*; Luther abhorred the book, declaring it 'grace's most dangerous enemy'. Italians, particularly since the revival of Platonism around 1460, held the created world to be both good and beautiful. Luther did not find the world either good or beautiful. He was shocked by the way clergy and laity alike had reconciled the spiritual with the physical, the pursuit of salvation with the pursuit of happiness here and now. While remaining spiritual beings directed towards the life beyond, they had completely adjusted themselves to the world below. Hence Luther's complaint that the Italians were 'Epicureans'. 'If, they say, we had to believe the word of God in entirety, we should be the most miserable of men, and could never know a moment's gaiety.'

Luther returned to Wittenberg in 1511 to resume teaching and his

study of St Augustine. Presently one of the great German princes, Albert of Hohenzollern, decided to acquire the archbishopric of Mainz. Since he was only twenty-four and thus well below the prescribed age, and furthermore was already Bishop of Magdeburg and Halberstadt, he applied to Rome for a costly dispensation. In order to help Albert, Pope Leo agreed that the St Peter's indulgence should be preached in North Germany on special terms. The great banking family of the Fuggers would advance the dispensation payment in return for administering the indulgence, half the proceeds of which would go to Albert, half to building St Peter's. As part of the ensuing campaign in 1517 a Dominican named Johann Tetzel began preaching near Wittenberg. He was somewhat imprudent in his methods, especially regarding indulgences for the dead, and a famous verse was attributed to him:

As soon as the coin in the coffer rings,
The soul into heaven springs.

Luther watched in dismay as the brewers of Wittenberg trooped across the Elbe to buy Tetzel's indulgence: those earning 500 gold guilders a year paid six guilders, those earning 200, three, and so on. For one who believed that man was justified by faith alone, the notion of achieving forgiveness by works, still more by work in the form of money, was utterly repugnant. Luther decided to protest. By nature conservative in his attitude to society, he did so in the approved manner, by writing letters describing the abuse to four local bishops. The result proved disappointing. Some scoffed at his scruples, others pointed out that this indulgence was the Pope's and outside their control.

Luther then drafted 95 theses stating his views on indulgences and other matters, and posted them on the door of the university church: a usual way of inviting discussion and in no sense a gesture of defiance. The first four theses are related and evidently express what was then uppermost in Luther's mind:

1. Our Lord and Master Christ, in saying 'Do penance', intended the whole life of every man to be penance.

2. This word cannot be understood as referring to penance as a sacrament (that is, confession and satisfaction, as administered by the ministry of priests).

3. This word also does not refer solely to inner penitence; indeed there is no penitence unless it produces various outward mortifications of the flesh.

4. Therefore punishment [of sin] remains as long as the hatred of self (that is, true inward penitence), namely until entering the kingdom of heaven.

The key words in the 95 theses—'tribulations', 'fear', 'punishment', 'despair', 'horror'—would have puzzled an Italian. Indeed, they are conspicuous by their absence from Italian writings of the day. Partly they reflect the national temperament, but to a larger degree they reflect Luther's own spiritual crisis and the solution to it he had found in St Augustine. Luther makes plain in the 95 theses that what counts in Christianity is inner disposition, not rites and sacraments. In February 1518 he made the point more forcefully still by addressing to Rome a highly critical *Resolution concerning the Virtue of Indulgences*.

Rome was now directly involved. At this time the city had only one topic of conversation: whether or not Roman citizenship should be conferred on Christophe Longueil, a French resident who had changed his name to Longolius and made stirringly Ciceronian speeches in praise of the city. Longolius had once compared Augustus unfavourably with Charlemagne: Leo thought this youthful indiscretion should be overlooked, but others held that it marked Longolius as an irredeemable barbarian. It is one of the tragedies of history that the large-minded Leo, who knew Germany at first hand from his years of exile, had never studied theology, and was therefore incompetent to treat with Luther, as he did with Longolius. The Luther affair passed to the Master of the Sacred Palace, a highly intransigent Dominican named Sebastiano Prierias, who once stated that 'anyone who denies that the doctrine of the Roman Church and of the Roman Pontiff is virtually infallible, so that even Holy Scripture draws its force and authority therefrom, is a heretic.' Shocked by Luther's *Resolution* Prierias dashed off a reply, abusing the German roundly, calling him a son of a bitch, and centring his arguments less on Luther's statements than on the fact that a humble friar had dared to question the teaching of the Pope.

Leo, however, did not leave it at that. He had a friend in the

leading Italian philosopher of the day, a man of the same moderate temperament as himself. This was Tommaso de Vio, known as Cajetan, a Dominican who at the time of the Council of Pisa had written a sensible defence of the Papacy, marred, however, by a failure to probe the metaphor underlying his description of the Pope as 'head of the Church corporate'. Leo instructed Cajetan, who was then in Germany, to hold an interview with Luther.

'I was received,' writes Luther, 'by the most reverend lord cardinal legate both graciously and with almost too much respect, for he is a man in every way different from those extremely harsh bloodhounds who track down monks among us ... I immediately asked to be instructed in what matters I had been wrong, since I was not conscious of any errors.' Cajetan began by pointing to a statement by Luther that the merits of Christ do not constitute the treasure of merits of indulgence; this, he said, contradicted an *Extravagante*[1] issued by Clement VI (1342–52). He did not expect Luther to know the *Extravagante*, which was absent from some editions of canon law. But Luther did know it and replied that it did not impress him as being truthful or authoritative, chiefly because 'it distorts the Holy Scriptures and audaciously twists the words into a meaning which they do not have in their context.' The Scriptures, he concluded, were in every case to be preferred to the *Extravagante*, which merely trotted out the teaching of St Thomas Aquinas. Further discussions then took place 'but in no one point did we even remotely come to any agreement.'

Agreement was precluded by the fact that Luther differed radically from Cajetan on the nature of the Pope's teaching authority. Luther began to see that there was more than a fortuitous link between Clement VI's attitude in the *Extravagante* and the behaviour of Popes in his own lifetime. Both tried to mould God to man's needs. So Luther's next move was to criticize the way papal authority was exercised by such Popes as Julius II and Leo X. In a letter to Leo dated 6 April 1520 *Concerning Christian Liberty*, Luther attacks the Petrine office less as an institution based on canon law than against its 'excessive', imperialistic claim to power, and its abandonment of

[1] That part of the canon law which 'wanders over' various matters not covered by the Decretals.

the notion of service to the Church as the community of the faithful. In a passage which shows how sensitive he was to the actual language employed in Rome, Luther writes: 'Therefore, Leo, my Father, beware of listening to those sirens who make you out to be not simply a man, but partly God—*mixtum Deum*—so that you can command and require whatever you will. This shall not be, nor will you prevail. You are the servant of servants, and the most wretchedly and dangerously placed man alive.'

Later in the same year Luther rejected the teaching authority of the Pope altogether and, putting himself at the head of the movement which saw in Rome the chief obstacle to reform, appealed to a Council to be summoned by the Emperor Charles V: a new Nicaea presided over by a new Constantine, at which not only clergy but laity too would hammer out a pure religion like that of the early Christians.

In Rome the machinery for dealing with revolt now slipped into action. Luther's appeal to a Council was rejected on the basis of Pius II and Julius II's prohibition of any such move. A commission presided over by Cajetan pronounced heretical 41 propositions in Luther's writings, most of them already condemned by the University of Louvain, a body which Luther himself had named as being impartial. Among the views condemned were Luther's conception of all-powerful sin ('In every good work the righteous man sins,' 'A good work done very well is a venial sin,' 'No one is certain that he is not always sinning mortally, because of the truly hidden vice of pride'), his interpretation of the role of faith, and of the sacraments, and finally his rejection of papal authority. On 2 May Leo examined a draft of the bull *Exsurge* at his hunting-lodge, and it was then submitted to the sacred college at no less than four consistories; it is noteworthy that the German episcopate was excluded altogether from proceedings against Luther, and this was later to have an adverse effect on Rome. In June 1520 *Exsurge* was published, condemning the 41 propositions, ordering Luther's writings destroyed, forbidding him to teach or preach, and threatening him with excommunication if he did not recant within two months. Copies were sent for enforcement to the Emperor and the German princes.

But Rome was already one move behind. In July Luther had published his *Letter to the Christian Nobility of Germany* in which, drawing on the views of John Huss and the Bohemians, he moved beyond an attack on the papacy to a complete rejection of tradition, in place of which he set up the holy word of Scripture. By taking his stand on Scripture Luther hoped to re-establish the sovereignty of God alone, over against anything the Church had said or might say. In December Luther publicly burned the bull *Exsurge*. On 3 January 1521 Leo excommunicated Martin Luther: cut him off 'as a dead branch'.

But Luther was hardly 'a dead branch'. As a Saxon and a Wittenberg Professor, he belonged to a vigorous community conscious of its independence and protected by the swaggering, moustachioed Frederick, Elector of Saxony, absolute lord in his own domain and the founder of Wittenberg University, whose professors he looked on as his own children. Frederick had no intention of handing Luther over to be burned at the stake, like poor John Huss a century earlier. Intellectually, too, Luther belonged to a flourishing band of scholars, notably Philip Melanchthon, the armourer's frail son who was the best humanist in Germany, and Ulrich von Hutten, a tough knight errant steeped in Tacitus's *Germania*, finding in that book the purity of morals and manliness he ascribed to the German character. And behind Luther stood the men of Germany, disliking and sometimes hating Rome, conscious of their new strength as a people. Roman cardinals might be rich, but they banked with the Fuggers; German mercenaries in Charles VIII's invasion army had scattered the Italians, thus proving themselves worthy successors of Arminius, the tribal leader who decisively defeated Varus in 9 A.D. The late Emperor, Maximilian, had confided to his sister that one day he intended to add the papal tiara to his iron crown: was it so impossible an ambition?

These were the men who read Luther's writings, and were stirred by his extremely powerful, scathingly witty style derived from Lucian. As so often happens, their reactions were at variance with the author's intention, and by sheer weight of numbers they were to drag Luther in directions he did not always want to go. What appealed to the average reader was less the corruption of man than

the corruption of Rome: that Babylon where Christian blood was shed with St Paul's sword, Plato and Aristotle were painted opposite the Blessed Sacrament, and Bembo advised Sadoleto to 'avoid the Epistles of St Paul, lest his barbarous style should spoil your taste'. In vain did Leo's representative, Girolamo Aleandro, argue that abuses committed by Rome should not be confused with Catholic truth; as a scholar, he could not see that it is love and hate, not calm reason, that determine most men's view of truth. In place of the authority of Rome Luther's followers erected the authority of Scripture interpreted by the individual Christian according to the light of the Holy Spirit. This had a profound appeal at a time when the printed word, so recent an invention, still wore something of a halo. And so the rift widened: Scripture against Church, Grace against Works, Predestination against Free Will, communion service against sacrifice, the priesthood of every Christian against the teaching authority of the Pope.

In the early 1520's it became evident in Rome that *Exsurge* had neither silenced Luther nor checked Lutheranism, which was beginning to erect itself into an organized Church, styled Apostolic and declaring the Roman Church heretical. An answer would have to be found, and found quickly: preferably a dogmatic answer to what was primarily a dogmatic challenge. But precisely here Rome found herself ill-prepared. Ever since 1380 when John Wycliffe first challenged *traditiones humanae* and William of Waterford made the mistake of defending unwritten traditions by arguing from the insufficiency of Scripture, a false antithesis had been set up: Tradition and Scripture, each envisaged separately. This had sufficed to condemn Huss, but not to provide refutation of his arguments. The Vatican had no books defending Tradition, only Raphael's painted defence of the Real Presence.

In method also Rome found herself at a disadvantage. As Erasmus remarked, Ciceronian Latin was useless for answering heresy, since it did not contain the necessary vocabulary. There was no chair of Scripture in the Sapienza, and in the words of the Augustinian General, 'Rome, the prince of cities, is the world's dunce in Biblical studies.' Sante Pagnine's translation of the Old Testament into Latin, made in Lucca in 1518, did not find a publisher until 1528, and

then only in Lyons. On his return in 1522 even Aleandro, one of Italy's foremost humanists, sadly and belatedly had to return to school: 'I have begun to extract from ancient authors passages which condemn the new enemies of the Church. Since the heresiarchs are always objecting that Latin authors are suspect to them, I have taken these passages from Revelation, from authors who cannot be attacked and from the Holy Councils of the early Church.'

It became obvious to the Pope and his advisers that a complete dogmatic answer could be neither quick nor easy. Meanwhile some other course must be found. The first and most obvious was to call a Council, for Luther had said, 'I know the Church virtually only in Christ, representatively only in the Council.' Only a Council could issue a decision which all concerned would regard as undoubtedly binding. Why then did none of the Pope's best advisers with first-hand experience of Germany—Cajetan, Campeggio, Aleandro—recommend a Council?

They were, to start with, victims of the false antithesis Papacy-Council, given new life by the recent Council of Pisa. They could not rid themselves of the fear that the rulers of Europe, acting through their bishops, would destroy the Pope's independence by whittling away his financial and temporal power. That is why the mere rumour of the summons of a Council caused a sudden fall in the price of all saleable offices. Secondly, and perhaps even more important, they realized that Rome was insufficiently prepared to enter the arena against the new, well-trained, well-armed German gladiators, and that tactical defeat before the assembled prelates of Europe might still further rend Christ's seamless robe. Twenty-five frustrated years were to pass before a Council would meet.

A third course presented itself: so thorough a Reform in Rome that the Lutherans' catchword would ring hollow. Here there were hopeful signs. As early as 1515, two years before Luther's 95 theses, a group of Roman priests and laymen had formed the Oratory of Divine Love in order to sanctify themselves by the sacraments and prayer, and so bring a reforming influence on others. Members set special value on humility: Gaetano di Thiene dwells in his letters on his unworthiness to offer Mass, wherein he, 'a poor worm of earth, mere dust and ashes, passes, as it were, into heaven and the presence

of the Blessed Trinity.' The Oratory soon numbered more than fifty influential Romans, and from it in 1524 were to issue the Theatines, a new Order of regular clergy vowed to stringent poverty.

To members of the Oratory it seemed nothing less than a direct intervention by the Holy Spirit when the conclave held in 1523 to elect a successor to Leo chose *in absentia* Adrian Dedal of Utrecht, the son of a poor shipwright who had made his way by intellectual brilliance to become tutor to the Emperor and later his viceroy in Spain. 'His face is long and pale,' wrote the Venetian envoy of Adrian VI, 'his body is lean, his hands are snow-white. His whole bearing impresses one with reverence; even his smile has a tinge of seriousness.' The new Pope arrived in Rome bent on reform. When told that Leo had employed 100 grooms, he made the sign of the cross and said that four would suffice for his needs, but as it was unseemly that he should have fewer than a cardinal, he would appoint twelve. When Cardinal Trivulzio asked for a bishopric to relieve his poverty, Adrian asked, 'What is your annual income?' '4000 ducats.' 'Mine was 3000, yet I lived on it and even saved.' It was not meant as a boast. 'All of us, prelates and clergy, have gone astray, and for long there is none that has done good; no, not one.'

Adrian celebrated Mass daily—and this for a Pope was an innovation. His meals, which he ate alone, were Spartan: a dish of veal or beef, sometimes a soup. When the *Laocoön* was proudly shown him, he observed dryly—and inexactly: 'They are only the effigies of heathen idols,' and ordered all the entrances to the Belvedere walled up save one, the key to which he kept himself. Leo's poets and painters he would not even see, far less employ. All his time he gave to economies and the appointment of holy, hard-working bishops, who might do something to improve the Italian clergy, only two per cent of whom understood their Latin breviary.

But Adrian lacked warmth and a knowledge of the Italian mind. A Venetian applied to him Cicero's remark on Cato: 'He acts as though he were living in some republic of Plato's, not among the dregs of Romulus.' The 'dregs' hated Adrian. Starved of the pomp which filled their pockets and made their eyes brighten, they jeered

at the Pope as a barbarian and mocked at the tongue-twisting names of his advisers: Enkevoirt, Dietrich von Heeze, Johann Ingenwinkel. They composed bitter pasquinades:

> *Caduto è a terra il gran nome romano*
> *a dato in preda al barbero furore*
> The great name of Rome has tumbled
> And become a prey to the furious barbarian

—little knowing that the lines held a tragic prophecy. At every turn the Romans opposed reform, the whole idea of which they ridiculed. As a result Adrian lived a lonely, wretched life, taking stringent precautions against poison. Then, only thirteen months after entering Rome, he fell ill of a kidney disease induced by the climate —it too was hostile. After asking that no more than 25 ducats be spent on his funeral, this would-be reformer left a world he could not reform. While the Romans facetiously gave thanks to his doctor, an epitaph was cut for his tomb: 'Alas! how much do the efforts [*virtus*], even of the best of men, depend upon time and opportunity.'

It now remained to be seen whether Adrian's successor could achieve the reform for which all Christendom waited. Giulio de' Medici, who took the name Clement VII, was the son of Giuliano de' Medici, stabbed to death in Florence Cathedral, and a first cousin of Leo X. Blameless in his personal life, the new Pope possessed a long handsome face, cultivated tastes and the Medici intelligence, without, however, the Medici drive. He had been born an orphan and illegitimate, and all his life he remained to an extreme degree timid and vacillating. He seemed to lack a core.

Clement was, however, full of good intentions and decided to cut the 'spiritual' taxes so hated abroad. This was less easy than it sounds. The taxes were payment for legal and secretarial work involved in issuing briefs, dispensations and so on, performed by more than 2000 Curia officials who had bought or inherited their jobs; that is, they or their fathers had put up capital on which they were entitled to a 10% return. If Clement reduced taxes, he would reduce the return, and would have to make good the difference from some other source. But there was no other source: in fact, as certain German princes embraced Lutheranism, income fell sharply. But

Clement did make one useful discovery. He saw that the remuneration of Curia officials was being confused with what was in effect the Papacy's public debt and, banker's nephew that he was, began to clear up the confusion. When he had to raise money in 1526, he did so not with the creation of new offices but by issuing under the name *Monte della Fede* what were in effect 200 Treasury bonds, each of 100 ducats, yielding 10%. This discovery was eventually to make reform possible but only a generation later. For the moment it produced no immediate cut in taxes. If a reform of the Curia did not take place under Clement the reason is that, given the structure of papal finances, it could not take place.

Though Clement failed to heal schism through positive reform, at least it behoved him to prevent schism spreading. But here his indecisive nature proved his downfall. He lost Scandinavia and much of Switzerland, and during his reign occurred the break with England.

In 1505 Henry VIII had been granted a dispensation by Julius II to marry Catherine of Aragon, the widow of Henry's brother Arthur. Eighteen years later, having fallen in love with Anne Boleyn and being anxious for a male heir, Henry took the first steps towards obtaining a divorce. His conscience pricked him, he said, at being married to one within the forbidden degree of affinity. Instead of declaring unmistakably that a divorce was wrong and could not in justice be granted, Clement let things drift and lulled Henry with promises. In 1527 Clement was asked by Henry's agent, Knight, to grant a dispensation for the King's marriage with Anne Boleyn—this was necessary because Henry had earlier committed adultery with Anne's sister Mary—in the event of the union with Catherine being at some future date legally dissolved. Clement issued the dispensation. This hardened Henry's resolve to procure a divorce, and inclined him to think that Clement would continue to grant his wishes.

In July 1528 Clement sent Campeggio to England with instructions to protract the affair. This he did for almost a year. In March 1530 Clement referred the case to the Rota in Rome. Here again delays, false hopes and bargaining antagonized many Englishmen who might otherwise have remained loyal to the Pope. In 1532 the

Archbishop of Canterbury died and Clement blithely accepted Henry's nominee, Thomas Cranmer. He still did not understand his man, still saw Henry as 'Defender of the Faith', a title earned by a tract against Luther containing the statement: 'the whole Church not only is subject to Christ but, for Christ's sake, to Christ's only vicar the Pope of Rome.' By this time Anne Boleyn was pregnant and Henry would not wait any longer. In May 1533 Cranmer pronounced Henry's marriage to Catherine invalid and the following month crowned Anne queen. Clement excommunicated Henry, but only in March 1534 did he definitely declare the marriage to Anne null and void, and order Henry to take back Catherine. Of course Henry refused. Luther's successful revolt had created a precedent and in this sense the English break followed from the German. By the time of Clement's death in September 1534 Henry had made himself Supreme Head of the Church in England, the English schism was an accomplished fact and the Papacy grievously weakened.

If Clement's handling of Henry was disastrous, his handling of the Emperor was equally so. Having appointed two Secretaries of State, the first favourable to Germany, the second to France, Clement followed the advice now of one, now of the other. When François I invaded Milan in 1523, Clement could not resist making a secret alliance with him in the hope of curbing the Emperor. But he had seriously overestimated French strength and at Pavia in 1525 François lost 'everything save honour'. He was taken prisoner and released on a solemn promise that he would form no further anti-imperial alliances. Clement, however, once again entered into a League with François against Charles, thus giving papal support to open treachery. The League proved ineffective and Charles retaliated by inciting the powerful Colonna family to make turmoil in Rome. Clement sought safety in the Castel S. Angelo and there vacillated still further, intriguing first with one side, then with the other, thus justifying Berni's lines:

> Un papato composto di rispetti,
> Di considerazioni e di discordi,
> Di piu, di poi, di ma, di si, di forsi,
> Di pur, di assai parole senze affetti. . . .

A papacy composed of cautiousness,
Of much consideration and discourse,
Of 'well', and 'but', and 'if', and 'no', and 'yes',
Of scores of words that haven't any force. . . .

In late autumn 1526 superior Italian and Swiss forces stood poised to scatter the Emperor's army in Northern Italy, as once Julius and the Swiss had scattered the French. Instead of striking swiftly and hard, Clement called a truce, withdrew his troops behind the Po and tried to negotiate with Charles. He had been lulled into a false sense of security by the dispatches of his ambassador Baldassare Castiglione —author of *The Courtier*—who, taking a bright view of human nature, depicted the Emperor as a paragon of virtue, a man of peace eager to obey the Pope in everything. Charles, in the event, declined to be 'the Pope's vassal', as Clement tactlessly called him; indeed, he proved distinctly cool. Moreover, for months the Imperial troops had received no pay; hearing of the talks, they got out of hand and crossed the Po, bent on loot. This coincided with another misfortune. The bravest Italian commander, Giovanni of the Black Bands, his device a flash of lightning, was fighting like an ordinary soldier in the front ranks when a cannon-ball from a falconet broke his leg, which had to be amputated. A week later he died in the arms of his friend Pietro Aretino, and henceforward Italian troops were under the sole command of Francesco Maria della Rovere the gouty, who waged war from his litter with Fabius Cunctator as a model. Francesco's vacillation matched Clement's. He announced his intention of repelling the Germans, but only at the head of two armies, each equal to the enemy's, and each spearheaded by 5000 Swiss—who were then being recruited in far-off Switzerland! While Francesco acquired the nickname *Veni, vidi, fugi*, the invaders swept southwards unopposed. In vain did the Florentine patriots, Guicciardini and Machiavelli, beg Clement to fight it out: Florence was surrounded and bought her safety for a huge sum. This, however, proved insufficient to appease the enemy's appetite for plunder. On 4 May 1527 they arrived, to the number of 27,000, at the walls of Rome.

Since the revolt of Luther Rome had become a demoralized city. Grass and weeds grew in the crevices of Bramante's piers and arches

for the new St Peter's. Francesco Berni, a cardinal's pet, composed viciously obscene verses in a style of irresistible charm. The novel everyone was reading described the adventures of a beautiful prostitute: its author was a Spanish priest residing in Rome. Marcantonio Raimondi, an artist whom Leo had employed on better things, catered to low tastes with pornographic engravings, for which young Pietro Aretino wrote a set of equally pornographic sonnets. On Holy Thursday 1527, while Clement blessed the faithful in St Peter's square, a hermit named Brandano of Petroio, clad only in a leather apron, a mad look in his eyes, clambered on to the statue of St Paul. There, brandishing a crucifix and a skull, he shouted to Clement: 'You bastard of Sodom, for your sins Rome shall be destroyed!' The epithet was a calumny, but it held true of others in the Vatican. Since then the city had lain under a sense of doom.

The attack came, in dense fog, on the morning of 6 May. 'Caesar's army', part German, part Spanish, advanced to the foot of the scantily-defended walls nearest the Vatican and Janiculum, set up ladders made of vine-poles, and began to scale them. The French envoy hurried to warn Clement, who was praying in his private chapel. Bishop Paolo Giovio flung his violet mantle over Clement's white clothing as a disguise, then hurried him across the open wooden bridge to the Castel S. Angelo. There, in the marble-faced mausoleum of Hadrian, the Pope was joined by thirteen cardinals: one of them, Armellini, had to be hauled up in a basket. Raphael's brave paintings of the chastisement of Heliodorus, and of Leo I's meeting with Attila proved no substitute for guns, and the enemy poured into Rome, killing indiscriminately. Only the Swiss Guards stood firm and fell almost to a man. On that first day 8000 people lost their lives; for six days more the streets were to run with blood, until 13,000 Romans lay dead.

The Germans, who were mainly of Lutheran tendency, took the lead in looting churches and monasteries, showing a religious hatred absent from every previous sack, even the last, by Guiscard's Normans, in 1084. One soldier, dressed in a cardinal's long robes and hat, paraded with a barrel of wine on his shoulder, while comrades parodied hymns. Nuns were traded on the throw of a dice or sold for two ducats. The holy Gaetano di Thiene and his co-founder of

the Theatines, Gianpietro Carafa, were arrested, brutally treated and thrown into prison. Cardinal Ponzetti was dragged through the city by a rope until friends raised 20,000 ducats' ransom. Cardinal Numai, an invalid, was torn from his bed, dragged through the flaming streets on a bier and lowered into a crypt at Aracoeli, with the threat of being buried alive unless ransom was paid.

The enemy sacked the Sapienza, destroyed many of the Vatican Library manuscripts, ripped the lead from bulls in order to make cannon-balls, and even tried to extract the gold thread from Raphael's tapestries. On one of Raphael's frescoes in the *Stanze* a soldier's pike carved the name of Martin Luther. Painters such as Perino del Vaga, Marcantonio Raimondi and Giulio Clovio were tortured and robbed of all they had. Peruzzi, the architect in charge of St Peter's, was captured and because of his dignified appearance suspected of being a rich prelate. To prove himself just a poor artist, he was forced to make a drawing of the corpse of the Constable of Bourbon, the Imperial commander killed in the first assault. Only after this grim experiment was he spared.

Benvenuto Cellini and two other artists, Lorenzo Lotto and Raffaello da Montelupo, had found jobs on the roof of S. Angelo as gunners. Cellini tells how, as the siege of the castle continued, Clement sent for him. He found the Pope amid a heap of jewels, reliquaries and tiaras; these he was told to remove from their gold settings, wrap up in paper and sew into the lining of the Pope's clothes and those of a faithful servant: a plan for escape which, like so many of Clement's plans, never came off. On another occasion Cellini fired a lucky shot and wounded the Prince of Orange, who was then carried into an inn. There all the Imperial commanders presently gathered. Clement ordered every gun trained on the inn, firmly intending to blow it to bits. Then a cardinal intervened: if all the commanders were killed, their troops would run amok, storm the castle, and kill the Pope and cardinals. Clement immediately began to waver. 'The poor Pope,' says Cellini, 'seeing himself harassed from within and without, completely despaired and said he left the decision to them. So the order was countermanded.'

The Emperor was not responsible for the sack but, angered by so much double-dealing, considered the Pope deserved what he got.

Finally he agreed to free Clement in return for several cities, including Piacenza and Parma, and a payment of 400,000 ducats. Clement called in coiners to melt down many of the beautiful objects created in the past seventy-five years: chains, crosses, chalices, reliquaries, anything with gold. Having raised the first instalment of 150,000 ducats, he was allowed to flee. Crushed by six months' imprisonment, penniless and disguised as a pedlar, Clement arrived in the fortress town of Orvieto; his feet were painfully swollen and, as he noticed sadly, 'Even the canopy above my bed is not mine, it is borrowed.' Clement had left behind a city shorn of 10 million ducats and 13,000 lives, its intellectual, artistic and spiritual leaders either killed, imprisoned or scattered, a Rome that was no longer Rome.

The sack is a turning-point in Italian history. It marks the discrediting of two concepts which had their roots in the classical past and which so affronted the Germans: first the imperial-Roman concept of a powerful Papacy, heir to the glories of the Caesars, and like them using war as an instrument of policy; second, the concept, derived from Florence, of Rome welding together Christianity and the classical heritage. It made clear in unforgettable and symbolic fashion the Lutherans' hatred of a city which would not, they thought, let God be God. It also proved finally and beyond doubt what had already been clear to many after Fornovo: that an Italy of small principalities was no match for her northern neighbours, and had entered a period of political subjection. Even the brave and usually unemotional Florentine, Francesco Guicciardini, who as the Pope's Commissioner had done what he could to give Clement a core, was tortured by remorse and went into gloomy retirement, where in his own hand he copied out the dark prophecies of Savonarola.

The Courtier's World

LUTHER's theological views, which found a political expression in the sack of Rome, precipitated a crisis in Italy: what may be termed the crisis of the Renaissance. They placed in doubt the sort of life man should lead, the truth he should seek, the art he should produce. They raised fundamental questions about grace, good and evil, inwardness and authority. Could Italians summon up answers which would, on the one hand, satisfy the Lutherans, and on the other remain true to all that was best in the classical heritage? Could Italians find their way to a genuine religious renewal? But religious renewal is only one part of a total spiritual renewal, and this in turn is the sum of all man's civilized activities. The religio-theological answers, then as always, were to spring out of the texture of the Italian way of life. So in order to understand the crisis fully and how Italy responded to it, it is necessary to look at the Italians' view of history, their progress in science, their achievements in the arts, and, first of all, at life and literature in the Courts, as exemplified by three highly influential city-states in the northern half of Italy.

The first is the duchy of Urbino. It lies on the slopes of the Apennines, facing the Adriatic; despite poor soil and a climate of extremes, it managed to support a population of 40,000. The town stands on a height and is centred in a fortress-palace remarkable for Francesco Laurana's graceful courtyard, *trompe l'œil* marquetry panelling and the most sumptuous classical library in Italy. Here between 1482 and 1508 the amiable, gout-ridden Guidobaldo kept court, aided from 1489 by a charming wife, Elisabetta Gonzaga, daughter of Federigo, Marquis of Mantua, and of Margaret of Bavaria. Their values were Florentine, they helped scholars and artists, and encouraged the art of conversation. Under Julius II

Urbino passed to Francesco Maria (*Veni, vidi, fugi*) della Rovere, and under Leo X, to Leo's nephew Lorenzo de' Medici.

A hundred miles north lay the second court, Ferrara, overlooking vast flat fields of wheat, maize and hemp, dotted by mulberry trees and vines trained round tall vine-poles. The duchy is considerably larger than Urbino and protected from the Adriatic by dykes; at Comacchio land and sea merge in immense lagoons, famous, during spring and autumn, for their catch of eels. The Este family ruled from a moated, turreted four-square castle, and encouraged the arts, notably drama. Among their duchesses was Lucrezia Borgia, who lived in Ferrara after her third marriage in 1502 until 1519.

The third court is Mantua. It stands amid marshes formed by the river Mincio, from which at dawn and on still autumn days a lavender mist rises over the stone buildings and brick towers. The marshes are rich in duck, the fields in wheat. Like Urbino and Ferrara, Mantua prided itself on military traditions and had long provided Italy with war-horses and with generals, the latest being Francesco Gonzaga, who had lost the battle of Fornovo: his chunky head with black fringe and pointed beard is familiar from Mantegna's painting. Now weakened by syphilis, Francesco lived in one plain wing of Mantua Castle, amid hounds, falcons and buffoons, while his Ferrara-born wife, Isabella d'Este, continued the city's Virgilian traditions by entertaining poets in lavish apartments decorated with alabaster and vaulted with florid allegories.

All three Courts were linked by marriage alliances and a common way of life based on feudal estates yielding considerable wealth. There was no real need here to exert oneself, as Florentine merchant-adventurers had done, nor to raise money abroad, as Popes were forced to do. Court existence was easy: a little hunting, occasional war, and ample leisure for gracious living.

The spokesman of this way of life is Baldassare Castiglione of Mantua. He was born in 1478, the son of a blue-blooded army officer and a highly cultivated lady of the Gonzaga family, and to this remarkable mother he remained devoted all his life. After a thorough education in Greek and Latin, he fought at the battle of Garigliano in 1503, when a French army with some Mantuans in it lost the kingdom of Naples to the Spaniards. Castiglione then

entered Duke Guidobaldo of Urbino's diplomatic service and in 1506 visited England in order to collect the Order of the Garter with which Henry VII had invested the Duke. He remained in Urbino until 1513. Three years later he married a noblewoman, Ippolita Torelli, and to please her had his portrait painted by Raphael. It shows a man with an unusually open face, bearded, with a serious, rather sensitive expression. He wears a black velvet hat and black velvet clothes trimmed with grey, in accordance with his own view that a courtier should follow the Spanish custom and wear sober colours—black, brown or grey—in order to show his *riposo*, or inner calm. Calm Castiglione certainly was, though he felt deeply the sack of Rome, which occurred two years before his death. When the Spanish humanist Valdes openly defended the enormities, Castiglione wrote an able and poignant reply, arguing that the remedy for evil must never be a worse evil, and that even Pompey in 63 B.C. had refrained from violating the Holy of Holies in Solomon's Temple.

Castiglione published his highly influential dialogue, *Il Cortegiano* —*The Courtier*—in 1528, but the action takes place in Urbino during the spring of 1507, shortly after Julius II had passed through the town after capturing Bologna. Some of his suite had lingered on, including Bibbiena, author of the *Calandria*, and they gather with courtiers of Urbino in the Duchess's apartments, under the informal direction of her friend Donna Emilia Pia, in order to decide 'what qualifications a person ought to have to deserve the title of a perfect courtier'. The variety of current opinions had placed the matter in doubt, but 'everything has its perfection, though we do not always know it,' so the answer could be discovered by experts.

The courtier, it was agreed, should be of noble birth, good-looking and of medium height, since tall men lack agility. He should receive a solid education in Greek and Latin, possess a good literary style and be proficient in music and painting, for the French were mistaken in their belief that 'the knowledge of letters is an impediment to nobility.' His career should be soldiering. Castiglione's courtier was, then, first and foremost an educated cavalry officer. As such, his bearing should be easy and unaffected. No courtier, for example, would 'keep a looking-glass in the bottom of his hat, or

have a servant at his heels, up and down the streets, with a brush and blacking-pot.'

The courtier's aim in life should be to keep on good terms with his prince, not least by telling amusing stories—such jests, however, should never be anti-religious—in order to instruct him in virtue, check any wilful use of his power and incline him to peace. The courtier cheerfully accepts one-man rule, because this most resembles God's government of the earth, and because in the battlefield, on board ship and in constructing a building responsibility is given to a single man. This was contested, however, by Bibbiena, who remarked that many animals, such as deer and cranes, varied their leaders. Ideally, the prince should act on the advice of a council of nobles and a council of the commons—Castiglione had been impressed by the English constitution—but human nature and society being what they are, the courtier would have to influence his prince indirectly, by purveying 'honest and honourable pleasures'. His political role, in short, was rather humble: to 'sweet the potion, gild the pill'.

The courtier should take a bright view of life, as Castiglione did himself: sometimes too bright, as we have seen in his misleading dispatches to Clement VII. He knew that Nature was 'the origin and mother of all good things', and did not intend us to be subject to passions and infirmities. It is noteworthy that Castiglione's characters are for ever smiling. When one of them remarks that Italians imitate foreign fashions in dress, and that this is a sign of their subjection, he quickly shies off such 'melancholy reflection'. Similarly, when a speaker claims that it is more dishonourable for the Italians to read too much than for the French to know nothing at all of learning, again he politely cuts short his analysis: 'it is better to say no more about this than to discourse with sorrow and reluctance.'

The courtier was a man who acted with grace. The word Castiglione uses is a translation of the Greek *charis* and the Latin *venustas;* originally a term from aesthetics, it had been applied by Pliny to the painter Apelles. Grace, according to Castiglione, was a kind of careless ease, an amateur's approach. It was 'a gift of Heaven and nature' but, if deficient, could be promoted by study and application. Grace was a matter of language as well as of behaviour. As one book

of etiquette pointed out, 'It is a more proper and peculiar speech to say, "The shivering of an ague," than to call it "The Cold",' and 'it better becomes a man's and woman's mouth to call Harlots "women of the world".' Whereas the theologians' grace, the *charis* of the New Testament, helped to make a man good, this aesthetic grace helped to make him a success at court.

Yet the courtier's grace was also in an oblique way religious. Drawing on the courtly love tradition in medieval poetry, Castiglione states that one of the chief sources of a courtier's grace is the love of a good and beautiful woman; in loving her he is loving God and sharing in God's grace. Her very presence could aid him: 'the conversation of every courtier is always imperfect if the society of ladies does not lend it that share of grace which gives to courtiership its utmost beauty and perfection.' A successful courtier, then, was a man in love, and therefore the third book of Castiglione's dialogue discusses the perfect woman.

It has to be remembered that the actual status of women was still not high. In Rome a bride was given honey to eat, but only while a naked sword was held over her head, to recall the perils of dalliance. She owed absolute obedience to her husband, and if ever she chafed, says Erasmus, she should ask herself whether, in an emergency, she would prefer a monkey or a lion. In Ferrara adultery was punishable at the stake, though if an errant wife were forgiven by her husband, she was allowed to return to him. The only women to enjoy independence and fame were certain Roman courtesans, such as Imperia, who was praised by many poets and decorated the outside of her fine house with nymphs surrounding a Venus in her own likeness.

But now Castiglione sang the praises of the ordinary virtuous woman. Her beauty, he says, is an inspiration to men, her conversation a pleasure. But he criticizes the fact that she was usually educated just like a boy. It was a mistake, he says, for young ladies to ride, play tennis, or wrestle, and when dancing they should avoid quick or violent movements. They should, in short, be as feminine as possible. True, Greek and Roman history showed that they could be brave, but their role in present-day society was rather to entertain men and make themselves lovable. Bibbiena agreed and deplored the absence in Rome of women's gentle influence.

Where the fifteenth century had discovered the dignity of man, the sixteenth discovered the dignity of women. Castiglione's theme was taken up enthusiastically in a chorus of books: Domenichi's *La Nobilità delle Donne*, Lando's *Lettera a gloria del sesso femminino*, Capella's *Della eccellenza et dignità delle Donne*, and dozens more. As almost every courtly writer put women on a pedestal, the courtier's world became largely a woman's world. This was not a principle of classical antiquity: according to Pericles the best woman was the one no one talked about, and if the Romans set high store by married love, they never exalted women. The movement derives rather from courtly love in medieval Provence but, as we shall see, it justified some of its forms by invoking Plato.

The results of the movement were far-ranging. It became customary for rulers and prominent public figures to strike medals not only of themselves but also of their wives, thus reinforcing their own glory with their wives' classical profiles. Montaigne found that 'the men dress very simply whatever the occasion, in black serge from Florence'; if they permitted themselves a gold medal in their hat, it usually portrayed a woman, like the *Leda and Swan* Cellini made for Cesarini, Gonfalonier of the Roman people. But of the ladies Montaigne says, 'there is no comparison between them and ours for richness of clothes: everything is loaded with pearls and precious stones.'

Not man's *virtus* but the nature of feminine beauty became the question of the day. According to Agostino Nifo, philosopher and professor at the Sapienza, in length the nose should equal the lips, the lips the ears, the two eyes, taken together, the mouth, while the lady's height should be eight times the length of her head. Long fair hair, slender arched eyebrows and a dimpled chin completed Nifo's ideal, which he claimed existed in the person of Joanna of Aragon, wife of the Constable of Naples. A follower of Raphael has left a portrait of Joanna and although the face is indeed perfectly proportioned, her expression is insipid, and one is tempted to agree with Castiglione that beauty depends as much on quality of soul as on harmony of features.

The cult of woman made for gentler manners. According to Giovanni della Casa's influential *Galateo*, 'Jests must bite the hearer

like a sheep, but not like a dog,' while 'To grind the teeth, to whistle, to make pitiful cries, to rub sharp stones together, and to file upon iron, do much offend the ears,' therefore should be avoided. 'And,' warns della Casa, 'when thou hast blown thy nose, use not to open thy handkerchief, to glare upon thy snot, as if thou hadst pearls and rubies fallen from thy brains . . .' Gentle manners, however, did not preclude rough deeds. When his sister was given an illegitimate child by a Veronese with the splendid name of Giovanni Andrea Bravo, Francesco Maria della Rovere immediately had Bravo stabbed to death.

In such a society the favourite topic of conversation was naturally the one nearest women's hearts. Can love exist without jealousy? Can two people fall in love without seeing each other? Which is more painful, to lose the lady one has pleased, or never to please her? Can a miser fall in love? Is man by nature more faithful than woman? Which is more difficult to feign, love or indifference? Sometimes the questions turned on the intricate matter of emblems. What colour should a lover wear to indicate an ardent and undeclared love? Answer: Grey, for it resembles ashes smouldering with secret fire.

This leisured society found time also for games of love. In 'The Ship' each lady chose two gentlemen, then, pretending a storm obliged her to throw one overboard, decided whom she wished to save and why. In 'Lovers' Hell' the company enacted the roles of lovers passed to the next world, and revealed to Minos any transgression against the spirit of love, for which they were assigned by him an apt penalty. In 'The Game of Blind Men' each player pretended he had become blind through love, and explained the circumstances; he performed some action in proof of his blindness, and was then suitably rewarded by the ladies.

But was love really blind? Some said No, among them the courtier Giuseppe Betussi, who in his dialogue *Il Raverta* defined love as a 'voluntary wish'. The Roman courtesan Tullia d'Aragona, in her aptly entitled dialogue *Dell' infinità d'amore*, asks which love is stronger: blind or voluntary, but Varchi, her Florentine guide, shies away from the question, for it would involve discussing those lengthy and dangerous subjects, fate and predestination. Piquancy, not weighty conclusions, was what mattered, hence a favourite

subject with Isabella d'Este: was Lucrezia right to commit suicide? —a question with immense possibilities, since Lucrezia was a favourite name of courtesans.

The courtly love inspired by this growing appreciation of women flowed into two quite distinct channels. In the first ran the pure, cold waters of Platonic love, dispensed chiefly by Pietro Bembo. Born in 1470, the son of a Venetian senator, Bembo is depicted on his medal as a fine-looking man with high brow, long thin nose and long straight hair swept back from his face; the reverse shows him reclining languidly by a stream, sheltered by a cane-break. Languor was Bembo's failing; for this reason he never obtained the post of ambassador he wanted and instead entered the Church, becoming domestic secretary to Leo X. In Rome he fell in love with Morosina della Torre, who gave him three children, but he could not afford to marry her, since this would have entailed surrendering his benefices—a common dilemma at this period and one which had troubled Bembo's twin-spirit, Petrarch. Under Clement Bembo lived in and near Padua, writing poems and championing a chaste form of the vernacular against Latin. After Morosina's death he became a cardinal, dying in 1547 rich and glorious.

In his late twenties Bembo frequented the society of Caterina Cornaro who, after relinquishing her late husband's Kingdom of Cyprus to the Venetian Republic, had been granted a small castle and court at Asolo, complete with dwarf buffoon, hounds, apes and peacocks. Here, shut off from harsh reality by chestnut woods and a garden of bay-trees 'so carefully cut that not a single leaf was out of place', Bembo used to discuss the nature of love. In 1505 he published their discussions in an immensely influential little book, the *Asolani*.

The first speaker, Perottino, claims that love is basically a kind of venom, hence the words 'Venus' and 'venery'. Any joy it may cause is excessive and ends in sleepless nights, elegies and sighs. Perottino's misfortunes have come from falling in love. Finally he takes out the handkerchief once given him by his lady in a kinder mood, wipes away his tears and tenderly apostrophizes the little square of damp linen, which the company then examine, much moved.

Next day a certain Gismondo replies. True, he says, that if we never loved, nothing bitter would befall us, but one might as well

argue that because we should not die unless we were born, our birth is the cause of our death. If, as Perottino claimed, more writers have spoken ill of love than have praised it, that was because human nature tended to blame rather than praise. He then enumerates the good effects of love, making the point that 'if love's spur had not pricked him on, he might not have been known by any man or, to speak more truly, might not have known himself.'

The third speaker, Lavinello, tries to reconcile the two attitudes by pointing out that love could be good or evil, according to its object, and this lay within our power of choosing. That very morning, he continues, he had chanced to meet a wise hermit, who explained what seemed to Lavinello the true theory of love, namely that good love is the desire of eternal Beauty. The hermit's theory Bembo develops more fully when his turn comes to speak in the fourth book of Castiglione's *The Courtier*. A young man, says Bembo, may indulge in sensual love, but one of middle age should recognize that the body is not the fountain whence beauty springs, but rather a mirror palely reflecting a much brighter light. He should be satisfied with a kiss, because in a kiss two souls meet. A kiss will permit his imagination to paint a beauty even more perfect, and he will wish to develop his virtue in order to keep pace with these successive embellishments. Finally, even in this life, his soul will be transformed into an angel: 'without any veil or cloud she views the immense ocean of pure divine Beauty; and receives it into herself, and enjoys that supreme happiness which is incomprehensible to the senses.'

What is one to make of Bembo, and 'the new religion in love', as John Suckling was to call it? Girolamo Zoppio of Bologna remarked that it was for eunuchs, a sentiment echoed by John Cleveland in *The Antiplatonic*:

> Love that's in contemplation placed
> Is Venus drawn but to the waist . . .
> Give me a lover bold and free,
> Not eunuched with formality!

But such criticism misses the point. The new religion in love suited the needs of a society many of whose members, Bembo for example, and Giovanni della Casa and Agnolo Firenzuola, author of an influen-

tial *Dialogo della Bellezza delle Donne,* were clerics who could not marry. It also suited the needs of married ladies in a small society where no misdemeanour escaped notice. Finally, this kind of love was associated with the prestigious name of Plato, though in fact such an attitude to women was alien not only to Plato but to the Greek world.

Bembo's version of Platonic love is an important fact of the sixteenth century. Though sometimes 'a mere trick to enhance the price of kisses', on the whole it increased respect for womanhood. It refined many men, as well as their manners, in an age which might easily have embraced cynicism, and it spurred them to give of their best. It also inspired a vogue for Petrarch, and through him, much of the century's literature. Fine ladies carried about the *Canzoniere* in miniature volumes—*Petrarchini*—attached to their girdles by gold chains, and rhyming dictionaries of the *Canzoniere* were compiled to help countless sonneteers in their imitations of the master. These sonnets are notable less for their ardour than for their stereotyped epithets—golden hair, topaz eyes, coral lips, pearly teeth—which Shakespeare was to satirize in the sonnet: 'My mistress' eyes are nothing like the sun.' Among the best, because the most artificial, are Bembo's: polished and repolished, he used to send them to friends, adding one natural touch in the shape of a little basket of strawberries freshly picked by the author in his rose-garden. If Petrarchism produced little of worth in Italy, it was to prove a happy influence on French and English poetry; as so often happens inbreeding produced effeteness, cross-fertilization strength.

One Italian did succeed in making something original of the Petrarchan sonnet and a Platonic love that was more than a pose or the result of vows. This was Michelangelo, and it is significant that he stood outside the Courts. In one of his rugged sonnets Michelangelo uses 'grace' in the half-aesthetic, half-religious sense endorsed by Castiglione and Bembo:

> *La forza d'un bel viso a che mi sprona!*
> *C'altro non è c'al mondo mi diletti:*
> *ascender vivo fra gli spirit' eletti,*
> *per grazia tal, c'ogn'altra par men buona. . . .*

How strong an incentive is a lovely face!
Nothing on earth I hold so rich a prize:
To soar, while still alive, to paradise,
By way of such incomparable grace. . . .

At the age of sixty-three Michelangelo conceived a Platonic affection for Vittoria Colonna, a lady of thirty-eight who belonged to court society, being a granddaughter of Federigo da Montefeltro and the widow of the Marquis of Pescara. Her medal shows Vittoria to have had a Greek profile, intense eyes, long dishevelled hair and a beautiful bust, but what Michelangelo admired in her was her strong-mindedness, charity and sincere religious searching. The painter of the Sistine titans addressed to Vittoria some of his best sonnets: only she, he says, can draw from him deeds worthy of his trembling soul, 'for in me there is neither will nor strength of mine.' 'Through you,' he tells her, 'my soul is made to look upon God.'

Vittoria herself wrote a sonnet sequence of Platonic love in memory of her late husband: 'I grow to love Heaven more by my Sun's grace.' But Vittoria was not for long content with this vague religiosity: she is unique among courtly sonneteers in moving beyond Platonic love to authentic religious renewal. The following lines show her response to all that was best in Luther, and also a less ambiguous use of the word 'grace':

> Due modi abbiam da veder l'alte e care
> Grazie del ciel: l'uno è guardando spesso
> Le sacre carte, ov'è quel lume espresso
> Che all'occhio vivo sì lucente appare;
> L'altro e, alzando del cor le luci chiare
> Al libro della croce, or' egli stesso
> Si mostra a noi sì vivo et sì dappresso,
> Che l'alma allor non può per l'occhio errare.

> We have two ways to see the high and dear
> Graces of heaven; one is often to read
> The written word of God, where Light indeed
> To the purged eye so radiant doth appear;

The second, lifting the heart's vision clear
Unto the Cross's book, where He who freed
Mankind doth seem so high to those who heed,
That the soul, through the eye, no fall can fear.

But Platonic love is only one channel into which the growing
appreciation of women flowed. The other channel is romantic love.
Marriages were still arranged on the basis of the dowry, but this
system no longer completely satisfied a society which demanded
more of a wife than making excellent pickles. So, increasingly, love
and love-matches—often in defiance of hostile parents—became a
central theme of Italian literature. One of the most popular tales was
'Romeo and Juliet' by Luigi da Porto. Porto gives the plot one more
twist than Shakespeare: he allows Juliet to revive in her tomb, and
to rejoice at finding her lover there. She does not know that,
supposing her dead, Romeo has already swallowed poison.

Romantic love found its chief expression in tragedy. The first
Italian tragedy worthy of the name was written in 1515 by that same
Giangiorgio Trissino whose comments on Germany have been
quoted. Dedicated to Leo X, Trissino's *Sofonisba* is based on Livy's
account of a Carthaginian princess who drinks poison rather than fall
into Roman hands. Unities of time and action are scrupulously
observed. Within twelve hours Sofonisba learns of the defeat and
death of her first husband, Siface; goes into mourning; meets, loves
and weds Prince Massinissa; is sent, a captive of war, to Scipio's
camp; receives by messenger the poisoned bowl; drinks, and so dies.
Stylistically, too, the play seeks to imitate ancient modes: written in
eleven-syllable lines, an unrhyming equivalent of the iambic tri-
meter of Greek tragedy, it is thus the first substantial Italian com-
position in blank verse.

Among the most notable successors of *Sofonisba* are *Rosmunda*, by
Giovanni Rucellai, *Didone in Cartagine*, by Alessandro Pazzi de'
Medici, who, like Rucellai, was a nephew of Lorenzo the Magnifi-
cent, and the nine tragedies by Giambattista Giraldi of Ferrara. The
central character of nearly all these plays is a woman, and the plot
turns on romantic love.

The new importance of women at court demanded not only that
the chief character should be the heroine, but also that women in

their new role of sensitive creatures should be spared the sight of any lurid events. Playwrights therefore, while retaining Aristotle's dictum that tragedy is a reversal of fortune, turned away from the more harrowing Greek drama to Seneca, whose plays were meant to be read, not staged, and therefore call for little action, and to Horace's rule of decorum, which demands that the catastrophe be not actually witnessed, but merely reported.

Although a large number of tragedies were written and performed in the *cinquecento*, and by their experiments, even by their failures, Italians made possible masterpieces elsewhere, in England, Spain and France—where Mairet's treatment of Sophonisba was the first regular tragedy—something fundamental is missing from Italian tragic drama. There is no appreciation of man's essential guilt or his nothingness in face of the Infinite. There is no searing anguish of heart: no lonely struggle against society or the established order. It is doubtful indeed whether the audience wanted tragedy in the strict sense. No less than six of Giraldi's nine tragedies have a happy ending and, writing in *Galateo* of a tragedy with a tearful dénouement, della Casa declares:

> It will ill become us to drive men into their dumps: especially where they be met to feast and to solace themselves, and not to mourn. For if there be any that hath such weeping disease: it will be an easy matter to cure it, with strong mustard or a smoky house. So that, in no wise, I can excuse our friend Philostrato, for his work that he made full of duel and of death, to such a company as desired nothing more than mirth.

The implications of della Casa's advice, when taken with the special features of Italian tragedy, extend beyond literature to the crisis of the age. It was unlikely that men and women with a craving for mirth would ever be able to understand the spiritual experience which had prompted Luther's revolt, far less to evolve a formula for coming to terms with it.

Romantic love and its attendant theme, gallantry, found their most successful expression at the hands of the court poet, Ludovico Ariosto. Born in Reggio Emilia in 1474, eldest of an army officer's ten sons, Ariosto studied law in Ferrara. On his father's death in 1500

he generously came to the support of his brothers by taking a commission in the Duke of Ferrara's army. He served Cardinal Ippolito d'Este from 1503 until 1517, part of the time as his agent in Rome, where Julius II once threatened to throw him into the Tiber and Leo X, as we have seen, welcomed him with a kiss and a copyright. From 1522 to 1525 he governed the unruly district of Garfagna, ending banditry there but modestly comparing himself to the proverbial Venetian, who, given a spirited Arab horse, was promptly thrown. He seems in fact to have done the job unusually well for a poet.

Ariosto, after a design by Titian

His medal shows Ariosto to have possessed manly good looks, a high-bridged nose and full beard. He was honest, sensible and sturdily independent: 'Rather than eat thrushes, partridges and wild boar at someone else's table I prefer a turnip cooked by myself at home on the end of a skewer, seasoned with vinegar and wine. I sleep just as soundly behind a simple curtain as I do behind silk and gold hangings.' According to Ariosto, every man possesses one grain of folly and his, he says, is freedom. But freedom was strengthened, not diminished, by a woman's love. Like Ippolita Castig-

lione, who during periods of separation would imprint kisses on Raphael's portrait of her husband, Ariosto firmly believed in romantic love between man and wife, and he declared that 'without a woman at his side no man can enjoy perfect happiness.' In 1527 he married the charming Alessandra Benucci of Florence, built himself a small house in Ferrara inscribed with the Horatian motto, *Parva sed apta mihi*, and had two sons, to whom he was a good and thoughtful parent.

Ariosto published forty cantos of the *Orlando Furioso* in 1516, and the complete, revised edition of forty-six cantos in 1532, the year before his death. Its theme is one of the great traditional themes of medieval romance: the struggle of Charlemagne and his knights against the Moor; but it is treated in an original way, as we see from the opening lines, with their echo of Virgil's *Aeneid*:

> *Le donne, i cavallier, l'arme, gli amori,*
> *Le cortesie, l'audaci imprese io canto. . . .*

> Of loves and ladies, knights and arms I sing,
> Of courtesies, and many a daring feat. . . .

The main plot concerns Orlando, Charlemagne's nephew and the bravest of those knights then defending Paris against the Moor. Orlando is in love with Angelica, daughter of the Great Khan of Cathay, a flighty creature in more senses than one, for she possesses a magic ring which, when placed in her mouth, renders her invisible. During a journey she is captured by pirates and exposed naked on a rock as food for the terrible orc. She is saved by the bravery of a Moorish lord, Ruggiero, who then falls in love with her. Ungratefully Angelica slips away and returns to France, where she cures and tends a wounded Saracen of obscure birth named Medoro.

Orlando is so deeply in love that he leaves the endangered Christian camp to try and find Angelica. In a wood he discovers certain trees on which Medoro has carved declarations of love for Angelica: they are in Arabic, but Orlando knows that language 'as perfectly as Latin'. He is shown a gold ring by a shepherd to whom Angelica has handed it as a reward for his help: it is the very same ring Orlando once gave her as a pledge of love. Finally Orlando

learns that Angelica has married Medoro and gone to live in Cathay. The shock is such that after much suffering he loses his reason. He becomes *furioso*, wandering about unclothed, behaving like a wild beast, throttling any man who disturbs him and resisting all attempts at capture.

Astolfo, an adventurous English knight with magic powers—he imprisons the winds and changes branches into ships—resolves to help Orlando. Borrowing Elias's chariot, he flies to the moon, knowing that in the moon is stored all that men have lost through time, chance or their own folly: such things as fame, unfulfilled vows, lovers' tears and sighs, broken treaties, counterfeit coin, even a heap of once fragrant, now fetid flowers, which represent the Donation of Constantine. Towering over all, like a mountain, is the common sense which men on earth have lost: a soft, thin liquid, stored in flasks and phials, each bearing its former owner's name. St John the Apostle gives Astolfo the phial containing Orlando's lost senses and he returns to earth. After a titanic struggle Orlando is overpowered by a group of knights and made to inhale his lost senses. He at once recovers his sanity and with it his sense of duty. He then kills the Moorish king, Agramante, and returns with his companions in triumph to Paris.

Parallel with this runs the love-story of Ruggiero, a *pius Aeneas* who never puts a foot wrong, and Bradamante, a Christian lady whose feats of bravery equal those of the knights. After many adventures, including the conquest of the terrible fairy Alcina by the brightness of an enchanted shield, Ruggiero is converted to Christianity by Bradamante and takes her for his wife—meanwhile he has become, almost without trying, King of the Bulgarians! From this marriage one day will stem the glorious Este family, rulers of Ferrara.

Interwoven with the two central plots are numerous self-contained episodes recounting the feats of this or that knight, as well as shipwrecks, tournaments, imprisonments and love scenes, each in a different setting, for it is one of the characteristics of this epic written during the age of discovery that it takes as its stage the whole world, and wanders freely from Ethiopia to England, from Iceland to India.

The values of the *Orlando Furioso* are essentially the same as those of medieval romance. As in Malory, an exalted role is accorded to women. Most of the brave deeds are performed specifically in order to save or win a fair lady. Even when Orlando leaves beleaguered Paris, Ariosto excuses him, since he is seeking Angelica. Love is beyond and above the law, so that one who yields to love is never guilty. Not only does love stimulate courage, it improves character: even Angelica, after marrying Medoro, loses her former flightiness. It is axiomatic in the poem that if a man fails to win his sweetheart, he has nothing more to live for, and, should her lover die, a lady will retire to a cell near his tomb, and before long join him in the next life. Indeed, the epic which began with the words 'Of loves and ladies' closes with a celebration of the most lovable ladies of Ariosto's day. Where Castiglione holds that a courtier owes his grace to the love of a beautiful lady, Ariosto goes even further: he claims that the fair sex inspires a knight's prowess, and can even inspire the liberation of Italy. For like an undercurrent to the epic runs Ariosto's belief that Italians must relearn valour and drive out those 'fierce and hungry harpies, that on blind and erring Italy so full have fed.'

This leads to a second very striking feature of the *Furioso*: the rivers of blood. How often bodies are cleft with a single blow, heads fly from shoulders, 'And through that champaign ran the reeking blood, As to the valley foams the mountain-flood.' No one in Ariosto's day could possibly have witnessed bloodshed on such a mammoth scale, and the poet evidently provided it in order to answer a defeated people's deep-seated need. It was partly compensation, partly a clarion-call. Yet the clarion-call has one flat note. Warfare had begun to turn on cannon, falconets and bombards: it was with these that the French had won at Ravenna in 1512, the costliest battle in recent history. But Ariosto will have nothing to do with them. Orlando, finding the first man-made cannon, flings it, together with its powder and ball, into the deepest part of the ocean, cursing it as a devilish device, then sails away, confident that the chivalrous virtues have been saved. But two cantos later Ariosto bitterly predicts that the cannon will be fished up with grapnels by the Germans and spread through Europe, so that 'the trade of arms becomes a worthless art.'

The truth is that Ariosto hates modern war as much as he loves chivalry, an attitude he shares with tough Guicciardini who, in his *History of Italy*, refers to guns as 'diabolical rather than human'. Vannoccio Biringuccio of Siena, head of the papal foundry and arsenal, published in 1540 a book *De la Pirotechnia*, treating of minerals, assaying, alloys, casting, melting, fireworks in warfare and festivals. But note that he adds a final chapter dealing with 'the fire that consumes without leaving ashes, that is more powerful than all other fires and that has as its smith the great son of Venus.' What fire is that? Love. This was a very Italian, very gallant way of bringing to a close the first metallurgical treatise and it chimes well with Ariosto's attitude.

Because Ariosto saw that personal chivalry was threatened by modern techniques of war and because he wrote under the shadow of foreign invasion, the *Orlando Furioso* is one of the bravest poems ever written. It has something of the cheeky daring of Julius II's lone attack on snow-bound Mirandola. In a world of tough national armies Ariosto has the courage to celebrate, with gay good humour and unflagging invention, intrepid deeds, comradeship in arms, and the winning of beautiful women. The poem's stirring quality, expressed as it is in sonorous language, appeals to all men who prize honour and has made it one of the half-dozen most influential works in Western literature.

It was influential above all in its own day. The *Orlando Furioso* is one of the central facts of the sixteenth century. It became a force in the life of every educated Italian, so that Niccolò dell' Abate would paint Alcina receiving Ruggiero as naturally as he would the abduction of Proserpina. It did much to restore Italians' confidence in themselves, for the heroes, despite their French or oriental setting, are wholly Italian, and it kept alight the flame of patriotism. When Clement VII signed the treaty of Bologna in 1530, thus acquiescing in the Emperor's partition of Italy, national unity was rendered impossible for more than three centuries, but the longing for unity remained, and the *Orlando Furioso* became its anthem.

The *Orlando Furioso*, Castiglione's *Courtier* and Bembo's *Asolani* sum up the courtier's world and reveal the large extent to which it was a woman's world. The implications of this change of emphasis

are evident. Since the role of women in society is conservative, their improved status will certainly present a strong obstacle to religious innovations from beyond the Alps. In this respect Vittoria Colonna, who was exceptionally strong-minded, is a unique example of the opposite tendency. The latent frivolity of the courtier's world will also prove a strong obstacle to religious heart-searching. As for courtly love, by exalting women it turned men's minds to quite another variety of religious experience from that which Luther had known.

On the other hand, this world of courtiers furthered many of the principles of Christian humanism. It increased man's knowledge of Greece and Rome. It favoured the Platonic dialogue, the form *par excellence* of free enquiry, and developed a sophisticated literature as a means of examining human nature. Its literary rendering of romantic love was to pave the way for marriages based on love and mutual respect rather than on parental bargaining. As we have just seen, it set high store by bravery and patriotism, yet valued peace. Finally, it corrected a lingering view that woman was one of nature's mistakes, best kept in the kitchen, and began to evolve a distinctive type of education that was to make of her a lady.

CHAPTER 6

The Growth of History

THE READING and the writing of history had been essential to
Italian achievements since 1400; the former by providing new ideals
and new fields of endeavour; the latter by defining civic origins,
values and a programme for the future. In writing history Italian
historians were keenly aware of the classical authors they had read,
and it was characteristic of all of them that they sought to link the
present to the greater past. Leonardo Bruni, for instance, in his
pioneer *History of Florence* showed that his city by upholding
political liberty against tyrants was continuing the glorious role of
republican Rome. The notion of 'continuing', of upholding some-
thing basically unchanged is fundamental, and was borrowed from
the classical historians whom Italians used as models. Livy, from the
beginning of his narrative, treats Rome as ready-made and com-
plete. He projects such institutions as augury, the legion and the
Senate into the very first years of the city. The idea of development
is missing altogether, even in the matter of character. Tacitus, for
example, in order to explain how a man like Tiberius deteriorated
once in power, represents the process not as a change but as the
revelation of vices hitherto hypocritically concealed.

This notion of history as something essentially unchanging had
received support from scientists, who claimed that the 'natural' state
of the cosmos was rest, and from theologians, who, making no
distinction between the periods of the Prophets or the Apostles, and
that of the Councils, Fathers and Popes, described as 'inspiration' by
the Holy Spirit, or as 'revelation', the whole of the Church's past.
As for change, it was compared to cycles of a wheel that turns
without advancing: an idea of Indian origin made popular by Plato.
Polybius is typical of many when he speaks of 'the cycle through

which states in rotation pass, whereby they are changed and transformed until they get back to the start.' There is a reshuffling and recombination but no transformation of the constituent parts. Change takes place on a bed-rock of unchangingness.

When, therefore, Italian historians spoke of a rebirth, or restoration, in their own day, they meant that the wheel had been brought full circle to the same high point attained by Athens and republican Rome. There was no development, but rather repetition often in strange guise: 'the same events recur endlessly,' wrote Francesco Guicciardini, 'and nothing happens that hasn't been seen before; but since everything changes name and colour, it is only wise men who recognize them.' The notion of beginning quite anew was alien. We have seen an example when Julius II laid the foundation stone of St Peter's. Although he was in fact building a new basilica, he claimed to be restoring the old.

The notion of history as a wheel that turns without advancing remained fundamental in the sixteenth, as in the fifteenth century. Even the most original thinkers took it at least as their starting-point. Here we shall look at the two major historians of the sixteenth century, and two other Italians who also extended and deepened the concept of history.

The two major historians were both Florentines, and in order to understand their achievements it is necessary to look briefly at the history of Florence since 1494. In that year Charles VIII's army swept through Tuscany, entered Florence and seized Pisa. In that year also Florence remodelled its constitution on that of Venice, instituting a Great Council of 3,000 citizens, and building a hall for them which was an exact reproduction of the hall in the palace of the Doge. But the new Council merely intensified class strife and followed an ignominious foreign policy based on the payment to France and Spain of heavy protection money. Fifteen years of incompetent, often cowardly war were required in order to regain even the one town of Pisa. In 1502 Pier Soderini, a good but politically naïve citizen, was elected Gonfalonier for life. He introduced a citizen militia, but when the French were driven from Italy in 1512, they proved no match alone for trained troops. The militia, and Soderini too, fled before the Spanish army who in 1512 restored the

Medici. The Medici remained in power until 1527 when the Florentines, taking advantage of the sack of Rome, drove them out and proclaimed a republic. Three years later Florence fell to the troops of Charles V, and the Medici were again restored, this time definitively, under the aegis of the Emperor and the Pope. Since 1494 therefore Florence's history had been disastrous almost beyond belief: she had lost both her republican constitution and her independence.

The historian who analysed these disasters, Niccolò Machiavelli, was born on 3 May 1469, the son of an impoverished lawyer of good family and a mother who wrote hymns to the Virgin Mary. 'Machia' to his friends, to posterity 'Old Nick', at the age of twenty-eight he entered the service of the Florentine Government, and as observer or envoy was sent on many diplomatic missions, including four to France and two to Cesare Borgia, where he early came to realize the fundamental importance of force in politics. Machiavelli won the confidence of the new Gonfalonier for life—he was called Soderini's *mannerino* or lackey—and persuaded him to form the citizen militia. Soon after the return of the Medici in 1512 Machiavelli was arrested for his supposed part in a plot, and subjected four times to the *strappado*. After Leo X had expressed a wish for leniency, and with the help of Giuliano de' Medici, he was released in the spring of 1513. He found himself without a job or the hope of one, and had seen the ruin of everything he believed in, from the Great Council to the citizen militia. But he showed himself no Cato to the new Caesars. He tried to win Medici favour by dedicating books to members of the family, but without success. For the rest of his life— he died in 1527—he had no power, no important job and practically no money. So Machiavelli's career was as much a disaster as that of Florence.

It is important to understand Machiavelli the man, for like many a highly original thinker, he poured himself into his works. A polychrome terra-cotta bust shows him to have been slender, with a conspicuously small head, keen eyes, dark hair, slightly aquiline nose and tightly closed, somewhat shapeless mouth. It suggests a sharp observer and thinker, but not a man of action or even a leader. The body lacks weight, and this shows itself in Machiavelli's changeable

nature: 'you cannot keep in the same mind for an hour,' a friend once told him, while to his wife Marietta he was repeatedly unfaithful.

Machiavelli's most distinctive personal trait is a fascination with low life. In retirement he consorted with the local innkeeper, butcher, miller and bakers: 'vermin' he called them, but he spent every day in their company, playing at dice games and squabbling over a throw. Again, when he was forty, in a dimly-lit room in Verona, 'driven by sexual desire' he had relations with the washerwoman who had laundered his shirts. In a letter to his friend Luigi Guicciardini he dwells with fascination on the horrible details. 'When it was over, since I had a fancy to see the merchandise, I took a burning piece of wood from the stove and lit a lamp which was over it—and hardly was it alight when it nearly fell from my hand. Ugh! I nearly dropped dead on the spot, she was so hideous.' He then describes the woman: wrinkled, toothless, squint-eyed, louse-ridden, and with fetid breath. 'My stomach,' he concludes, 'unable to stand the strain, revolted and heaved so much that I vomited, and having then paid her in the coin she deserved, I left.'

Such a man naturally took a low view of human nature. Machiavelli's earliest piece of writing—now lost—was a play entitled *Maschere* (*Masks*), based on *The Clouds* of Aristophanes. In *The Clouds* the hero goes to a thinking-shop in order to learn the sophists' technique of making the worse appear the better case, and it is symptomatic that Machiavelli should have been drawn to a play in which the new art of perverting the truth triumphs over traditional piety. In *Mandragola* Machiavelli makes every character act from base motives. Of his former friend and protector, the idealist Pier Soderini, Machiavelli wrote a contemptuous poem, consigning Soderini not to hell, but to limbo 'with the babies'. To command his citizen militia, Machiavelli could think of no one better than a bloodthirsty tyrant named Don Michele Coriglia, a former employee of Cesare Borgia and known as 'The Strangler'—a tactless appointment which led to trouble and had to be revoked. In 1506, when Julius II rode into Perugia well ahead of his troops, Machiavelli was astonished that Baglione missed the chance to swoop on the defenceless Pope and kill him, concluding that 'he did not dare'.

Coupled with this low view of human nature went soaring imagination. After dining with the 'vermin' he would replace his sweaty working clothes with the scarlet gown of the Florentine citizen and settle down to study. 'I enter the antique courts of the ancients and am welcomed by them, and there I taste the food that alone is mine, and for which I was born.' Whatever the occasion, Machiavelli saw big. When Julius II crossed Florentine territory in 1506 Machiavelli suggested that the Pope should be offered provisions, and specified the most expensive delicacies: Bolsena eels and white truffles. The thrifty Signoria settled for wine, cream cheese and a load of Camilla pears. In 1504 Machiavelli planned to capture Pisa by diverting the Arno, and immediately set 2000 men digging canals and building a dam. Once again the plan proved far too grandiose, and had to be abandoned, though not before it had cost 7000 ducats. As his friend Francesco Guicciardini complained, Machiavelli was always going to extremes. It is the secret of his success as a playwright, and of his failure as a practical politician.

Machiavelli entered Florentine service in the year Savonarola was burned at the stake. Both men were extremists, both were dissatisfied with actual conditions, both raised the question 'Christianity or paganism?' But where Savonarola chose Christianity, Machiavelli opted for paganism. Reflecting on the disasters of his time, Machiavelli decided that the reason why Florentines had failed so ignominiously to become ancient Romans was that they had adulterated their Romanism with Christian meekness and morality. The remedy was to throw over Christianity altogether. In a letter written during the last year of his life he makes the point with characteristic bluntness: 'I love my native land more than my soul.'

By native land Machiavelli meant Florence, not Italy. Although he loathed the foreign invaders and wrote, '*A ognuno puzza questo barbaro dominio*: this barbarian domination stinks in everyone's nostrils,' he confessed to Vettori in 1513, 'As to the union of the Italians, you make me laugh.' The stumbling-block was the Papacy. Machiavelli hated the Papacy because it was not strong enough to unite Italy itself, yet too strong to allow any other city-state to do so.

When we turn to Machiavelli's political and historical writings,

we find that at every point they reflect the man: his personal disappointment—*triste* is a word that recurs often—his low view of human nature, his soaring imagination, his love of extreme solutions, his Florentine patriotism, his committal to the principles of classical antiquity untainted by Christian accretions. Of the two books he wrote at the beginning of his enforced retirement, *Il Principe* (*The Prince*) was intended for Lorenzo the Magnificent's 'good' son, Giuliano, who was planning to found a state for himself in northern Italy but died in 1516 before he could do so. Machiavelli's purpose in writing the treatise is to describe how to found and preserve a successful state, by which he means one that will be free from inner strife and foreign domination. His method was to examine Roman and to a lesser degree Greek history for, in common with all Italians of his day, Machiavelli believed in the wheel of history, and that any solution to present problems would involve restoring the best of the past.

The particular solution Machiavelli found in the Roman dictator: the strong man such as Camillus or Julius Caesar who accepts other men for what they are: bad unless by compulsion made good. Machiavelli thought he had found an example of such a prince in Cesare Borgia, and on his second mission to Cesare it is noteworthy that he sent post-haste to Florence for a copy of Plutarch's *Lives*. Doubtless he eagerly thumbed through the *Lives* with one eye cocked on Cesare's latest audacity, indulging in that favourite occupation of the age: finding the past in the present; an occupation that was deemed legitimate since society was basically unchanging. The resulting figure of the New Prince is not a portrait of Cesare, but a literary counterpart of a Renaissance bronze in the classical style, a unique compound of classical and modern.

Machiavelli's Prince is one who has come to absolute power by his own ability. To retain power, he must have a strong army, lead it himself in the field, and treat every other state as a potential enemy. Such a man, says Machiavelli, may practise deliberate cruelty, deceit, treachery, even murder, and he should appeal always to men's fear rather than to their respect. 'The end justifies the means, provided the end be good,' where 'good' means effective. As in *Mandragola*, the solution is not so much immoral as amoral.

Machiavelli here does more than return totally to the classical past, for the Romans were not without a conscience; he goes beyond classical antiquity to complete paganism. He warns princes that if they do break the moral law they must take care to hide the fact from their own people, and this shows that he was aware of the originality of his doctrine. In fact, the moral conscience in Machiavelli's day was still strong: Louis XII summoned a council at Tours to ask whether a projected war was justified and Henry VIII consulted the universities before divorcing Catherine of Aragon. True, in his *Utopia* Thomas More proposed that a nation at war should try to assassinate the enemy ruler and poison enemy wells, but there is a world of difference between such exceptional measures and the amorality which Machiavelli raises to be a norm in peace no less than war.

It would be a mistake to regard *The Prince* as an exceptional *tour de force* unrepresentative of its author, and 'Machiavellianism' as a later invention unjustly attributed to Machiavelli. In fact the amoralism of *The Prince* is stated just as plainly in a late work, the *Life of Castruccio Castracani*, written at the age of fifty-one during a mission to Lucca. In this little book Machiavelli takes the loose framework of Castruccio's life—he had been lord of Lucca from 1320 to 1328—and toughens it with incidents from Diodorus Siculus's biography of the Syracusan tyrant, Agathocles, who, unlike the historical Castruccio, really had been an unscrupulous character. Castruccio, in Machiavelli's version, is a strong, secretive, lonely general, a foundling ('great men are usually of vile extraction') who never marries and dedicates his life to getting more power. Tall, well-proportioned, with close-cropped red hair, he always goes bare-headed. He speaks mainly in cynical maxims: for example, praising pre-marital intimacy—'after all, we don't buy a crystal vase without first flicking the crystal.' Ruse he prefers to force. A rebellion breaks out and is eventually quieted by his elderly friend, the peace-loving Stefano di Poggio. Promised a general reprieve, Stefano brings in the rebels, whereupon Castruccio coolly has them all slaughtered, including Stefano. Someone remarks that he did wrong to kill an old friend. 'You're mistaken,' says Castruccio, 'I rid myself not of an old friend but of a new enemy.' Next he wishes to seize Pistoia. He

lulls the leaders of the two parties, 'Blacks' and 'Whites', into believing that he will march in on a certain night to crush their adversaries. But when the moment comes, at a given signal he falls on both parties, crushes them and has them all put to death. 'Thereupon,' concludes Machiavelli, 'everyone, being full of hope, and chiefly stirred by his *virtù*, subsided into quiet.' If the basest form of political cunning is the twisting of words, Machiavelli certainly cannot be acquitted of Machiavellianism.

In his second great book, *I Discorsi sopra la prima Deca di T. Livio*, Machiavelli again reflects on the failure of a state and how to cure it, but whereas *The Prince* had advocated 'strong medicines' in the form of a dictatorship, the *Discourses* assume a republican government in Florence and offer less drastic remedies. The questions now are: What form should such a republic take? How is it to be preserved from class strife, from revolution and from moral decay? The answer again takes the form of a 'restoration' of what was excellent in the past, this time of the early Roman Republic as described by Livy.

What is the end of the state? asks Machiavelli as a prelude to his main questions, and his answer is: longevity. The greatest state is the one which lasts longest, and if a republic is preferable to a princedom, that is only because it is likely to endure longer, 'the diversity in the character of its citizens making it more adaptable.' The quality of life in the state does not interest Machiavelli, and when he came to write his *History of Florence* he had little to say about moral attitudes, literature, the arts, commerce or religion. He alludes to Cosimo's patronage, but does not enlarge on the new lay culture. Partly he is following his models, but partly also he is not interested in ordinary people, those who 'follow certain middle ways, which of all possible courses are the most pernicious'. What does interest this playwright-historian is dramatic action, and early in the *Discourses* he makes much of Romulus murdering his brother—a deed which Machiavelli condones because it furthers the interests of the state.

How can a state be saved from moral decay? Machiavelli had no doubt at all that Italy was in decay. Everywhere he saw treason, ill-faith and cowardice, such as occurred in 1505, when Florentine infantry refused to storm an 88-yard breach in the walls of Pisa,

trembling at the thought of 200 Spaniards within the town: finally they had to be marched away and disbanded.

Machiavelli's diagnosis was this. Decay is really a partial turn of the wheel, and the cure lies in bringing the wheel full circle. 'In order that . . . a republic should long survive it is essential that it should often be restored to its start:' that is, to the principles of its founder; and Machiavelli cites St Francis and St Dominic as men who 'restored' an institution. The medicine of restoration is of four kinds. First, poverty must be reintroduced, or at least a check on wealth, which leads to vainglory and unscrupulous rivalry for office. Second —and related to the first—the state must be isolated from other nations. The Germans—Machiavelli means the Tirolese and Swiss, whom he had studied at first-hand—'have no chance of adopting the customs of the French, Spaniards or Italians, nations which, taken together, are the source of world-wide corruption.' Later he quotes Juvenal on the ill-effects of foreign customs on Rome: 'gluttony and self-indulgence took possession of it and avenged the world it had conquered.' Third, citizens must be armed and disciplined. In the *Art of War* Machiavelli lays great stress on battle formations and with all the trust of a layman in outward forms believes that these alone will create courage. The most striking instance of this trust in outward forms is Machiavelli's statement that the Romans' sacrifice of bulls proved a stimulus to military virtue. Bring back blood sacrifice, Machiavelli urges, and Italians will again become brave.

Machiavelli's fourth remedy for moral decay is very odd. Religion, he declares, must be revived, for 'it will be plain to anyone who carefully studies Roman history how much religion helped in disciplining the army, in uniting the people . . .' Machiavelli seems to envisage not the humble worship of God, but a cult of the *patria*, for this, not the gods, had been the focus of the Romans' loyalty and their incentive to virtue. Machiavelli seems to have believed that because the monarch had become the focus of a para-religious loyalty in France, Spain and Germany, the 'barbarians' fought more effectively than Italians, and that only by instituting a similar cult in Florence could morale be revived. Though he left details obscure, the idea was tragically prophetic.

Perhaps the most original feature of the *Discourses* is its form.

Chapter headings usually consist of some political maxim: 'To preserve liberty in a state there must exist the right to accuse;' or 'The authority of the Romans and the example of ancient warfare should make us hold foot soldiers of more account than horse.' In the chapter itself Machiavelli treats each maxim as a hypothesis and seeks to verify it by citing historical examples, chiefly from Livy. This was a new method of trying to discover truth, for earlier thinkers had sooner or later appealed to an authority such as Scripture or Aristotle. Though he himself applied it imperfectly, being biased in favour of republican Rome, Machiavelli had invented the inductive method.

The consequences of the inductive method for the writing and study of history were to prove far-reaching. Facts in themselves were now to become of less interest than the truths they illustrate. Machiavelli often triumphantly concludes an argument with the phrase: 'and this must be held as a general rule.' He is seeking the perennial in the transitory, the proved maxim that can help a statesman here and now to curb a riot or to trick a rival.

The inductive method was a major discovery, which Francis Bacon, a careful student of Machiavelli's works, was later to state explicitly. Applied with care, it can reveal important laws of cause and effect. But as used by Machiavelli it has two grave weaknesses. First, it assumes the basic unchangingness of society. It was a mistake to compare an agricultural state defended by legions with a mercantile city that had to sell textiles abroad and defend itself from armies equipped with muskets and cannon. The new factors amounted to a difference in kind, which rendered invalid any sustained comparison. Secondly, such a method tends to underestimate the human factor: personal friendships, diplomacy, compromise and mutual trust which play so important a part in political affairs. Machiavelli uses the word 'cause' in history to signify a demonstration of a political maxim, not a human choice. Thus, in his *History of Florence*, he is precluded by his method from attempting to link Cosimo's success to his prudence, tact and innumerable friendships. A similar weakness underlay his approach to politics in his own day: an accurate assessment of the character of François I would have led him to realize how untrustworthy the French alliance was bound to prove.

In conclusion, it may be said that Machiavelli's greatest achievement was to raise the question of the conflict between expediency and moral precepts. However, the answer he gave—that expediency is always justified if it benefits the state—has generally been judged erroneous by posterity, since it fails to take account of the public conscience. Men living under the Christian dispensation can never wholly assume the conscience of republican Rome: certain crimes, certain kinds of deceit will stick in their gullet. In this sense Machiavelli was again a victim of his presupposition about the unchangingness of human nature and human society.

The next Florentine historian is complementary to Machiavelli, in that he concerns himself less with politics than with civilization, less with imaginary characters than with real persons. Giorgio Vasari was born in Arezzo in 1511, the eldest son of a large family. His father was a potter, and his paternal grandfather too: 'he rediscovered the technique of colouring earthenware in red and black, which had been employed by the Etruscans of Arezzo in the days of King Porsena.' Young Vasari was taught how to draw by his cousin Luca Signorelli, then getting on in years, and at thirteen went to Florence to study painting under Andrea del Sarto and sculpture under Baccio Bandinelli. He sat in on the Medici children's lessons from Piero Valeriano, who believed Egyptian hieroglyphs to be not picture writing but allegories and symbols, and thus laid the basis of Vasari's interest in allegory. In 1527 during riots against the Medici a bench thrown from the Signoria struck an arm of Michelangelo's *David*, breaking it in three; it was young Vasari and a friend who ran out among the soldiers to rescue the precious pieces. The assassination of his patron, Duke Alessandro de' Medici, in 1537 caused him to wander through Italy for several years, not only painting but filling notebooks with sketches of works he liked. On his return to Florence he became a highly successful painter, chiefly of historical frescoes, a designer of festivals, and architect of the Uffizi. His pay from Duke Cosimo was 450 ducats a year—four times Machiavelli's pay as Secretary—as well as a town house and a country house. In 1571 he was knighted by the Pope. By the time of his death in 1574 his word was law on matters of art throughout Italy.

His self-portrait shows Vasari to have been a big man physically, but his face is soft, almost flabby, and the expression lacking in virility. He wore his finger-nails long, he was compliant by nature, and his friends meant more to him than his pretty wife Nicolosa, whom he married when he was thirty-eight, after five years of negotiations that almost collapsed owing to his half-heartedness and exacting demands. There were no children. Vasari was a pious man and belonged to the third Order of Camaldoli. All in all, he seems to have been a decent person, immensely hard-working and kind even to his enemies: whereas Cellini slandered Vasari in his *Autobiography* as a liar, coward and homosexual, Vasari in his *Lives* gave Cellini the praise he felt sure he deserved.

The first edition of Vasari's *Lives of the Most Excellent Architects, Painters and Sculptors* appeared in 1550 and contained 175 biographies; the second edition was published in 1568, with 250 biographies and, reflecting a growth of interest in painting, the wording of the title was altered to 'Painters, Sculptors and Architects'. As a historian of the arts Vasari ignores the military defeats that had preoccupied Machiavelli and sees a steady improvement since the end of the Middle Ages: not so much linear progress as a turn of the wheel, a recovery of classical excellence. In his own days, Vasari says, art has achieved such perfection that he fears a decline, for 'the arts, like human beings, are born, grow up, become old, and die.' He explains that one of his motives in writing the *Lives* is that should the arts decline, the book may encourage artists and patrons to arrest it before it gets out of hand. The cycle is 'loss, rediscovery, restoration'. Of Michelangelo's statues in the Medici Chapel Vasari says that 'if the art of sculpture were lost they would serve to restore to it its original lustre.'

'Restoration' is one of Vasari's key ideas. 'Cimabue was, so to speak, the first cause of the renewal of the art of painting;' 'Giotto alone, by God's favour, rescued and restored the art of good painting.' Like Machiavelli, Vasari took the idea from classical historians, but unlike his fellow-Florentine, he merged it with the Christian concept of restoration. Isaiah restored flesh to the dry bones of the Israelites, Christ restored health to the sick, life to the dead, and the Incarnation itself was the supreme act of restoration—'O Lord, Who

hast wonderfully created the dignity of human nature, and still more wonderfully renewed it.' Certain great works of art, according to Vasari, resemble the glorification awaiting us in the next life, and this is why he says of Michelangelo's statue of Moses, 'God has willed to restore and prepare this man's body for the Resurrection before that of anyone else.'

Vasari attributes the restoration of the arts at the end of the Middle Ages to certain great artists, nearly all Tuscans. He is aware that Tuscany favours the arts, and speaks of 'the subtle air of Tuscany', as though this somehow fed spirituality. But he fails to see the importance of political and economic conditions, or for that matter of cultural values: the Platonism underlying geometrical construction of a painting, the new civic pride underlying Donatello's *David*.

Vasari's notion of the 'great artist' is, however, original and useful. He plays a somewhat similar role to Machiavelli's Prince, in that he it is who alters the course of history. But whereas the Prince's *virtù* is his own making, the artist's genius is only partly so, and partly a gift from heaven. The great architect resembles the Prince in that he will base his works on the plans of ancient buildings, but great painters and sculptors are less tied to the past: they will 'copy the most beautiful things in nature and combine the most perfect members, hands, head, torso, and legs, to produce the finest possible figure.'

Such a work will be full of grace. By grace Vasari means a sense of effortlessness and, in the last resort, a spiritual soaring comparable to the workings of God's grace in a good man. While grace precludes severity, which was one of the marks of horrid Gothic, it must contain a certain heroic element. To this extent Vasari's grace is closer than Castiglione's to that of the theologians. Indeed, Vasari sometimes suggests that the two are related. Apropos his commission to paint the Great Hall in Florence, Vasari explains that it was 'chiefly because the grace of God supplied me with strength that I undertook the work and executed it in contradiction to the opinion of many.' Michelangelo was thinking along these lines when he claimed that only an artist of blameless life can paint a satisfactory Christ.

In his Preface to Part II Vasari says he hopes to emulate those classical historians who 'explained the opinions, counsels, decisions and plans that lead men to successful or unsuccessful action.' This hope he fulfils in a few of his Lives, such as those of Uccello, Brunelleschi and Michelangelo. But Vasari's real achievement lies in probing the characters of so many of his artists. He has an eye for the revealing quirk—Leonardo during his two years of sickness and frustration in Rome attaching home-made wings to a lizard, and inflating sheeps' bladders until they filled the room and pushed horrified visitors into a corner; old Michelangelo, oblivious of comfort, wearing dogskin buskins for months on end, so that when he removed them, often part of the skin came from his legs as well—and although he does not fully relate temperament to style, Vasari is aware of the importance of the connection. This was a useful step forward in history-writing: a break with the notion that man is a standardized truth-finding instrument.

Useful too is Vasari's main theme of improvement through a timely artist-discoverer. In the Medici Chapel Michelangelo broke 'the bonds and chains that had previously confined artists to the creation of traditional forms': in other words, he went beyond the rules. Here is a dynamic element lacking in previous historians save Machiavelli: a recognition of the fact that creation is partly a step into the unknown. And when he claims that Michelangelo has surpassed all the artists of antiquity, Vasari is hinting at the notion of absolute progress, though he is too committed to the wheel of history to explore it fully. In these two ways, then, he moves beyond his premise that human nature tends to repeat itself from age to age.

How relevant was Vasari's book to the problems of his day? His choice of Italian artists and his hostility to Dürer worked against a sympathetic understanding of Lutheran views. On the credit side, by formulating definite critical criteria, Vasari enabled the ordinary man to sift good art from bad. His notion of a rebirth of the arts proved a stimulus to writers as well as to painters. Most important of all, at a time when Italian political fortunes were low, he enlarged man's conception of his own past to include achievements other than

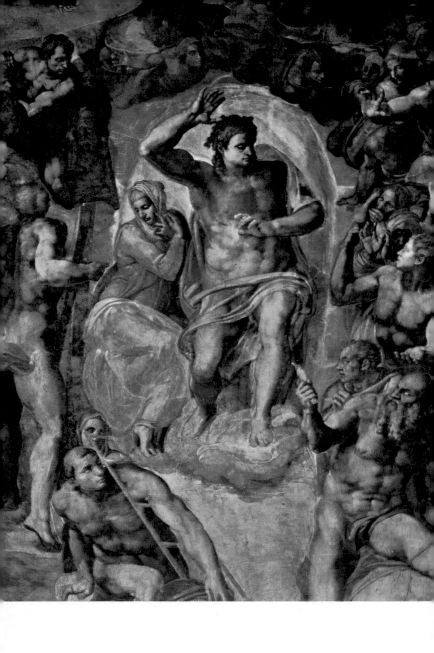

Christ and the Virgin from *The Last Judgement* by Michelangelo

Descent from the Cross by Pontormo

The Doge Leonardo Loredan by Giovanni Bellini

The Storm by Giorgione

political. As the first historian of civilization in part, Vasari struck a blow for civilization as a whole.

Francesco Patrizi was born in 1529 in the Adriatic island of Cres. While studying at Padua he became an admirer of Plato; for many years he held a chair of Platonic philosophy in Ferrara, and later in the Sapienza. His interests extended to history, oratory, science and poetry—he invented a thirteen-syllable line for his poem *Eridano*— and he travelled widely, visiting Cyprus, Corfu, France and Spain. A philosopher of history rather than a historian proper, in 1560 he published his ten dialogues *Della Istoria*, a little-known but highly original work, in which he sets out an even broader notion of history than Vasari's.

Patrizi begins with the working definition, 'History is public memory,' and cites as the earliest example the recording on a stone pillar of the rise and fall of the Nile. But 'public' should be understood in the sense of 'made public'. History should deal not just with public figures, but with private persons too, provided their actions are relevant to our own day. It should take account of philosophers, orators, poets, musicians, painters and sculptors, for all these are concerned with making life perfect.

Patrizi holds that the historian should describe the origin, growth, maturity, decline and fall of a particular state. He should write not only about war but about peace too: indeed one of his tasks will be to show how peace has on past occasions been secured. Another original suggestion is that the historian should analyse how a state feeds its population and whence it draws its revenues, thus pointing the way to economic history.

Patrizi takes issue with Aristotle, who, conceiving history as a calendar of unrelated incidents, writes in the ninth chapter of the *Poetics*: 'Poetry [in particular, tragedy] is more scientific and serious than history, because poetry tends to give general truths while history gives particular facts:' a weighty pronouncement that for long reduced history to the level of a second-class subject. Patrizi denies strongly that history is lacking in general truths as Aristotle understands them, that is, in the inevitable sequence of cause and effect; indeed he claims that history and tragedy have the same

content. History, like tragedy, provides the wise man with guidance how to avoid disaster. It also reveals the hidden causes of events, and these are general truths, on a level with those expounded by philosophy.

Patrizi wishes the historian to be an artist, and to arrange facts much as a writer of tragedy arranges fiction, and although he does not elaborate the point it is clear what he has in mind. Italy's reversal of fortune in the sixteenth century obviously contained the moving and dramatic elements of tragedy, and should be treated as tragic narrative. Moreover, just as tragedy is an expression of flawed character in action, so on a wider stage is history, hence the importance of portraying the main protagonists—artists and thinkers as well as rulers—in the round.

Like Machiavelli and Vasari, Patrizi suffers from a major limitation. He has no notion of the development of society or of ideas. By comparing history to tragedy, he assumes that human society over the years preserves a definite identity, like the hero of a drama. All these authors were steeped in the classics, that is, in books, and books, as Plato remarks, are unsatisfactory, because you cannot cross-examine them. Italian historians closed their eyes to the first-hand evidence of explorers that was pouring in from the two Americas, from India and from the East Indies. This was living history if only they chose to see it as such.

In his description of life in the New World, based on talks with navigators in Seville, Pietro Martire d'Anghiera is one of the few to try to assess the implications of primitive man. The natives, he says, 'seem to live in that golden world of which old writers [such as Ovid] speak so much: wherein men lived simply and innocently without enforcement of laws, without quarrelling judges and libels, content only to satisfy nature, without further vexation for knowledge of things to come. Yet these naked people also are tormented with ambition to enlarge their dominions; hence they wage war and destroy one another: a plague from which I suppose the golden world was not free.'

Pietro Martire is obviously not happy about his last remark. Even while applying the cyclical theory he is aware that it does not quite fit. But he leaves it at that. And no other Italian writer of the

sixteenth century set himself to examine the life of savages and try to fit it into a historical context. The nearest anyone came to doing so was not a professional historian but a painter of Florence.

Piero di Cosimo is the most eccentric artist in Vasari's *Lives*, and his eccentricities help to explain his work. He lived alone in primitive surroundings. He never allowed his room to be swept, his garden weeded, or his fruit trees pruned. 'He preferred to let everything run wild and said that it was better to leave all to nature.' He took no regular meals and instead, over the fire on which he prepared his glues and varnishes, would cook hard-boiled eggs, fifty at a time, and eat a few when he felt hungry. Piero was primitive also in his preoccupation with death: he made his name with a gruesome skeleton for carnival and once announced that he wanted to die cleanly, 'like a criminal on the gallows'. He was interested in wild animals and several times painted giraffes, while his greatest work, *The Death of Procris*, shows the beautiful young princess who has been accidentally killed by her husband's spear lying between a satyr and her faithful hound Laelaps, whose dumb incomprehension is wonderfully conveyed and lends the death an intense poignancy.

Some time before 1513 Piero received a commission admirably suited to his temperament. He was asked to paint the house of a rich wool merchant named Francesco del Pugliese with a series of pictures tracing the early history of man. Vespucci's description of savagery in the Caribbean, including cannibalism, was then circulating in Florence and would obviously have appealed to such a person as Piero, whose originality lies in applying Vespucci's description to early man. Rejecting Ovid's rosy portrayal of early man at peace amid plenty—then the prevalent theory, and an influence in Michelangelo's Sistine ceiling—Piero turned to a diametrically opposite view handed down by Lucretius and Vitruvius. According to this, primitive men had existed 'like wild beasts in woods and caves and groves, kept alive by eating raw food', and had gradually escaped from savagery through technical and intellectual progress, notably the invention of fire, sometimes symbolized by the arrival from heaven of Vulcan. This was the view Piero chose to illustrate, adding details from Vespucci's description of American Indians.

The first picture in Piero's series, a *Hunting Scene*, shows a fight to the death between cavemen, wild animals, satyrs and centaurs—here to be understood as actual creatures resulting from the promiscuous mating of man and beast. The cavemen are clad in skins and hides. One of them grapples with a lion, which a satyr prepares to kill with his wooden club, for iron weapons have not yet been invented. A lion attacking a bear and at the same time being attacked by a man shows how pitiless is the struggle for survival. The next picture, *The Return from the Hunt*, shows the group bringing back their booty in two boats. The masts are of untrimmed tree trunks and one is hung with totems in the form of boars' skulls. Women, absent from the previous scene, now make their appearance, one riding on the back of a centaur.

A forest fire, visible in the background of the first two pictures, dominates the third. It sweeps through the vegetation, putting to flight, lions, bears, cattle and birds. A man in a leather jerkin tries to capture and yoke some of the fleeing oxen. The forest fire, mentioned by Lucretius and others, symbolizes nature outside primitive man's control, and leads to the next picture in the series, *Vulcan alighting in the island of Lemnos*, where he is to teach men how to master fire. The fifth and final picture shows four men, naked save for loin cloths, building a crude house from unsquared tree trunks, while Vulcan forges a horseshoe. Civilization is about to begin.

Piero's paintings are not only highly original and imaginative works of art, they show a deep understanding of history in the light of current ethnological discoveries. They pick up and retail clues in classical authors which were generally ignored by contemporaries who, if they thought of early man at all, considered him as having lived at peace with provident nature. They have the stamp of authenticity. However, like Leonardo's inventions, these paintings were solitary insights that remained without progeny. The very loneliness which made them possible precluded their being discussed and passed around in learned circles. When Francesco del Pugliese was exiled in 1513, his house and the pictures in it doubtless fell on evil days. Perhaps, in any case, they ran too far ahead to exert any detectable influence.

According to *Genesis*, man's fall from grace damaged his will

though not his intelligence, so that Adam's sons were not brutish. This lent weight to the 'static' view of history. Ovid's 'golden age' chimed in with *Genesis*. But Piero's pictures did not. They posed a problem ignored by historians of the sixteenth century. So that although history-writing improved in this period, historians may be said to have failed at the point most relevant to contemporary issues. They failed to evolve a suitable idea of development. They failed to take account not only of primitive man, but of all the evidence within Europe to suggest that man's way of life and ideas had developed radically from age to age. Obsessed by the notion of rebirth, they required that past and present should correspond. When the time came for the Council of Trent to meet, this inadequacy in historical thinking was to have unfortunate consequences.

All Things in Movement

DURING the Middle Ages scientific thinkers, being usually clerics, set high value on calm, both physical and spiritual. It meant much to them that at the centre of revolving crystalline spheres the earth should be stable and at rest, for man himself in his highest moments also achieved rest, chanting the liturgy from his misericord, bowed in prayer or contemplation. Rest was the *summum bonum* sought by nature. If you dropped a stone, it fell to the ground because it sought rest. What happened in the sixteenth century was that scientific thinkers, in a variety of fields, replaced the concept of rest with the concept of movement.

This was a profoundly revolutionary change, perhaps second in importance only to the hypothesis of evolution in the early nineteenth century. It was no accident that it took place when it did. Scientists do not operate in a vacuum. For their most fundamental ideas—often those that are subconscious and never directly expressed —they draw on the kind of world in which they happen to live. Now Italy, in many ways a self-contained land during the fifteenth century, from 1494 onwards became subject to intense movement of various kinds. First came invasion by French, Germans, Swiss and Spaniards, bringing foreign languages, dress, customs and values. Next came the consequent appreciation of Italy and interest in her achievements. Foreigners flocked to Italian universities, while abroad princes and the rich sought Italian artists, tutors, scholars. The printed book carried Italian ideas to every corner of Europe, and in turn, as the northern countries imbibed the new learning, brought back original ideas. In astronomy and cosmology, medicine and technology scientists found that they were working not in isolation

but in one part of a larger continent, to which Italy was joined by a constant ebb and flow of men and ideas.

This formed part of an even wider process. In a chapter quaintly entitled 'Concerning Natural though Rare Circumstances of My Own Life' Girolamo Cardano, one of the best doctors of his day, states that 'the first and most unusual circumstance is that I was born in this century in which the whole world became known; whereas little more than a third part of it was familiar to the ancients.' Among the discoveries he jubilantly names are Brazil, Patagonia, Peru, 'New France and regions more to the south of this toward Florida', and Japan, concluding that we should rejoice in the new variety 'as in a flower-filled meadow'. When in 1522 eighteen survivors of Magellan's expedition, having departed westwards, sailed back to Lisbon from the east, no one could look on the globe in quite the same way again. For one thing, the globe was more sea than earth, and its watery surface was rendered even more unstable by tide-rips and hurricanes. It had been encompassed by the movement of man, and was soon to be regularly criss-crossed by caravels and galleons laden with bitumen, maize, the turkey, tobacco, the potato and cacao seeds, as well as gold—the primum mobile. Movement, for so long considered suspect, was seen to be more and more useful and profitable, and as such it began to preoccupy men's minds.

The mind, first of all, of Leonardo da Vinci. After leaving Florence in 1482 Leonardo lived in Milan until 1499, when French troops occupied the city. He then served Venice as a naval engineer and Cesare Borgia as a military engineer. He returned to Florence in 1503, served as an engineer in the war against Pisa and it was probably then, so to speak between siege operations, that he painted the *Mona Lisa*. From 1506 to 1514 he was again in Milan, observing and taking notes about the Alps. The notes, like all Leonardo's writings, reveal a mind that had received no formal schooling and therefore was much influenced by a character strongly masculine yet possessed also of a marked feminine streak. This made for an inner dialectic and also for self-completeness. So Leonardo had none of the longing for fame usual at this period, no ambition to appear in print,

and was content to record, in codes and mirror writing, perplexities, plans and experiments for his eye alone.

To a degree unique in the early sixteenth century Leonardo was aware of movement, and his *Notebooks* swirl like a torrent with forceful verbs: rising, falling, expanding, revolving, dragging, flowing, ebbing, pouring, penetrating. Leonardo gazed at the Mediterranean and found it not a static lake or sea but 'the greatest river of the world . . . flowing from the source of the Nile to the Western Ocean'. His distinctive temperament led him to conceive reality in terms of a dualism that resolves itself. 'Two weaknesses leaning together create a strength. Therefore the half of the world leaning against the other half becomes firm.' In the human body this dualism becomes interaction. 'We make our life by the death of others. In dead matter there remains insensate life, which, on being united to the stomach of living things, resumes a life of the sense and the intellect.' Leonardo expresses the idea of interaction in a powerful image: 'OF THE LIFE OF MEN WHO EVERY TEN YEARS ARE CHANGED IN BODILY SUBSTANCE. Men will pass when dead through their own bowels.' Even society he conceives in terms of interaction. Doctors, he says, live upon the sick, and friars upon saints long since dead.

Leonardo is particularly fascinated by water in movement, and devotes more space to this subject—hitherto rarely treated—than to any other in the *Notebooks*. Having observed the Arno and Po in flood, he concluded that water is more destructive than war or fire, and made urgent plans for a book on how to protect cities from flooding rivers. He became an expert in water control and under Leo X was employed to make proposals for draining the Pontine Marshes. Leonardo's plan called for recutting the ancient Roman canal running parallel to the Appian Way, and to use it (following the Romans) as a cut-off channel for the waters coming down from the Lepini mountains. Though this project remained on the drawing-board, another of Leonardo's innovations in water control was realized when six lock gates for the Milanese Naviglio Interno were installed in 1497. Leonardo replaced the traditional portcullis-type gate with neater, more wieldy mitre-gates, a considerable improvement which was copied in 1518 by Missaglia's designs for the locks

Leonardo's plan for controlling a river with weirs and locks
A retractable gate and (below) a mitre gate

on the Paderno canal, by Giacomo da Vignola's three locks near Bologna in 1548, and which is still employed today.

The mitre-gate, with its twin sections, is only one of several two-in-one inventions frequent with Leonardo and perhaps reflecting that mixture of masculine and feminine already mentioned. Examples in his art include the epicene figure of John the Baptist, and his juxtaposed drawings of a beautiful youth and a wrinkled old man, while in the field of technology there is his prophetic proposed reconstruction of a town with traffic on two levels: the high-level streets for pedestrians, the lower for vehicles. The former are approached by viaducts at the entrances to the town. Flights of steps connect the two levels at frequent intervals. All streets are arcaded, the arcades on the lower level being lighted through openings on the upper level.

Air fascinated Leonardo almost as much as water, and for the same reason: 'The air moves like a river and carries the clouds with it; just as running water carries all the things that float upon it.' His study of comparative anatomy prompted him to ask why man should not be able to do what birds do. This called for imitation, and imitation for his wonderfully detailed observations about wings, the set of feathers, the tail, and how different movements are employed for gliding, soaring, balancing and alighting without breaking their legs. Flight itself is defined in characteristically Leonardesque terms: 'When two movements of impetus meet, the percussion is more powerful than if they were without encounter. As therefore the impetus of the bird encounters the impetus of the wind its simple impetus increases and the reflex movement is greater and higher.'

Leonardo invented two types of flying machine: one with wings that a man could activate by lowering and raising his legs, the other lifted by an air-screw revolving round a vertical axis. He listed possible materials. 'Net. Cane. Paper. Try first with sheets from the Chancery. Board of fir lashed in below. Fustian. Taffeta. Thread. Paper.' Finally he adopted a cane frame covered with linen dipped in starch. Such flimsy materials might fall apart in mid-air, and this danger Leonardo foresaw. 'If a man have a tent made in linen of which the apertures have all been stopped up, and it be twelve

braccia across and twelve in depth, he will be able to throw himself down from any great height without sustaining injury.'

Leonardo's interest in movement and process is further revealed by his notes on geology. He was the first European to understand the true nature of organic fossils, having been forestalled only by the Persian, Avicenna. He observed in the mountains of Italy fossilized leaves, seaweed, shells of cockle, scallop and crab. Rejecting the traditional explanation that fossils were caused by some unspecified astral influence, Leonardo reasoned that sea-water had once covered the earth: 'in course of time the level of the sea became lower, and as the salt water flowed away this mud became changed into stone; and such of these shells as had lost their inhabitants became filled up in their stead with mud.' Here was history written by the earth itself, even older than the Pharaohs, and Leonardo could not hide his emotion: How many changes of state and circumstance have followed 'since the wondrous form of this fish died here in this hollow winding recess? Now, destroyed by Time, patiently it lies within the narrow space, and, with its bones despoiled and bare, it is become an armour and support to the mountain which lies above it.'

Leonardo's notes remained hidden and without issue, but even during his lifetime, in 1517, the world of fossils was revealed by accident to a larger public. In order to repair the citadel of San Felice at Verona, large amounts of stone were quarried in the nearby hills, and these happened to contain a variety of organic remains, many recognizable even to the layman. Girolamo Fracastoro, a scholarly young gentleman of Verona, showed that they were truly organic remains, and furthermore could not be the relics of the Biblical deluge, for that had been local and had lasted only 150 days. Here was an original insight which, had its implications been worked out, could have revealed the immense age of the earth—virtually a new dimension in Time—and so carried a stage further the concept of the earth undergoing continuous change. As it happened, however, like many original ideas Fracastoro's was very slow to gain a foothold, and when towards the close of the century Mercati made a collection of minerals for Pope Sixtus V and Olivi catalogued the Verona minerals in 1584, both men, who had so many fossils in their care, persisted in considering them as sports of nature.

In the field of medicine the tendency to think in terms of move-
ment produced more immediately useful results, indeed Italian
medicine at this period led the field in Europe. It began the century
by meeting the challenge of a new disease, hitherto confined to
America, and brought to Europe in 1494 by Columbus's sailors.
Italians called it the *morbo gallico*, Frenchmen the Neapolitan disease
—they had first contracted it while fighting in Naples—Englishmen
the French disease; only in 1521 did it acquire the name syphilis.
From 1495 the disease spread with frightful rapidity. Writers
dwelled with horror on flesh falling from the limbs and exposing the
bare bone, the mouth losing its teeth, the breath becoming fetid, the
voice reduced to a whisper. One of the earliest treatises was written
by Caspare Torella of Valencia, physician to Pope Alexander VI,
who in a period of two months treated and observed seventeen out-
breaks of syphilis in the Pope's family and court, and with no
squeamishness described five typical cases. While earnest churchmen
explained it as a punishment for lax morals and composed an inter-
cessory prayer to St Denis of Paris, Ulrich von Hutten, who con-
tracted the disease and got rid of it, dedicated a treatise on the
subject to the Archbishop of Mainz, saying that he hoped his Grace
had escaped the pox, but should he catch it (Heaven forbid, but one
could never tell) he would be glad to treat and cure him.

As early as 1497 it was generally known that syphilis could be
contracted by sexual intercourse. In that year Aberdeen Town
Council issued an edict in respect of the 'infirmitie cum out of
Franche and strang partis . . . all licht women be chargit & ordanit
to decist fra thar vices & syne of venerie.' Italians were less repres-
sive. A statute of Faenza dated 1507 states that 'women desiring to
devote themselves to prostitution should present themselves at the
office called The Guard so that it may be known if they come from
a suspect locality and if they have a healthy body; and no one of
them should be permitted to serve who had the French disease.'
Doctors quickly found two cures: mercury, Europe's traditional
remedy for skin diseases, and guiac, the hard brownish-green wood
of a violet-blossomed tree growing in the West Indies and South
America, the healing properties of which were known to the natives.
Mercury was usually applied by surgeons—Benvenuto · Cellini

underwent this treatment and complained characteristically of the high fees—while guiac was administered by physicians, usually in the form of infusions taken for a month after prolonged fastings.

The physician who studied syphilis most closely was Girolamo Fracastoro, the gentleman of Verona we have already met as a geologist. Born in 1478 of a patrician family, he took a medical degree at Padua but like so many of the original thinkers of his day he was a polymath. He wrote good Latin verse, including a narrative poem about Joseph, son of Jacob, and he helped Giambattista Ramusio, the Italian Hakluyt, to compile his edition of Voyages and Travels. He was generous, public-spirited and very popular: six years after his death in 1553 the people of Verona erected a statue to him, the first so to honour a doctor.

In 1521 Fracastoro wrote a Latin poem modelled on Virgil's *Georgics.* 'What varied fortunes,' it begins, 'and what germinations have produced a fierce and rare disease, never before seen for centuries, which ravaged all Europe and the flourishing cities of Asia and Libya, and invaded Italy in that unfortunate war with the Gauls which has given it its name—all this I shall tell in my song.' The disease, says Fracastoro, is not in fact new but the reappearance of one which Apollo inflicted, as punishment for an insult, on the rich and beautiful young shepherd Syphilus. Fracastoro describes its symptoms, recommends treatment by mercury and guiac and declares it to be on the wane, thanks to the propitious reign of Leo X. Fracastoro entitled his poem *Syphilis sive de morbo gallico,* and thus gave its name to the disease.

It is a strange fact that syphilis in Fracastoro's day appeared in subjects who had not had sexual intercourse with infected persons; in some places it was disseminated in epidemic form, hence the rapidity with which it spread. Fracastoro asked himself how disease could be contracted at a distance. Hippocrates proved no help in the matter, for he held that disease is an imbalance of the four humours, a drama originating and enacted within the individual's body, influenced only by the seasons. The usual opinion was that diseases were spontaneously generated when a general 'corruption' crept into the air, about which nothing could be done. Fracastoro, having studied syphilis, plague and typhus, claimed that they were all

caused by contagion. In his *De contagione et contagionis morbis* of 1546 he distinguishes three forms of contagion: by simple contact, as in scabies and leprosy; by the agency of infected clothing and bed-clothes, which can carry the seeds of contagion (*seminaria prima*); and by transmission from a distance, without direct or indirect contact, which may happen in plague and smallpox. Fracastoro says that syphilis can be transmitted in either of the first two ways. He goes on to state that the *seminaria* spread themselves by selecting the humours for which they have an affinity, and by attraction, being breathed in through nose or mouth, and so carried to the heart.

The notion of *seminaria*, minute invisible bodies with the power of reproduction, carrying disease from one person to another, marks an important advance in medicine, and adumbrates the concept of a germ. It meant that henceforth infectious disease was, in theory, controllable. The first immediate practical result occurred in 1547, when cases of plague occurred in Trent, and Fracastoro, Physician to the Council, insisted that delegates leave the infected town. His advice was followed and the Council moved for a time to Bologna.

Another who contributed to the idea of movement in medicine was Girolamo Cardano of Pavia, polymath, specialist in diseases of the chest and author of the *cinquecento*'s most candid autobiography. 'I am a man of medium height,' writes Cardano, 'my feet are short, wide near the toes, and rather too high at the heels, so that it is difficult for me to find well-fitting shoes and I usually have them custom-made. My chest is somewhat narrow and my arms slender. The thickly fashioned right hand has dangling fingers, so that palmists have declared me a peasant; it embarrasses them to know the truth . . . But my left hand is beautiful, with long, tapering, well-formed fingers and shining nails.' Cardano completes his self-portrait by saying that his face is oval, his hair and beard yellowish, his eyes grey-blue and short sighted, his voice unpleasantly shrill. He has, he says, a great fondness for pets, keeping in his house not only cats and dogs but kids, lambs, hares, rabbits and storks, and for most of his life has been a compulsive gambler, living for two years solely on his winnings at the table and writing a manual on how to win, 'as a physician writes of an incurable disease, not praising it, but showing how to make the best of it'.

Cardano trained two of his dogs to carry stones, then mated them and observed that their puppy learned to carry stones in eight days instead of the usual two months. From this and similar experiments he concluded that acquired characteristics may be hereditarily transmitted. In defending his son on a charge of wife murder he argued that the properties of arsenic are not unchanging and will disappear altogether when cooked, hence the arsenic in question, which had been mixed into a cake and then baked, could not have caused the woman's death. He propounded the view that physique and environment can alter character: hence his statement that Caribs practised cannibalism because their islands contained no red meat, only fish and turtles, and his fond hope that criminals might be reformed by receiving a transfusion of blood from men of better heart.

In 1552 Cardano travelled to Edinburgh to treat John Hamilton, Archbishop of St Andrews and brother of the Regent of Scotland, who for ten years had been troubled by severe asthma. The Archbishop slept badly and suffered from fits of gasping, which lately had been getting worse. Both Hippocrates and Galen attribute asthma to excessive phlegm from the head. The Archbishop started his day, under Cardano's supervision, by chewing a couple of tears of mastic gum to promote an appetite, which he then satisfied with two to four pints of ass's milk. His main meal consisted of turtle soup and thick barley-water mixed with wine and a little cinnamon or ginger. He was obliged to take cold showers and apply to his shaven head a most peculiar nightcap compounded of Greek pitch and ship's tar, white mustard, euphorbium and honey of anathardus.

This treatment helped the Archbishop without however curing him, and he still slept badly. It was now that Cardano showed his keen powers of observation. He noticed a connection between his Grace's asthma and his bedclothes. He seems to have divined that the feathers in the mattress and pillow emitted a fine dust or other noxious agent which caused the Archbishop's gasping. He ordered the feather mattress and pillow to be replaced by a mattress of unspun silk and a pillow of dry finely chopped straw or well-dried seaweed; as for the leather pillow-case, it was to be replaced by one of linen, sprinkled with perfume. After this was done the asthma

disappeared permanently and the Archbishop was able to resume his normal duties. He was so delighted that he paid Cardano 1800 gold crowns, more than the agreed fee. It would be untrue to say that Cardano fathomed the mysteries of allergy, but he certainly discovered that nervous spasms can be caused by the movement into the body of invisible particles.

Among Cardano's friends was the great Flemish physician, Andreas Vesalius. Born in 1514, Vesalius studied in Paris under Sylvius, one of the old school, who skipped the hard passages in Galen and demonstrated from limbs of dogs dissected by an assistant. Vesalius, an impatient man, soon bridled at this and in 1537 came to Padua as Professor of Anatomy at 800 florins a year. Even in Padua Galen had immense prestige, all the more so since 1525 when Aldus published his complete works in the original Greek. Whereas Hippocrates had adopted a humble approach to nature, Galen was a know-all. The origin of every disease and the nature of every cure—nothing was hidden from Galen. Though his dissections were confined to monkeys, Galen transferred his observations without the least scruple to human anatomy. Moreover, living in the age of Marcus Aurelius, who was one of his patients, he subscribed to the Stoic view that the body is merely the instrument of the soul. This endeared his work to the Church and for long ensured it an impregnable authority.

Vesalius was the first anatomist to challenge Galen. Around 1539 he dissected the azygous vein in a human subject, became convinced that Galen could not have based his anatomy on dissection of the human body, and set about doing so himself. Even in Padua he could not obtain enough bodies for his tireless curiosity: he plundered churchyards and sometimes had to keep dead bodies concealed in his bed. In his epoch-making book *De humani corporis fabrica*, published in 1543, Vesalius correctly describes for the first time the sternum and the articular surfaces of the hand and the knee, and he corrects many of Galen's errors about the anatomy of the liver, the bile ducts and the uterus. He also notes variations in the shape of the skulls of different races, such as the brachycephaly of the Germans, and the dolichocephaly of the Flemings. Probably influenced by Leonardo's drawings, Vesalius had his book illustrated with beautiful woodcuts

by Stephen Calcar, a pupil of Titian: one of them shows a skeleton in meditation with a caption that strikingly reveals the new respect for human inventiveness: *'Vivitur in genio, caetera mortis erunt*—Only through his genius may man survive, everything else will die.'

Galen laid down that the liver produces and distributes the blood, which is carried only by the veins; arteries are for the passage of air carrying 'the vital spirit'. Vesalius was puzzled by Galen's statement that blood passes from the right to the left ventricle of the heart through small pores. He expressly states that he has not been able to find these pores. 'I do not see how even the smallest amount of blood could pass from the right ventricle to the left through the septum.'

This hint was taken up by Realdo Colombo of Cremona, Vesalius's successor in the chair of anatomy at Padua. In his *De re anatomica* of 1558 Colombo for the first time correctly describes what is called the smaller circulation of the blood—from the heart to the lungs and back to the heart. Referring to those who believe in a passage-way through the septum, 'they follow a false path,' he says, 'because the blood goes through the *vena arteriosa* to the lungs and is there attenuated; then, mixed with air, it goes through the *arteria venosa* to the left heart, just as everyone may observe, though no one has hitherto done so and no one has stated in writing.' Colombo goes on to say that two of the four great vessels of the heart are constructed so as to bring blood to the heart, which happens during diastole, and two others to carry blood away from the heart during systole.

The theory of the smaller circulation of the blood was reached independently by another Italian, Andrea Cesalpino of Arezzo, and the hypotheses of both were confirmed by William Harvey, who received his M.D. degree from Padua in 1602. Harvey quotes from the work of Colombo and almost certainly knew Cesalpino's writings, which by then had gone through several editions, but he did more than synthesize their views; he was a true pioneer in that he extended the principle of circulation of the blood to the whole body and confirmed it by twenty years of experiments. One of these proved conclusive. Having weighed and measured the capacity of the heart, Harvey found that in the space of an hour it would throw

out more blood than the weight of a man, far more than could be created in that time out of any nourishment received. The only acceptable hypothesis was that blood went streaming through the whole body time after time in a continual circulation. This proved a milestone not only in medicine but in man's concept of himself. Henceforth he knew that rest is illusory, that even asleep his body is never still.

Nowhere was the new concept of continuous movement to prove more far-reaching than in the field of cosmology. The innovator here was born in Thorn on the Vistula, in Poland, in 1473. His real name was Nicolas Copernick, but he Latinized it as Copernicus—a less radical change than that performed by one of his colleagues who, born Wodka, took the name Abstemius! Copernicus studied for ten years in Italy: canon law in Bologna, then medicine in Padua and Ferrara, where he discussed astronomy with the brilliant humanist Celio Calcagnini, who may have suggested to him that the earth rotates round its own axis. Copernicus read Plutarch's *Moralia* in the original Greek and there encountered the views of Aristarchus and other Greek astronomers who held that the earth moves in orbit round the sun, a view rejected by Ptolemy. On his return to Poland Copernicus, who was in minor orders, became a canon of Frauenburg cathedral. He practised successfully as a physician, proved an able and kindly administrator and also drew up a scheme for reform of the Polish coinage. His astronomical thinking was a sideline which he conducted in his study, and he made few observations: only twenty-seven are mentioned in his book. But there were enough to show growing discrepancies between the calculated and the observed positions of the stars and planets. Copernicus saw that Ptolemaic astronomy needed correction, and that the most satisfactory correction would be to re-apply Aristarchus's idea that the sun is the centre of the solar system. This he did, replacing the concept of a static world at rest by a world two ways in motion: rotating on its own axis, and rotating round the sun.

Copernicus, an unassuming man, was cautious about publishing the heliocentric theory, and only did so at the end of his life, after receiving the encouragement of two Popes, Clement VII and Paul

III. The *De revolutionibus* appeared in 1543, an *annus mirabilis* which also saw the publication of Vesalius's *Fabrica*, and one of the first copies was placed in Copernicus's hands as he lay on his deathbed. The book provoked intense hostility: Luther called Copernicus a fool because he held opinions contrary to the Bible, and said, with more truth than he could know, that 'he would overturn astronomy', while Cardano objected that so rapid a movement of the earth could not pass unnoticed by men. Even Tycho Brahe, the fiery Danish astronomer whose accurate observations of 777 stars in his magnificently equipped observatory called Uraniburg (Castle of the Sky) prepared the way for the next important hypothesis—elliptical rather than circular movement of the planets—had nothing but contempt for Copernican theory, asserting that it failed to account for the lack of parallactic motions in the stars.

Johann Kepler, who was born in Württemberg in 1571, was the next astronomer to develop Copernicus's theory, doing so in the face of bitter religious persecution. Kepler subscribed to the Pythagorean-Platonic doctrine of a fundamental correspondence between number and form; he was also much influenced by Greek writings on conic sections. Within this context he placed Brahe's observations and published his conclusions in the *Astronomia Nova* of 1609 in the form of three laws: the movement of planets round the sun is elliptical; the areas described by the vector radii are proportionate to their duration; the square of the duration of the orbit is proportionate to the cube of the main axis.

In the same year, 1609, Copernicus's theory received further strong support from observations made by Galileo, then Professor of Mathematics at Padua. Galileo Galilei was born in Pisa in 1564, the son of an impoverished Florentine nobleman. In 1589 he became Professor of Mathematics at Pisa, but the narrow Aristotelianism of his colleagues did not suit one whose bent was towards Platonism and experiment. In 1592 he moved to Padua, where he remained eighteen years. Galileo was convinced of the truth of the heliocentric theory, and wished to establish it beyond doubt as one part in a whole new theory of movement. But for this gigantic task he himself needed rest, and it is to the lasting credit of Cosimo, Grand Duke of Tuscany, that in 1610 he freed Galileo from his teaching

duties by appointing him his 'Philosopher', with ample leisure to meditate and write.

Galileo was strongly built, above middle height, with reddish hair and beard, and the quick temper that often accompanies such colouring. He possessed a dynamic temperament and an immense capacity for work, and used to say that occupation is the best medicine for mind and body. He preferred the country to the town, since there 'the book of Nature lay open.' But he liked company and never took a meal alone if he could help it. He was a connoisseur of wine and pruned his own vineyard. He also liked painting and playing the lute. He could recite whole pages of Virgil, Ovid, Horace, Seneca, Petrarch and Ariosto. He had a very high opinion of Pythagoras and Plato, but Archimedes was the only Greek he called 'master'. He never married, probably because he had no money during his youth, but while in Padua he kept a Venetian mistress, Marina Gamba, who bore him three children, two of whom became Franciscan nuns. With the elder, Sister Celeste, Galileo had a long, close and touching friendship. She would make him little presents of citron preserve and baked quinces, while he would send her gifts of money, medicines, curiosities such as a phial containing scorpions in oil, and it was he who repaired the convent clocks.

From his youth Galileo dedicated himself to the study of rest and motion. At eighteen he invented an instrument for recording the rate and variation of the pulse. He got the idea, says his disciple Viviani, while watching the oscillation of the heavy bronze lamp in the nave of Pisa cathedral, and in order to explain the lamp's movements he invoked the action of gravity. On the basis of these observations he conceived the principle of isochronism, which was to make possible the pendulum clock. He also invented a contrivance for measuring time by the uniform flow of water, and at Padua was to invent the thermometer. Like that other Florentine Platonist, Leonardo da Vinci, Galileo clearly intended to carry mathematical methods into the whole field of physics.

Physics was then a preserve of the Aristotelians, who held with great insistence the commonsense view that the normal state of a body is rest. Motion, they said, is of two kinds, natural and unnatural. Natural motion or gravity is the 'homing instinct' of a body

desirous of rest at the centre of the earth, that is of the universe: as it approaches the earth its homing instinct increases and hence also its speed. Unnatural motion is motion in any other direction, and results from continuous efficient causation. For example, once an arrow has left the bowstring, it is the rush of air filling in behind the feathering again and again that drives the arrow forward.

By Galileo's day this theory had become unsatisfactory at three points. The first and most important has already been mentioned: ordinary daily life was now observably an affair of activity and movement: it had become dynamic, hence a tendency to value and notice movement, say the swing of a pendulum, rather than rest, and this was heightened in Galileo by his own dynamic temperament. Secondly, if—as Galileo believed—the centre of the earth was not in fact the centre of the universe, then the notion of a homing instinct was rendered invalid. Thirdly, Niccolò Tartaglia and others had published books on ballistics, showing that a projectile describes a curve. It was awkward to explain the curve by blending the two kinds of Aristotelian motion, and it looked rather as though a single principle underlay both.

It is noteworthy that experiment played little part in Galileo's rejection of Aristotelian motion: in fact when in his youth he dropped a lump of lead and a block of wood from the top of the tower of Pisa, the results tended to favour Aristotle's assertion that the speed of falling bodies varies in proportion to their weight. Galileo, however, assured himself that the experiment was inconclusive, and that a tower twice as high would be required in order to prove or disprove the assertion. It was a new way of patterning reality, not the tower of Pisa, that unleashed Galileo's discoveries.

Copernicus may be said to have turned Ptolemaic astronomy inside out and Galileo did as much with Aristotelian mechanics. He claimed that it is not motion that is abnormal, but rest. A body would continue its motion in a straight line until something intervened to halt or slacken or deflect it, and a perfectly spherical ball on a perfectly smooth plane would continue to infinity. The planets revolving round the sun have a movement of just the same kind as such a spherical ball: not only are all things in movement, but the laws governing this movement are the same in the sky as

they are on earth. Even light Galileo saw as an emanation in movement, and he made the first attempts to measure it.

Though his theory has imperfections and did not completely free itself from the old idea that perfect motion is circular, it offered convincing answers to such problems as why falling bodies move at an accelerating speed and why projectiles have a parabolic trajectory. Not only did Galileo do more than any other thinker to establish the truth of the Copernican theory but he may be said to have laid the foundations of modern dynamics.

These various discoveries—in medicine, cosmology and physics—even at the time exerted an enormous influence. Though no one of them was accepted immediately, all found supporters among thinking Italians, and their cumulative effect was to alter fundamentally man's picture of the universe and of himself in it. First of all, as that perceptive precursor, Jean Buridan of Paris, had long ago observed, a new theory of motion must eliminate the need for Intelligences turning the celestial spheres. Having lost their thrones, Venus, Mars and the rest now began to lose their attraction for poets and painters, and also their influence on human affairs. No one could again propose, as Ficino had done in the *De triplici via*, that we could prolong our lives by capturing astral virtues. Cardano, like many contemporary scientific thinkers, had been a firm believer in astrology—he would cast a friend's horoscope at the drop of a birthday and even cast Christ's—but after Galileo's triumphant announcement that the stars are made of the same stuff and obey the same laws as our 'vile earth', astrology relaxed the stranglehold of centuries and henceforth was left to cranks.

The comforting picture of the earth as the centre of a closed, finite and picturable universe and of man the macrocosm was now shattered. It might have been expected that this would lead to a weakening of religion, but the opposite happened. The Copernican theory caused men such as Giordano Bruno and Tommaso Campanella to view space and the stars with greater wonder than ever before, and to see a more marvellous God in a changing than in an unchanging universe. At the same time, the notion that movement is the norm, whether it be the earth in space or the blood in our veins, was bound to confirm and strengthen man's esteem for the

active life. Contemplation, rest and isolation had been losing ground steadily since the time of Coluccio Salutati, but now science endorsed the intuitions of civic sense. Finally, these discoveries persuaded men of the need to go on discovering, even in the face of authority. As Galileo wrote in 1613 to the Professor of Mathematics in Pisa: 'I do not think it is necessary to believe that the same God who gave us our senses, our speech, our intellect, would have put aside the use of them, to teach us instead such things as with their help we could find out for ourselves, particularly with regard to these [physical] sciences, of which there is not the smallest mention in Scripture; and, above all, with regard to astronomy, of which so little notice is taken that the names of all the planets are not mentioned.'

The achievements of scientific thinkers offered the most hopeful approach we have so far encountered for resolving the crisis of the age. The principle of movement as fundamental to nature could be extended to include human nature and human thought in all its ramifications. This would involve a wholly new attitude to the past, a revision of the theory of unchanging truth, 'truth at rest', and a more open-minded attitude to unusual formulations of religious belief. On the other hand, scientific thinkers by challenging traditional truths to some extent also challenged those in authority. It remains to be seen whether princes, prelates and professors would welcome the new discoveries or whether they would reject them as a dangerous threat to the established order.

CHAPTER 8

The Arts

IT IS IN the fine arts that Italians best express their deepest feelings, and it is there that one should hope to find a response to those fundamental questions raised by Luther. Would there be a recognition of past failings, less interest in heroes and gods, and more in the mystery and power of Christ; or would the challenge prove overwhelming, and lead to an art of escape?

The period from 1517, the year of Luther's 95 theses, was one of growing strain and, especially after the sack of Rome, of political subjection. Many of the city-states, even Florence, owed allegiance to the Emperors. Their rulers adopted airs and pageantry, but being dependent upon German or Spanish troops, they were subject princes. They knew this but did not want others to know it. So a mood of tension and sometimes pretence overhung the courts, which was bound to have its effect on the arts. Venice, safely independent amid her lagoons, was an exception to the rule, and for this reason will be considered separately later.

If it was any comfort, Italians could find an exact parallel in the classical world. Another northern ruler, Philip of Macedon, had conquered Greece and ridden rough-shod over civic liberties. Greek artists had then reacted in one of two ways. Either they adopted a purely formal elegance as in the *Apollo Belvedere*, which could sometimes border on the fanciful, or, if they attempted to wrestle with the new situation, they distorted reality with irrational, wilful and subjective effects, as in the *Laocoön*. During the sixteenth century artists reacted along much the same lines. In so doing they were not directly influenced by classical precedent, but simply responding in a similar way to similar stresses. They did, however,

tend to borrow from Hellenistic works at a time when both these and classical works of the great age were being excavated. Italian art also divided into two streams. One, under the joint influence of Leonardo da Vinci and Raphael, sought peace, calm and serenity; the other, less detached and led by Michelangelo, tried to resolve its unease in movement, tension and violence. Sometimes elements in one stream flowed into the other, but it will be convenient to consider the two separately.[1]

The first of the 'serene' artists is Antonio Allegri, better known as Correggio after the town in Emilia where, around 1494, he was born. He possessed a sweet, sensuous nature and like others of this temperament, Desiderio da Settignano and Raphael, was to die young, in 1540. Correggio early fell under the influence of the Mantuan court painters, Mantegna and Costa, then of Leonardo. He painted mainly religious works, among the most characteristic being the *Madonna and Child with SS Jerome and Mary Magdalen.* At the left stands the patron of humanists, his long beard, bare right arm and leg providing a strong vertical upward thrust for a group otherwise composed of curves. Next to him a sweetly smiling angel holds open the Vulgate. In the centre the Madonna disposes her child, arms and legs outspread, in such a way that he can see the book. On the right, half-kneeling, Mary Magdalen lays her cheek against the child's leg, while in the background stands the young St John.

Correggio's technical originality, as Vasari noted, lies in his gay colours, which here range from rose to russet and gold, and in his faithful rendering of softly curly hair, glinting with high-lights. Both serve to create a mood of joy unprecedented in a Christian painting. The angel's smile seems to come from the pages of *The Courtier*, while Mary Magdalen's caressing gesture shows the extent of the intimacy now assumed between man and his incarnate God. The mood of trusting, innocent and joyful tenderness is in itself of remarkable beauty, but one has to ask just how far it accords with the Gospel text, or indeed with the traditional figure of Mary Magdalen, penitent and humble, such as Donatello had portrayed her.

[1] For reasons explained in Appendix B I have purposely avoided the term Mannerism.

The next artist in this tradition is Parmigianino. He was born in 1503 in Parma and spent most of his short life in that town. In 1527 he was at work in Rome on a large altarpiece in which the kneeling figure of the Baptist points at the Madonna and Child; German soldiers, breaking into his studio, were so impressed by the lifelike Baptist that they withdrew without molesting him. The Baptist is indeed a splendid figure, but Parmigianino achieves the lyric, soaring quality of Correggio at the cost of formal distortion: the Baptist's pointing finger, for example, is impossibly long. Formal distortion is again a feature of Parmigianino's curious *Self-portrait from a Convex Mirror*, and it was evidently this abiding interest in the transmutation of shapes that caused him in later life to abandon painting for alchemy and experiments in freezing mercury: 'he changed from the delicate, amiable and elegant person he was, and became a bearded, long-haired, neglected and almost wild man, plunged in melancholy.' Many another artist, as we shall see, was to break down under the strains of this troubled century.

One of Parmigianino's most remarkable works is the *Madonna del Collo lungo*, painted in the late 1530's for the Servite church in Parma. On the left stands a bare-legged boy angel holding a long slender amphora. Like St Jerome in Correggio's picture, he imparts a strong upward thrust, while the amphora provides the picture with a key shape. Beside the angel are visible the faces of four other angels. The Madonna, in a white ankle-length gown, is seated, holding the sleeping Jesus on her lap and touching her breast with her right hand. In the distance are a row of columns and a prophet opening a scroll. Almost every element of the work is elongated to an unusual degree: the columns, the child's body, Mary's body, her neck, her fingers, which are thin and tapering, and her right foot, which rests in a tip-toe position not on one but on two cushions. Parmigianino is evidently illustrating the new ideal of courtly womanhood celebrated in books of the period: highly-bred, dignified, possessed of a soaring quality, yet not without a marked affectation. It seems probable, though it cannot be proved, that he based his style on Lysippus, who had modified the canon of Polyclitus, making the body eight times, instead of seven times, as long as the head.

Francesco Primaticcio, who formed his style from Parmigianino,

was born in Bologna in 1505. His self-portrait shows an uneasy bearded face, one half in shadow, cap aslant on his head. He worked for the Gonzaga of Mantua until 1531, when he was invited by François I to Fontainebleau. To that castle and to Chambord he introduced the new elegant, elongated figures. Sculptor and architect as well as painter, he became superintendent of royal buildings, provided new decorative schemes and in 1540 visited Rome in order to buy 125 antique statues and busts for the King. Many of his drawings have survived, but few paintings, and of these *Ulysses and Penelope* typifies his languorous elegance. Ulysses is seated beside his wife: Penelope has evidently been counting on her fingers the years of his absence: Ulysses interrupts her, tilting her face towards him with strong thumb and forefinger, so that he may gaze into the eyes of her whose memory has brought him home. Few works better embody Leonardo's dictum that the painter should depict states of soul, and in order to do so should observe the gestures of the dumb, since theirs are the most natural. Interesting also is the fact that the theme is a new one: the celebration of married love.

Primaticcio was joined at the French court by an even more considerable painter. Niccolò dell' Abate had been born in Modena about 1509, worked in Bologna from 1547 to 1548 and is recorded at Fontainebleau in 1552, where he spent the rest of his life, engaged with Primaticcio on decorative work which has not survived. He too painted elongated female figures, mainly from mythology, but he set them in a northern landscape, whose rocks and woods he reclaimed for classical art, much as Ariosto reclaimed the *chanson de geste*. In *The Story of Aristaeus*, the scene is wild Thrace. Eurydice, wife of Orpheus, accompanied by three nymphs, is surprised by Aristaeus: she flees his advances, steps on a snake which bites her, and finally dies. Beyond, Aristaeus is seen with his mother Cybele: he is asking her why his cherished hive of bees has suddenly perished; Cybele refers him to Proteus (extreme right) who explains the loss as a punishment for Eurydice's death. In the middle distance Orpheus is shown charming animals, with his lyre; among them a unicorn, symbol of Eurydice's chastity; later he will use that music to good effect in order to win his wife's release from Hades.

But this is incidental to the landscape. Under a silver-grey sky

ranges of mountains glow like rock crystal, while dark trees contrast with the luminous grey stone of classical cities, rich in obelisks, columns, one topped by a statue, and even a round temple. So extensive is the landscape that one seems to be taking a privileged view of the whole earth from Olympus, that earth which was then being discovered by Niccolò's contemporaries. It is more than a merely decorative or fanciful work. Niccolò is the first Italian to show poetic wonder at the world's immensity.

Landscape, as we shall see later, was to be a favourite subject with Venetian artists, but outside Venice, in the courts, the great achievement of sixteenth-century painting is the psychological portrait. Raphael had gone a long way towards probing character, for example in his Cardinal Scaramuccia di Trivulzio, every inch the tight-lipped clerical lawyer, and he was followed in this course by the Florentine, Agnolo Bronzino. Born in 1503, Bronzino had the reputation of being a serene person and a good friend, but he too suffered from the tensions of his age, writing poems, for example, on such subjects as Need and Fear. He spent nearly all his life in Florence and, under Duke Cosimo, became Italy's first court painter.

Bronzino's style is already apparent in his early portrait of Ugolino Martelli, a humanist who later became Bishop of Grandeves. Ugolino's literary tastes are shown by means of an open copy of the *Iliad* and one of Bembo's works in the young man's left hand, and his connoisseurship by means of Donatello's marble *David*, which the sculptor had given to the Martelli family. Books and statues often appear in Bronzino's portraits: they help to define the subject, and lend the picture a monumental air; but when one contrasts these inanimate symbols with, say, the ermine in Leonardo's *Lady with an Ermine*, one is aware also of a certain decline in vivacity, at times almost a woodenness.

To the same period, when Bronzino was in his middle thirties, belongs the *Portrait of a Young Man*, perhaps one of the Dukes of Urbino. It might well be subtitled a study in assured independence. The young man's character is conveyed through his haughty expression, the hand on his hip and, more cunningly, through the fact that he has been interrupted in his reading. We feel that he is only awaiting our departure to take up his book again, and he holds his

place marked. The fact that the book is upright, not flat, is a detail that adds to the mood of *hauteur*.

Another portrait by Bronzino, that of Lodovico Capponi, shows a handsome young Florentine banker in a flecked shirt with lace sleeves and neck under a black pourpoint. In his right hand he holds a cameo, its face hidden. The cameo may represent Maddalena Vettori, to whom Lodovico was for three years secretly engaged, before overcoming opposition and marrying her in 1559. The Capponi were a proud family—Piero Capponi had been the only Florentine to defy Charles VIII in 1494—and seldom have assured good looks been so deftly caught in paint.

Bronzino succeeded equally well with women. In his portrait of Eleonora of Toledo, wife of Duke Cosimo I, he expresses her heavy Spanish taste in a dark, boldly patterned dress with fussy bows at the shoulders, such as no born Florentine would have been tempted to wear. The hair is drawn severely back, no attempt being made to soften the rather round face, the form of which appears again in her small son Giovanni. The expression of rank and cold haughtiness is unequalled even in Piero della Francesca's angels.

Bronzino's gift for conveying character is shown at its best in a portrait of Laura Battiferri. Born in Urbino in 1523, Laura married the architect and sculptor, Bartolomeo Ammannati, and lived in Florence; this portrait was painted when she was in her middle thirties. Her dress is as sober as Eleonora's is luxurious: a pleated blouse, black tunic and red sleeves, a gauze veil falling lightly to her shoulders, so that nothing distracts us from the profile. Her eye is large, arched by a thin brow that curves round into the line of the long, perfectly proportioned aquiline nose; the lips are tense with controlled emotion, the chin firm. The only other area of interest is the book she holds open: a manuscript copy of Petrarch's sonnets. Laura was a well-known poetess and compared by her admirers to Sappho—somewhat misleadingly, since her best work is a translation of the Seven Penitential Psalms. Her character Bronzino described in one of his own sonnets: '*Tutto dentro di ferro, fuor di ghiaccio*—A soul of steel in a body of ice', and this is certainly the impression conveyed by his portrait. Not only is it psychologically a master-

piece, it sums up Bronzino's art, which manages to resolve tension in a calm and sometimes cold serenity.

One of Bronzino's frescoes, *The Crossing of the Red Sea*, shows Egyptians and their horses drowning in smooth, lake-like waters, and the image of a lake conveniently sums up the work of the artists so far discussed. Over against these is a second group of artists, led by Michelangelo in his middle years, who sought not to control emotion but to express it as turbulently as possible. Their work may be likened to a river in full spate, an image not altogether fanciful since one of the sources of Michelangelo's mature style was the statue of the god Tiber unearthed in Rome, the midriff muscles exaggerated to suggest waves.

Michelangelo spent the years 1516 to 1534 mainly in Florence and mainly engaged in one great work, the Medici Chapel, commissioned by the future Pope Clement VII in order to house the tombs of his father and uncle, Giuliano and Lorenzo—the *Magnifici*—and of his two recently deceased cousins, the *Capitani*—Lorenzo Duke of Urbino, and the gentle Giuliano Duke of Nemours, who for a time had been Leonardo da Vinci's patron.

Michelangelo started from a familiar feature on Roman sarcophagi: an image of the dead person's soul raised above reclining figures of Ocean and Earth, who symbolize this mortal world; and from a simple bas-relief he planned to transform the whole into terms of architecture and sculpture. The tomb of Duke Lorenzo was to stand against one wall, under a seated portrait of the Duke holding a sceptre; opposite would be the tomb of Duke Giuliano, under a portrait of a pensive warrior; and both *Capitani* were to gaze broodingly towards their only hope of eternity: a statue of the Madonna and Child standing above the simpler tombs of the *Magnifici*. The focus of the chapel would be a fresco in the lunette high above the Madonna depicting the *Resurrection of Christ*, a spiralling figure with crossed feet and arms, of which only a drawing survives.

The problem facing Michelangelo was to counterbalance the heavily articulated blind portals and ponderous tombs in such a way that the seated figures would not appear earthbound. Now when he began work on the Chapel, Michelangelo was entering his forty-

sixth year and, as his letters reveal, much concerned with the passing of his youth. This mood expresses itself in his solution of the problem. Michelangelo placed on the tombs of the *Capitani* four reclining figures representing Time; but instead of taking stock allegorical images such as a white-haired old man with an hour-glass he sought to suggest the actual movement of time by means of four of its phases: Dawn, Day, Dusk and Night.

The Greeks had depicted Ares with bent knee in order to indicate his unpeaceful nature. Michelangelo made the bent knee almost a signature of his work and doubtless the right-hand figure of the *Laocoön* confirmed him in his view that such a posture admirably indicates strain and struggle. All four statues comprising Time Michelangelo endowed with one knee bent at an angle of about forty-five degrees, and at least one arm bent also. This not only suggests restlessness but makes of the body, so to speak, a coiled spring of immense power. The muscles of the torso he depicts like the surface of a turbulent river, suggesting the flow of time; in his own words: 'Day and Night speak; and they say: with our fast course we have led Duke Giuliano to death.' Again to suggest the fleetingness of Time, Michelangelo has set the figures reclining at an angle; indeed, because the chapel was left unfinished, they seem almost to be slipping from the tombs. Michelangelo intended to counterbalance this effect with four figures facing in the opposite direction on the floor beneath: river gods, symbolizing Earth.

Michelangelo had been portrayed by Raphael in *The School of Athens* as Heraclitus, who taught that everything is in a state of flux. It was a recognition of the fact that, like the scientists of his day, Michelangelo accorded great importance to movement, and nowhere has he better displayed this vision than in the restless serpentine attitudes of the statues of Time. They appealed in an age of instability, and the Medici Chapel became a 'school for all the world': in a drawing by Federico Zuccari we can see artists busy in the Chapel copying details from the tomb of Duke Lorenzo.

Perhaps the greatest artist influenced by Michelangelo is Benvenuto Cellini. Born in Florence in 1500, he spent his first nineteen years in that city, before embarking on that wild career which he describes in his *Autobiography*: boasting, seducing, duelling, killing,

fighting with the police, escaping from prison on knotted sheets, raising the devil in the Colosseum. Twice he contracted syphilis, on the first occasion from a girl of fourteen, and had to undergo a drastic seven-week guiac cure. He fathered at least eight children, most of them bastards. He was, as we have seen, one of Pope Clement's gunners during the sack of Rome, and he has left us a moving vignette of Clement on his deathbed, unable even with spectacles to see the medals Cellini had made for him, fingering them and sighing deeply. Cellini's work reveals the influence of Michelangelo in details large and small: in the figures of Dawn, Day, Evening and Night adorning the gold salt-cellar made for François I, and in the signature on a diagonal band, like that on Michelangelo's youthful *Pietà*, with which he blazoned his greatest statue.

This statue is the *Perseus*. Cellini's design called for the hero standing on the body of the Medusa, his right arm drawn back, holding a sickle, his left lifting high and forward the Medusa's head, while he himself averts his gaze. He was warned by Duke Cosimo: 'This figure can't succeed in bronze because the rules of art don't permit it'—people had now begun to think in terms of classical 'rules'—but Cellini experimented with the Florentine clay until it would support the uplifted arm, made two outlets for the bronze instead of one, and heated his furnace with quick-burning pine. When the casting was taking place, he ran out of bronze, and was obliged to throw in all his household pewter—200 platters and pitchers. At this moment part of his workshop caught fire, but in the end the statue came out perfect save for the right foot, which Cellini quickly rectified, and it was hailed as a masterpiece with twenty sonnets, including one by Bronzino.

The *Perseus* succeeds because it expresses Cellini's own vigour and driving will. The chest strained like a bow, the bent leg, the curve from the sickle up through the arms to the Medusa's head: these are almost a visual counterpart of Cellini's *Autobiography*. There is latent also that soaring quality so distinctive of the Italian spirit: one thinks of Leonardo releasing caged birds, Astolfo's winged steed flying to the moon, and the Pegasus on the reverse of Bembo's medal: an urge towards the heights which was to find its perfect expression in Giovanni Bologna's bronze figure of the winged *Mercury* in the act

of flying, the whole weight resting on one leg and the point of one foot.

Giovanni Bologna was born in Douai in 1529. At sixteen he came to Rome, where he profited much from Michelangelo's advice, and to Florence in 1562. Unlike Cellini he cared little for money: his one ambition was to equal Michelangelo. He had the master's tough wiry body, and although he limped, having broken his leg by jumping out of a window, he was so well preserved in old age that, we are told, when he rattled his teeth the sound could be heard at a considerable distance. He married a Bolognese girl, but she soon died, leaving him childless. He was a devout Christian and spent his scant savings on an elaborate chapel.

Bologna's other great work besides the *Mercury* is a bronze *Apollo*. The god has placed his lyre on a tree stump and on this is resting his left elbow and right arm. His head is shown in profile, looking over the left shoulder. His left thigh is thrust out in the same direction, balancing the upright lyre, and receding at the waist into an almost feminine curve. The right leg is also bent at the knee. Seldom if ever has the human body been shown in a posture of such sinuous grace.

Giovanni Bologna reached his highest point in the *Apollo*. Too often he concentrated on form and effects at the expense of his subject. For instance, he replied to Cellini's *Perseus* by making, in the more difficult medium of marble, a group of three figures all in violent action with many views in spiral. He considered the statue primarily as a technical challenge and only when it was finished did he give it a name: *The Rape of the Sabines*. In many another work, whether the title happens to be *Virtue Vanquishing Vice*, *Samson and the Philistine* or *Hercules Fighting the Centaur*, Giovanni creates the same twisting, writhing movement—for its own sake, not as an expression of character: indeed, his faces are quite vacant. Even a standing female figure such as Astronomy shrinks, as though from a nettle, into a coiled and convoluted position. From art such as this the way lies clear to baroque.

So much for the sculpture of Michelangelo and his followers. We turn now to painting in the same tradition. Here the influence of Michelangelo was the more widespread but less beneficial. Any

artist who felt troubled in spirit—and there were many in this troubled century—felt called upon to express his anguish in terms of Michelangelo's snake-like forms. Such were Ferruci, who always wore a doublet made of the flayed skin of a hanged man; Rustici, who lived with an eagle, a porcupine and a raven, dabbled in necromancy and walled up a room in which he used to keep adders and snakes, so that he might enjoy 'watching them there, particularly in summer, at all their mad games and wild tricks'; Bartolomeo Torri, whose excessive interest in anatomy led him to 'poison the air of the house by filling his rooms with human limbs and fragments of bodies which he even kept under the bed'; and Rosso, who dug up rotting corpses by night in the grounds of the episcopal palace at Borgo San Sepolcro, and after being oppressed all his life by ambiguous and morbid friendships, according to Vasari finally committed suicide in France.

Of these neurotic painters Rosso is the most considerable. At his best he is a master of strain and tension. In one of his pictures, the *Deposition*, he shows the difficulty experienced by the four men who are taking down the body of Christ from the Cross, and to one of the grief-stricken women he gives the haunted look of Michelangelo's *Jacob* in the Sistine. In *The Daughters of Jethro* six colossal nude warriors sprawl over the canvas, crowding into one corner a group of fleeing women. Although the contrast between their burly Michelangelesque bodies and the timid female figures is somewhat overdone, the picture succeeds in conveying an authentic feeling of tension.

An even better painter in the tradition of Michelangelo is Jacopo Pontormo, who was born in the Tuscan village of that name in 1494. A solitary and neurotic person, Pontormo lived alone and never married, though he did adopt as his son the young painter Battista Nadini. Part of the last three years of his life he recorded in an interesting diary. Pontormo noted each day's work, sometimes with a marginal sketch, the weather, and his food: even the precise number of ounces of bread, the exact number of figs, for he suffered from dropsy and had to be very sparing in his diet. Occasionally he planted some peach trees, or bottled his wine, or visited the tavern with his one real friend, Bronzino. It is the record of a humble,

hard-working, harassed life. We also know that Pontormo was 'so painfully afraid of death that he would never hear the subject mentioned, and took great care to avoid seeing a dead body'.

Pontormo painted his *Joseph in Egypt* at the early age of twenty-one. Although Joseph was well known as a type of Christ, the subject had only now become popular with artists and writers: evidently Italians found in this plight of the Jews in Egypt an image of their own political captivity. There are four scenes. On the left, Joseph, who is dressed throughout in a brown tunic and mauve cloak, pleads with Pharaoh that his father and brethren may dwell in the land of Goshen—their anguished suspense is well expressed in the twisted hands of the kneeling woman; on the right, seated on what is intended as a chariot, Joseph lends a receptive ear to the Egyptians' plea for bread; then he leads his two sons up a stairway, where they are received by a kinswoman; in the last scene, at the right-hand top corner, he presents his sons to the dying Jacob. In the background is a Dutch gabled tower, copied from an engraving dated 1510 by Lucas van Leyden: evidently Pontormo decided that its pyramidal shape would adequately symbolize Egypt.

The curved stone staircase imparts a strong spiral upward thrust to the picture, and this is emphasized in a different way by the three statues, the dominant one repeating the line of the steps in his silhouetted outstretched arms and linking it, so to speak, with heaven. Balancing this spiral motion is the horizontal curve of the room where Jacob is lying, so that the whole picture is based on two intersecting parabolas. The underlying Florentine geometry is still here, but developed into flowing rhythms, while truth of expression has been subordinated to an overall beauty of design.

Joseph in Egypt is a revolutionary work because for the first time in the history of painting the artist's whole approach is oblique. It is oblique in the sense that the dominating spiral staircase deviates from a straight line, and oblique in the deeper sense that it is un-straightforward. For example, the most important scene—Joseph pleading with Pharaoh—is relegated to a corner of the picture, and it possesses different spatial values from those used elsewhere in the work. Then again, the steps of the staircase have no support. All

these features combine to impress the viewer with a sense of insecurity, almost of vertigo.

When we turn to Pontormo's religious paintings, we again find obliqueness and purely formal beauty. In *Christ before Pilate* Pontormo overshadows the bound figure of Our Lord with a stairway terminating in a colonnade; silhouetted against the sky and therefore dominating the scene is the ominous figure of Pilate's servant, who is about to descend the stairway, carrying high a golden ewer and basin. Likewise, in the Carmignano *Visitation* Pontormo makes no attempt to evoke the women's emotion, but instead concentrates on their voluminous draperies, making a beautiful pattern of four dominant colours: blue-green, olive-green, orange and rose-pink. In his *Deposition* the colour scheme is no less rich—pale gold, blue, pink and red—and eleven figures are grouped with the utmost sophistication to produce a seemingly natural gyrating movement. Christ is carried by two curly-haired youths; his body is unmarked and he seems merely asleep. Behind him, to the right, his mother extends an arm as though to keep him by her. Perhaps no arrangement of this complicated scene has ever been so harmonious, yet there is a total absence of suffering and grief. The youths look incredulous, the women resigned, the Madonna merely faint. Furthermore, it is not the figure of Christ that draws the eye, but the curly-haired youth in the foreground, by reason of his unusual squatting posture—an anatomical *tour de force* by Pontormo but here a profane distraction.

Why do Pontormo's religious paintings fail? It seems that we demand of the religious artist a depth of feeling commensurate with that which we ourselves experience: a merely formal approach may be adequate to the death of Eurydice but not to the death of Christ. Yet this lack of religious feeling is not peculiar to Pontormo. It is found in nearly every Italian at this period. If we turn to a typical work painted in another city a dozen years later than the *Deposition*, Jacopino del Conte's *Baptism of Christ*, we are aware that Christ no longer imposes himself on the scene, as for example in Piero della Francesca's rendering of the same subject: instead, he bends his body, bows his head and crosses his arms in a posture of languid elegance. He has become just one more element in the design, yet because that

design is so firmly conceived and the anatomy of the figures so true to life, the fresco must still be described as art of the classical revival. It has not yet faded into cold academicism, though it certainly lacks the fire of religious fervour. The same may be said of the countless other works of religious art at this period. As the subjects grow more violent—the Massacre of the Innocents, the Scourging of Christ, the Beheading of St John—so the interest shifts to formal effects.

By the middle of the century it can be said that religion had ceased to provide inspiration save to Michelangelo, and, under the influence of the theatre, festivals and court pageantry, had been replaced by literary ideas. Vasari, who lived from 1511 to 1574, had now become the arbiter of taste. In his youth Vasari had designed stage sets in Venice and among the Florentine festivals he arranged was the wedding of Francesco I, for which two whole albums of his drawings survive. He was fascinated by literary symbolism, allegories and the like, and introduced them whenever he could to his paintings. Here he describes a picture he painted in 1543 for the papal chancery: 'Justice is grasping an ostrich, which bears the twelve tables of the Law. On her head she wears a crown of iron and gold, adorned with three feathers of different colours, symbols of the first judge; she is naked from the hips up. Fixed to her belt by means of golden chains are seven resisting captives symbolizing the seven vices: corruption, ignorance, cruelty, fear, treachery, falsehood and slander. Resting on their shoulders is the naked Truth, who is being led to Justice with a gift of two doves, symbolizing innocence; and Justice is crowning Truth with a wreath of oak-leaves, representing strength of mind.'

From this description, and from their work as a whole, it is clear that Vasari and his contemporaries shirked the effort of representing character through expression and gesture. They opted instead for externals, such as personifications of abstract ideas, which could be 'read' like a text. It was even decreed how these should be painted. Liberality, according to one expert, should be a woman with rather prominent eyes and square brow, like the lion, the most liberal of all beasts, and with aquiline nose, since the eagle is the most liberal of birds! All too often these personifications intrude. Vasari's *Creation*

of Cardinals is a straightforward picture of Pope Paul III bestowing
the red hat on new members of the sacred college, but in the fore-
ground lies prostrate a large nude female, devouring vipers, bursting
with venom, and writhing in the throes of death. This, one feels, is
not the most economical and therefore not the happiest way of
indicating the extinction of Envy.

Where did these hulking abstractions come from? The answer is
from books. Vasari's contemporaries, having exhausted the possi-
bilities of actual works of classical art, turned to the theory behind
them, and since this was scanty, to the rhetoricians, whose rules for
oratory they applied to painting, justifying themselves with Horace's
tag: *ut pictura poesis*. They found in the second book of Quintilian's
Art of Oratory this passage: 'A similar impression of grace and charm
is produced by rhetorical figures, whether figures of thought or
figures of speech, for they involve a certain departure from the
straight line and have the merit of variation from ordinary usage.'
This fateful passage was used to fertilize lingering medieval concepts
and so gave birth to Envy, Liberality, Modesty and a hundred other
figures of thought that crowd the canvases of late sixteenth-century
painting.

Roman rhetoricians also placed high value on the arrangement of
complicated material. Cicero and Quintilian defined invention not
as creative imagination, but as arrangement or *ornatus dictionis*.
Vasari's contemporaries inherited this view, and also its literary tinge.
Vasari, for instance, praises Raphael's invention because it gives his
scenes 'the narrative flow of a written story'. Such is the origin of
those sixteenth-century battle-scenes, even more crowded than
Uccello's, where horsemen by the hundred seem to be fighting less
with each other than for a place on the canvas.

In an influential dialogue on painting entitled *L'Aretino*, published
in 1557, Lodovico Dolce applied to art Castiglione's theory that
grace arises from negligence or careless ease. He claimed that
Raphael, like Apelles, was a master of grace and softness, that these
qualities were superior to Michelangelo's design and *terribilità*, and
that they went hand in hand with facility. 'Facility is the principal
evidence of excellence in any art, and the most difficult to attain.'
Despite his esteem for Michelangelo, Vasari agreed. 'Nowadays,' he

says, 'a painter who understands design, invention and colouring can execute six paintings in a year, whereas the earliest artists took six years to finish one painting—I can vouch for this both from observation and personal experience.' Indeed he could. He once boasted to Michelangelo that he and two assistants had painted mural frescoes for the vast salon of the Cancelleria—25 yards long—in the brief space of a hundred days, whereupon the master retorted: 'It looks like it.'

Facility fostered triviality. Florentine artists spent months making arches, cars, costumes and backcloths for festive processions: little better than pedantic exercises in narcissism. During the 1520's a company of twelve Florentines known as 'The Cauldron' met for a banquet to which each had to bring an 'inventive' dish. On one occasion Rustici brought a pastry representing the cauldron into which Ulysses plunged his father in order to regenerate him, while Andrea del Sarto contributed an octagonal temple mounted on porphyry columns: the base of gelatine, the columns sausages, the capitals Parmesan cheese, the cornice icing sugar, the apse pieces of marzipan.

It is almost a law of human nature that pretensions increase in inverse proportion to actual achievement. So now in the sphere of art. One meaning of *virtù* in Dante's day had been moral goodness, in the *quattrocento* it could mean civic virtue, but in the middle of the sixteenth century artists began to apply the word to themselves: they were the virtuous ones, *virtuosi*. One of the first uses of the word in this sense occurs in Cellini's *Autobiography*. Cellini, who was then the Pope's goldsmith, asked Clement VII for the post of *piombatore*, worth 800 crowns annually, to which the Pope said: 'You'd spend all day scratching your belly, lose all your marvellous skill, and get me blamed for it.' Cellini replied that the purest-bred cats make better mousers when they are fat than when they are starving, added poutingly that anyway he never expected to get the post, and ended like this: 'Since your Holiness does not want to let me have it, you would be well advised to give it to some deserving artist [*virtuoso*], and not to an ignoramus who would only scratch his belly, as your Holiness said.'

A passage in Cellini's *Art of the Goldsmith* clarifies the new meaning

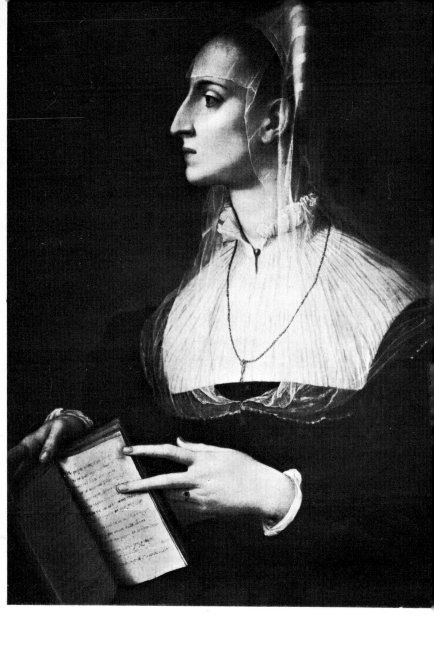

Laura Battiferri, holding a copy of Petrarch's poems. Bronzino has admirably caught the character of the poetess who is said to have had 'a soul of steel in a body of ice'

Later Florentine sculpture. *Dawn*, one of Michelangelo's statues in the Medici Chapel. Below, two works showing Michelangelo's influence: *Perseus*, by Benvenuto Cellini, and *Apollo*, by Giovanni Bologna

Joseph in Egypt. In a revolutionary departure from usual practice, Pontormo depicts on a single panel four episodes, each with different spatial values and perspective

Two views of Justice. For Julius II's private apartment Raphael depicted Justice simply, with sword and scales. Thirty-five years later, for the papal chancellery, Vasari attempted a more complex and literary rendering. Justice, with seven vices chained to her belt, is offered two doves, symbolizing innocence, by naked Truth, and crowns Truth with a wreath of oak-leaves symbolizing strength of mind

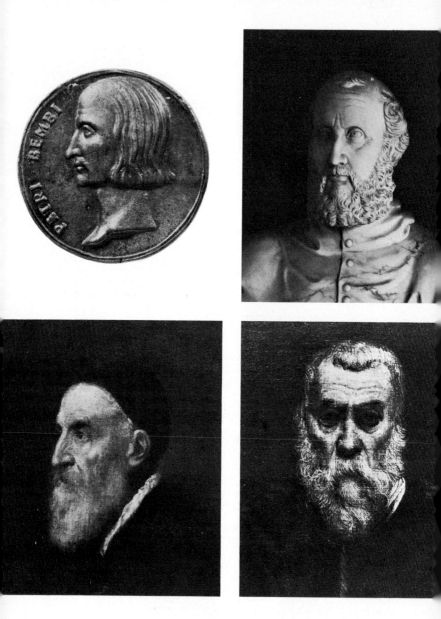

Four Venetians. Pietro Bembo, theorist of Platonic love and arbiter of literary taste; Gaspare Contarini, who worked for an understanding with Lutherans; Titian, who portrayed the great men of his age; and Tintoretto, the leading painter of religious subjects

The Campidoglio, Rome. As it was about 1540, and after Michelangelo's designs for the piazza and its three palaces had, with modifications, been carried out

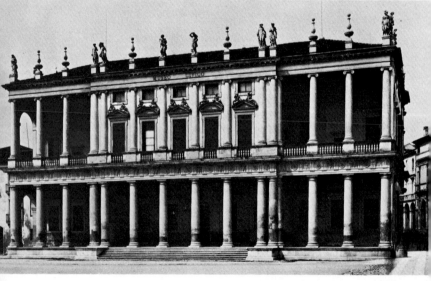

Classical-style buildings rose in the cities of the Venetian Republic. Sansovino's richly decorated library and loggetta in Venice and, below, Palladio's more austere Palazzo Chiericati in Vicenza, now a museum

of *virtù*. Speaking of one who patronized sculptors and goldsmiths, Cellini writes: '*Questo gentiluomo amava sopra modo e favoriva gli uomini virtuosi; tanto esso era amatore delle virtù*—This gentleman was extremely fond of men with artistic skill and advanced their careers, to such a degree did he love the fine arts.' *Virtù* in the plural is used by Ariosto to designate the fine arts or the liberal arts, and Pontormo, replying to Benedetto Varchi's questionnaire whether sculpture or painting is greater, employs *virtù* to designate an artist's technical prowess. It was this latter meaning that became current, and has survived until today in our word 'virtuoso'.

In the general degradation of *virtù* it is pleasing to find that one great artist had no part: indeed, instead of emptying the word of its true content, he replenished it. This was Michelangelo. The great Florentine had always followed an original course and continued to do so even into extreme old age. It is time now to consider certain of his later works of painting and sculpture, then by way of conclusion his architecture.

When he left Florence and returned to Rome in 1534, Michelangelo found the old stability gone. As a result of the Sack and Lutheranism, many Romans were tormented by doubts and guilt, while during that decade a number of holy men, notably the Florentine, Filippo Neri, and the Basque, Ignatius of Loyola, came to the city in order to labour for its spiritual rebirth. Michelangelo, sensitive as always to atmosphere, responded to the new seriousness and at the age of sixty or thereabouts underwent a religious conversion. He seems to have realized the inadequacy of *virtù* in the classical sense and reverted to Dante's conception of it as goodness made possible by God's grace. Save for the bust of Brutus, which is a political document, Michelangelo produced no secular works after 1534. He concerned himself with the age-old Christian drama of sin, justice and mercy. His own life became more austere. Formerly he had enjoyed a *fiasco* of wine in the evening but at the time of his death no wine was found in his cellar, only five jars of water and a small cask of vinegar. In his sonnets he deplored his earlier interest in the 'fables of the world' and sought refuge in Christ. For a medal which Leone Leoni made for him in his old age he himself chose

the reverse subject: a blind man with staff and water-flask, led by a dog, evidently symbolizing faith, while the legend comes from Psalm 51: 'I will teach the unrighteous your ways and the impious will be converted to you.'

It was Clement VII who first thought of asking Michelangelo to paint anew the wall behind the altar of the Sistine Chapel. Sixtus IV, a devotee of the Virgin Mary, had commissioned an *Assumption* from Perugino, but this no longer fitted in with the programme or style of the Chapel. A report by Agnello, dated Venice, 2 March 1534, states: '*Del Nino* [probably Rodrigo Nino, Imperial Ambassador in Venice] *alli* 20 [febr.]: *Chel Papa ha tanto operato che ha disposto Michelangnolo a dipinger in la capella et che sopra l'altare si farà la ressurrectione, si che gia si era fatto il tavolato.*' The subject Clement envisaged was probably the Resurrection of Christ. This was a favourite with Florentines, who saw in it a promise of their own resurrection with glorified bodies, and evidently a special favourite with Clement, for it is one of the scenes he required Cellini to fashion for a gold chalice. Clement, however, died in September 1534 and was succeeded by a Roman nobleman, Alessandro Farnese, who took the title of Paul III. As a cardinal, Farnese had kept a mistress and by her had three sons and a daughter, but in 1513 —one of the few good results of the Lateran Council's call for reform of the sacred college—he underwent a conversion, and in 1519 even had himself ordained priest. Though he kept a splendid court, the new Pope was a religious man and deeply concerned to promote reform. If Clement's choice was indeed the Resurrection of Christ, Paul III changed it to a Last Judgment. In the context both of the Chapel and of sixteenth-century art generally, this subject was a step backwards, not unlike those majestic, remote and awe-inspiring figures of Christ and the Virgin thrown up in Florence and Siena after the panic of the Black Death. Michelangelo's first sketch shows that he even thought of following Giotto's grouping of the Heavenly Tribunal almost in a semi-circle. But later he rejected this for a composition that has no precedent at all in art, and only a faint literary precedent in the flight of Dante and Beatrice from sphere to sphere in Paradise.

Under his Cross and the instruments of his Passion stands the

physically powerful figure of Christ. His mood is evidently that of a judge, since his mother has renounced her intercessory role and cowers, hooded, at his side. The S-shaped gesture of his arms both repels and exalts as, in an endless, unframed space, he winnows mankind, the wheat from the chaff. On the right the damned fall while the blessed rise on the left; beneath, Charon ferries lost souls across the Styx. The apocalyptic grimness is heightened by a colour scheme of brown and orange. In the recent past there had been fearful *Last Judgments*—Signorelli's in Orvieto, for example—but never before had Christ been depicted as a figure of such awesome power, dispensing punishment or salvation, in comparison with whom man, for all his strength and beauty, is a mere nothing. If the ceiling carried too far the celebration of man's angelic powers, the balance is here certainly righted.

In 1543, the year after he finished the *Last Judgment*, Michelangelo was commissioned by Paul III to paint two frescoes for his new private chapel in the Vatican. The subjects again reflect the new religious mood, the first being the *Conversion of St Paul*, evidently an allusion to Pope Paul's own conversion in 1513. Raphael had depicted this in one of his Sistine tapestries. Michelangelo studied the tapestry, borrowing from it the runaway horse, and a comparison between the two works is revealing. Raphael shows the figure of God, supported by cherubs, moving in a gentle diagonal line towards the prostrate figure of Paul, while onlookers gaze in surprise; Michelangelo on the other hand shows God striking vertically downwards like a thunderbolt, imparting not surprise but terror, while the cherubs have been replaced by a heavenly host, some joining their hands in suppliant prayer.

The other subject chosen for the Pauline Chapel was the *Crucifixion of St Peter*. Traditionally part of the Petrine cycle, it had been dropped in the carefree days before Luther and omitted by Raphael, but after the Sack it had begun to reappear, for example in Cellini's chalice for Clement VII. Michelangelo abandons the usual vertical composition, wherein the cross is shown upright. He places the cross aslant, in the act of being raised, so that Peter's head becomes the fulcrum for a turning movement. On this account and because his muscular body is the only one unclothed, it is Peter who dominates

the scene. The paradox of the victim triumphing is pointed still further by Peter's expression: not the traditional meek passivity, but a proud and angry defiance.

The note of suffering evident in all these frescoes was sustained in Michelangelo's last works of sculpture. About 1547 he obtained a huge block of marble which, in the fourth century, had been carved into a capital for the Basilica of Maxentius, and from this he began to make a *Deposition*. Following a Flemish custom, he decided to portray himself as Nicodemus. Since the work was not commissioned, he did not hurry, but in the middle of the night when the mood took him would rise and chip away at the marble, 'wearing a hat made of thick paper with a wax candle burning over the middle of his head so that he could see what he was doing and have his hands free'. He found the marble recalcitrant and full of emery, so that his chisel often struck sparks from it. Then one night an unlucky blow cracked the arm of the Virgin, and since he detested anything less than perfect Michelangelo gave the statue to his servant. Now in Florence Cathedral and known as the Florentine *Pietà*, though in fact it is a *Deposition*, it shows the figure of Nicodemus, cowled and grieving, supporting the broken, almost jagged body of Christ, while on either side his Mother and one of the Marys try vainly to hold it off the ground. The statue invites comparison with the *Pietà* in St Peter's, finished half a century before. Whereas the earlier work softens suffering into a serene beauty, here Michelangelo insists on the wrenching of death, and through the person of Nicodemus directly involves the viewer in pain, loss and abandonment. Most of his young contemporaries would even now have preferred to work in the style of the St Peter's *Pietà*, and if Michelangelo rejected such agreeable elegance it was not just stylistic experiment, but rather the visible sign of his deepening religious sympathy.

Meanwhile Michelangelo had also been active as an architect. For the Laurentian Library in Florence he designed a remarkable entrance vestibule which was built between 1555 and 1559. The dialogue which takes place in Michelangelo's statues between closed and open forms is here transferred to the white walls and the dark grey-green of columns, sinuous brackets and blind portals,

and from this dialogue, like a river from a mountain gorge, emerges the staircase. It begins as a single flight, then, as it slowly falls, widens to three, divided by balustrades, the treads on the outer flights being straight-edged, those on the inner one curved: water falling and foam swelling forward. Of all Michelangelo's works this is perhaps most representative of his age, and of the pleasure men took in tension and movement.

Stairways also play an important part in Michelangelo's reorganization of the Capitoline Hill. Here the Kings of Rome had chosen to erect the first great temple of Rome, in honour of Jupiter, and had summoned Etruscans, including the famous Vulca, to help in its construction and adornment. It was fitting then that two thousand years later in 1536 Paul III should have invited a Florentine to redesign the Hill for the triumphant entry of the Emperor Charles V. Michelangelo found a bleak, irregular plateau and a single building, the medieval towered Senators' Palace. He began by turning the main alignment of the Hill through a full half circle, so as to face the new city growing up around St Peter's. He masked the rough stonework of the Senators' Palace with giant pilasters running through two whole storeys—an important innovation—and with a double flight of steps, then formed a piazza by designing two smaller palaces almost at right angles to the new façade. The fourth side he left open, to be approached from the foot of the hill by a gentle inclined ramp of steps. In the centre of the piazza he placed the equestrian statue of Marcus Aurelius in such a way that the dutiful Stoic Emperor should welcome with hand outstretched his no less dutiful successor Charles. Thus with drama and decorum the millennia were bridged. Although the piazza was finally completed only in 1655, Michelangelo's designs were respected, and the piazza is in all essentials his.

Michelangelo's other great work in Rome is St Peter's, which owes more to him than to any other architect. In 1539, at the request of Paul III, Antonio da Sangallo had made a new, fussy model for the basilica, and when seven years later Sangallo died the same Pope asked Michelangelo to become architect. He was then aged seventy-one and still looked on himself as a sculptor; only a strong sense of religious duty made him accept. He was to hold the post to his death

and declined all payment. But he did insist on a completely free hand and this was granted both by Paul III and his successors. Thereupon he transformed Sangallo's plan, removing its fussy additions and ambulatories, and reducing the basilica to an even more simple form than Bramante had envisaged, while slightly extending the eastern end. He then succeeded in getting the Board of Overseers, all Sangallo's men, to change their course, demolish the south transept, and rebuild according to his own ideas. He reinforced Bramante's four main piers that were to bear the weight of the dome, and even installed two spiral stairways, up which donkeys could carry mortar and brick to the topmost level of the arches. On the outside walls, between coupled pilasters, he hollowed out niches, treating them for the first time not as superimposed mural decorations but as regions of repose in the dramatic flow of the exterior.

Bramante's flat dome, modelled on that of the Pantheon, Michelangelo discarded. A Florentine to the end, he wished to crown St Peter's, as Brunelleschi had crowned S. Maria del Fiore, with a high dome visible to all. His first plans were directly modelled on Brunelleschi's. He designed a structure in two shells, strengthened by external ribs—the number of which he doubled to sixteen—and he even retained the bull's-eye windows in the drum, though these were to disappear from his final version, to be replaced by windows between paired columns, crowned by garlands. When, thirty years after Michelangelo's death, the dome came to be built, the one major alteration in Michelangelo's plans was to render it even more visible by raising the height fifteen feet.

Towering 400 feet into the Roman sky, Michelangelo's dome triumphantly completed the new basilica which had been the occasion of so much strife. It ended on a confident soaring note his own often tormented life, and his almost sixty years' association with the Popes, for it was on the night before Julius II laid the corner-stone of the new St Peter's that Michelangelo had first fled from Rome in an agony of frustration. In its sophisticated use of classical motifs it sums up the mood of sixteenth-century art much as its simpler sister in Florence does that of the previous century.

Michelangelo stands alone among sixteenth-century Italian artists by virtue of his religious feeling. He was ready to admit past failings

and so grew into a more profound awareness of Christian truths. But he was the exception. His friends and contemporaries no longer found inspiration in religion. True, they painted and carved plenty of religious works, but in a cold and perfunctory manner. Their hearts were not in it. Their Apollos possess a fire and conviction lacking in their Christs. This fact is ominous. For if artists as a whole cannot rise to a challenge, it is unlikely that less sensitive men will make a better response.

If generalizations are to be made about the art of this period, it can be said faithfully to reflect the turmoil of the age and the somewhat affected values of the courts. It often attains an elegant beauty, but even oftener slips into obliqueness, or attitudinizes, or takes flight into the realm of literature. It achieves great perfection of form, but only at the cost of shirking the main issues. It prefers personifications to persons, virtuosity to virtue. There is less soul in the artists' vision and in their subjects than there was at the beginning of the *cinquecento*. There is a steady decline from the classical principles of regularity, economy and concentrated strength. However, that is only one side of the picture. There is a whole aspect of Italian art that remains to be considered: the Venetian school. Independent Venice may be found to produce what was lacking in the rest of Italy.

The Venetian Republic

THE EXCEPTIONAL brilliance of the Italian Renaissance lies partly in the fact that Italy was polyhedral. The number and variety of Italy's city-states made for scintillation and also for continuity. To change the metaphor, like singers in a polyphonic composition, each state had its own distinctive note to add to the whole, and as one voice slackened or fell silent so another struck up. In the sixteenth century the strongest voice, and the one that soared highest, was that of Venice. The reason is that Venice was the only secular state of importance to come through the foreign invasions with her full independence, and it was there that many of the best Italians gravitated, whether an architect such as Sansovino of Florence, or the holy Theatines, who established themselves in Venice after the Sack. The Olympic flame which Florence had lit in the *quattrocento* and then handed to Rome was now carried by Venice.

The first trustworthy date in Venetian history is A.D. 421, when fishermen dwelling on the lagoon in wattle huts 'like sea-birds' nests' dedicated a church to S. Giacomo; but it was only in 811 that sailors and traders from near-by Malamocco settled in force on the lagoon islands in order to repel Pepin of the Franks. Their town grew to be the most active commercial port in the Mediterranean, exporting German silver, copper and gold to Asia Minor and North Africa, bringing back spices and Oriental luxuries. She expanded overseas, down the Dalmatian coast into Greece, Crete and Cyprus. To her maritime empire she added in the fifteenth century another on the mainland: Padua, Vicenza, Verona, Udine, Brescia and Bergamo. This territory, a considerable part of north Italy, comprised the Venetian Republic, and was administered from Venice,

which in 1500 was the world's greatest commercial city, with a population of 100,000 and an annual revenue of one million ducats, three times that of Florence.

The city was a triumph of technical skill in that it was built on 117 small islands in the middle of a lagoon and many of its brick and white Istrian stone houses rested on piles driven into the grey mud. It needed and possessed no circuit of fortified wall, since enemy ships could never negotiate the lagoon's complicated shallows, nor had it any of the medieval towers that loomed over such a city as Bologna. Here all was open and smiling: the red stone of the Doges' palace inlaid with marble, palazzi with big pointed windows, St Mark's with mosaics even on the outside.

Technical skill was the stamp also of Venetian manufactures. First of these were the big oak-hulled galleys, powered by 180 oars, that carried spices, bullion and so on up and down the Mediterranean. Then there was woollen cloth, a new and rapidly growing industry in the sixteenth century: from 1512 to 1602 production multiplied twenty-two times. Other industries included leather, rope and cordage, embroidery and lace, and goldwork and jewellery of exceptional richness: in 1532 Soleiman II bought a Venetian helmet of gold enriched with gems for the huge sum of 100,000 ducats. But nowhere was Venetian skill so evident as in her crystal. On the island of Murano artisans who were also artists blew great glass bubbles, then with spatula and pincers, but without mould or model, wrought the glowing mass into light and graceful cups, bowls, candelabra, vases, chalices and flowers which took a ruby, emerald or opal tint as the glass cooled.

Every Ascension Day the Doge, in cloth of gold, was rowed out on the State barge to the Adriatic, where he dropped a gold ring into the water with the words, 'We wed you, O sea, as a sign of perpetual domination.' This prompted du Bellay in 1538 to remark, 'Maybe, but you have been cuckolded by the Turk.' The Turk had indeed seized many of Venice's Mediterranean possessions, but Venetian trade remained intact long after the fall of Constantinople in 1453, of Beirut in 1516 and of Alexandria in 1517, long after Vasco da Gama had landed in Calicut and, incidentally, found even there the Venetian ducat. By the 1560's Venice's spice trade was earning

bigger profits than ever. Until about 1580 the sixteenth century was not a period of decline but the height of her prosperity.

This prosperity was based on naval strength, the secret of which lay in Venice's Arsenal. The largest industrial plant of the age, it covered sixty acres of ground and water, and employed up to 2000 workmen, who were served free wine five times daily. A Spanish observer describes their advanced methods: 'Out came a galley towed by a boat, and from the windows they handed to the occupants, from one the cordage, from another the bread, from another the arms, and from another the balistas and mortars, and so from all sides everything that was required, and when the galley had reached the end of the street all the men required were on board, with the complement of oars, and she was equipped from end to end.' In six hours the Arsenal could fit out no less than ten war-galleys.

In origin and still largely in practice the Venetians were men of the sea, and their virtues those of the seafarer. They were hardy and venturesome, and not above swapping tall yarns. But since their livelihood came from trade they were also precise and pragmatic. They worked well as a team—much better than the Florentines—and the State ventures which usually failed on the Arno succeeded on the Adriatic. They had a deep respect for law and justice, and every commercial move was covered by minute regulations. The men dressed in a long mantle, usually black, and moved with grave dignity: a Milanese visitor in 1498 remarked that they all looked like Doctors of Law. Senators wore a long black or azure robe, the wide sleeves fastened at the wrist with strings in wet or cold weather, and a cap of black or red velvet. Their way of talking revealed the proximity of Germany in certain Teutonic inflections and the age-old link with Asia Minor in a number of Greek and even Arabic words, such as arsenal. They tended to replace g with z and to omit the last syllable in proper nouns—Shakespeare's Iago is really Iacopo.

The Venetians had evolved a remarkable constitution, whose stability was envied by many and actually imitated, though unsuccessfully, by Florence in 1494. The Venetians ran their city like a ship in the sense that there was an unbridgeable gap between officers and crew, the officers being a hereditary patriciate of some

2500 men, all of legitimate birth and most with a high sense of responsibility. The patricians discussed policy and voted in the Great Council; they captained galleys and held magistracies throughout the Republic; they provided members for a Senate of 220 and a Council of Ten. In the uncertain period following Venice's mainland conquests the Council of Ten had been detested for its rigorous methods, but in the *cinquecento*, when Venice felt more secure, these methods were much relaxed. The doge, who in the Middle Ages had been a monarch, was now little more than a personification of the Most Serene City; he was elected for life—usually a long one, for he had few worries—and all dispatches went out in his name, but his servants were forbidden to carry arms, and in winter he had to send every member of the Great Council a gift of five wild duck.

The Venetians were good Catholics, but they kept Church and State quite separate. Spices and souls were never allowed to mix, as they did, say, in Portugal. A strict watch was kept on money going to Rome, and in March 1515 the Senate forbade the publication of the St Peter's indulgence within its territories. A patrician, if he entered the Church, had to renounce both his property and his hereditary privileges, while it was the Senate and clergy who elected bishops by a plurality of votes. In appointing parish clergy, Venetians followed a remarkably liberal policy: as in the early Church, priests were chosen by the parishioners themselves, though their choice had to be ratified by the patriarch of Venice. The laity in fact were accorded a status they enjoyed nowhere else in Italy, and this was expressed by the brilliant Venetian theologian Paolo Sarpi: 'I take the word Church to signify an assembly of the faithful, not of priests only.'

The Venetians showed a similar large-mindedness to foreigners, and encouraged large colonies of artisans or traders to settle in the city: Jews, Armenians, Greeks, Swiss, Germans and many other ethnic groups, including Negroes who came as slaves: Carpaccio depicts Negro gondoliers, and Danese Cattaneo in the middle of the sixteenth century was to cast the first known statue of a Negress. As long as they did not contravene the laws, these foreigners were free to do their jobs and practise their religion without fear of molestation. Venetian tolerance was based on commercial self-interest—as

Shakespeare's Antonio puts it: 'The trade and profit of this city Consisteth of all nations'—and is quite different from the ideological tolerance evolved in Florence by Ficino and Pico, but for that reason perhaps it possessed longer life and was better able to make itself felt in the council chambers of Italy. Liberty meant to the Venetians not freedom to rise to the highest magistracies, but freedom from the invading foreigners, freedom—save in strictly Church matters—from papal interference, and, as a consequence of both, freedom of thought and expression. It was Venice's greatest achievement, during her opulent sixteenth century, to keep liberty in this sense alive in Italy.

In Venice the revival of learning occurred later than in Florence or Rome, and took a different form. Having no roots in the classical past, Venice felt no urgent call to study classical history as an aid to establishing her own identity and, possessed of a stable constitution, felt no call either to hero-worship Cicero as a defender of the republic against potential tyrants. On the other hand Venetians felt a natural curiosity about Cicero the orator, and about oratory and diplomacy in general, for these were useful in preserving their vital trade-routes. Facing east in more senses than one, they felt a keen sympathy for those other seafarers, the Greeks, and conceived an admiration for the literature of Athens. The classical revival in Venice was predominantly Greek and, as in Florence, it lay largely in the hands of amateurs: hence closely related to the interests and needs of daily life.

Now the central strand in Venetian life, as we have seen, was liberty, and the classical revival can best be studied in terms of four important figures, each expressing a particular aspect of liberty. First there is Aldus Manutius, who typifies Venetian freedom of the press; second Sperone Speroni, a characteristic Venetian humanist in that he thought for himself; third, the poetess Gaspara Stampa, who expressed without inhibition the sensuous, passionate element in the Venetian character; and lastly, Pietro Aretino, an outspoken champion of political and intellectual freedom.

Teobaldo Manuzio, better known as Aldus Manutius, was born of Roman parents in 1450 and educated in Rome and Ferrara. From 1482 to 1484 he stayed in Mirandola as a guest of Giovanni Pico,

and there became friendly with a Cretan scholar named Emmanuel Adramyttenos. The fall of Constantinople had set up a wave of sympathy for Greeks, and very soon Aldus had become a fervent Philhellene. In 1485 he was appointed tutor to Pico's nephew, the young Prince of Carpi, who five years later put up money for a publishing business, the aim being that preached by Poliziano: to build on the basis of Greek texts a new encyclopaedic humanism.

Venice was already the publishing centre of Italy. In the last decade of the fifteenth century the city counted no less than 200 printers, who issued a total of 1491 works, compared with Rome's 460, Milan's 228 and Florence's 179. Moreover, she possessed a large colony of Greek-speaking Cretans, that island having been purchased by Venice after the Fourth Crusade. So conditions were favourable for Aldus. He set up his press in 1494, published his first dated book in 1495, and the following year his first Latin book, Bembo's dialogue on the ascent of a volcano, *De Aetna*. In 1498 he contracted the plague, vowed, if he recovered, to become a priest, did recover, and was released from his vow by Pope Alexander VI, so that in 1499 he was free to marry Maria, daughter of Andrea Torresano, a respected printer. Maria's dowry amounted to 460 ducats, and she bore her husband three sons and one daughter.

Before he could realize his ambition of publishing classical texts, Aldus first had to track down manuscripts, no easy task since many were being destroyed or lost in the wars of the day. He did this either personally or through friends, sometimes as far afield as Poland or England, which yielded a fifth-century codex of the Spanish Christian poet Prudentius. Aldus then collated the manuscripts in order to arrive at an accurate text. Meanwhile, he had to procure ink that would resist sunlight, and the finest white Fabriano paper, which would take without blotting the handwritten notes readers liked to add in the margins. Dissatisfied with existing typefaces, Aldus invented one of his own, the Aldine or italic, based on Petrarch's handwriting: he boasted that a book set up in Aldine was barely distinguishable from one written by a scribe's quill. He also designed Greek characters, and had them cut by goldsmiths in a mixture of tin and lead. Last, Aldus had to train members of the Cretan colony as compositors and proof-readers for the Greek

books. One understands why he posted a notice on his office door: 'Whoever you may be, if you wish to speak to Aldus, keep it short and then leave him to his labours, unless you wish to shoulder part of the burden, as Hercules did for exhausted Atlas. Be sure that whoever puts a foot in here will find work.'

Aldus was fond of repeating Cato's remark that a man's life is like iron: use it constantly and it gleams, stop using it and it rusts. Yet he lived and died a poor man. The expenses of the printing works were 200 ducats a month, and every day thirty-three sat down to meals. This has to be remembered when reading Erasmus's account of a stay in Aldus's house. The house, says Erasmus, was draughty in winter, and in summer so full of fleas and bed-bugs that sleep was impossible. Aldus watered the wine, bought mouldy flour for baking, often giving his employees little but lettuce, and his guests thin soup, cow's beef, bean-flour and cheese hard as a paving stone.

Parsimonious Aldus may have been, but clearly he was liked and respected, otherwise he would never have been able to form the Aldine Academy. This body, created in 1500, met once a week to discuss, in Greek, literary questions, texts which deserved publication, and the choice of readings. Its members included several Venetian senators, also Girolamo Aleandro, Pietro Bembo and a Cretan scholar, Marcus Musurus, a former protégé of Lorenzo de' Medici and almost as hard-working as Aldus—according to Giovio, he took only four days' holiday a year.

Helped by the Academy, Aldus issued a number of important Greek editions, including an Aristotle in five folio volumes. One day a friend complained of the unwieldy format and high price of these fine books. Aldus then decided to launch a series of classics, Greek, Latin and Italian in size small octavo, which would make them suitable both for the pocket and for the pocket book. This marks the beginning of the modern book and modern publishing methods. The first to appear, in April 1501, was a Virgil, in an edition of one thousand copies. Soon it was followed by many other masterpieces, Bembo making himself responsible for the text of Dante's *Comedy* and *Terze Rime*, Musurus for Pindar. When Aldus started business, only four Greek authors had appeared in print in Italy; by the end of his life—1515—he had published either as Aldine

classics or in a larger format first editions of more than twenty, including Aristophanes, Aristotle, Herodotus, Pindar, Plato, Sophocles and Thucydides.

From 1502 Aldus printed on his books a device which he borrowed from medals of the Emperors Titus and Domitian, showing a dolphin twisting round an anchor. He meant it to symbolize speed and constancy, and he often added the motto, *Festina Lente*, a favourite adage of Augustus. In the imprint he sometimes referred to himself as Aldus, Roman and Philhellene. He considered the books he published as in some sense his own, justifiably so, since he had often rescued them from the βιβλιοτάφοι, connoisseurs who buried manuscripts in their libraries, one of Aldus's favourite terms of abuse. So he felt free to dedicate them, to write introductions, and on occasion to include an elegant blurb in Greek verse. In his preface to Proclus's *Sphere*, which Linacre had translated for him into Latin, Aldus wrote warmly of England which, he said, by furthering classical studies, was now repairing the damage she had done with Ockhamism. At the end of his edition of Martial Aldus added an angry warning to the Lyons printers who were the bane of his life: 'If you pirate this book, damnation take you.'

Aldus may be said to have completed in Venice the work begun exactly a century earlier in Florence by Poggio Bracciolini and Niccolò Niccoli. He produced books that were as accurate as the available texts allowed and also a joy to the eye. His classics have the simple, crisp neatness of a well-starched lace ruff, and they were prized as works of art by princes of the day. Aldus also produced one decorated book of conspicuous beauty, Francesco Colonna's *Il Sogno di Polifilo (The Dream of Poliphilo)*. This allegorical novel, which is part love story, part description of the festivals, monuments and customs of antiquity, he illustrated with woodcuts, fine in line, to match the light lines of the roman letters. The type is clear, open without being too round, bold but not black and disposed with generous margins.

After Aldus's death, the printing business was continued by his youngest son, Paolo, who preserved the firm's high standards. But the main work, the transmission of the classics of Greece, had already been done.

These texts exerted enormous influence on every aspect of Venetian life. Particularly important is the fact that in Padua, the university of the Venetian Republic, Aristotle came to be studied in the original Greek, with the help of Greek commentators, notably Alexander of Aphrodisias. It then became quite clear that Aristotle had taught that the soul dies with the body. Pomponazzi, Professor of Philosophy in Padua, expounded Aristotle in this sense and added that immortality cannot be proved but has to be taken on faith. His views were condemned by the Lateran Council, and Pomponazzi in despair starved himself to death. Instead of turning wholeheartedly to Plato, as the Florentines had done, the leading Venetian and Paduan thinkers set increasingly high store by Aristotle, who appealed to their strong medical and empirical traditions, while in the matter of immortality they fell back on St Thomas Aquinas, who now came into vogue in northern Italy.

Pomponazzi's successor was in many ways a typical thinker of the Venetian Republic. The second son of Bernardino Speroni, Leo X's physician, and Lucia Contarini, a Venetian noblewoman, Sperone Speroni was born in 1500. He was a quick, eager person, easily roused either to sympathy or anger. After taking doctorates in both medicine and philosophy, he taught philosophy in Padua until 1528, when he resigned in order to take charge of family affairs. From 1532 to 1548 he held high office in Padua. He married an heiress, Orsolina Stra, but the union proved unhappy and he transferred his affections to his daughter Giulia. For Giulia, the apple of his eye, and for his two other daughters, as well as for nieces and granddaughters, he took a great deal of trouble arranging happy marriages. Speroni led a sober life, his evening meal consisting of honey, lettuce and a dessert. Sobriety had become almost a Venetian cult since 1558 when the patrician Luigi Cornaro wrote his *Della vita sobria*, a charming book in which the author praises old age as the period when we can still enjoy the simple pleasures of this world, yet look forward to the imminent pleasures of the next. Sobriety helped Cornaro to attain the age of ninety, and Speroni the age of eighty-eight, by which time he was known as the Paduan Nestor. Speroni was a good Christian, though his outspoken criticism of superstitious practices bothered many. Pius IV, who created him a knight, once said to him

in Rome, 'The rumour here is that you believe in very little.' 'Then I'm making progress,' Speroni replied. 'In Padua I'm said to believe in nothing at all.'

Speroni was a brilliant orator. Following the Venetian Pietro Bembo, he based his Italian style on the classics. 'My one aim has been and always will be to squeeze the milk of fluency—*facondia*—from the Greek and Latin languages,' and his handbook was Aristotle's *Rhetoric*. The mixture evidently proved heady, for when he pleaded in Venice all business came to a standstill. It is interesting that one of the causes for which Speroni spoke—unsuccessfully—was the preservation of Petrarch's house near Padua cathedral, which the canons wished to demolish.

Speroni was a humanist in the sense that he valued practical rather than speculative knowledge. He treated Aristotle not as a supreme authority but as one ancient philosopher among many, his views subject to correction by personal experience. Following Pico, he considered man the centre of the universe, but whereas the Florentine saw him as a harmonious whole soaring heavenwards, Speroni, writing so to speak next door to the university dissecting theatre, was much more aware of his dual nature: 'Mankind is composed of body and soul, just as the Christian is a composite of human nature and grace, and Jesus Christ of Divinity and humanity.' Following Aristotle, he says that man's aim in life is the habitual practice of virtue, but he can achieve this only because God 'courteously supplements the defect in his nature and understanding'.

Speroni wrote prolifically, often in dialogue form, on such subjects as Fortune, Duelling, Dante, Women—whom of course he praised—Painting and Reform of the Calendar. Two long dialogues on History he composed at the age of eighty-six. He wrote a lot of perceptive literary criticism and castigated the *Aeneid* for lack of invention. He also wrote a tragedy entitled *Canace*, about incest between brother and sister, and spent the rest of his life defending such a bold theme.

Speroni's essay 'In Praise of Printing' was clearly inspired by the work of Aldus and is one of the earliest salvoes in the Battle of Ancients and Moderns. Speroni claims that in food, dress, ornaments and means of transport we are the equal of the ancients. In

building, the arts and literature we are behind, not because our intelligence is inferior, but because the Greeks and Romans were richer and spent more on building and works of art. The key to civilization, Speroni suggests, is wealth and a sound system of patronage. In navigation we are well ahead of the ancients, as in hunting and shooting. But our most striking success is the printed book. Like human thoughts, like an angel in fact, one book can be in many different places at the same time. Some say that a manuscript is more beautiful than a printed book, but if we are to be just we should compare the manuscript not with one but with a thousand books, since these can be run off in the time it takes to copy a manuscript. One good result of printing is that young men no longer have to join a religious community in order to gain access to books.

Speroni may be said to have taken a balanced, moderately optimistic view of man. He admired the ancients, but not uncritically: such Delphic utterances as 'Nothing in excess' and 'Know yourself' he claimed were sophistries that did more harm than good. His approach to problems was piecemeal and cautious, not speculative and bold, like the Florentines'. He knew Luther's opinions and judged them for himself. He accepted that grace is necessary for the good life but, with his Aristotelian training, stood by the notions of good works and merit. This attitude, typical of his age and milieu, was to play its part at the Council of Trent.

In the field of literature no less than of philosophy the Greek classics exerted an important influence on Venetians. Musurus's edition of Pindar made the Pindaric ode popular with poets of the vernacular, while the odes of Sappho, counteracting the languorous influence of the Petrarchan school, helped one Venetian poet at least to give voice to an authentic passion.

Gaspara Stampa was born about 1525 in modest circumstances. Her father, a jeweller, died when Gaspara was a child, and then the family moved from Padua to Venice. Her brother wrote poetry and perhaps it was he who introduced Gaspara to Fortunio Spira, from whom she learned the craft of verse. Though not beautiful, Gaspara had a very pleasing voice: she and her sister Cassandra sang to the lute and mixed with writers. In 1545 Francesco Sansovino dedicated

to Gaspara a discussion on the art of love. This does not imply that she was a courtesan. She seems simply to have enjoyed that growing intellectual and social freedom accorded women in Venice.

In her early twenties Gaspara met a nobleman of her own age, Conte Collaltino di Collalto. A soldier by profession, the Count fancied himself as a poet and kept open house for writers. Gaspara fell passionately in love with him, and at least once stayed with him and his family in their princely castle in the foothills of the Alps, its chapel recently decorated by Pordenone. In 1549 Collaltino took part in a French expedition against the English in Boulogne; on his return he and Gaspara continued to see each other. Three years after their first meeting, he told her that he intended to marry a lady of rank: this was Contessa Giulia Torelli. Gaspara sought to forget him in a love-affair with a Venetian patrician, Bartolomeo Zen, but this proved brief and unsatisfactory. She died in 1554, aged about thirty, and her poems, three of which already appeared in an anthology, were published later that year by her sister. The book bears a device showing Virtue and the motto *Virtus Dei donum*: Venetians had no patience with the superficial view of virtue as technical skill.

The heart of Gaspara's work is 218 sonnets in which she recounts her love-affair. She opens on a note of exaltation, describing her meeting, around Christmas time, with her 'lord', and marvelling at his good looks, his bravery, his lineage, which goes back to the Scipios. Though aware that physically and socially she is his inferior, from the start Gaspara is utterly in love, and knows that this is her destiny:

> *Arsi, piansi, cantai; piango, ardo e canto;*
> *piangerò, arderò, canterò sempre*
> *(fin che Morte o Fortuna o tempo stempre*
> *a l'ingegno, occhi e cor, stil foco e pianto).*

> I burned, I wept, I sang; I burn, sing, weep again,
> And I shall weep and sing, I shall forever burn
> Until dark death or time or fortune's turn
> Shall still my eye and heart, still fire and pain.

'As trained eyes find new stars in the sky', so she finds new perfections in her lord. When he is distant and cold, she is glad to suffer

for the sake of her love. She takes the name Anassilla, after a stream on his estate, to show that she belongs totally to him. When he is in France, she is afraid that he will forget her, French ladies having a name for beauty. She longs to die, and it is only fear of displeasing him that deters her from suicide. Then despair ebbs, and she feels a faint hope. Her lord's characteristic is infinite bravery, but she can match it with fidelity and pain:

> *Lassa, ch'io sola vinco l'infinito!*

> Tired and alone, let me master infinity!

When at last her lord returns from France, she spends a night with him and is utterly happy. But the conquest has been too easy, and he shows that he is tired of her. He confesses that when they are apart he stops thinking of her. When he speaks of a *mariage de raison*, she feigns indifference and says she will continue to love him. But without him she believes she will die, and she composes her epitaph:

> *Per amarmolto ed esser poco amata*
> *visse e mori infelice, ed or qui giace*
> *la più fedele amante che sia stata.*
> *Pregale, viator, riposo e pace.*

> Having loved much, and been in her love unblessed,
> She lived and died unhappy. Now she lies here,
> The most faithful lover ever to shed a tear,
> Pray, passer-by, that she may find peace and rest.

Jealousy torments her, but it is only right that she should suffer, since he is a king, she a slave. Slowly she is overcome with weariness. She takes refuge in love for another man, but in this second love the first reappears. Soon it becomes a cause of mortification and shame. Finally she turns to Christ on the cross, begging Him to send His grace and rescue her from her sea of misery.

Gaspara's passion was her whole existence, and she describes it with a sincerity unknown since Sappho. Her imagery is seldom new; what is new is her absolute frankness and her psychological acumen. Every shade of passion is described, joy shifting to pain and back again to joy, the love that promises peace and brings only torment. She is completely caught up in her love, and subservient to

it: not for her the heroics, the firmness of Plutarch's Roman women. She reclaimed for art a whole new area of human experience: the nuances of a woman passionately in love. And by describing them without attitudinizing and with admirable singleness of purpose, proved herself a classical writer.

Each of the figures so far considered illustrates one aspect of Venetian liberty. But it was above all her political and intellectual freedom that made the Republic such a force for good. No one used and abused that freedom with greater bravura than Pietro Aretino. The illegitimate son of a cobbler and an artist's model, Pietro was born in Arezzo in 1492. At thirteen he ran away to Perugia, taking a job in a bindery as the best way of getting at books. Already he had a streak of irreverence: he is said to have touched up a mediocre fresco of Mary Magdalen tearfully weeping at the feet of Christ by putting a lute in her hands and changing her expression from remorse to something much more in character. A big, blustering, talkative fellow, with a strong, prominent nose and thick sensual lips—almost a satyr's face—at twenty-two he went to Rome and obtained a menial job 'backstairs' in the house of Agostino Chigi. There he made a name with cynical epigrams, a cruel epitaph about Adrian VI ('He was named shepherd, though himself a sheep') and sixteen scurrilous sonnets to match a set of lewd sketches by Giulio Romano. Aretino was a man who would stop at nothing. He was penniless at this time but that did not prevent him sending a wealthy friend a pair of cheap bone mule stirrups, claiming gravely that they were a present beyond price, having once belonged to St Peter. He got away with this pretence, as with countless others. To his credit, however, Aretino was a patriotic Italian. He wrote several fearless pamphlets denouncing the pro-French policy of Clement VII's adviser, Gianmatteo Giberti, whereupon he was attacked one night by a masked man, probably in Giberti's pay, who severed two fingers of his right hand.

In March 1527, foreseeing the Sack of Rome, Aretino came to Venice, where he was to spend the rest of his life: one of a large group of artists, including the architect Sanmicheli and the sculptor Danese Cattaneo, who found in Venice opportunities denied elsewhere. He rented a house on the Grand Canal, made friends with the

Doge, Andrea Gritti, and settled down to enjoy the colour, movement and intellectual excitement of a city he loved from the start. 'I should wish God to change me into a gondola when I die, or else into its canopy, or if that is considered beyond my deserts into one of its oars, rowlocks or cleaning rags. Even a bailing scoop would do.'

Aretino now launched and perfected a new literary form: the open letter, addressed to a prince or other influential person, and purporting to reveal the whole truth about him. He would drop a hint who his intended correspondent was to be, and if the correspondent sent the expected fat fee in time, the letter turned out to be highly flattering; if not, it was sour and abusive. The letters were later reprinted in book form, where they fill over 3000 pages.

Aretino styled himself 'Scourge of Princes' but his friend Titian was nearer the mark in calling him a 'literary brigand'. In eighteen years, wrote Aretino, 'the alchemy of my pen has drawn over 25,000 crowns from the entrails of various princes.' In 1533 he received from François I a gold chain decorated with vermilion tongues worth 600 scudi, and from Henry VIII, for whom he had proposed the motto *Omnia vincit amor*, a promise of 300 scudi. When Henry died and the sum did not arrive Aretino heard that it had found its way into the pocket of Harwell, the English ambassador. So he dashed off one of his open letters, accusing Harwell of embezzlement. The Englishman showed more fight than some of Aretino's Italian foes, for he waylaid the Venetian, set seven of his English servants to beat him black and blue, and left him unconscious in the gutter. It is a measure of Aretino's prestige and popularity in Venice that he succeeded in enlisting public opinion on his side: Harwell had to apologize and hand over the 300 scudi.

Aretino's prestige came from the fact that he attacked cant and poked fun at foibles wherever he found them, even among the great. 'If Michelangelo hears anyone praising the Sistine ceiling, he modestly says that he is a sculptor, not a painter. Likewise, when he is praised for the statues of Giuliano and Lorenzo de' Medici, he hangs his head and murmurs, "I'm a painter, not a sculptor." '

Aretino became a Venetian institution. 'My features are carved along the fronts of palaces. My portrait is stamped upon comb-

cases, engraved on mirror-handles, painted on majolica'—and, he might have added, painted also as St Bartholomew in Michelangelo's *Last Judgment*—'I am a second Alexander, Caesar, Scipio. Nay more: I tell you that some kinds of glasses they make at Murano are called Aretines. Aretine is the name given to a breed of cobs—after one Pope Clement sent me, and I gave to Duke Federico. They have christened the little canal that runs beside my house upon the Canalozzo, Rio Aretino. And, to make the pedants burst with rage, besides talking of the Aretine style, three wenches of my household, who have left me and become ladies, will have themselves known only as Aretines. So many lords and gentlemen are eternally breaking in upon me with their importunities, my stairs are worn by their feet like the Capitol with wheels of triumphal chariots . . . I have come to be the Oracle of Truth, the Secretary of the Universe: everybody brings me the tale of his injury by such and such a prince or prelate.'

Aretino encouraged others to flatter him, since it added to his reputation and hence his market-value. One correspondent told him that he united 'the subtlety of Augustine, the moral force of Gregory, Jerome's profundity of meaning, the weighty style of Ambrose,' while another went so far as to write: 'One might well say that you, most divine Signor Pietro, are neither Prophet nor Sibyl, but rather the very Son of God, seeing that God is highest truth in heaven, and you are truth on earth.'

We notice the inflated language. Granted that Aretino told the truth, he did so in terms of hyperbole, and his style spread to all who knew him. Everything became, like the man himself, larger than life. Antonfrancesco Doni, a Florentine who settled in Venice in 1547, noted how authors spent their time thinking up a bombastic title:

Just try and tell people to touch a volume labelled *Doctrine of Good Living* or *The Spiritual Life*! God preserve you! Put upon the title page *An Invective against an Honest Man*, or *New Pasquinade*, or *Pimps Expounded*, or *The Whore Lost*, and all the world will grab at it. If our Gelli, when he wanted to teach a thousand fine things, full of philosophy and useful to a Christian, had not called them *The Cobbler's Caprices*, there's not a soul

would so much as have touched them. Had he christened his book *Instructions in Civil Conduct* or *Divine Discourses*, it must have fallen stillborn; but that *Cobbler*, those *Caprices* make everyone cry out: 'I'll see what sort of nonsense this is!'

This was a habit that appeared in England and elsewhere later on. Doni himself published an invective against Aretino, under the rolling appellation: *The Earthquake of Doni, the Florentine, with the Ruin of a Great Bestial Colossus, the Antichrist of our Age*.

Aretino has been called the first modern journalist, and deserves the title, for his pen is always racy and amusing, as well as occasionally unscrupulous. But journalism was only one aspect of his life. What is much more important is the conception of freedom behind his journalism. Aretino loved Venice in the last resort because there, and there only, a man was free to publish exactly what he thought, without fear of reprisal. Others might call themselves kings by the grace of God, Aretino boasted that he was '*per la grazia di Dio uomo libero*—by the grace of God a free man' and even printed this on the frontispiece of his books. To be a free man, he implied, is the greatest glory on earth. He saw that freedom was threatened in Italy, and it was as much in order to defend it as to make a living that he attacked princes for failing to honour the rights of their subjects, or for that matter his own rights. To the aristocracy of birth Aretino opposed an aristocracy of talent. He worked tirelessly, recommending artists to patrons and securing them decent fees, tirelessly publicizing work he admired, whether Titian's pictures or Cattaneo's statues. He did more perhaps for the arts than any patron of his day.

Aretino had immense gusto for life, whether a pretty woman, the colours of a sunset over the Grand Canal, or the good fare sent by admirers, which he shared with the other two members of his triumvirate, Titian and Sansovino: Trebbian wine from the sovereign Lady of Correggio, thrushes cooked with laurel leaves and Friulan hams that came from Gaspara's *beau idéal*, Conte di Collalto. It was this zest for life that made him mock dry-as-dust humanists who sought less to revive the past in the present than to escape life in books. There was a lavishness about him that one cannot but admire. 'Even with half a million crowns, I would be hard up. Everyone

comes to me as though I were chancellor of the exchequer. If a poor girl has a baby, or someone is thrown into prison, it is to me that they turn. Soldiers in need of equipment, penniless foreigners, a troop of cavalry on the move—all come and restock at my place.'

Doni calls Aretino an Anti-christ, and it is true that sometimes in the *Ragionamenti*, roaring with laughter, he carried lewdness beyond bounds. But it is equally true that he possessed the virtues of courage, friendship and generosity. When he tired of his mistresses he arranged good marriages for them: though never a rich man, he gave substantial dowries to his two grandiloquently named daughters, Adria and Austria; he wrote a sincere and passably good *Life of St Thomas Aquinas*; and on his deathbed in 1556, struck down by apoplexy, he confessed, received Holy Communion and Extreme Unction. Even then he could not resist a last quip: 'Now that I am oiled, keep me from the rats.'

Venetian Architecture

OF THE TWO most important buildings in Venice, one, St Mark's, is Byzantine, and the other, the Doges' Palace, Gothic. These styles appealed to Venetian taste, with its fondness for glitter and elaborate ornamentation, and as late as the 1520's were still influential. Well-to-do Venetians variegated their houses with marbles, tiles and numerous windows fitted with roundels of the local bottle glass, and they heaped them with furniture, for more than most Italians the citizens of Venice prized ostentatious objects: heavy tables of carved walnut, majolica, gold and silver vases, damascened swords, cups of jasper, ewers, lutes, sea-shells, armillary spheres; while hanging from the ceiling or attached to the walls were Oriental lamps of bronze, either gilded or worked in niello. It was quite possible that people with these tastes would never choose to erect simple and symmetrical classical buildings. However, the Sack of Rome caused a Florentine to seek refuge in Venice in 1527, and it was he who, in the language of the day, restored architecture to the sound principles known to the ancients.

Jacopo Sansovino was born in Florence in 1486. He came of quite a well-known family, the Tatti, and Vasari tells us that it was Jacopo's mother who allowed him secretly to follow his bent and study drawing, encouraged by the fact that he had been born in the same street as Michelangelo. Jacopo grew up handsome, with a fair complexion, red hair and a quick temper. After studying under the sculptor Andrea Sansovino, whose name he adopted, he went to Rome, where for Bramante he made a bronze of the *Laocoön*. Illness forced him back to Florence, where for the cathedral he carved a marble statue of St James remarkable for the delicate folds of its drapery, and, about 1512, a life-size marble statue of Bacchus.

Sansovino chose to portray the young god looking up at a drinking-bowl held high in his left hand, and although it was winter arranged that one of his assistants, Pippo del Fabbro, should pose naked a good part of the day in this difficult and unprecedented stance. The statue, Sansovino's masterpiece, seems almost a living creature, but by a tragic irony Pippo had his mind deranged by long posing in the cold and became convinced that he was not a man but a statue. One wet day Sansovino called out 'Pippo' and, getting no answer, went to look for him. He found him on the chimney on top of the house, in the pouring rain, striking the attitude of Bacchus. At other times, draping himself in a sheet, Pippo would take the pose of a prophet or apostle or saint, remaining motionless and silent for up to two hours. But it was the Bacchus pose which haunted him and which he chiefly adopted, until his death a few years later.

Around 1518 Sansovino returned to Rome, where he practised as a sculptor and also as an architect, among his designs being a church for the Florentine colony. Rome had now succeeded Florence as the centre of modern architecture. Brunelleschi's light, almost dainty colonnades and Alberti's pilastered façade of the Palazzo Rucellai were considered *vieux jeu*, and were being replaced by a heavier style, deriving chiefly from the double order of half-columns in the Theatre of Marcellus. The two buildings which most influenced Sansovino—and other young architects also—were Bramante's town house, where Raphael later lived, and hence known as the House of Raphael, in which the ground floor is rusticated and the *piano nobile* has half-columns and pedimented windows; and Antonio da Sangallo the Younger's Palazzo Farnese, the court of which in its original two-storey form combines half-columns with arches and blind arches.

At the Sack of Rome Sansovino fled to Venice, intending to go on to France, where he had been offered a job by François I. But the Doge, Andrea Gritti, who happened to be a humanist and lover of the arts, invited Sansovino to stay, first in order to strengthen the cupolas of St Mark's, which were in danger of collapsing, and in 1529 to become architect to the Republic. For the rest of his life Sansovino worked in Venice. He enjoyed a close friendship with Aretino and with Titian, who painted his portrait, and his son

Francesco became a leading man of letters. In his old age he walked like a young man, could read without spectacles, and enjoyed talking to pretty women. During summer he lived on vegetables and fruit, eating three cucumbers at a time and half a lemon. By virtue of this regime he weathered four apopletic strokes and attained the age of eighty-three.

Sansovino received a number of commissions for private houses and these, in Venice, presented difficulties. To start with, since there were neither horses nor wheeled traffic, they needed no central courtyard, therefore had no central well of light. The main room on the *piano nobile* extended through the whole width and required very large openings for light, front and back; thanks to Venetian skill in glass-making, these openings took the form of glass windows. In the Palazzo Vendramin-Calergi, completed in 1509, the windows, divided by a shaft and surmounted by a roundel, are still the most prominent feature. What Sansovino did, in a series of remarkable houses, was to reduce the fussiness of the windows and subordinate them to the orders. The best of his houses, the Palazzo Corner, has a high rusticated basement surmounted by two identical floors wherein the windows, simple round-headed bays, are separated from one another by pairs of half-columns. There is a definite gain in regularity and unity. No more could be expected until the whole concept of the palazzo had been rethought, as Palladio was later to do.

In 1472 Cardinal Bessarion had bequeathed his collection of 900 Greek and Latin manuscripts to Venice, evidently hoping to promote ecumenicism in a city so favourably sited. Sixty years passed before the Venetians bestirred themselves to house the collection, but when they did, there was nothing petty about their plans. They asked Sansovino to erect a great library along one side of the Piazzetta di S. Marco, therefore facing, and competing with, their two key buildings: the basilica, and the Doges' Palace.

Sansovino rose to the occasion by designing a long, low two-storey building, in which the Doric and Ionic orders are combined as they were in the Theatre of Marcellus and the court of the Palazzo Farnese. On the ground floor an open arcade of 21 bays is supported by a Doric order of half-columns. The entablature is surmounted by a balcony running the whole length. Above is a second arcade

resting on Ionic columns. In each bay is a round-headed window between smaller, fluted Ionic columns. Finally there is a frieze richly decorated with swags, and another balcony crowned by statues, in the line of the columns. The total effect is of classical symmetry and strength, yet more richly textured than any classical building would have been. If this was partly a reflection of Venetian taste it was also virtually a requirement on a building intended to face up to the elaborately carved Gothic colonnade on the Doges' Palace.

When five bays had been completed Sansovino began that part of the barrel vault interior nearest the Campanile. At one o'clock in the morning of 18 December 1545 the vault suddenly collapsed, bringing with it part of the outside. In the panic that followed angry crowds abused 'the Florentine', and a zealous official threw him into prison. Called before the Procurators, Sansovino explained that exceptionally cold weather had frozen the mortar, which had then cracked under reverberations from a salvo fired to welcome the galley-fleet from Beirut. In a confidential letter to Bembo he also blamed his masons for removing props before the ceiling had had time to dry. By the combined efforts of Aretino, Bembo and Titian the unhappy architect was freed, and the fine of 1000 ducats imposed by the Procurators reduced to 900, payable over several years. A year later all damage had been made good, but Sansovino was told to roof the library more simply, with horizontal beams, under which there would be a light vault of canework and plaster. This was eventually to be painted by Veronese and others. By 1568 work had been going on for thirty years and had cost 150,000 ducats; it was completed only after Sansovino's death, in 1588. Not only was it the largest and most splendid library building in the world: it was a statement, in the heart of Venice, of classical architectural principles.

Sansovino's library conveniently masked the south side of the tenth-century campanile of St Mark's, but to the east the campanile's heavy brick base stood out incongruously among its richly decorated neighbours. In 1537 Sansovino was commissioned to make a loggetta in front of the campanile on this side. Its upper part would house the Procurators' tribunal—the same that fined him when part of his library collapsed—but the loggetta's main purpose would be to serve as a beautiful screen.

Sansovino designed a building reminiscent of a Roman triumphal arch, but having all three openings of the same size. These are separated by Corinthian columns in pairs, between which stand statues, in niches, of Minerva, Apollo, Mercury and Peace. The entablature is broken forward over each of the columns, surmounted by six panels of bas-relief and crowned by a balcony. The loggetta is even more richly decorated than the library and has historical importance because for the first time sculpture and bas-reliefs are fully integrated into a classical building. They play as vital a role as the columns and arches. In this sense the loggetta is the characteristic work of an architect who was also a practising sculptor. The Apollo is an excellent statue in its own right, while some of the sea-nymphs in the bas-reliefs are also of great beauty.

While Sansovino was beautifying their sea-girt city, more and more Venetians were turning their attention away from the sea to the mainland territory conquered in the *quattrocento* by their forbears. Newly appointed officials were draining deltas, cutting canals and building dykes in order to grow more corn and wine to feed a population that nearly doubled between 1500 and 1575. As markets became more competitive, rich Venetians who had formerly invested in, say, a cargo of Turkish rugs or Arabian incense preferred to buy farmland. Farmland offered a smaller return, but the return was and would always be sure. In a striking reversal of their past, great families who had once made quick fortunes on the Rialto began to buy pig-farms, vineyards and fields for growing wheat: the Pisani along the Gorzone and the Adige, the Memo in Friuli, the Morosini near Ceneda.

It is one thing to invest in land, quite another to set up house and live there, and if many Venetians also took the second step the explanation is to be found in the popularity of the younger Pliny's *Letters*. In these the good-natured and immensely rich proprietor lovingly describes his various villas: he had several on Lake Como, one for winter—with a heated swimming-pool—on the sea near Rome, and another for summer in the Tuscan hills. He paints an idyllic picture of country life, writing a little in the morning, riding out in the afternoon, supping with friends beside the garden fountain

to the sound of music. These letters enticed many rich Italians of the sixteenth century, Roman cardinals in particular, into building villas and making gardens. But nowhere was the movement from town to country so marked as in the territory of Venice, nor, perhaps, was affection for landscape stronger than among people who for centuries had lived on and by the sea. Hills and trees which in a Bellini Madonna are just living details spread across the canvas until in Giorgione it is the landscape which dominates all, even the mood of the people.

Families wishing to settle in the Venetian countryside first had to build suitable houses. These eventually came to follow a well-marked pattern, and the pattern may be said to originate with Count Giangiorgio da Trissino. We have already met Trissino as Leo X's nuncio in Germany and as author of the tragedy of *Sofonisba*; in some ways he is the most attractive of all the versatile men of this age. He was born in Vicenza in 1470 and despite a sickly boyhood learned Greek from Demetrio Chalcondylas. He married young and lost his wife before he was thirty. Of an amiable disposition and pleasing appearance—he had gold-blond hair and beard—he then gave himself to the pleasures of friendship, literature and study. His *impresa* shows a fleece hanging from the branches of an ilex and guarded by a dragon, with a motto taken from the *Oedipus* of Sophocles: 'He who seeks finds.' In particular Trissino was seeking a sure technique for writing a great epic, and the answer he found in Homer's practice of giving plenty of true-to-life detail. The resultant epic, *Italia liberata dai Goti—Italy Liberated from the Goths*—is a call to the German Emperor to free Greece from the Turk, as Justinian had freed Italy from the Ostrogoths, and, in imitation of Homer, it is packed with vivid descriptions of clothes, meals, toiletry and siege engines; unfortunately the details, excellent in themselves, swamp the action, and as for the heroic element, it is missing completely. Trissino's *Italia liberata* remains one of the brave failures of Italian poetry: a warning of just how difficult it is to follow a classical model.

Trissino also proposed to enlarge the Italian alphabet with new letters: ε to represent the open *e*, ω the open *o*, ζ the soft *z*; and to distinguish *j* from *i*, and *v* from *u*. Although he published a book of

poems printed in the new style, only the distinction between *v* and *u* caught on and was permanently adopted.

In 1536 Trissino decided to settle in the country and found a small public school or Academy where, for eighty ducats a year, young noblemen of Vicenza could be educated according to the precepts of Castiglione's *Courtier*, and study, in country calm, philosophy, astronomy, geography and music. To this end he designed a house, architecture being another of his many accomplishments: by name the Villa Cricoli. It is not a very good house—two projecting towers linked by a double loggia—but it so happened that one of the workmen employed to carve the decorative stonework was a man of genius who attracted Trissino's attention because of an innate gift for mathematics. His name was Andrea di Pietro, he had been born in 1508, the son of a Paduan carpenter, and since the age of sixteen inscribed at Vicenza in the guild of bricklayers and stonemasons. Trissino very generously decided to educate Andrea and to train him as an architect. In 1545 he took Andrea with two other friends, a poet and a painter, to spend two years in Rome studying the remains of classical antiquity. He also gave Andrea the surname Palladio, derived from the word palladium meaning an image of Pallas Athena, on which the safety of a Greek town was believed to depend. The most famous palladium was that of Troy, which Aeneas is said to have carried to Italy. Trissino evidently meant to imply that his protégé would introduce to modern Italy the principles of Greek architecture, even as he had introduced those of Greek epic poetry and tragedy.

Little information has survived about Palladio the man, not even a portrait. He is known to have been popular and a good husband and father. He used to read Caesar's *Commentaries* with his two sons, who bore the promising names Leonida and Orazio, and it was doubtless a great sadness to him when they both died young. In their memory he published an illustrated edition of Caesar. He was not well off until his sixties when commissions began to flow in from Venice.

On his return from Rome to the Venetian Republic Palladio designed fifteen country houses, and it is with these that his name is chiefly associated. Before Palladio, Venetian country houses were of

two kinds. There was the rural version of the town house, such as the Villa Colleoni, in which machicolated turrets are blended queerly with Gothic windows above an arcade, and there was the *castello*, a squat, unfortified farmhouse comprising a central feature between two wider projecting tower-like blocks. This had been the basis of Trissino's Villa Cricoli, but Trissino's attempt to place a classical stamp on the central feature was mere patchwork. It became clear to Palladio that he would have to rethink the whole concept of a country house.

As Trissino had turned to Homer before beginning his epic, so Palladio turned to the most authoritative classical text in his field. This is Vitruvius's *Ten Books on Architecture*, possibly the worst-written work in Latin, and maddeningly disproportionate. Vitruvius devotes only a few specially dense pages to private houses. From these it emerges that Greek and Roman houses face inwards, on to peristyle or atrium. They have one storey only; no part is of dominant height, and in Greek houses the men's quarters are separated from the women's. Having read this, Palladio may be said to have gone away and designed houses in every respect the opposite. He did so not from any anti-Vitruvian bias, but because Vitruvius devotes two whole books to temples and the orders which are their most important feature, and it was this part of the treatise that made an impact on Palladio. When he and his contemporaries thought of a classical building, they pictured a temple, its façade proportioned down to the last acanthus leaf; Vitruvius's obscure pages about houses they ignored or forgot.

Much the same situation applied to visible remains. No Roman country houses survived, and anyway they would not have interested men of Palladio's day, since we now know that they were very casually planned. On the other hand there were many public buildings to be seen in Rome, notably the Pantheon, which deeply impressed Palladio. However, the curious thing is that nothing in Vitruvius or Pliny and no surviving monument can explain Palladio's decision to design country houses with a dominant centre, an equal number of subordinate parts on either side, and symmetrical about only the short axis. Such a house is as different as it can possibly be from its Greek and Roman predecessors. Yet it is truly

classical because Palladio has mastered the principles underlying Greek and Roman buildings and applied them to the needs of his day.

Having decided on the basic plan of his house, Palladio's next problem was the façade. Here again he went far beyond his authorities. He decided that private houses had been the model for ancient temples, and therefore that houses had façades in the form of the classical temple front. We now know this belief to be mistaken, but the interesting point is that in arriving at his mistake Palladio employs the same static notion of history we have noticed elsewhere. Unable to think in terms of organic development, because comparative anatomy was still in its infancy, he envisages certain basic and unchanging units, which are merely contracted or extended. Palladio actually reconstructed an ancient house for Daniele Barbaro's edition of Vitruvius in 1556, and shows it with a portico of eight Corinthian columns crowned by a pediment and three statues. But when he came to design villas Palladio modified this scheme profoundly. The portico he retained as a central feature but save in the Villa Rotonda he dispensed with statues, and he reduced the number of columns from four to six. But these columns are Greek, not Roman, in character. They are light and graceful, like those in the temple of Nike in Athens. It is almost certain that drawings of Greek temples were circulating in Venice, for as early as 1470 a Venetian traveller, name unknown, counted twenty columns of the temple of Olympian Zeus in Athens, and left some appreciative notes on the Parthenon. Palladio's silence about Greek buildings in his treatise on architecture means not that he did not value them, but that he had not seen or measured them, and therefore could not find a place for them in his book.

The portico is the hallmark of Palladio's villa style. He explains that it adds grandeur and is convenient for placing the owner's coat-of-arms or emblem. But such is Palladio's virtuosity it never becomes banal. In the Villa Foscari it is free standing, in the Villa Badoer it recedes into the plane of the wall, in the Villa Cornaro it is divided into two tiers. But however it is handled the portico is no mere ornament, it is an outward expression of the same basic inner pattern: a hall in the central axis flanked by rooms arranged in absolute symmetry.

The second remarkable feature of the Palladian villa is a systematic

linking of the rooms, one to another and to the villa as a whole, in strict accordance with a given proportion. If this is 3 : 5, then some rooms will be 12×20, others 18×30 and so on, but none will depart from the basic proportion. By designing in this way Palladio believed that he was expressing in architecture the mathematical principles according to which God had designed the universe— hence his declaration that 'architecture imitates nature.' These principles, as Pythagoras had demonstrated, were manifest also in music, and for his more sophisticated villas Palladio uses a three-term 'harmonic' proportionality, which is a visual equivalent of a musical harmony. He extends this three-term formula into a series so that not only rooms and façade, but the whole plan of the villa is designed proportionally, and knit together as closely as a fugue.

One of the most perfect of Palladio's villas was begun in Maser about 1555 for Daniele Barbaro and his brother Marcantonio. Daniele Barbaro is another of those remarkably versatile Venetians, like Trissino and Sperone Speroni, whose dialogues, incidentally, Barbaro edited. Born in 1513 of a rich Venetian family, he took a doctorate at Padua, where in 1545 he established the first botanical garden in order to supply the medical faculty with simples. From 1548 to 1550 he served as ambassador in England; on his return he was granted 1000 ducats by the King and the right to add the English rose to his coat of arms. In 1551 he was appointed Patriarch-elect of Aquileia and, as we shall see, was to play a role in the Council of Trent. He had a theory that underlying all the arts is a single principle, which he called *euritmia*, and in 1556 he published an edition of Vitruvius for which Palladio made remarkably good illustrations.

The Villa Barbaro comprises a main block with temple front, flanked by lower arcaded wings each containing three groups of three rooms. Like most of Palladio's villas, it is built, even the columns, of rough brickwork with a coating of stucco, which could be painted according to the owner's taste; stonecarving was reserved for the bases and capitals of columns and for window frames. The villa is dignified without being grandiose: an excellent house for a gentleman farmer. As a student of Vitruvius Barbaro certainly knew the passage in Book VII, chapter 5, which says that rooms should be painted with columns, gables, landscapes, legends and imitation

statues, and he had also written a little book on perspective. So when he commissioned Paolo Veronese to fresco all the rooms of the upper level, he evidently specified Vitruvius's choice of subjects and asked Veronese to create the illusion of space extending outwards in all directions. The result is a beautiful series of frescoes, mainly in cool blue and white. On one ceiling Bacchus reveals the mysteries of wine: he is crushing grapes into an upheld cup, while Music and her attendants glide down over a sleeping figure of Time. One of the walls of the same room depicts a villa with open arcades approached by an avenue along which ladies are driving in one of the newly invented four-wheeled carriages drawn by white horses. Elsewhere an illusionist effect is created of columns, niches and even members of the Barbaro family with a pet dog and parrot looking over a balcony.

This was the first time that frescoes and domestic architecture had been so closely integrated. In the day-to-day life of the Palladian villas these two arts were joined by a third, namely music. From about the turn of the century Venetians took an intense interest in musical composition and in 1541 the irrepressible Trissino published an edition of Ptolemy's *Harmonics*, in which he made the interesting suggestion that modern composers should follow the ancients in using chromatic and enharmonic scales, that is, scales proceeding by semitones or quarter-tones. In the mid-sixteenth century no Venetian party was complete without songs to the lute and pipe or madrigals, a development which can be traced in painting from the musician lutist in Carpaccio's *Presentation*, who is just a delectable detail, to Titian's *The Concert*, where the whole subject is music. So Palladio's villas, designed according to musical intervals, would often have rung to the sound of music. Barbaro in particular must have been well satisfied on such occasions when three arts combined to express that *euritmia* which was a manifestation of the cosmic order running through the universe and through the soul of the well-balanced man.

Venetian villas were built for men engaged in farming, so they lack the complicated pleasure gardens attached to Roman villas, where rich cardinals and courtiers could afford to indulge in expensive entertainments. The garden of the Villa Barbaro is simple, its chief feature being a nymphaeum, where the wall bounding the lily-pond is adorned with stucco statues of gods and goddesses, each

in a niche and identified by an epigram, the work of a Venetian sculptor, Alessandro Vittoria.

Palladio also designed a dozen town houses and public buildings, mainly in Vicenza. One of the earliest and most considerable is a two-storey loggia, known as the Basilica, built round the medieval Council Hall of Vicenza. Following Sansovino's Library, Palladio uses Doric columns on the lower storey, Ionic on the upper, and crowns the whole with statues that stand out against the skyline. But his building is much less richly decorated than the Library, and the entablature is broken forward over each of the columns, as in Sansovino's loggetta, producing an effect of rugged strength. A similar combination of Doric and Ionic is to be found on the façade of one of Palladio's most beautiful town houses, the Palazzo Chieri-cati, but here it is used to create an effect of cool elegance. The three-part façade is open save for the upper central section, which, like the temple front in a villa, serves as a central core.

Michelangelo had used a giant order of pilasters in his Capitoline palaces, and Palladio did the same in certain houses of his middle period. But later he went much farther in this direction and used a giant order of half-columns. In the unfinished Palazzo da Porto-Breganze and the Loggia del Capitanato these create a hitherto unknown impression of power. They have the monumental quality of the best ancient Roman buildings, and prove that Palladio could work equally well in the Roman and in the Greek idiom.

One other Vicentine building deserves mention: a theatre commissioned by the Accademia Olimpica, a group of humanists who met for poetry readings, lectures on mathematics, concerts and theatrical performances. Basing his design on surviving Roman remains in Vicenza, Verona and elsewhere, Palladio devised a wooden theatre in which thirteen rows of seats are arranged in an ellipse, surmounted by a row of twenty-eight Corinthian columns, carrying a loggia and balustrade. The proscenium, based on a central arch, was richly decorated with statues and reliefs. More a reconstruction of what Palladio imagined a Roman theatre to have been than an original work of classical inspiration, it nevertheless served the Academy's purpose and opened in 1584 with Sophocles's *Oedipus Tyrannus*.

When Sansovino died, Palladio began to receive commissions in Venice and in 1570 moved there with his family. He built two large churches, S. Giorgio and Il Redentore, and one church façade, that of S. Francesco della Vigna. In all three works Palladio found himself facing the old problem of how to give a classical front to a building with a high nave and lower aisles. Alberti in S. Andrea at Mantua had combined a temple front with a triumphal arch, but this solution did not appeal to Palladio. Instead, he took a cryptic phrase in Vitruvius about the 'double arrangement of gables' in the Basilica of Fano to mean that the Romans had used for their basilicas two different interlocking temple fronts. This principle he applied to all three of his Venetian façades. In S. Giorgio, for instance, he covers the aisles with a wide low temple front resting on pilasters, while the nave he covers with a second narrower front, surmounting the first, resting on four tall Corinthian columns. The result is not entirely harmonious, since the bases of the pilasters and columns are not on the same level, but it was as satisfactory a compromise as the data would allow.

The interiors of Palladio's Venetian churches are of great interest. The pioneer of church architecture, Brunelleschi, had made his central feature two lines of columns supporting round arches: these by the logic of perspective lead the eye up the nave to the high altar. Such an approach Palladio altogether rejects. Dispensing with rows of columns, he makes his main feature the church walls. These are strongly moulded with pilasters and half-columns supporting a heavy cornice. The horizontal line of the cornice is so marked that, in Il Redentore at least, the church seems to stop short at the cornice. The plain white ceiling is of no importance and merely serves as a source of light, which streams down through a dome above the crossing and half-moon windows copied from those in the baths of Rome. Attention is no longer directed to the high altar, but dispersed outwards to the richly textured walls.

Although his commissions in Venice called for cruciform churches, Palladio, like Alberti and Bramante before him, firmly believed the best type of church to be round: 'every part being equidistant from the centre, such a building demonstrates extremely well the unity, the infinite essence, the uniformity and the justice of God.'

Palladio knew perfectly well that ancient temples, such as the Maison Carrée in Nîmes, which he had seen and measured, were nearly always rectangular, but here again he preferred the principles of Platonism and a rare survival of a round temple to the full weight of historical evidence. Happily, Palladio did get a chance to build one nearly round central-plan church. This was the chapel for Villa Barbaro. Palladio combines a Greek cross with the half dome and portico of the Pantheon, and decorates it with a richness worthy of Sansovino. The capitals of the six Corinthian columns are linked by free-swinging swags, and profuse stucco relief covers every surface of the interior. It is an old man's prophetic vision of rococo.

Palladio ensured that his architectural principles would become well known by producing a book in which the clarity of the text is matched by the excellence of the illustrations. *I Quattro Libri dell' Architettura*, published in Venice in 1570, restates the principles of Vitruvius, discusses the five classical orders, reconstructs a variety of ancient buildings from temples to bridges, and provides illustrations of most of Palladio's own works. Among the reconstructions are the Baths of Caracalla. It is now known that all the vaults in these Baths were of equal height, and none was visible from the street, but in Palladio's reconstructions of sections the dome of the Calidarium is shown larger than those of the Frigidarium and Tepidarium, with the implication that it was both dominant and conspicuous. Palladio was not actually falsifying the visible evidence, but he could not help imposing his own original vision, even on other men's works. His book transmitted to Europe one man's view of antiquity, with the emphasis on Greek proportion and symmetry, and illustrations of his own buildings, notably the country houses, which, as we have seen, would have been unrecognisable to the Greeks and Romans.

Venetian Painting

VENICE being a northern as well as a Mediterranean city, in painting no less than in architecture the Gothic tradition long remained powerful. The drawings of Jacopo Bellini and the paintings of Crivelli revel in fussy decorative details that hide rather than reveal human character. As for the Mediterranean form *par excellence*, the female nude, this came late to Venice, and by way of Germany. In 1483, half a lifetime after Ghiberti's *Eve* on the 'Paradise Doors', Antonio Rizzo made a statue of the same subject for the Doges' Palace, but Rizzo's *Eve* is cast in a Gothic mould, with narrow, sloping shoulders, almost no waist, heavy hips and bulging stomach. It is as though Rizzo had never set eyes on a classical bas-relief or statue.

About a dozen years after Rizzo's *Eve* the Venetian Vittore Carpaccio cast an even colder northern eye on the female form in the painting known as *Two Venetian Women*. This scene is a roof-balcony. It was here that women dyed their hair blond in a mixture of orange-peel, eggshell and sulphur, then dried it in the sun, wearing a dressing-gown and large crownless straw hat called a *solana*, over the brim of which they spread out the hair, arranging it round their shoulders, which were protected by a cape. Carpaccio's two women are shown in profile, seated: one, wearing a hat, stares into space, the other holds the paws of a begging lapdog while into the mouth of the larger dog she thrusts a wand. They are short and plump, for it was difficult to take exercise in this city of canals and muddy foot-paths which necessitated the wearing of pattens, a pair of which Carpaccio shows. Venetian women generally seem to have been buxom, and are depicted as such by most Venetian painters, in contrast to the Florentine ideal, which was tall and slender. Carpaccio's

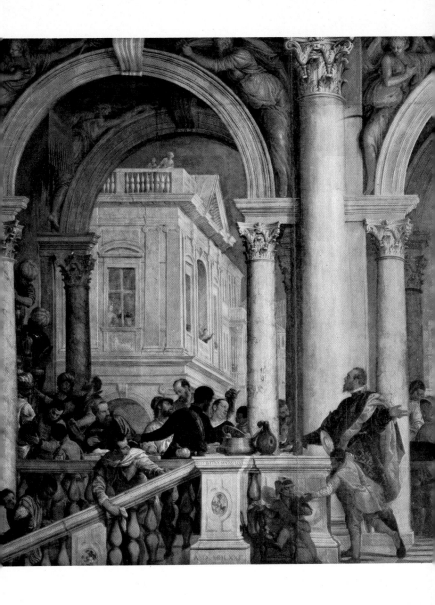

A detail of *Feast in the House of Levi* by Veronese

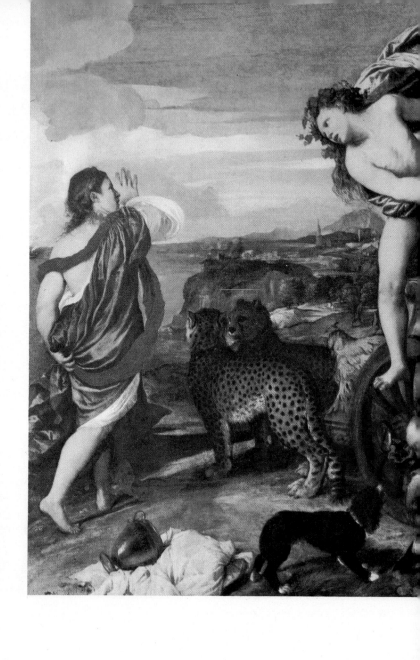

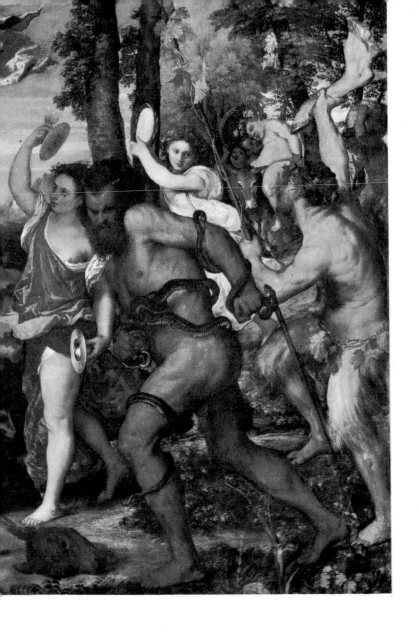

Bacchus and Ariadne by Titian

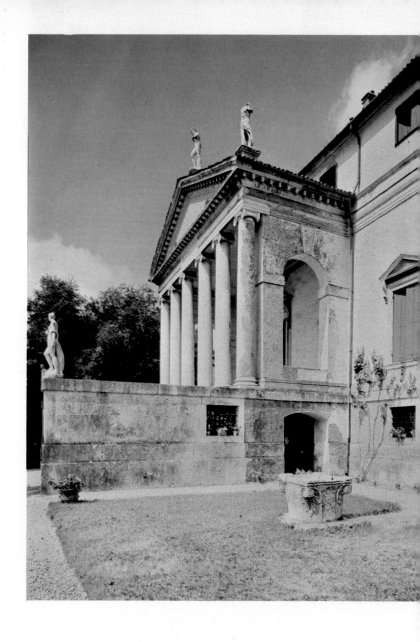

La Rotonda, Vincenza by Palladio and Scamozzi

women are probably courtesans, and it has been suggested that the wand—an attribute of the sorceress since antiquity—may point in moralizing fashion to these women's power to convert men into beasts. Courtesans or not, Carpaccio has depicted them in a most unflattering light, with double chins and vacant look.

To begin to idealize the female body is one of the most revolutionary changes that can overtake any civilization. It happened in Venice within a few years of the painting of Carpaccio's *Two Venetian Women*, and as a result, of course, of the study of classical antiquity. For the Greeks the human body was the visible expression of God's beauty, and the body's proportions were so perfect that they must underlie all beautiful works, whether temples or houses. The Venetians came to accept this belief at a time when courtly writers were proclaiming the dignity and excellence of women, man's inspirer. So Venetian painters gave great prominence to the female nude. In tracing the main achievements of Venetian *cinquecento* painting we shall do so too, noticing also the importance of the nude in religious painting, as well as occasional works of a different nature that bear on the main theme of the book.

The first Venetian to paint women in classical terms was Giorgione. He was born probably in 1478, in Castelfranco, a fortress town thirty miles north-west of Venice amid beautiful rolling country which he turned to again and again in his pictures. He was christened Giorgio but known affectionately as Giorgione or Big George, 'because of his physical appearance and his moral and intellectual stature'. He came to Venice as a youth and studied under the best living master, Giovanni Bellini. Besides painting, he played the lute beautifully: this gift and his gentle, courteous nature won him a place in educated society, which was then in a period of ferment. Aldus Manutius had begun publishing the Greek classics and his Academy met weekly; rich men were building up antique collections—we know that Gentile Bellini, the brother of Giorgione's teacher, possessed a head of Plato and a statue of Venus said to be by Praxiteles; in the pages of Lucian and Philostratus they read about ancient paintings of nudes and were ready to commission similar works for their homes. In this respect Giorgione was just the artist to suit them because, as Vasari puts it, 'he was always a very amorous

man,' so amorous in fact that he continued to visit his sweetheart even after she had contracted the plague: Giorgione was to catch it also and to die in 1510, in his early thirties.

We know that Giorgione painted a portrait of Caterina, the former Queen of Cyprus in the garden of whose palace at Asolo Pietro Bembo set his *Asolani*. Bembo was living in Venice from late 1503 to 1506, and in later life is known to have possessed a nude by Giorgione. If we are to judge by Giorgione's choice of themes, it is probable that Bembo knew the young painter and certainly he influenced him. So Giorgione would have approached such statues as the *Venus* of Praxiteles in terms of Bembo's gentle Platonism. Whereas the Florentine painters, under the highly intellectual influence of Ficino and Poliziano, had usually depicted nudes as part of a complex myth or allegory with Christian overtones, Giorgione's approach is simpler. He is content to set his women—and his men also—within a beautiful landscape, and to convey by subtle transitions of colour and tone and shadows, the divine harmony imbuing all created things.

Such a work is his *Sleeping Venus*. Giorgione places the goddess in an undulating landscape. He has simplified and beautified her body in the best traditions of classical Greece, emphasizing her height by the position of the right arm above the head, her slenderness by tucking the right leg out of sight. The position of her left hand is similar to that in the Cnidian Venus by Praxiteles, a version of which was unearthed in the early years of the sixteenth century on the Belvedere. Perhaps Giorgione saw an engraving of it, or perhaps Gentile Bellini's statue of Venus, which he would have known, was a Cnidian Venus. Anyhow, the influence of this classical work seems certain.

Giorgione's Venus is asleep. Now the Greeks never represented the goddess of love as asleep—it would not have been in character—and it is here that the influence of courtly Platonism makes itself felt. Bembo used to describe a beautiful woman as 'a reflection' or 'a mirror' of God's beauty, and it is just this quality that Giorgione depicts, making his Venus like a calm lake, mirroring the sky.

Giorgione has also made the notable discovery that the female body and a gentle landscape are beautiful in somewhat the same way,

and that the beauty of one can enhance the beauty of the other. The mantle in the foreground corresponds to the sky, just as the upper part of Venus's body has an exact counterpart in the swelling grass bank, two trees, and square tower overgrown with grass, the blind arches of which echo Venus's closed eyes and oval eyebrows. The landscape was actually painted by Titian, evidently in accordance with the intentions of Giorgione, who left the picture incomplete. Titian also added a Cupid on the right, but this has since been over-painted. Clearly the Cupid was not a happy touch, for the presence of another figure would inevitably disturb the mood of stillness and of intimate harmony between the earthly and divine.

Giorgione's pictures, unlike those of the Florentines or of Titian, can seldom be related to a particular text. Rather, they hint at some truth or mood or experience beyond what is actually depicted. Sometimes the hint is so oblique that, like certain *imprese* of the day, the pictures can be puzzling. In the work known as *The Three Philosophers*, representing three men of different ages and dress beside a cave, Giorgione is evidently making a statement about man's quest for truth and the divergences it leads to, but exactly what we cannot be sure. Similarly in the picture known as *The Storm*, which is described in an early inventory as '*El paesetto cun la tempesta, cun la congana et soldato.*' A gipsy woman is seated beside a stream where she has evidently been washing. She is only partly clothed and is suckling a child. On the opposite side of the stream stands a soldier holding a pole and looking covertly at the gipsy. She does not look at him, however: she gazes ahead out of the picture. Behind the soldier are a ruined wall and two broken columns. In the background the stream is crossed by a wooden bridge, above which grey storm clouds are split by a flash of lightning.

The structure and mood of the picture suggest that the central theme is separation. The sky is rent by lightning, the landscape by water, and it seems reasonable to suppose that the soldier and the gipsy, wanderers both, are now parting. The child is evidently the soldier's. His relationship with the gipsy is symbolized by the bridge, which is of wood, therefore ephemeral, whereas the wall and columns, symbolizing a permanent, socially-approved relationship, are broken. But this interpretation, like any other, can at best be

mere conjecture and the result is that *The Storm*, like a line of highly imaginative poetry, remains inexhaustibly haunting.

Among the books circulating in Giorgione's Venice one of the most influential was the pastoral romance *Arcadia*, by Jacopo Sannazzaro of Naples. Published in 1504, it tells how Sincero is rebuffed by his sweetheart and comes to Arcadia seeking distraction, which he finds for a time in the pleasures of country life, not as it is but as it might be, had peasants the sensibility and tastes of Sannazzaro. *Arcadia* delighted the highly urban society of Venice, just as Theocritus's idylls had delighted the citizens of Alexandria, and Virgil's *Bucolics* the sophisticated court of Augustus. Grave Venetian senators enjoyed reading about amorous shepherds cutting sylvan songs in the rough bark of beech trees 'which please no less than the studied verses printed in the smooth pages of gilded books'; and harassed bankers, awaiting cargoes of silk on the Rialto, began to sigh for a simple life in tune with nature in an Arcadia that never was.

This is the world Giorgione depicts in the picture known as *Concert champêtre*. Two men are seated in a field, one playing the lute. Opposite sits a woman, unclad, holding a flute. A second nude woman stands near by, drawing water from a stone cistern in a crystal ewer. Beyond are trees, a farm and a shepherd with his flock.

We know enough about Venetian society to be sure that no such gathering as this ever took place. Giorgione is clearly painting an imaginary idyll. Going a step farther than any previous artist, he has merged the nudity familiar to him from Greek art with an actual pleasure outing in Venezia. He has blended two worlds into a third, which has no actual existence yet being so harmoniously constructed imposes itself more lastingly than either. Botticelli had done this, in the service of Christianity, with *The Birth of Venus*, but here there are no religious overtones. There is indeed a ripeness about the female bodies which at the hand of any other artist might have become sensuality. But Giorgione stops short of sensuality: Venus is not yet the goddess of pleasure. It is noticeable that the men do not look at the women, and the standing woman turns quite away. The men and women are not really in relationship. This is because Giorgione's approach is wholly aesthetic. He is interested in the nude primarily

as a beautiful object, and can treat it as dispassionately as the swelling trees beyond.

The artist who brought to birth Venus the goddess of pleasure was a younger contemporary of Giorgione, by name Tiziano Vecelli. Born about 1487 in the mountain village of Cadore, seventy miles north of Venice, Titian inherited from his forbears—mainly farmers and soldiers—a robust constitution, immense energy, thrift and down-to-earth common sense. Sent at the age of nine to the home of an uncle in Venice, he served his apprenticeship under the mosaicist Sebastiano Zuccato and Giovanni Bellini. He turned down an invitation from Bembo to go to Rome as court painter to Leo X, probably because he hoped to become official painter to the Republic. This ambition he achieved in 1516, succeeding Bellini, who died in that year, as 'broker' in the Fondaco, an undemanding post which brought in 100 ducats a year. In 1525 he married a lady named Concilia, who bore him a daughter and two sons. He himself had been named after a saint—S. Tiziano of Oderzo—but to his children he gave the resoundingly classical names of Lavinia, Pomponio and Orazio. When Concilia died in 1530 Titian was very much saddened and did not remarry: his sister Orsa kept house for him. Meanwhile he was becoming rich, and obtained for his father a good job as inspector of iron mines in Cadore.

Titian's versatility was such that he could paint with equal ease classical subjects, portraits and religious scenes. In 1518 he painted for the Franciscans an *Assumption*, in which the movement skywards of the Blessed Virgin is both convincing and stirring. The good friars, accustomed to static Madonnas by Bellini and Giorgione, at first refused to accept it, and only changed their minds when everyone hailed the composition as masterly. Titian's religious pictures reveal piety, but no profound spiritual insight: it is significant that he once boasted of 'making upwards of 2000 scudi' out of Mary Magdalen. As a portrait-painter, however, his insight is unequalled at this time. Great princes sat to him, including Charles V who, with his heavy lower jaw, knew himself to be ugly but claimed that his portraits made him uglier still, so that visitors were even pleasantly surprised. From this stricture, however, the Emperor excepted Titian, and in 1533 he created him Count Palatine and Knight of the Golden Spur.

Titian treated princes as equals and declined to finish a painting unless payment was forthcoming, preferably in gold. He led a happy, full, sociable life with such friends as Aretino and Sansovino right up to the solemn age of eighty-nine.

Titian developed the nude from the point where Giorgione had left it. The earliest of a series of masterpieces on this theme he painted for Niccolò Aurelio, Grand Chancellor of Venice, probably about 1513. The picture is first mentioned, in a Borghese inventory of 1613, as *La beltà ornata e la beltà disornata* (*Adorned and Unadorned Beauty*); a more familiar title, *Sacred and Profane Love*, dates only from 1700 and is misleading. Two women are seated on a sarcophagus, with a boy between them. She on the right is derived from a classical nereid riding a sea beast, but the position of her right arm follows Giorgione's *Concert champêtre*. Indeed the picture is still largely Giorgionesque: figures separated by a marked interval, looking in different directions, and blending with the landscape. The colours however are richer. Both women's hair is 'Titian', the body of the nude golden, her mantle red.

Titian's painting was intended to evoke a well-known Venetian novel of the day, *The Dream of Poliphilo*, and to understand the painting we must consider the novel. Its heroine is a beautiful, somewhat cold girl named Polia. In fulfilment of a vow of chastity, taken when stricken by the plague, she is serving in the temple of Diana. Here she is visited by her childhood friend and former suitor, Poliphilo, who begs her to leave with him. Polia however rejects Poliphilo cruelly. Afterwards she feels some remorse. She is carried by a storm into a wild forest where she witnesses Cupid in the form of a young man quartering two naked girls with his sword. Another storm carries her home to bed, where she dreams that two monstrous men attack her and pull her blonde hair. She tells her nurse of these experiences and is advised to abandon her coldness. She then decides to dispense herself from her vow of chastity and leave the service of Diana. Poliphilo helps her to escape, and the two take refuge in the realm of Venus, where they prepare for their wedding. They are led by nymphs to an inner sanctuary centred on a marble sarcophagus adorned with reliefs, containing the ashes of Adonis and water. This is the place where Venus saw Adonis being flogged by

The sarcophagus of Adonis, from *The Dream of Poliphilo*

the jealous Mars; the goddess ran out of her bath to help Adonis and in doing so pricked her leg on the thorns of a white rose-bush. The roses then became red. Every year, say the nymphs, on the anniversary of Adonis's death, Venus comes out naked from the basin of water and, accompanied by her son, transforms the white roses into red. Polia has meanwhile gathered flowers to adorn Poliphilo and is asked by the nymphs to tell her story: 'how you, who always despised love, have been won to love.'

In Titian's picture Venus has actually arrived in the sanctuary—as she does at the end of the novel—and is seated beside Polia on the sarcophagus of Adonis. One of the reliefs shows an unbridled horse,

symbol of passion; the other, following a woodcut in Aldus's edition of the novel, shows Adonis being flogged by Mars. Between the reliefs is the coat-of-arms of Niccolò Aurelio. Growing in front of the sarcophagus is henbane, a well-known narcotic. Its presence in the foreground is intended to show that what is happening, like everything else in the novel, is nothing but a dream. Venus's gesture is clearly a call to love, a call that Polia has already decided to heed: hence her crown of *myrtus conjugalis*. The house in the background and the rabbits, a symbol of fertility, evoke the family life that will follow her marriage to Poliphilo. The picture might well be entitled *The Call to Love*.

In 1516 an important influence entered Titian's life in the person of Alfonso d'Este, Duke of Ferrara, the old enemy of Julius II. Alfonso was a fierce-tempered man of great physical strength who would spend whole nights in the marshes of Comacchio, tracking wild boars in the roughest weather; but he was also a perceptive patron of the arts. He built the sumptuous marble villa of Belvedere on an island in the Po and sought to enliven his grim family castle with joyful paintings in the classical style. One room in particular, his study, he wished to hang with mythological scenes, to compete with the famous study of his sister Isabella d'Este in Mantua. In 1514 he had invited Giovanni Bellini to paint for one of its walls a *Feast of the Gods*, and two years later was searching for further subjects. His sister had lent him 'a certain booklet by Philostratus which treats of painting', as we know from two letters in which she tried to recover her precious volume, and here Alfonso did eventually find a suitable subject. He passed it to Titian, from whom he had already commissioned pictures, together with a canvas of the size required. Titian's reply, dated 1 April 1518, has survived: 'Having read and noted the contents [of your letter], I considered them so pretty and ingenious as to require no improvement of any kind; and the more I thought it over, the more I became convinced that the greatness of art among the ancients was due to the assistance they received from great princes content to leave to the painters the credit and renown derived from their own ingenuity in commissioning pictures.' Due allowance made for Titian's well-known courtesy, it must be admitted Alfonso deserves the compliment, for

he had divined Titian's ripening gifts and found a subject to match them.

The text Alfonso sent Titian was Philostratus the Elder's description of a certain painting in a house outside Naples: 'The stream of wine which is on the island of Andros, and the Andrians who have become drunk from the river, are the subjects . . . the men, crowned with ivy and bryony, are singing to their wives and children, some dancing on either bank, some reclining. . . . Probably the theme of their song is . . . that this river makes men rich, powerful in the assembly, helpful to their friends, beautiful, and four cubits tall.'

To this text Titian adhered closely when, between 1518 and 1519, he painted the *Bacchanal*. In the shade of trees, within sight of the sea, a dozen men and four women are holding a drinking party. Wine runs literally in a stream, and is drunk in shallow antique drinking cups. But, as in Giorgione's *Concert champêtre*, the ancient and modern worlds overlap: the pitchers are of fine Venetian crystal, two of the women wear Italian dress, and the sheet of music on the ground is a French drinking song: '*Qui boit et ne reboit, ne sait que boire soit*'—doubtless introduced at the request of Alfonso, who was a Francophile. Reclining musicians, one with a flute, compose the foreground, and behind them three men and a maenad-like girl join hands in a dance. The girl's eager, pulsing body, and the sidelong glance she throws at one of her partners sum up the mood of revelry. Apart from its incidental activity, the picture has a definite movement from darkness to light, from the earthy, grotesque shapes on the extreme left through the music and graceful dancers to the recumbent Bacchante on the right, her head thrown back in ecstatic sleep. Titian, a master of detail, emphasized the theme of wine in two telling touches: almost in the centre of the canvas a crystal ewer of wine is held aloft by a reveller, who gazes at it in reverence, admiring its colour perhaps and its power. The other detail, copied from a classical relief, is a small boy, crowned with leaves, calmly making water amid the revellers—a detail incidentally which also adds to the scene a note of innocence.

The recumbent Bacchante has a curious history. In 1505 Perugino painted for Isabella d'Este's study a *Combat of Love and Chastity*. The picture failed to please her, but it contains one beautiful and unusual

figure: a prostrate nymph, taken prisoner in the battle, being dragged away by the hair. In the same room hung Lorenzo Costa's *Triumph of Comus*, likewise containing a prostrate figure. Evidently Alfonso asked Titian to include a nude like these, for in autumn 1519 Titian paid a quick visit to Mantua in order to see Isabella's paintings, and to his sleeping Bacchante, a prisoner of wine, he has given a pose deriving from Perugino's prisoner and Costa's nymph.

Its variety of strong yet graceful postures gathered into a single élan make the *Bacchanal* a landmark in painting. But it is also a landmark in the history of the human spirit. More even than Florentines, the Venetians recognized the dual nature of man, and the rights of the body no less than those of the soul. Here Titian shows himself a true Venetian. He is celebrating less a particular piece of revelry than that curious phenomenon, human joy. He shows it to be an earthy, grape-given thing, yet not totally or even predominantly earthy, since it soars into music, dance and love. This radiance of joy, such is Titian's sureness of touch, seems almost inevitable. Yet just how difficult it was to achieve can be seen by comparing the *Bacchanal* with Bellini's *Feast of the Gods*, where the feasting deities are solemn as grave-diggers, with Piero di Cosimo's *Misfortunes of Silenus*, where wine is seen in terms of orgy and grotesqueness, or with a *Bacchanal* by Alfonso's favourite court painter Dosso Dossi, where revelry topples into lewdness: one of the women places her hand suggestively on the thigh of a nude man. Titian's tone is quite different. Himself physically strong, he knows how to carry his wine, to use it as an instrument of happiness, indeed of civilization, for the Greek legend tells that Bacchus introduced the grape and civilization at one and the same time to the peoples of Asia. He portrays the physical abandonment, but also, overriding it, exaltation of the spirit. In thus depicting the radiance of human joy he reclaimed for Christian civilization a whole area of experience long shunned as marshland.

Titian was commissioned to paint a final picture for Alfonso's study, but he now had more orders than he could deal with and kept delaying. Prompted by Alfonso's curt reminders, he finally came to Ferrara in January 1523 to complete and deliver the picture. The kind of rations he and his assistants received in Ferrara is known from

an account book: salted meat, oil, salad, chestnuts, oranges, cheese and just a little wine—Spartan fare on which to wax ecstatic. The text this time was the 'Epithalamium of Peleus and Thetis' by Catullus, a copy of whose poems Titian is known to have possessed, certain details being supplemented from Ovid's *Ars Amatoria*. Catullus describes how Bacchus arrived in Naxos, where Ariadne was living after being deserted by Theseus, and how, burning with love— *incensus amore*—he flew through the air seeking the princess. Catullus uses the word *volitabat*, which Titan has translated into a flying leap wonderfully expressive of the god's frenzied passion. Bacchus is followed by his suite, 'Some waving thyrsi with shrouded points, some tossing about the limbs of a mangled steer, some girding themselves with writhing snakes'. The last detail prompted Titian to echo the *Laocoön*: indeed that too-famous statue may be said to have visited Italian *cinquecento* painting with a plague of snakes.

Catullus also describes with verve the noise made by the procession: their tambourine, cymbals and horn. These Titian dutifully paints, but he adds a much more telling touch in the shape of Ariadne's small dog: it is the dog's barking we seem to hear, as he tries in vain to keep off the clamorous intruders. Ariadne's fear is well suggested by a fallen vase and the gesture with which she gathers up her mantle; by the simple device of giving her a red scarf which echoes Bacchus's red cloak Titian suggests their eventual union. The crown of stars in the sky is the one given by Bacchus to Ariadne at their marriage, and afterwards placed among the stars for all to see. It is an important element in the picture: here as in his *Bacchanal* Titian is suggesting that passion is merely part of a larger harmonious whole.

In 1545, at the age of fifty-eight, Titian visited Rome for the first time. He was shown round by that best of cicerones, Vasari, and said he regretted not having come twenty years before. At the invitation of Pope Paul III he stayed in the Belvedere, and among the classical works he saw there was evidently a Cupid after Praxiteles, arms raised, as if he had just used his bow. When Titian received a commission from one of the Pope's grandsons to paint a *Danaë*, he introduced this Cupid into the picture, reversing the action of the legs and body, and altering the turn of the head.

The figure of Danaë herself probably derives from Michelangelo's *Night*. As early as spring 1535 Aretino had received from Vasari drawings of the Medici tombs; these Titian would certainly have studied, and his memories of them were doubtless reawakened by nudes in the Belvedere. Titian reversed and slightly unfolded Michelangelo's figure; he also softened the pose by drawing back the head, and laying the right arm easily on a snow-white cushion. But the mood is totally different: while the figure of Night is darkly tense, Titian's *Danaë* is relaxed and glowing.

The most original feature of the *Danaë* is the slanting position Titian gives her body; the head is made subordinate to the throat, abdomen and prominent thighs. This increases the picture's voluptuous quality. At the same time Titian makes her body very tall—it measures ten lengths of the head instead of the usual seven. Since tallness lends a spiritual, soaring quality, Titian's *Danaë* is to a rare degree both voluptuous and spiritual. As a figure of acceptance, not only of the golden rain, but of life itself, she touched a responsive chord in contemporary feeling, and Titian was commissioned to paint her again in several versions.

Vasari brought Michelangelo to see the *Danaë*. The grizzled old sculptor praised it highly but added that it was a pity good draughtsmanship was not taught at Venice. The heart of the difference between Florentine and Venetian art lies in this remark. For Florentines the basis of art was line, expressive of intellect; for the Venetians it was colour, expressive of a sensuous response to reality. Yet there was nothing improvised about Titian's use of colour. Palma Giovane tells how Titian began his pictures with a mass of pigment, such as red-ochre or white, which served as a bed or foundation: on this 'with the same brush, which he dipped in red, black or yellow, he created the plastic effect of the light portions. With four strokes he could indicate a magnificent figure.' He then turned the picture to the wall. Later, sometimes months later, he would turn it right side up and 'like a surgeon setting a bone', correct any fault of anatomy. 'This quintessence of a composition he then covered with many layers of living flesh. . . . In the last stages of the work, he painted more with his fingers than with the brush:' an

earthy touch for which Michelangelo would surely have felt sympathy.

While in Rome Titian painted one of his greatest portraits, and since the main person portrayed in it was to convoke the Council of Trent it may be considered here in passing. This is *Paul III with his Grandsons*. The Pope, aged seventy-seven, sits hunched in his armchair in the Vatican. His narrow shoulders are enveloped by a red cape and over his shrunken head a red cap comes down almost to his eyebrows. With his long white beard and the lynx lining of his sleeve he looks like some small furry animal. On the table beside him stands an hour-glass, suggestive of the short time remaining to him. Behind the Pope stands Cardinal Alessandro Farnese, a tough-minded prelate who built the vast Villa Caprarola. On the Pope's right is Ottavio Farnese, who commissioned the *Danaë*. He is shown in profile, bowing one knee, a black-plumed hat in his gloved hand, his fingers on the sheath of a rapier, as sleek a courtier as ever prowled a palace corridor. He is evidently requesting a favour, and the drama of the picture lies in the confrontation between his worldly obsequiousness and the strong clenched hand with which the Pope grasps his armchair.

There had been portraits of the Pope with advisers as far back as Sixtus IV. But this is more than a portrait: it is a hieroglyph of nepotism. Titian, a Venetian to the core, was not afraid to speak his mind on this point, which was very much in the air in 1545, when the Pope gave his natural son, Pierluigi Farnese, the dukedom of Parma, thus adding one more knot to the already tangled problem of the temporal power, and tried to obtain Milan for Ottavio. It is hardly necessary to add that the picture did not please the Pope and it was hastily put out of sight in Naples. Had it remained in the Vatican it might have served as a salutary reminder to the next Pope but two, Paul IV, whose nepotism went beyond all bounds until it even embroiled the Papacy in war with the Spaniards.

In March 1546 Titian received Roman citizenship and in June returned to Venice. He still had thirty years' work before him, much of it in the form of classical '*poesie*', as they were called, for King Philip II of Spain. He continued indefatigable right into his last years, though it is said that he began to retouch, and spoil, certain

pictures painted in his youth. His pupils hit on a scheme for preventing this. They mixed olive oil among his colours, and because olive oil does not dry, when Titian had gone on to some other task it could be washed out again afterwards. In this way, we are told, many good pictures were preserved. Though he assured Philip II that he was poor, Titian enjoyed a considerable income from three cottages, two saw-mills, and twenty-three fields, not to mention pensions from Spain and Milan. His house was visited by the famous, including Vasari, who concluded rightly enough that Titian had 'received from heaven only favours and blessings'. In the summer of 1576 Titian died of the plague and, wrapped in his Count Palatine's cloak, was buried in the chapel of the crucified Saviour, at the Frari, for which he had been preparing his last picture.

Artists of towering genius more often have imitators than successors, and it is a measure of Venetian vitality that Titian should have been followed by two prolific painters, each with a distinctive personal style. The lesser of the two, Paolo Veronese, was a stonemason's son who lived from 1528 to 1588. He had a gift for colour, notably wine-reds and the green that bears his name. He could paint pleasing country scenes, like those in Palladio's Villa Barbaro, but he excelled at sumptuous Biblical feasts, such as the vast *Marriage of Cana*, and scenes of crowded pageantry. In 1556 he won the competition for the ceiling of Sansovino's Library, adjudged by the architect and Titian. In rendering his plump, pearly-fleshed women he shows no psychological insight, and prefers to deck them out in rich silks rather than portray them nude. In general Veronese, for all his verve and love of life, lacks that spiritual awareness that had marked Giorgione and Titian and which is found in his greater contemporary, Tintoretto.

Jacopo Robusti was born probably in 1518 or 1519, the son of a prosperous silk-dyer, hence his name of Tintoretto, the Little Dyer. He was apprenticed to Titian, but after ten days left to continue his training alone. In 1548 he painted his first considerable picture, *St Mark rescuing a Slave*, which Aretino made famous in one of his influential letters. About 1555 he married Faustina dei Vescovi, who was of patrician family and evidently also richer than her husband, for it was she who gave Tintoretto his spending money and

demanded an account of it. She also insisted that whenever he went out he should wear the long cloak, distinctive of well-bred Venetians. She bore him at least eight children, of whom his favourite was Marietta. As a child Marietta mixed Tintoretto's colours, and accompanied him wherever he went, dressed as a boy, until she was sixteen. Later she became a good portrait-painter and worked as her father's assistant. Unlike Titian and Veronese, Tintoretto had no taste for display and gay society. He led a quiet life with his family in an unpretentious house near S. Maria dell' Orto, and left Venice only twice. Marietta died young, in 1590, and Tintoretto followed her to the grave four years later.

As a young man Tintoretto was reproached by Aretino with being proud: a better word would probably be independent. He had his own vision of things and intended to keep it intact: in doing so, his quick temper sometimes blazed up. His other characteristic, which he shared with Titian, was a tireless capacity for work. In early life he offered to paint murals at cost price, and his most important commission, the decoration of San Rocco, he secured by actually painting and putting in place a complete panel instead of submitting a mere sketch like other competitors. A contract exists in which he promises two large historical pictures and seven portraits in two months. Towards the end of his life he was helped by Marietta and three of his sons, but even so he himself painted more than 300 pictures, including a colossal *Paradise* for the Hall of the Great Council, which measures 30 by 94 feet, and contains some 600 figures. Inevitably in such a prodigious output the quality is uneven.

Tintoretto's education consisted of studying the human body from life and in the dissecting-room, and of copying casts of works by Michelangelo, Jacopo Sansovino and Giovanni Bologna. Also, according to Ridolfi, his seventeenth-century biographer, 'he practised by making small wax and clay models, dressing them up with bits of material and carefully studying the contours of the limbs with the folds of the draperies. Some he also set up in small houses and in perspective scenes made of wood and cardboard, and by placing small lamps in the windows he introduced lights and shadows.' Tintoretto was thinking in terms of stage design,— naturally enough, since drama was very popular in Venice just then:

devotees would swim canals and scale walls in order to attend a favourite performance. In almost every one of Tintoretto's works there is drama.

A second distinctive feature of Tintoretto's style is that he crowds his sky with heavenly figures. Evidently he derived this habit from the many ceilings he painted. His earliest recorded work, in 1545, is a fresco ceiling of *Apollo and Marsyas* for Aretino, while Ridolfi tells us that Tintoretto 'hung models by threads to the roof beams to study the effect they made when seen from below, and to get the fore-shortenings of figures for ceilings.'

Tintoretto is said to have placed a sign on his studio: '*Il disegno de Michel'Angelo, et il colorito di Titiano.*' This is a fair description of his first big success, *St Mark rescuing a Slave*. The figure of Mark striking down with his right arm is obviously derived from Michelangelo's *Conversion of St Paul*, while the rich colours—cherry-red, orange, blue and green—are favourites of Titian. But the studio sign became less and less valid as Tintoretto developed and evolved for himself a new style in which the most important element is light.

It was natural that Tintoretto, born and bred in Venice, should have felt the influence of the most distinctive works of art in the city, the mosaics of St Mark's and Torcello, where multi-coloured figures catch the sun on a background of gleaming gold. Where Duccio and others had used merely the gold background, Tintoretto uses the figures aglow with light, translating them into terms of sixteenth-century painting, and treating light as a symbol of God's grace. We see this in a picture of *Susannah and the Elders* painted probably around 1550. Susannah is seated in the shade of a tree, screened by a rose-covered hedge. One leg is dangling in the water, the other she dries with a fringed towel. Beside her are a silver canister, an ivory comb, a pearl necklace, a hairpin, rings, and her dress. Her attention is directed at her looking-glass and she does not notice two old men who furtively peer at her from either end of the hedge. In the background is a pool of water, with ducks, bordered by saplings, and, above, a thin line of creamy sky.

Susannah's hair is braided like spikes of corn and from her ear hangs an unmounted pearl. But her real affinity is with the water and sky. She seems to belong to both, to form a link between them.

Her body catches the light like crystal, or rather light shines from it, as from an alabaster lamp. This light is not only pleasing in itself but is an image of Susannah's innocence, of her grace in the theological sense. This is a new dimension in the treatment of the female body. Giorgione's nudes are at peace with nature, Titian's exult in nature, but Tintoretto's go beyond nature to the supernatural.

Tintoretto painted one other great picture of nudes, the *Liberation of Arsinoë*, in which a knight in a gondola rescues two women from prison. But the fashion for female nudes was waning. Most of Tintoretto's commissions came from the confraternities—groups of Venetian notables who wanted religious pictures for their church and hall, where they met for discussion and prayer. Had he wished, Tintoretto could doubtless have worked for Italian and foreign courts, like Titian, but evidently he preferred religious subjects. A remark made towards the end of his life is revealing. He said that he was glad to be painting the *Paradise*, for it might well be that 'the paradise I long for after my death will be withheld from me.' This is the remark of a man who has been influenced by Protestant teaching on predestination, who is deeply aware of sin and grace: a man who lives between trembling and hope.

Awareness of the spiritual lies at the root of Tintoretto's conception of space, in the technical handling of which he is as much an innovator as in his treatment of light. That limited, harmonious space, with man at the centre, which had been the great achievement of fifteenth-century Italian painters, did not satisfy Tintoretto. Perhaps he found it too comfortable. Instead he sought vast, unusual perspectives, seen from an unexpected viewpoint—up a flight of stairs, down from a balcony, or sideways along a plunging curve. For Tintoretto space is man's link with heaven. And so it is vertiginous. It is at once terrifying and full of hope, for space is the element of the supernatural. From space, at any moment, may burst forth saints, angels, and miraculous happenings in general.

Between 1562 and 1566 Tintoretto painted for the Scuola di San Marco three pictures of miracles performed by St Mark. All are remarkable for their rendering of the male nude and for dramatic action, but the one which best illustrates Tintoretto's distinctive treatment of space is *The Finding of the Body of St Mark*. In 829 two

Venetian merchants, Buono and Rustico, determined to rescue the body of St Mark from a basilica in Alexandria, before it fell into the hands of the Caliph, who was planning to pillage all Christian churches. They dug the body up by night, hid it in a basket under a layer of herbs and joints of pork, and carried it by camel on to their ship under the very noses of customs officials, to whom pork was repulsive.

The setting of Tintoretto's picture is a long vaulted hall in the basilica. Buono and Rustico and others in on the secret are uncertain where exactly the Saint is buried. One dead body has already been removed and lies on a rug; another is being lowered from a wall tomb. On the left St Mark appears and with raised arm makes clear that the quest is over, that the body being lowered is his. A bearded man in cloth of gold—the donor, Tommaso Rangone—kneels humbly before the Saint, while on the right a miracle takes place: at St Mark's appearance the devil departs from a man possessed in a cloud of smoke.

In the background two men examine a crypt with torches, and it is these that illuminate the vault, the other main source of light being the Saint's glorified body. The torchlight coming from beneath is itself unusual and unexpected: it lends an intangible quality to the whole hall, and indeed to the people in it. The composition is a series of rapidly receding diagonals, the curve of the vault cunningly matched by the curved supports of the wall tombs, and the general movement is upward. Nothing appears frontally or uncompromisingly. How different this is from the calm world before Luther shattered man's confidence in himself can be seen by comparing this work with, say, Piero di Cosimo's *Building of a Palace*, painted about 1500. In Piero's picture man is in total control; his buildings are solid, four square, perfectly proportioned, and he finds himself imaged in them. There is no vertiginous space to disturb them, for here it is man who measures and delimits space. In Tintoretto's picture harmony has been superseded by something more urgent. Despite the title, the general impression is of disembodiment, of matter under the action of grace dissolving into spirit. It is a vision unknown to the ancients, and in order to express it Tintoretto has had to break with classical art.

In the Scuola di San Rocco, where Tintoretto painted eighty pictures between 1564 and 1587, space and light are pressed still farther into the service of a religious vision. In *The Last Supper*—a favourite theme at a time when transubstantiation was being questioned—the table is placed diagonally, and Christ relegated to the far end, in a daring suggestion of the divine humility. In *St Mary the Egyptian* light seems to drip from the palm fronds into a stream below, like a benediction on the penitent Saint; in *The Baptism of Christ* the nude figure of Christ is even more suffused with grace than Susannah's had been, but now a chief protagonist is the sky, that Venetian sky to which Titian had first opened men's eyes and which is described in a letter to Titian by Aretino. Looking out on the Grand Canal, Aretino observed that 'the houses, though of stone, appeared phantasmal. The air in some directions looked transparent and alive, in others thick and dead. . . . In the middle distance clouds seemed to touch the roofs, while other clouds retreated far away. To the right they resembled a poised mass of greyish-black smoke. I was amazed at the variety of their hues. Those near at hand burned like fiery suns. Those in the distance glowed dully, like half-molten lead.' In the *Baptism* Tintoretto has depicted just such a sky, and although there are no phantasmal houses, the people standing on the river bank are indeed phantasmal. They have as little substance as cobwebs hung with dew. Certain saints are said to have possessed the gift of looking into a man's soul, of being able, so to speak, to smell his moral nature. Tintoretto approached the world somewhat in this way. Here he shows the heavens opening and earthly things revealed for what they are. Using the silvery greys and pale blues he had inherited from the aging Titian, Tintoretto goes beyond appearances to depict the inner silvery veins of grace. In perhaps a dozen pictures he succeeded in making a continuum of earth and sky. In doing so he was giving expression not only to his own temperament but also to an enduring strain of religion in the Venetian character. This it is now time to examine.

The Response to the Crisis

THE VENETIANS, with their long tradition of intellectual freedom and political independence, were peculiarly fitted to act as a reforming influence on the Church in Italy. This role they fulfilled in the sixteenth century with considerable zeal. Sensitive to the dangers as well as to the benefits inherent in Christian humanism, a series of earnest reformers sought to rid the Church of simony, ignorance and Caesarism, as well as to meet the challenge from Germany. The life of one of them, certainly the most versatile and among the most gifted, admirably illustrates the first—what may be called the Venetian—phase of the attempt to answer the crisis of the Renaissance.

Gaspare Contarini was born in 1483 into a family which had produced seven doges and four patriarchs. Physically impressive, with a big forceful-looking head, domed brow and calm serious eyes, he combined a warm nature with a keen intelligence, while in his high moral ideals and gift for friendship he resembled his contemporary, Sir Thomas More. At Padua University he studied science and philosophy, steeping himself in Aristotle—friends claimed that if the Stagirite's works were lost Contarini could supply them all again from memory—and writing two books to show that immortality of the soul could be proved by reason. Returning to Venice in 1508, he was employed by the Government as a senior engineer: he conducted a cadastral survey, he built an aqueduct at Bassano and dykes to control flooding of the Adige. When he was twenty-eight he underwent a spiritual crisis. It seems to have been caused by reading St Augustine on grace and by the entry into a monastery of his two closest friends. His experiences, which he described in a series of heartfelt letters, are not unlike Luther's. He wanted to become holy,

constantly tried, and no less constantly failed. His failure cast him into near-despair. 'Suppose I underwent every imaginable penance and more besides, that would still be insufficient to make me a great saint, it would not even compensate for my past misdeeds.' He believed that the salvation of his soul, unobtainable through penance, could only be found through grace, authentic grace, which Jesus Christ has dispensed to those who are united to him by faith, hope and 'that modicum of love of which we are capable'. Should he enter a monastery? 'It is too difficult for a man of flesh and blood to renounce sense experience and turn to the contemplation of God . . . we must, as Augustine says, love and worship God in our neighbour.' But he was still tormented by doubts and fears. He fell into so deep a melancholia that he could not even read his favourite *Song of Solomon* and *Proverbs*. During much of 1512 he lay ill. Next year he steadily recovered, and plunged with admiration into Augustine's work on the Trinity. In 1516 he wrote a booklet entitled *Duties of a Bishop*, based on his memories of Pietro Barozzi, Bishop of Padua during his student days, in which he expressed his belief that the Church could be reformed through the inner renewal of men according to the spirit of truth and grace, which the Church had never lost and—despite present corruption—still dispensed. So that although Contarini underwent a crisis of the same kind as Luther's—and at the same date—his background and scientific training led him to different conclusions. He valued good works too highly to make Luther's total committal to inwardness, while his Venetian respect for law and the established order kept him loyal to Rome.

In 1520 Contarini was appointed Venetian ambassador to Charles V. During his term of office Magellan's ship, the *Victoria*, returned from her voyage round the world, laden with cloves from the Spice Islands. She docked a day later than her log-book showed, and Contarini alone was found able to explain what had become of the missing day. On another occasion two Venetian businessmen were arrested in Murcia for having imported and sold an 'unorthodox' book, Rabbi Solomon's Bible in Latin, Hebrew and Chaldaean. Contarini hurried to their defence, declaring that in Italy, as in most Catholic countries, people were allowed to read hostile authors,

Averroës for example, in order to refute them, since to refute from blind ignorance would be ineffectual and unjust; and Rabbi Solomon's Bible was often quoted by Aquinas, Nicholas of Lyra and other Catholic teachers. Contarini got the prisoners off with a nominal punishment—walking round a certain church holding lighted candles—but writing home he pronounced the Holy Office 'a terrible institution'. He proved a highly efficient ambassador and his term of office was extended.

Contarini returned to Venice in 1525 and while continuing to hold important appointments became the leader of a group of humanists bent on Church reform. One of the group was Bishop Gianmatteo Giberti, Pope Clement VII's political adviser, who after the Sack of Rome broke with the Curia, went to live in his diocese of Verona and turned it into a model see. Giberti founded a Society of Charity to tend the destitute and the Accademia Gibertina, prototype of the seminary, which brought together scholars in the loggia of the Bishop's palace, overlooking the River Adige, in order to study the Greek Fathers and to write Christian verse. Marcantonio Flaminio, whom we met in Leo's Rome as a poet of Diana, lived in the Spartan surroundings of Giberti's house for ten years, and there rendered the Psalms into prose and verse. We have already seen Laura Battiferri doing this: it was a familiar outward sign of a conversion from classical to early Christian ideals. Others in the movement were Reginald Pole, a kinsman of the King of England and a student at Padua from 1521 to 1527: he too sought a rebirth of Christian piety in the study of the early Fathers; and Pole's close friend, the Platonist Jacopo Sadoleto, an endearing figure with dreamy eyes and drooping moustache who wished to see the Church admit her responsibility for past abuses and on that basis seek reunion with the Lutherans. All these men were scholars of a retiring disposition—Giberti's voice was so weak that he could not preach, Pole consistently speaks of himself as though he were a hunted deer running for the shelter of a cloister, while Sadoleto buried himself when he could in his see of Carpentras; Contarini, while sharing their ideals, differed from them in being a man of action. Inevitably he became their leader.

In 1535 the new Pope, Paul III, performed one of the most hopeful

actions of an ill-fated century by giving the red hat to men who deserved it, among them Giberti, Pole, Sadoleto and Contarini. The choice of the Venetian caused much surprise, for he was still only a layman. However, swallowing his earlier doubts, he took orders without delay and hastened to Rome, where Pope Paul chose him to head a nine-man commission, its purpose to advise on Church reform.

Contarini's report, issued in February 1537, is the most outspoken denunciation of abuses ever made by a papal commission. It attacked non-residence of bishops, and stipulated that only men of blameless life should in future be consecrated. All monasteries that had become corrupt should be allowed to die out, and no new Orders founded. In the core of the report, Contarini rejected Curia teaching that the Pope's will is law. 'This is the Trojan horse out of which all the abuses and diseases have crept into the Church of God, and so it is through our guilt, ours I repeat, that the name of Christ is blasphemed among unbelievers.' In a characteristically Venetian argument Contarini declared, 'The law of Christ is a law of freedom, and it is contrary to that law to subject Christians to a leader who would enact or annul decrees at will.' 'A Pope may not sell what is not his but God's. He may not do it even to finance a Crusade or to ransom Christian prisoners, or for any other pious purpose. St Paul says it is wrong to do something evil in order to obtain something good, and all theologians and philosophers agree with him.' Machiavelli's *Prince* evidently had not come Contarini's way.

Paul III had been a cardinal for forty years and was now aged sixty-nine. Although he said he welcomed Contarini's report, he was too much the child of an earlier generation to act on its advice. For one thing, abolishing the sale of benefices and dispensations would have halved his revenues, and Farnese liked the luxuries of life, both for himself and for his greedy grandsons. He ordered a bull on episcopal residence to be drawn up but it was never published, partly because bishops protested that living in their dioceses would be tantamount to living in the poorhouse. However, Contarini's work was not forgotten and many of its recommendations, though not those curbing papal power, were later to be made law at Trent.

It says much for Contarini's tact that in 1541 Paul III appointed

him as his personal representative at an important dialogue to be held in Regensburg between Catholics and Protestants. In late January Contarini left Rome and to the dismay of his suite pressed straight on across the snowed-up Apennines. Like Pole and Sadoleto, he felt optimistic about this last throw for unity and repeatedly told the Pope, 'On essential points there will be no major divergence of views.' At Regensburg he made a promising start. Every morning before the six-man commission met he had an hour's talk with the Catholic members, guiding them in the attitude they should take to the agenda, as well as moderating the violent and now apoplectic Dominican, Eck. According to one eye-witness, 'he displays the greatest gentleness, wisdom and learning, so that even his opponents are beginning not only to love but to reverence him.' Largely thanks to Contarini, the commission reached agreement on the first four articles, concerning sin and free will.

A thornier problem was man's justification, that is, how he comes to be freed from the penalty of sin. This of course had been the main point at issue in Luther's original protest. Contarini, in the light of his experiences as a young man, was deeply sympathetic to the Lutherans when they said that justification was an absolutely free gift from God. Finally Contarini approved a two-tier formula which declared that there are two kinds of justification: one the result of Christ's grace, which co-operates with man in the performance of good works, and the other, a higher kind, the result of faith. This satisfied the Protestants but was bitterly criticized as too large a concession to 'inwardness' by Contarini's enemies in Rome.

The next controversial question was the Eucharist. The Lutherans said they rejected Catholic doctrine that the substance of bread and wine was changed into Christ's body and blood. This came as a surprise to Contarini, because no such declaration occurred in the most authoritative Lutheran statement of faith, the Confession of Augsburg, drawn up eleven years before. Charles V, desperate for a settlement, proposed that the commission should simply declare that Christ is really and personally present in the Blessed Sacrament, leaving a precise formulation to be made by the Council when it met. Despite his longing for agreement, Contarini could not bring himself to do this. He would not, he said, place in doubt a truth

clearly expressed in the words of Christ and St Paul and 'confirmed by every theologian and doctor of the Church, ancient and modern.' When charged with making a fuss about one word—transubstantiation—he replied that at Nicaea too the debate had turned on a single word—*homoousion*: 'of the same nature'—which yet embodied a fundamental truth. The dialogue broke down on this question, and finally ended on 28 July with all hope of agreement gone.

Why did this happen? Why did Contarini, with the best will in the world, and supported in Rome by such able men as Pole, Sadoleto and Giberti, fail to make more progress with the Lutherans? The answer is twofold. First, Contarini like all Italian scholars of his day was miles behind the Germans in his knowledge of the Fathers. When the Protestants produced this or that unanswerable phrase from, say, St Ambrose, Contarini should have been able to place it in the context of its chapter and the book's declared purpose in order to evaluate its exact meaning. John Fisher, Bishop of Rochester, had been one of the very few Catholics to apply this method before going to the scaffold in 1535. When Protestants quoted Tertullian's statement that Christ gave his disciples the 'figure' of his body, Fisher traced the phrase to its source, a book of controversy *Against Marcion*. He found that in more considered works, such as the *De resurrectione carnis*, Tertullian clearly teaches the real presence, and so was able to situate the controversial phrase in the light of Tertullian's theology as a whole.

The second part of the answer is less a personal failing of Contarini's than a failure of the age. Though Christendom had been bedevilled by errors for sixteen centuries she still had no adequate notion of how error arises out of historical development. The question of the real presence would probably have yielded to a historical approach: an examination of the circumstances surrounding each statement about the Eucharist from those of Christ and St Paul to the decree of the Fourth Lateran Council in 1215; of the needs each statement was designed to meet or of the heresy it was designed to combat. Other subjects on which the commission at Regensburg failed to agree—papal authority, the episcopacy, the cult of saints and monasticism—would doubtless have yielded to a similar approach. But the notion of historical development lay well in the future, though scholars

sometimes caught a glimpse of it. Sadoleto, for example, in his *Commentaries on St Paul*, hints that right knowledge of Scripture is cumulative. Each age, by further study, uncovers a fuller depth of understanding. St Augustine, says Sadoleto, had only a limited command of Greek and this reduced his capacity to understand St Paul, with the result that critical passages of the Epistles had long been misread. But Sadoleto did not work out the practical consequences of his theory, and Contarini could not benefit from it. As it was, Contarini's failure is implicit in his statement: 'the words of Christ are confirmed by every theologian ... ancient and modern'— a way of thinking which treated truth as a piece of monolithic granite extending unchanged throughout history.

Contarini returned to Italy a broken man. Dialogue, Plato's chosen way to truth in which he and his friends believed, had failed to achieve union. Worse still, because of his doctrine of double justification he was stamped by enemies as a traitor, and in July 1542 given the second-rate post of Legate in Bologna. Soon after taking it up he caught a chill, which led to high fever. His devoted secretary urged him to consult a doctor: 'The Emperor is coming soon, and you are to meet him.' 'I am going now to a greater Emperor,' Contarini answered, and in August he died. He was only fifty-nine and the long-delayed Council of the Church, for which he had toiled, was to open just three years later, in December 1545.

On the eve of this Council, which was to formulate a reply to Lutheranism, it becomes opportune to summarize the mood of Italy as it has appeared in preceding chapters. Now the first conclusion to be drawn is that though Italian achievements at this period were very great indeed, they were not of a kind to lead to an *entente*. Luther had emphasized the nothingness and loneliness of man, the feebleness of his will and the need for inwardness, and for fear and trembling in any approach to God or in interpreting His message. But the courts, as we have seen, had no use for humility such as this; to grace they preferred graceful behaviour, and their tragedies showed no real sense of a dichotomy between man and society. As for the historians, only Machiavelli viewed man as corrupt, but the salvation he prescribed was not of a kind to satisfy Lutherans. The scientists' achievement, though highly important, was not immediately

relevant to this situation. As for the artists, save Michelangelo and Tintoretto, they failed to penetrate the sufferings of Christ or the notion of grace, and set higher store by beauty than by Gospel truth. Even in Contarini's city the conservatism inherent in a patrician constitution made for religious conservatism, and it was Aretino of Venice who dismissed Luther as '*pedantissimo*'.

This was sad, but equally sad was the fact that Italian achievements were not of a kind to safeguard the principles of Christian humanism. Rather the contrary. In a situation of doubt—political, moral, artistic and theological—instead of welcoming individual responses, Italians were turning increasingly to authority and to rules. Courtiers had their handbooks on what to say and how to say it; —how to write love letters and how to blow their noses. Historians sought methods whereby the present might conform to the past. In science Ptolemy and Galen were for the vast majority still law: resistance to Copernicus's theory grew steadily from 1543, and such was the storm of criticism aroused by his *De fabrica* that Vesalius left Padua in disgust. In the arts too the authority of the ancients was codified in rules: typical was Sebastiano Serlio's *Regole generali di architettura . . . che per la maggior parte concordano con la dottrina di Vitruvio*, the first part of which appeared in 1540. In literature, Trissino wrote an epic by following Homer and Speroni a tragedy by following the rules of Aristotle. Educated men everywhere were growing uncertain of their own powers and coming together in Academies, which now mushroomed across Italy. Here Italians sought the security of respected names and the authority of a long tradition. As Lutheranism divided Europe, the lesson they drew was that any kind of innovation was extremely dangerous. Studying authors in the original could lead to error, grappling with the big problems of human existence could lead to damnation. Always more numerous than the creative humanists, these imitative humanists in their fear also became more articulate in a shrill way, so articulate indeed that they set the tone for society. In a highly perceptive passage of his *Orazione al Re di Navarra*, Sperone Speroni declares that Luther, by causing doubts among Italians, turned them more towards the Church, 'caused them to hold on to the strong high columns of the holy Catholic Church'. Instead of seeking to

lead the Church forward, they cowered beneath its mantle, demanding guidance on every subject from comets to sonnets.

Such in brief was the intellectual mood in Italy when the Council opened on 13 December 1545. It was held in Trent, on the frontiers of the Empire and away from Rome, because the Emperor hoped it would heal the Lutheran schism. The first sessions were attended by four archbishops, twenty-two bishops, five generals of Orders and two ambassadors, under the presidency of three papal legates. The Council was several times interrupted by political rivalry or war. After holding meetings until September 1547, it resumed its work in 1551 and sat until 1552; a third period lasted from January 1562 to December 1563. The final meetings were attended by 270 prelates, of whom 26 were Frenchmen, 31 Spaniards and 187 Italians. Though the town of Trent was German, the Council that met there was overwhelmingly Italian.

The Council's first task was to state as clearly as possible the nature of revealed truth and how it is known. Luther had defined it as Scripture alone, the actual text of the word of God, the correctness of any interpretation of Scripture being guaranteed by the Holy Spirit. Luther held traditions to be 'traditions of men' in the pejorative sense, since what does not have God for its author is the child of the devil. In the manner of the prophets he offered an alternative: either God alone, absolutely true, or his creature, who is a liar. This definition takes account of history to the extent that it insists on the importance of returning to the original sources but it still treats truth as something static, standing outside time.

The Council could not accept this definition. It put forward the view that revealed truth comes to us in two ways, by Scripture, and also orally. 'This truth and the rules for a moral life are contained in Scripture, which is written, and in traditions, which are unwritten, received from the mouth of Christ by the Apostles, or dictated by the Holy Spirit to the Apostles, and have been handed down to us.' Scripture and traditions are on a par, and the Church treats them 'with equal respect'. Later Paolo Sarpi, a Venetian critic of the Papacy, was to ask sarcastically: Just what constitutes a tradition? The Roman Church does not permit the ordination of deaconesses, or parishioners to elect their clergy, 'although the latter was custom-

ary in Apostolic times and current practice for over 800 years. Furthermore, communion under both kinds, instituted by Jesus Christ, preached by the Apostles, observed by the whole Church until 1416 and still observed by all Christian people, save the Latin Church, is a tradition if ever there was one, yet it is no longer permitted.' Sarpi's criticisms are justified to the extent that the Council's decree on revealed truth is poorly worded and distressingly vague. The subject had not been fully thought out. But the decree was more positive than Sarpi thought. It was a glimpse though only a flickering one, of the fact that truth is communal and cumulative.

As regards interpretation of Scripture, the Council reaffirmed the right of the Church to decide between opposing views. Scripture does not suffice in order to yield its true meaning, and only the teaching body of the Church, drawing on wisdom present and past, is qualified to judge what that true meaning is. In short, while Protestants stressed the purity of truth, the Council defended its plenitude.

The second major topic on which the Council issued decrees was the nature of man: in what original sin consists and how he is justified and sanctified. Luther and his followers had so stressed the action of God in his gift of grace that they often tended to neglect the necessary co-operation of man—a concept equally Scriptural. The Council tried to right the balance by heavily stressing the role of man, and the necessity of works, whereupon the Lutherans accused the Council of the Judaizing heresy of 'justification by works of the Law'. Once again, each side was stating a partial truth elicited by the nature of its opponent's attacks. But here a deeper misunderstanding divided the two sides. In the New Testament the word *pistis*, usually translated by 'faith', has several shades of meaning, and these, in the heat of controversy, were ignored. The Lutherans took it to mean the whole dynamic response of man to the gift of God (a meaning which includes hope and charity), while the Catholics understood it as the assent of the intellect to revealed truth. The Council, thinking of faith in the second sense, condemned the formula '*sola fide*' as heretical. What should have been condemned is inadequate philology on both sides.

So far the Council had confined its activities to strictly religious

matters. It was right that the Church should thus answer views she considered heretical by restating the truth as she saw it. But in the third and last period the Council extended its scope to spheres well beyond religion. It pronounced certain decrees which were to have the very widest bearing on the lives not only of Italians but of all Catholics, not only in the sixteenth century, but for three hundred years to come.

The man who more than any other gave the impulse in this direction was Gianpietro Carafa. Born in 1476 into one of the oldest families of Naples, as a boy he twice tried to join the Dominicans, and although prevented, he was always at heart a 'hound of the Lord'. Tall, with deep-set dark eyes, burning with energy, passionate, an incessant talker, he ate little but drank a dark red Neapolitan wine which he called his 'war-horse'. Appointed Bishop of Chieti in 1503, he took as his motto a text from St Peter: 'The time is ripe for judgment to begin, and to begin with God's own household.' His stern principles appear in his rule for the Theatines, of which he was co-founder: members were vowed to absolute poverty and, though they might receive alms, were forbidden to ask for them. As a Cardinal, Carafa consistently worked against Contarini, of whom he is the antithesis, and against the Emperor, whom he believed—unjustly—really favoured the Protestants in Germany.

It is characteristic of the new mood in Italy that such a man was elected Pope in 1555. The first in a series of reforming pontiffs, he took the name Paul IV. He was already in his eightieth year, but is described by the Florentine ambassador as 'a man of iron, and the very stones over which he walks emit sparks'. He informed the Venetian ambassador that he would skin himself and then proceed to skin others, priests as well as laymen, if by so doing he could effect a single reform. The 'skinning' began with the Jews of Rome. Reversing the liberal policy of previous sixteenth-century Popes, Paul IV shut up the Jews in an overcrowded three-acre ghetto, the doors of which were locked at night; the men had to wear a yellow hat, the women a yellow star of David. They were forbidden to own property outside the ghetto or to speak to Christians except on business.

It is a notorious fact of history that when a society finds its beliefs

threatened and at the same time is lacking in the vigour to defend them intellectually, it will seek to stir up another kind of vigour by singling out 'enemies'. It then galvanizes itself to frenzied activity through fear and hatred. So it is not surprising to find that Paul IV's detestable conduct towards the Jews was only one part of a larger whole. As early as 1542, while still a cardinal, he had persuaded Paul III to constitute the Inquisition as the 'Holy Office', and during his own pontificate he vastly extended its range of victims to include sodomites and even those who failed to observe a fast-day. He also extended the word 'heresy' to include 'simoniacal heresy', such as payment of money for administering the Sacraments, ordination of those under age and sale of benefices: offenders under these headings could now be sent to the stake. One of his Cardinals, Giovanni Morone, had unwittingly distributed a book of Lutheran tinge entitled *The Benefits of Christ's Death*, whereupon the Pope had Morone flung into prison. Reginald Pole, also suspected of Lutheran sympathies, he dismissed from his post as Legate to England. 'Heresy,' he told the Venetian ambassador, 'must be rigorously crushed like the plague, because in fact it is the plague of the soul. If we burn infected houses and clothes, with the same severity we must extirpate, annihilate and drive out heresy.' As a Greek scholar praised by Erasmus. Paul should have known that heresy was originally a neutral word meaning free choice, and therefore that his metaphor was quite inapplicable. Indeed, there seems to be something deeply irrational in the Pope's fury against heretics. It may have been partly an attempt to compensate for a family scandal: his great-nephew Galeazzo Caraccioli renounced Catholicism and in 1551 deserted his wife and children to settle in Geneva, where he became one of the pillars of Calvin's Church.

Books, thought Paul IV, are one of the chief 'carriers' of heresy. In 1559, the last year of his pontificate, he officially sanctioned the censorship of books and issued the first *Index Purgatorius*. Paul's memoranda on the subject were forwarded to Trent by his successor, and the Council in its final stages debated them. The Venetian delegate Daniele Barbaro pleaded for the exemption of indiscreet works written in their youth by writers since famous, and for a graduated system of penalties, whereby excommunication would

follow from violating an article of faith, but not for lesser errors. Neither plea was heeded, for the Council was now in a rabid mood. In its decree on the subject, promulgated by Pius IV in 1564, the Council kept closely to Paul IV's intentions and in so doing jettisoned two of the main principles of Christian humanism: openmindedness and free enquiry.

The Council laid down that of books published before 1515, the most dangerous should be banned altogether. These included the Koran, all the works of Abélard, Wycliffe and Huss, and Dante's *De Monarchia*. Only approved Catholic versions of Scripture might be published. As regards pious books and books of religious controversy, these had to be sanctioned by the local Bishop: Erasmus, to whom Paul III had offered a red hat, was now described as *damnatus primae classis*, and all his works prohibited. Obscene books were forbidden, unless by pagan authors and in elegant language; these, however, must not be taught to children. Boccaccio's *Decameron* and Poggio's *Facetiae* both came under this ban. Books with a few reprehensible passages were permitted, provided the offending matter was corrected. Books of superstition and astrology were forbidden (this was the only category for which a precedent exists in Scripture: St Paul, in *Acts*, is said to have publicly burned such works at Ephesus). Finally, rules were laid down regarding publication. Outside Rome every book must be examined by the Bishop and a local Inquisitor before being sent to the printer, and inspectors must visit bookshops and printing houses. Every piece of writing whatsoever, if it were destined for the press, would henceforth come under the Church's scrutiny.

The situation is shot through with tragic irony. It had been the pride of Athens and of republican Rome that a society can exist and be strong without being totalitarian; that it can endure considerable divisions of sentiment within it, and that it can even protect the right of individual conscience without paralysing the communal will. Now the very men who had rediscovered this ideal and made it their own, turned against it, ran their pens through whole paragraphs praising the conciliatory Erasmus. Just as the Academies sought to purge the Italian tongue of rough, barbarous words, and artists sought to give a smooth, rounded form to their simpering saints and plump cherubs,

so legislators at every level sought to bring society into what they imagined was a polished unified whole, such as Aristotle and Cicero would have approved. With the knife of classical form they gelded the classical ideal.

Most people would probably grant that we cannot have Christianity in this world without some sort of authority, and that, given the

Erasmus struck through by the Congregation of the Index

variety of human nature, such authority should be flexible, allowing as wide a play as possible to individual development and freedom. Indeed, authority has no value or meaning except in a context of freedom. That had been the lesson even of the Roman Empire. Foreign cults were tolerated provided they did not pretend to be substitutes for the official cult. There was syncretism but not exclusivism. How, then, had the idea of religious intolerance come to birth? The question is important enough to call for a full answer.

Early Christians had believed in tolerance. Tertullian in the third century declared· 'According to both human and natural law every man is free to adore the god of his choice; an individual's religion neither harms nor profits anyone else. It is against the nature of religion to force religion . . .' But when Christianity became the only State cult, opinion hardened. Contradicting his own famous phrase, '*Credere non potest homo nisi volens*—No man can believe against his will,' St Augustine was one of the first to urge constraint of heretics, citing the Gospel text, 'Compel them to come in.' But he never demanded the death penalty. It was the canon lawyers of the twelfth century who, confusing the spiritual and temporal, asserted that political unity depends on unity of belief, and it was they who invoked Old Testament texts to bear out the principle that heresy is punishable by death: the laws of *Deuteronomy* and the terrible sentence of *Exodus*: 'He who sacrifices to the gods, let him be wiped out.' The principle was first put into effect on a large scale against the Albigensians at the beginning of the thirteenth century; in Italy a few years later. Between 1224 and 1238 the Emperor Frederick II decreed the death-penalty for obstinate heretics in the territories under his jurisdiction, including Sicily and North Italy. In 1252 Innocent IV made Frederick's decrees applicable to the Catholic world at large by inserting them in his bull *Cum adversus hereticam pravitatem*. Aquinas countenanced them: 'heretics may rightly be put to death by the secular authorities, even if they do not pervert others, for they blaspheme against God by following a false faith.'

Around 1400, when detailed study of Greece and Rome began, Italians stood amazed before the variety of ancient religious opinions and the tolerance accorded them. Socrates, it is true, had been put to death, but for political not religious motives, and by and large all men were free to follow Epicurus or Plato or the latest philosopher from the East, to profess that the soul survived or did not, to worship Astarte or Poseidon. By studying such men Italians learned a new notion of human dignity and the rights of the individual conscience. Although they never abandoned their search for unity of belief, they became large-minded. They believed in tolerance for the time being, until all men should be gathered, at God's discretion, into a single fold. During the fifteenth and first half of the sixteenth

centuries Italy became the most tolerant country in Europe. In fact censorship, like the death-penalty for heretics, originated not in Italy but abroad: the first known censorship office was established in Mainz as early as 1486.

We have a glimpse of the ordinary educated Italian's attitude in this matter in a short *Life of Christ based on the Four Gospels* written around 1540 by a physician and expert on herbs, one Antonio Brasavola of Ferrara. Brasavola states his view that no punitive action at all should be taken against Protestants who do not actively proselytize. As for proselytizers, they should be warned three times before action is taken against them, and then it should be tempered by consideration of the parable of the tares and the wheat. Brasavola's tolerance is compounded partly of a compassionate nature and partly of recognition that Catholic failings had prompted the Protestant revolt, but above all of classical humanism.

In 1530 the same Luther who two years before had declared the burning of heretics to be contrary to the will of the Spirit, demanded against the Anabaptists those terrible punishments which were promulgated against blasphemy in the Old Testament. In 1536 he said that the parable of the tares applied to preachers but not to the state, which 'is bound to repress blasphemy, false doctrine and heresy, and to inflict corporal punishment on those that support such things'. Not one of the founders of the Reformation tried to undo that rigid principle of the Middle Ages: one religion in one state. In a way they even reinforced it, since they put the power to rule religion into secular hands.

Faced with such rigorous methods on the part of their opponents, and finding precedents for them in their own earlier history, it would have required more moral courage than they were capable of for the Italians not to abandon the classical precept of tolerance. From 1542, the year when the 'Holy Office' was constituted, the Catholic reaction gathered force, and it is so unpleasant a phenomenon that more than one historian, in his love of Italy and the Italians, has claimed that the Catholic reaction was not Italian at all, but a hateful importation from medieval Spain foisted on Italy by the early Jesuits. This theory fails to fit the facts and contains two profound psychological errors. No civilized people has ever allowed or

could allow a dozen or so foreigners to impose against the general will a policy touching almost every aspect of their lives; secondly, because a people has behaved adventurously for several generations, that is no guarantee that it will continue to behave adventurously: a point made abundantly clear in Savonarola's Florence. No, the Catholic reaction is an expression of the Italians' own character, and their responsibility alone. It is doubly tragic in that it was quite unnecessary. Lutheranism had made almost no inroads in Italy and, even before repressive measures were introduced, was on the wane. As a result the full weight of the new measures was to fall, in default of Lutherans, on Catholics of an inquiring turn of mind.

CHAPTER 13

After the Crisis

IT IS TIME to look at Italian civilization after the Council of Trent. The Papacy had emerged from the Council with increased authority, and in the Inquisition and Index possessed powerful new instruments for exercising control even over Catholics who were fundamentally loyal. As the Inquisition spread it is to the honour of Italy that a few brave men protested: such was Ferrante Sanseverino, Prince of Salerno, who in 1552 fought the establishment of the Holy Office in Naples and as a consequence lost his estates and was sent into exile. The Inquisition helped to change the character of Italian civilization, but it did so in Italy only very rarely through terror and torture. Its usual methods were much more subtle. They can be seen in action among thinkers and artists whom we have already met.

In 1564 Sperone Speroni learned with alarm that a book of his, entitled *Dialogues on Love*, had been placed on the Roman Index. Speroni, now aged sixty-four, was invited to defend this youthful work, published when he was twenty-nine, before the Congregation of the Inquisition. At first he fell into a deep gloom, then set out for Rome. There he managed to have a quiet word with the chief inquisitor, who indicated the offending passages. Speroni then asked permission to defend some of them before the Congregation. He did this ably and was delighted to find a majority of the tribunal Cardinals well-disposed. Instead of placing his book on the Index, they gave Speroni permission to rewrite all the censured passages, retain those he had shown to be harmless, and to republish the *Dialogues*. They also urged him to publish his *Defence of the Dialogues*. This he did. It is a remarkable little work in which Speroni claims that his *Dialogues*, far from corrupting, will purge the reader's lustful appetites. He cites the catharsis clause from Aristotle's

Poetics, which he says was derived from Lycurgus's habit of showing drunken slaves to young Spartans in order to instil habits of temperance. He then goes on to declare: 'Ignorance which does not know how to choose and reject is not goodness, and the man who does not know what vice is cannot know the meaning of virtue.' These were brave words as well as true, yet they were not Speroni's last. He seems to have felt that the Inquisition, so sure of itself and so strong, might possibly be not altogether mistaken in its censure of his book. It is never easy to believe that everyone but you is out of step, and it is very much less easy when you are treated with the mild indulgence due to an errant child or a demented dodderer. Anyway, Speroni felt remorse. The proof lies in a little work which he wrote after his brush with the Inquisition and which he believed would atone for his youthful mistake. Quite unlike his early liberal self, it is a prudish *Dialogue against Courtesans*.

The case of Girolamo Cardano presents certain points of resemblance with Speroni's. In 1566 a Dominican ex-Inquisitor became Pope with the title Pius V and at once issued a number of severe decrees. One of them ordered physicians to leave any patient who failed to confess his sins within three days; another expressed disapproval with the Inquisitors of any town failing to yield a large crop of penal sentences. As the result of the latter decree on 13 October 1570 Cardano found himself thrown into prison on a charge of impiety, some zealous official having discovered a youthful work in which Cardano had cast the horoscope of Christ. Eventually he was allowed to return home on bail, and through his friend Cardinal Borromeo, the previous Pope's saintly nephew, and Cardinal Morone, a patient of his, he was released by the Inquisition but prohibited from lecturing or printing books. In effect, he was denied the means of earning a living.

A few weeks later Cardano was astonished to receive an invitation from Pius V to come and live in Rome, and the offer of a pension equal to his lost income. Cardano accepted, and it was under the Pope's wing that he spent his last six years safely in Rome as a private person. Nevertheless, a stigma attached to him. A French visitor described Cardano as 'a madman of impious audacity, who had tried to subject to the stars the Lord of the stars'. He was allowed

to write books, but not to publish them. One was his *Autobiography*, which teaching duties might otherwise have prevented him writing, but in this otherwise frank work Cardano fails to give the reason for his imprisonment in Bologna, fails indeed to mention the whole affair. It looks as though, like Speroni, he had been driven by the lurking threat of sterner measures to feel himself guilty.

The Council of Trent had laid down that religious painting should be seemly and contain no novelty at all. One summer's day in 1573 Paolo Veronese found himself summoned by the Inquisition to its meeting-place, the chapel of S. Teodoro in St Mark's, in order to explain *The Last Supper*, which he had painted for the refectory of the Dominicans at SS. Giovanni e Paolo. 'What,' he was asked, 'is the meaning of those men dressed German style, each with a halberd in his hand?' ... 'Were you commissioned by any person to paint Germans and buffoons and such-like things in this picture?' 'No, my lord ...' Why had he represented St Peter cutting up a lamb and another apostle using a fork as a toothpick? 'I intended no irreverence,' replied Veronese. 'Does it seem to you fitting that at our Lord's last supper you should paint buffoons, drunkards, Germans, dwarfs, and similar indecencies?' 'No, my lord ...' 'We painters,' he explained, 'take liberties just like poets or people touched in the head.'

Though a good point, it was not one likely to appeal to the Inquisitors. They decided that the picture must be censured. However, they did not impound the picture, nor burn it, nor impose a fine on Veronese. They simply ordered him to alter the offending sections at his own expense, within a month. But figures are less easily removed from a painting than paragraphs from a book. Veronese evidently believed that alteration would spoil the picture. Finally he decided to leave it as it was and change the title to *Banquet in the House of Levi*. The Inquisitors were satisfied and the picture has been known by its new title ever since. But again, it was Veronese who changed course. He painted no more Germans nor did he again use poetic licence in interpreting the New Testament.

Bartolomeo Ammannati, the husband of Laura Battiferri, was born in Florence in 1511. He went for a time to Venice and worked under Sansovino, like him practising both as sculptor and architect. After

five years in Rome he returned to Florence, where he extended the Pitti Palace, introducing bold rustication similar to that used by Sansovino for the Mint in Venice, and designed the exceedingly graceful Trinità bridge across the Arno. In 1575 he completed the Neptune fountain for the Piazza della Signoria, a group dominated by the giant nude figure of the sea god—the Grand Dukes fancied themselves as lords of the Tyrrhenian. Ammannati's clerical friends criticized the statue. They doubtless reminded him that the Council of Trent had passed a decree against books 'which *ex professo* discuss, describe or teach lascivious or obscene subjects', and statues were books in stone. Ammannati was getting on in years, and if he raised objections, they were soon overcome. In 1582 he wrote a letter to the Academy of Art, in which he denounces nude figures and claims that they can be occasions of sin. This in the city of Ghiberti's *Eve* and Michelangelo's *David*! He wishes, he says, that some of his own works could be destroyed, and specifically mentions the Neptune fountain.

The steady growth of prudery can be seen from the life of Michelangelo. Paul III's master of ceremonies, Biagio da Cesena, strongly objected to the nudes in *The Last Judgment*. Unperturbed, Michelangelo went ahead with the nudes, and added a portrait of Biagio as Minos, in the depths of hell, with ass's ears and a serpent round his loins. Despite Biagio's complaints to the Pope, Michelangelo declined to remove either the nudes or the portrait. The next Pope but two, Paul IV, denounced *The Last Judgment* as a 'stew of nudes', and it was his successor Pius IV who asked Michelangelo's permission to have the nudes covered over. Michelangelo replied scornfully that it was a small matter to expurgate a picture, but a large one to straighten out the world, which was the proper business of his Holiness. The fact, however, is that Michelangelo yielded, and the nudes in *The Last Judgment* were given breeches or loin-clothes by Daniele da Volterra, who was known ever after as *il braghettone*—the breeches-maker.

Michelangelo yielded because he saw no point in useless protest. There were a few others like him, men who yielded on small points without abandoning their principles. But for the majority of older writers and artists the Church had become so sure of itself, so

strong, that they began to wonder whether she might not after all be right; and of their own accord such men moved toward conformity.

In the younger generation also we find an eagerness to conform. Architects sought to observe the rules decreed by the great theorists, Palladio, Serlio and Scamozzi, while Vignola's church of the Gesù in Rome having been pronounced excellent, was exactly reproduced scores of times in and outside Italy. Pictures and statues were mostly arid reproductions of hackneyed forms that no longer corresponded to the artist's aspirations. Finish became smoother, detail more meticulous, narrative more explicit, but the style itself was dead.

It so happened that two large groups had recently been unearthed in Rome: the *Punishment of Dirce*, who is shown attached to the horns of a bull by the sons of Antiope, and the even more pathetic *Daughters of Niobe*, which Cardinal Ferdinando de' Medici bought in 1583. Both groups belong to the Hellenistic period, and are grandiloquent and emotional in the extreme. They proved very influential. The nude—touchstone of the classical spirit—having now been renounced, attention became focused on facial expression, often of an exaggerated kind. The immediate result was a multitude of simpering saints and Christs with upturned eyes, though later this style was to make possible some important statues, like Bernini's *St Theresa in Ecstasy*. When a rare artist such as Caravaggio tried to reintroduce a more robust approach to painting he got into trouble through iconographical inexactitude. In one of his finest works, the *Death of the Virgin*, he showed Mary dead instead of in a coma, as she should have been, and for this reason the picture was removed from S. Maria della Scala, though it was later bought by a cardinal. In another work Caravaggio depicted the Virgin and Boy Jesus simultaneously stepping on the snake of heresy, but evidently his iconography conflicted with a recent bull on Mary's redemptive role by Pius V, and the picture was rejected by the canons of St Peter's who had ordered it.

In the field of literature an even more rigid situation prevailed. Aristotle's *Poetics* first became widely known when Francesco Robortello of Udine published a full commentary on it in 1548. Like most Greek philosophers and critics, though unlike the writers

themselves, Aristotle valued literature chiefly for its moral effect. So characters, he believed, should be good: 'We should paint people better than they are.' This statement was to prove enormously influential. It became the philosophical justification for whole libraries of edifying literature.

Plato had argued that poetry deals in feelings and particular facts, but Aristotle denies this. Poetry, he says, represents universal truths, 'not what has happened, but what would happen', given a certain situation. He does, however, admit that tragedy arouses the emotions of fear and pity and by so doing acts as a purge. Like the good biologist he is, he dissects the structure of various poetic forms and dramatic plots, but fails altogether to analyse the peculiar pleasure imparted by great poetry. His book reduces poetry—as Robortello says, and he intends this as a compliment—'to certain propositions that reason can grasp'. Robortello then concludes that in writing poetry we must follow laws, just as we do in mathematics.

Six years later Robortello published the first edition of Longinus's *On the Sublime*, a work of Platonist inspiration in which the author describes his feelings on reading this or that poem, and by so doing comes much nearer to defining poetry than Aristotle. In Longinus there is no ethical twist: the pleasure given by poetry is a sufficient end in itself. Longinus inveighs against mere correctness, triviality, empty bombast and lack of vigour: just the vices of contemporary Italian literature. But did the Italians heed him? Not a bit. They immersed themselves in Aristotle, who answered their new need for reassurance, reasonableness and order, and turned out books based on the *Poetics*.

The Venetian Senator Sebastiano Erizzo published in 1567 a selection of stories in order to show the reader 'as in a looking-glass' 'what he should shun and likewise what he should imitate'. The stories were widely read but they are sour, bigoted and boring. Giambattista Giraldi of Ferrara in his highly popular *Ecatommiti* of 1565 published 112 stories in which the characters are either angels of virtue or devils of malice. One of them, concerning a certain Desdemona, suggested to Shakespeare his great tragedy of jealousy. Luigi Tansillo, learning that his licentious work *Vendemmiatore* had been placed on the Index, atoned by writing a spiritual lament, all

sighs and shudders, entitled *Le Lagrime di S. Pietro*. Published posthumously in 1585, it delighted countless readers. Giovanni Maria Cecchi of Florence decided to play safe and included in his dramas only married women. In 1590 Erasmo da Valvasone, a citizen of the Venetian Republic, wrote the *Angeleida*, an edifying epic in which good angels trounce the bad; afterwards, on their flight back to heaven, they pass the planet Jupiter, on which they notice effigies of Sixtus V and of Venice, surrounded by Peace, Piety and the Arts. The poem interested Milton, if only as a warning of what to avoid. By 1597 edification had reached a pitch where another Venetian citizen, Giulio Cornelio Graziano, could write eight cantos entitled *Orlando Santo*, in which Ariosto's tough, very human soldier and lover is almost unrecognizable under his halo. In 1610 Anton Giorgio Besozzi, a friend of the saintly reformer, Carlo Borromeo, published *Brancaleone*, blandly described on the title-page as 'a pleasing and moral story, in which everyone can find useful information for controlling himself and other people'. The list could be made much longer.

When not being edifying, writers descended to games and trivia. One adopted the grotesque name of Fidenzio Glottocrisio Ludimagistro, while another published a poem with the title, 'Exhortation to Noble Ladies to Breast-feed their Children'—as Peruvians did. Luigi Groto of Adria, an orator and playwright blind almost since birth, who had acted the part of Tiresias in the Vicenza production of *Oedipus Tyrannus*, thought fit to address his sweetheart, Deidamia Fanula, in these terms:

> *Donna da Dio discesa, don divino,*
> *Deidamia, donde duol dolce deriva,*
> *debboti donna dir, debbo dir diva?*
> *dotta, discreta, degno di domino . . .*

and so on, for a whole untranslatable sonnet.

No less distressing displays were offered in the field of non-fiction. Biographies became apologetic and adulatory, such as those of Contarini and Pole by the Bolognese prelate Lodovico Beccadelli. In the field of history Valla's scientific principles had been forgotten and Machiavelli of course was on the Index. Historians sought to edify, however preposterous their claims: Carlo Sigonio of Modena

actually wrote a treatise to prove the Donation of Constantine authentic. Nearly every considerable work of history at this time is flawed by a pronounced monarchical bias. If anyone still held republican principles, he did not feel sure enough of himself to commit them to paper. Study of the ancient world degenerated into minute exploration of obscure points: that at least was safe.

As for books written in a more robust age, they were systematically bowdlerized. The Grand Duke of Tuscany wished to reprint the *Decameron*, which was on the Index. So it went before the Roman Inquisition. Doubtful dogma, the names of saints and allusions to the devil and hell were struck through, while monks and priests who kept concubines were transformed into students and professors, unchaste nuns and abbesses into citizens' wives. The revised edition was published in Florence in 1573, but it did not satisfy Sixtus V, a former counsellor to the Venetian Inquisition, who demanded an even more thorough expurgation. This appeared in 1582.

Amid such 'revisionism' and just plain worthless writing it is refreshing to come on a truly good poet—though he did what he could to try and become a bad one. Torquato Tasso was born in 1540. His mother was a timid Tuscan lady, his father, Bernardo, a courtier in the service of the Prince of Salerno, author of a number of excellent verses about married love and an unsuccessful epic, *Amadigi*, about the knightly Amadis of Wales and his wooing of Oriana. Torquato had a painful childhood, because his father loyally followed Prince Sanseverino into exile when the latter opposed the establishment of the Inquisition in Naples, and on his return to Italy for long wandered penniless: Torquato recalls him sitting up in bed to darn his single pair of stockings. His father's poetic sensibility and his mother's timidness combined to produce in Torquato a strong strain of melancholy. He could take a certain voluptuous joy in life, but it was always shadowed by unnameable fears. His portrait shows a pale drawn face with black hair and dark hunted eyes.

After attending a Jesuit school Tasso spent several years in Venice and Padua before going to the court of Ferrara. Here he wrote one of his two great works, a pastoral play entitled *Aminta*, which was performed in the summer of 1573 in the islet of Belvedere on the Po. The play is set in the golden age, when the notion of honour did

not yet tyrannize man, free to disport himself '*fra le liete dolcezze de l'amoroso gregge*'. Aminta is vainly in love with the proud huntress Silvia. While bathing, Silvia is seized by a satyr and bound to a tree; Aminta frees her, but scorning her rescuer she rushes off. In the next act we are told—not shown—how Aminta in despair has thrown himself from a cliff, and how Silvia, penitent, bewails him. Finally we are again told, not shown, how Aminta's fall has been broken by a bush and that all ends well. The appeal of the *Aminta* is clearly not in its action, but in Tasso's style. This is no longer classical, but sentimental, elegant, dainty, tinged with a mood 'most musical, most melancholy'.

Tasso had studied Aristotle's *Poetics* carefully, not just the commentators, and the rule he chose as most important was unity of action, which he interpreted as organic unity. This was a happy choice, for it was just what his dreamy, errant nature required in order to embark on an epic poem. The subject Tasso set himself was the Christian struggle against the Turkish threat, now more pressing than ever: in 1558 Tasso's sister, with other girls of Sorrento, was all but carried off into slavery by Turkish raiders. Tasso completed his epic in 1575 and, doubtful about its value, submitted it to four critics, including his former teacher Speroni. Their comments were pedantic and censorious. They condemned the enchantments and 'excessive' interest in love-affairs. Disappointed and also deeply troubled, Tasso twice went out of his way to consult officials of the Inquisition as to some imagined heterodoxy in the poem. Their reassuring words did not calm him: he dreaded lest the Inquisition should pass his work and then suppress it. Finally he decided that his poem could not be published in its present form, that he must rewrite it. The task occupied him off and on for almost twenty years, and the result was a perfectly correct and regular poem embodying all the advice of scholars and clerics, but lifeless, sanctimonious and now forgotten.

Succumbing to delusions of persecution, in 1580 Tasso had to be shut up. This proved his literary salvation, for while the poet lay helpless in prison, a certain Celio Malespini got hold of the original epic and published it at Venice in a pirated edition under the title *Il Goffredo*. A year later, in 1581, also piratically but with more care,

Angelo Ingegneri had two editions made, and it was he who chose the title *Gerusalemme Liberata*. Released from prison in 1587, Tasso disowned these editions, and it was the revised but inferior epic that he continued to believe was his masterpiece. He called it *Gerusalemme Conquistata*: freedom was a bad word.

> *Canto l'armi pietose, e'l Capitano*

> The arms of pious men I sing, and their leader

—so begins *Gerusalemme Liberata*, echoing the *Aeneid*. The leader is Godefroy de Bouillon, commander of the First Crusade, and it is typical of this new age that piety should appear in the very first line, like a plea to the censor. Happily it does not appear often thereafter, though the main theme of the poem is highly moral: the Christian knight Rinaldo, having been enticed away from camp by the enchanting princess Armida, is made—by means of a miraculous looking-glass—to see that he is being undutiful, and to return to his proper job of slaying the heathen. After confessing his sins to Peter the Hermit and kneeling in prayer on Mount Olivet, he leads the assault on Jerusalem. Armida, in fury and despair, offers her hand to the man who will bring her Rinaldo's head. Her champions engage the Christian knight, and one by one are slain. Armida, hating and loving at once, is about to kill herself:

> *Sani piaga di stral piaga d'amore,*
> *e sia la morte medicina al core.*

> I'll heal this wound of love with wound of dart,
> And giving death, give medicine to my heart.

But Rinaldo intercepts the blow, promises her kingdom back and persuades her to become a Christian. At the end she meekly surrenders to him in words that echo the Virgin Mary's: '*Ecco l'ancilla tua*—Behold thy handmaid!'

Tasso treats the Crusade with earnest and unsmiling seriousness. He sees it as a struggle between good and evil, and really cares about the outcome. Yet he is too aware of the suffering involved on both sides to view the capture of Jerusalem as a mere triumph. The prevailing tone is melancholy, interrupted by moments of lushness during the love scenes. Tasso's men lack the gusty vigour of Ariosto's,

but his women—Clorinda, Erminia and Armida—are an improvement on those of the earlier epic: truly feminine creatures caught up in the cross-tides of deep feelings. As for the style, it resembles painting of the day. Simplicity and directness are conspicuously absent, while verbal legerdemain, antithesis and rhetorical conceits abound, as in this example:

> Seguì le guerre; e in quelle e fra selve
> Fera agli uomini parve, uomo alle belve.

> When she to battle or through forest ran,
> Wild beast to men she seemed, to wild beasts man.

Such convolutions were all the rage—and were to become so in Elizabethan England; they were applauded by Tasso's contemporaries: only Galileo dared to criticize them, growling that he preferred the straightforward style of Ariosto.

The quest for fuller truth in spiritual matters was not totally dead. There were still Italians who sought to know themselves in all their contradictions, and God in all his variety. In an age which claimed that all the answers were known, these men asked awkward questions; in a society which accepted the *status quo* as God's will for men, they fought for a better society. They constituted the still, small voice of opposition. Two are particularly important: both Calabrians—men of Magna Graecia—both Dominican friars, both brave enough to suffer for their beliefs.

Giordano Bruno was born in the hamlet of Cicala, near Nola, in 1548. The Calabrians are superstitious and as a child Bruno fancied he saw spirits on hills where beeches and laurels grew. He often gazed at Vesuvius from the sunlit vineyards of Cicala and noticed how bare and forbidding it looked. But one day his soldier father took the boy there, and he found its slopes covered with trees and greenery, while Cicala had become dark and dim. 'Astonished at the strange change,' he writes, 'I became aware that sight could deceive.' The seed of doubt was sown; soon he would ask, 'What are the grounds of certitude?'

Because he wished to study, at fourteen Bruno joined the Dominicans. Ten years later he received ordination. He was slightly

built, of medium height, with chestnut hair and beard; he spoke very quickly, with lively gestures, and he was more aware of nature than of people. Steeping his vivid imagination in Lucretius, Copernicus and Ficino's version of Plotinus, the young Dominican moved towards mystical pantheism. He began to doubt—but not to deny—the doctrine of three distinct Persons in the Trinity, finding support in Augustine, who declared the term Person to be new in his time. He saw the Son rather as the 'intellect of the Father' and the Spirit as 'the soul and love of the universe'. When his superiors became suspicious Bruno fled, throwing into the privy his copy of Erasmus on St Chrysostom and St Jerome. The forbidden book was found and the Inquisition ordered Bruno's arrest. He crossed to Geneva, then to Toulouse, Paris, and finally, in the suite of the French ambassador, to England. In 1585 he lectured on the immortality of the soul at Oxford, where the dons, he claimed, 'knew much more about beer than about Greek'. At Fulke Greville's house he met Sir Philip Sidney, and the three discussed 'moral, metaphysical, mathematical, and natural speculations'. Bruno also expounded 'the reasons of his belief that the earth moves'. Though Sidney had little sympathy with Bruno's religious theories, the Calabrian dedicated two books on moral subjects to his English friend. Returning to France in 1585, he once more became a wanderer, describing himself as 'a citizen and servant of the world, child of this sun and mother earth'.

Bruno's view of human nature emerges from his play, *Il Candelaio* (*The Chandler*), which concerns three kinds of folly. There is Bonifacio, an old man who deserts his beautiful young wife for a vile prostitute; Bartolomeo, who has a passion for money and is tricked into believing that he has learned the secret of making gold; and Manfurio, a pedant who is the prisoner of his own foolish but impassioned beliefs. All of us, suggests Bruno, are largely irrational, and like Manfurio tend to limit ourselves, to shut ourselves up in a prison.

According to Bruno, we have no certainty that Christianity is true. We have to accept it by faith and through revelation. It is the best religion because it proclaims the doctrine of love: it 'began, increased and maintained itself with the raising of the dead, the healing of the sick and self-sacrifice for others.' Yet in some respects

Bruno found paganism superior. It was more tolerant and under-stood that 'God lay hid in Nature.'

Bruno in the last analysis felt certain of only two things: the infinity of God and of His universe. To him they were facts of experience. He was really aware of the universe pulsating with divine life, and believed it his mission to free God from an Aristotelian prison. 'There is', he claimed, 'an endless number of individual worlds similar to our earth. Like Pythagoras, I regard the earth as a star; the moon, the planets and the other stars being similar to it.' They were probably inhabited, some with creatures better than us, others with worse, for space was the place where all aspects of being were developed.

Following Plotinus, Bruno held that God reveals himself, mainly through the stars and planets, in a series of emanations. The divine glory and majesty therefore come to us by stages, not, as Contarini thought, in one complete Revelation. This view Bruno carried over to human affairs. It is the Calabrian's most remarkable achievement to have stated that truth gradually develops as the centuries pass. In *La Cena de le Ceneri* (*The Ash Wednesday Supper*), written during his visit to England, Bruno declares:

> It is we who are older and who have a greater multitude of years than our predecessors; at any rate as regards certain topics, like the one with which we are dealing at the moment [the Copernican theory]. The judgment of Eudoxus who lived shortly after the rebirth of astronomy (if the rebirth did not actually take place through him) could not be so mature as that of Callippus, who lived thirty years after the death of Alexander the Great; and who, as year succeeded year, could add observation to observation. Hipparchus for the same reason must have known more than Callippus. . . . More has been seen by Copernicus, almost in our day.

Strangely, Bruno failed to apply this theory in religious matters. Here he was a fundamentalist. He wanted to throw over the doctrine of transubstantiation, 'with which St Peter and St Paul were un-acquainted'. With the removal of such questions he claimed that religious turmoil would disappear.

In 1591 Bruno returned to Italy. He chose Venice as being a safe

place, and tried to be received back into the Church. He did not hide his past, and a seeming friend denounced him to the Inquisition. He was cross-examined, chiefly about the Trinity and his theory of an infinite universe. Questioned also about his extravagant praise of Queen Elizabeth, he explained that this was a convention, but acknowledged his error. Heretical passages in his books he pleaded were not in defiance of the Catholic faith but were philosophic opinions.

In 1591 Bruno was extradited to the Inquisition in Rome, and for seven years remained a prisoner in Castel S. Angelo. The documents of his case have been lost. At first he showed a willingness to abjure, but later stood firmly by his beliefs. To laymen who bowed meekly Inquisitors were prepared to be gentle, but not to a renegade priest. The poor 'Academician without an academy' was declared an impenitent heretic, to be handed over to the secular court, while orders were given that his books should be burned, and listed on the Index. Facing his judges, Bruno said, 'Perhaps you who bring this sentence against me are more afraid than I who receive it.' 17 February 1600 was the day fixed for his execution. As he was led to the stake in Campo dei Fiori, he declared that his soul would ascend in the smoke to Paradise.

Bruno's fellow-countryman and fellow-rebel, Tommaso Campanella, was born in Stilo in 1568, the son of an illiterate cobbler. Stocky and strong, he had a tough, squarish head on which were seven protuberances: later, when his poems were published in Germany, he signed them 'Settemontano Squilla: Campanella of the Seven Bumps.' He was deeply religious, interested in the stars and a firm believer in astrology. Like Bruno, he joined the Dominicans at fourteen, but his was a genuine vocation: he had a deep respect for religious authority and valued community life. He came under the influence of a fellow-Calabrian, Bernardino Telesio, who in 1586 published a book declaring that philosophy should be based on sense-experience—Francis Bacon called him 'the first of the new men'. Though Telesio's book was placed on the Index, Campanella wrote a similar anti-Aristotelian work, *Philosophia sensibus demonstrata*. This cost him several months in prison. In 1592 he went to the University of Padua. For holding the atomic theory taught by Democritus he

was prosecuted, and for failing to report a theological discussion with a Jew tortured, condemned and imprisoned. In 1594 he was transferred to a Roman prison and again tortured. In 1595 he abjured his heresies and for two years was placed in a Roman monastery. He was again arrested, imprisoned and, on his release, ordered to return to Calabria.

Campanella had been born under the influence of six planets in the ascendant and took this as a sign that he was to become a reformer. Like all Calabrians, he loathed the Spaniards who misruled his country. Inspired by portents and prophecies and surrounded by malcontents, Campanella headed a conspiracy to overthrow the Spanish régime and establish Calabria as a religious republic under his leadership. The plot was discovered, and Campanella taken to Naples. At first he underwent repeated torture and escaped execution only through a pretence of madness maintained for more than a year. Once, at the limits of pain, he did break down and begged the torturers to stop. 'Why do you care so much about your body', asked the magistrate in charge mockingly, 'and so little about your soul?' 'Because,' groaned Campanella, 'my soul is immortal.' This was taken as further proof of his madness.

For eight further years Campanella lay in an underground dungeon. Only his strong physique and indomitable will enabled him to survive. After twenty-three years in a Neapolitan prison the wretched man was released, only to be imprisoned anew by the Holy Office. He was set free shortly afterwards, but suspicion dogged him still and he was obliged to flee to France. He died in 1639.

Campanella's most important prose work, *La Città della Sole* (*The City of the Sun*), was written in prison about 1602. It takes the form of a dialogue between a Grandmaster of the Knights Hospitallers and a Genoese sea-captain who in his travels has visited a remarkable city lying in a tropical island. The city is built in seven concentric rings round a domed circular temple, on the vault of which are painted all the stars and planets, with their power to influence human events inscribed in verse. The ruler of the city is a priest-philosopher named Hoh, which signifies Metaphysic. Hoh is a polymath, for 'he who knows only one subject does not really know either that or the

others.' Hoh is helped by three princes, Pon, Sin and Mor—Power, Wisdom and Love. The last-named is responsible for the mating of men and women according to the best genetic principles. The Solarians 'laugh at us who take such care breeding horses and dogs, but neglect the breeding of human beings.' Names are given by Hoh, at first according to physical characteristics, later according to achievements: Nason, for instance, might become Nason Fortis: Big-nose the Brave.

Property, women and children are held in common, for 'when we have taken away self-love, there remains only love for the State.' Here the Grandmaster objects that no one will do any work; they will all want to live off their neighbours, 'as Aristotle argues against Plato'. The sea-captain replies that the Solarians are deeply patriotic, and imbued with a spirit of charity towards all, 'as in the time of the Apostles'. Since only four hours' work a day is necessary, no one is likely to shirk it.

All Solarians wear white clothing and a toga. Women are forbidden cosmetics, to replace their wooden shoes with high-heeled boots, or to wear dresses down to the ground. It is women who provide music, though drum and horn are entrusted to men. Goods from abroad are obtained by barter, and no money is admitted to the city. Only ambassadors and explorers may use coin.

Education is exclusively scientific. The vast wall surfaces are painted with mathematical figures, maps and alphabets, with pictures of lakes, seas and rivers, of the animal, vegetable and mineral kingdoms, of inventors and their inventions, and of famous men, such as Moses, Osiris, Mahomet, Christ and the twelve Apostles. Children start at the age of three by going for guided walks along the murals, and visiting the workshops of tailors, painters, goldsmiths and other craftsmen. They then study the natural sciences, mathematics, medicine, engineering and agriculture.

Religion is natural, not revealed. Priests pray in turn, singing 'the deeds of the Christian, Jewish and Gentile heroes, and of those of all other nations', for envy is unknown in this city. Sacrifice takes the form of a volunteer being hoisted on ropes under the dome, where he fasts for three or four weeks, 'until God's anger is appeased'.

The Solarian religion is summed up in the maxim, 'Do unto others as you would be done by' and to the Grandmaster this seems 'not far from Christianity'.

Such is Campanella's ideal State. Clearly it owes a great deal to Plato, much to More's *Utopia*, and something also to Savonarola's Christian republic in Florence. It is unlikely that an entire people could live contentedly under such a regime, however benevolent, and it is strange that one who suffered so much from authority should continue to believe in its good effects. But by making patriotism the driving force in society Campanella, like Machiavelli, shows himself a true prophet. Certain other features, such as the holding of property in common, marriage according to genetic principles, and education based on science, however radical, were certainly well worth putting forward, if only for discussion. Unfortunately that discussion did not take place in Italy, though abroad his books in translation excited many.

Campanella above all lives as a poet. Through the long years of his early imprisonment he wrote poems, chiefly sonnets, of the first rank. From his sufferings and doubts, his anguish and tension and spiritual aspirations there arose poetry hard and strong and brilliant. It flashes like forked lightning above the small verbal fireworks of his happier but conformist contemporaries. In the following lines he describes the black dress introduced by the Spaniards to Italy, one of his reasons for specifying that the Solarians dress in white:

> Convien al secol nostro abito negro,
> > pria bianco, poscia vario, oggi moresco,
> > notturno, rio, infernal, traditoresco,
> d'ignoranze e paure orrido ed egro.
> Ond'ha a vergogna ogni color allegro,
> > ché 'l suo fin piange e 'l viver tirannesco,
> > di catene, di lacci, piombo e vesco,
> di tetre eroi ed afflitte alme integro.

> Black robes befit our age. Once they were white;
> > Next many-hued; now dark as Afric's Moor,
> > Night-black, infernal, traitorous, obscure,
> Horrid with ignorance and sick with fright.

For very shame we shun all colours bright,
 Who mourn our end—the tyrants we endure,
 The chains, the noose, the lead, the snares, the lure—
Our dismal heroes, our souls sunk in night.

Campanella was a convinced Catholic, but he was also large-minded and prison had taught him pity. In a sonnet entitled 'The Samaritan' he describes how a bishop and a cardinal ignore a poor man who has fallen among thieves on the road from Rome to Ostia, while a German Lutheran, who does not believe in good works, stops to tend him.

> *Chi più merita in questi? chi è più umano?*
> *Dunque al voler l'intelligenza cede,*
> *la fede all'opre, la bocca alla mano;*
> *mentre quel che si crede,*
> *s'a te ed agli altri è buono e ver, non si:*
> *ma certo è a tutti il vero ben che fai.*

> Now which of these was worthiest, most humane?
> The heart is better than the head, kind hands
> Than cold lip-service; faith without works is vain.
> Who understands
> What creed is good and true for self and others?—
> But none can doubt the good he doth his brothers.

The following sonnet, from 'Three Prayers in Metaphysical Psalm-form Joined Together', seems to me to possess even in its doubt more religious feeling than any Italian poem of the age:

> *Omnipotente Dio, benchè del fato*
> *invittissima legge e lunga pruova*
> *d'esser non sol mie' prieghi invano sparsi,*
> *ma al contrario esauditi, mi rimuova*
> *dal tuo cospetto, io pur torno ostinato,*
> *tutti gli altri rimedi avendo scarsi.*
> *Che s'altro Dio potesse pur trovarsi,*
> *io certo per aiuto a quel n'andrei.*
> *Nè mi si potria dir mai ch'io fosse empio,*

se da te, che mi scacci in tanto scempio,
a chi m'invita mi rivolgerei.
Deh, Signor, io vaneggio; aita, aita!
pria che del Senno il tempio
divenga di stoltizia una meschita.

Banished, almighty God, and rendered nought
By a relentless Fortune and my own despair
At hearing no answer to my heartfelt prayer
Or getting the opposite of what I sought,
Yet obstinately I come back anew,
Since other remedies bring no relief;
Were there another God for my belief,
To him would I gladly turn, and not to you.
For who can blame me if I disavow
A God who thrusts me from the promised land
And cling to one who extends a welcoming hand?
O Lord, I wander; help me, help me now
Before the sanctuary where Wisdom rules
Becomes a mosque for gibberers and fools.

Campanella's voice, like that of Giordano Bruno, went unheard in Italy, where the sanctuary of Wisdom had become if not a mosque at least a prison. His sonnets were not even printed in Italy at this time; no literary Academy sponsored elegant essays on his work. This age of conformism cared only for the trivial and sanctimonious. But precisely because they escaped the conformism of the age, Campanella's voice and Bruno's were to prove lastingly effective; as a French poet had written in 1552 among the antiquities of Rome:

> *Ce qui est ferme est par le temps destruit*
> *Et ce qui fuit au temps fait résistance.*

CHAPTER 14

Sunset in Venice

ON CHRISTMAS EVE of 1522, at the Spanish court, a powerfully built man in his early fifties with a weather-beaten face and forked beard paid a secret visit to the Venetian ambassador, Gaspare Contarini. 'I was born,' he explained, 'in Venice, but brought up in England. I am now Grand Pilot to the Emperor at a salary of 300 ducats, but Wolsey has offered me even more if I pass to the King of England. I don't want to do that. What I want is to serve my native city. I am ready to return to Venice now at my own expense to set out on a voyage of discovery.' The speaker was Sebastian Cabot, who had led ships across the Arctic Circle and into the La Plata river. Contarini became convinced of the genuineness of Cabot's offer and was much touched by it. But on reflection he replied in these terms. 'You want to mount a Venetian expedition—but how? Ships built in Venice would have to pass the Strait of Gibraltar, which Spain and Portugal would never allow. Then either you build ships on the Red Sea—and there's no timber there—or on the German coast, and for that the Emperor would never give permission.' Though the ambassador and the explorer became friends, Cabot's proposals were turned down in Venice, and he remained in the service of Spain.

This incident foreshadows Venice's decline as a great power. Geography had denied her access to the new world; more and more she was shut up in a corner. But, as we have seen, her economic decline did not become serious until the end of the century. One reason is that the Spaniards were slow in exploiting the mines of Peru and Mexico. In 1557, however, they introduced a much improved technique of working silver: ore was crushed by hammers, mixed with salt, vitriol and mercury, distilled and finally filtered

through hempen cloth. Between 1591 and 1600 2707 tons of American silver reached Spain, as well as nineteen tons of gold. This harmed Venice in two ways: it lowered the real value of her treasure, and provided capital for new industries among her rivals.

Meanwhile, Venice declined as a centre of shipbuilding. One reason was the shift of capital to farms and estates, another the shortage of oak for hulls. Oak forests had been felled indiscriminately and the Senate's efforts to conserve and replant came too late. In the 1550's Venice was buying oak abroad; by 1561 the building of medium-sized cargo ships, of around 120 tons, had practically ceased, and towards the end of the century the building of large ships, of 240 tons and upward, also fell off alarmingly. Government subsidies to private shipbuilders met with a poor response; by 1606 about half the large ships in the Venetian merchant marine had been built in such distant regions as Holland (which could draw on Baltic timber), Patmos and the shores of the Black Sea.

Simultaneously, the merchant marines of rival powers increased. Portuguese caravels with improved rigging imported spices direct from India, by-passing Venice, before yielding this profitable trade to the Dutch. English and Dutch ships entered the Mediterranean and began to replace Venetian carriers. In 1609 thirteen ships dropped anchor at Venice with a cargo of Spanish wool; only three flew the flag of St Mark. The following year these three had been wrecked and all the Spanish wool arrived in foreign ships.

In July 1570 the island of Cyprus, key to Venice's near-Eastern trade, was attacked by a Turkish force of 50,000. Alarmed to the point of forgetting their differences, Venice, Spain and the Pope formed a Triple Alliance, to which the Italian city-states contributed. On 7 October 1571, off the Greek town of Lepanto, an allied force of 200 galleys, six enormous Venetian galeasses and a few smaller ships routed a more numerous Turkish fleet, sinking 50 of their ships, killing or taking prisoner 15,000 Turks and setting free 10,000 Christian galley-slaves. The Venetians covered themselves in glory, but it was the Spaniards who claimed the lion's share of loot. On one of the Spanish galleys each soldier received booty worth 2000 ducats, while the Venetian captain, Sebastiano Venier, received only 505 ducats, a coral chain and two African slaves. Indeed, while Lepanto

was hailed as a victory throughout Europe and given its own feast in the Church's calendar, for Venice it really marked a cruel defeat, since its immediate result was to stir the Turks to an extraordinary display of energy. A year later they had rebuilt their fleet to the number of 210 ships, seized Tunis and closed the Eastern Mediterranean. In 1573 Venice, deserted now by Spain, had to make a humiliating peace, in which she ceded Cyprus.

In this general decline the nobility began to grow poorer. Returns from land were smaller than from commerce, and in the later part of the sixteenth century it became the custom for only one of a group of brothers to marry, so that the hard-pressed family fortune would remain intact. Then came the plague of 1575-7, which reduced the number of noblemen by a quarter. Instead of 2500 noblemen to fill the Republic's 100 key posts there were now about 1875. As a result of the new marriage policy the number of births also dropped off. Whereas in the 1580's about 1200 children were born to noble families, the number was lower by 100 in the 1590's, lower by another 100 in the 1600's, and continued to decline. It became more and more difficult for the Great Council to find candidates in sufficient numbers and with sufficient wealth to hold the more important governorships, where salary did not cover expenses. Increasingly they had to give important posts to inexperienced men. The manpower shortage among the nobility was to become critical in later centuries, but already by 1590 it was sufficiently severe to place a burden on the already hard-pressed ruling class.

It is one of the glories of Venice that even in economic decline she continued to keep the torch of liberty alight. Indeed, her role in the cause of freedom now became more important than ever. As Rome increased her interference in the internal affairs of Italian states. Venice alone dared to resist. Though she did not always win, to many her resistance was a symbol of all that had been best in the classical revival.

In 1565 Pius IV published a bull enjoining universities to award degrees only to Catholics. The Venetian Senate disregarded the bull and, affirming its absolute sovereignty in cultural as well as political affairs, named a Procurator to Padua University empowered to grant degrees without regard to the faith of the candidate. As a

result Padua remained a truly international university; among those who received the degree were two young men later to become distinguished physicians: Salomone Lotio, a Jew, in 1589 and William Harvey in 1602.

The Venetians never felt happy about the Inquisition. While Pier Paolo Vergerio, Bishop of Capodistria, ridiculed both it and the Index in a series of pamphlets modelled on Aretino's open letters before finally leaving the Church in disgust, the Venetian Government laid down strict conditions for inquisitional activities within the Republic. Three senators, known as the *Savii all'heresia*, had to be present during proceedings, so that they might inform the Doge and Senate of all that took place; outside Venice the governor of the city had to be present. Usury, bigamy, blasphemy, the wounding of images and the chanting of 'impure litanies' were placed outside the Inquisitors' jurisdiction. Jews, Greeks and infidels might not be prosecuted. No one might be put in prison before a charge was framed, property might not be seized and torture was forbidden. Felice Peretti, later Sixtus V, counsellor to the Venetian Inquisition in 1557, was found to be disregarding these conditions, whereupon the Senate in 1560 secured his recall to Rome.

Venetians were no less active in resisting the Index, which Paolo Sarpi, the Republic's official theologian, described as 'the finest secret ever discovered for applying religion to the purpose of making men idiotic'. First of all, it damaged the Venetians economically. After publication of the Index in Venice in 1596, within the space of a few months the number of presses fell from 125 to 40, with the result that presently many of the liveliest Italian books, such as the poems of Tassoni, were to be printed not in Venice but in Paris.

The Index also damaged Venice politically. Venetians claimed that Roman censors were passing for publication only books which exalted ecclesiastical authority and attributed to Satan governments based on secular principles. Not only that, when it came to emending books written after 1515, the censors, who were allowed to add as well as to expurgate, altered the argument in such a way as to favour the Papacy and denigrate Venice. Strong Venetian protests led to the signature of a concordat with Clement VIII stipulating that the Venetian press would be subject only to State control and not to

Roman tribunals. However, Venice was not always powerful enough to secure her rights under the concordat, and the economic handicap remained, since elsewhere in Italy censors could prevent the sale of Venetian books.

These and similar strokes on behalf of her liberties won the applause of all who believed in freedom of expression. When he came to write his *Heptaplomeres*, a discussion between seven wise men all of different Christian beliefs, Jean Bodin set it in Venice, as the likeliest place such a discussion would be allowed, while Campanella wrote one of his finest sonnets to Venice:

> *Nuova arca di Noè, che mentre inonda*
> *L'aspro flagel del barbaro tiranno*
> *Sopra l'Italia, dall' estremo danno*
> *Servasti il seme giusto in mezzo all'onda. . . .*

> A second Noah's ark, amid the blight
> Of tyranny and barbarous ways
> That crushes Italy, you save from death
> The line of just men, far out at sea. . . .

Set on a course of decline, harassed by quarrels with Rome and threatened by Spain, Venice could not survive by brave gestures alone. She had to use her wits. She did so most notably at this period by perfecting an elaborate diplomacy based on intelligence services second to none. The ambassadorial reports of the Barbaro brothers, who built the Villa Maser, are models of detailed description and perceptive analysis. Daniele's account of his embassy to England is an accurate and comprehensive picture of that country, while from France Marcantonio kept the Senate abreast of the dark doings of Catherine de Médicis; later he was sent to Constantinople and when the Cyprus war broke out imprisoned; even so he managed to smuggle news to Venice about troop movements and kept open the door to peace.

The high point of Venetian diplomacy was a show of pomp and splendour designed to prove to the world that Venice was still vigorous. Whenever a prince, duke or dignitary who could be useful to the Republic came anywhere near Venice, he was treated to revelry of unsurpassed brilliance. Venice's navy might be crumbling,

but she could still stage a thrilling mock-battle between a Venetian and Turkish galley; her cannon might be obsolete, but at least they could fire salvoes of welcome. The most spectacular welcome of all was given in 1574 to Henri III, the new King of France.

The favourite son of Catherine de Médicis and a grandnephew of Pope Clement VII, Henri was then a youth of twenty-three, dark and slight, with a wide intelligent brow tapering to a nervous mouth and small chin masked in a stubble of beard. He had received a classical education from Amyot, translator of Plutarch, and could make a well-turned speech. At the moment he showed promise; later he was to become a student of Machiavelli. 'As Tacitus said of Galba, he would have been judged worthy of a throne if he had never reigned.'

Coming from Poland via Vienna, Henri arrived at the Venetian frontier on 10 July and was escorted by slow stages to Marghera, where seventy Senators clad in crimson silk awaited him in gondolas hung with velvet and damask, long fringes dangling to the water. Offered a choice of three gondolas, each decorated in different colours, Henri selected the one hung with gold brocade, and on this, escorted by 2000 small craft, was rowed towards Murano, saluted by cannon fire from each of the islands he passed. The smooth water of the lagoon, by reflecting the crimsons and golds, joined in the general welcome. Near Murano yet more gondolas appeared—500 of them—to meet the King and escort him to lodgings in the palazzo of Bartolomeo Capello, where liveried musicians played festive serenades.

Forty thousand visitors, among them Tasso, crowded Venice next day, Sunday the 18th, to watch the King's entry. First the Doge crossed to Murano and made a speech of welcome, assuring Henri of Venice's devotion to the house of France. Then Henri was rowed on a new galley across the lagoon to the Lido, where Palladio and Sansovino had constructed an arch like that of Septimius Severus in Rome. The arch was made of wood painted to look like marble, decorated with Henri's battles, and inscribed with tributes to Venice's 'incomparable guest', 'bold defender of the Christian faith' —forgotten now was the Senate's rebuke to Henri two years earlier for his part in the Massacre of St Bartholomew. Nearby, in a loggia

decorated with incidents from Henri's life by Veronese and Tintoretto, the King knelt for a *Te Deum*. He then mounted the *Bucentaur*, regilded for the occasion, and was rowed slowly up the Grand Canal, escorted by gondolas belonging to noblemen and Senators, by 150 brigantines belonging to the guilds and 50 warships with orchestras. Crowds cheered, church bells rang, and a choir on the *Bucentaur* sang Henri's praises in Latin couplets to music by Giuseppe Zarlino. Towards later afternoon the procession reached the Ca' Foscari, where the King's apartments had been furnished with cloth of gold, tapestries, marble tables and paintings by Giovanni Bellini and Titian. As the sun set, windows of all the houses along the Grand Canal and beyond began to twinkle with candle-lit lilies, crowns and pyramids, while fireworks were let off from gondolas. After attending a play acted by the Gelosi, a troupe recalled specially from Milan, Henri retired for the night between sheets embroidered with gold thread and crimson silk.

In the next eight days the King watched a demonstration of glass-making, saw a galley assembled, launched and completely armed—all inside an hour—attended regattas, bought jewellery and 1000-scudi worth of musk, visited Giovanni Grimani's antique collection, called on Titian, had his portrait painted by Tintoretto, was inscribed in the Libro d'Oro as a Venetian nobleman, and at night slipped out for certain unofficial diversions. Among the courtesans he visited was the poetess Veronica Franco, who recorded his patronage, if that is the word, in two sonnets: one tells how the King 'like Jupiter, took human form' and entered her dwelling 'without royal pomp'; in the other 'he who has proved himself adroit a thousand times in peace and war' fills Veronica's soul with '*nobile stupore*'.

In the hall of the Great Council, decorated by Carpaccio, the Bellinis and Titian, its windows festooned with flowers and fruit and dominated by a huge pyramid laden with heavy gold and silver salvers, Henri attended two banquets. At one the hall was decorated with ornamental statues by Sansovino, depicting doges and deities, virtues and planets, animals, flowers and trees—all made of sugar. The knives, forks, bread, tablecloth and napkins were also made of sugar. The menu has not survived, but it is likely that it too was

largely composed of sugar. Scappi, Pius V's chef, lays down in his cook-book that a meal should consist of four courses: the first being crystallized fruits, the second and third meat and game alternating with sweet dishes and the fourth, custard and syrups. In the last quarter of the century there are signs that Italians consumed an increasing amount of sugar: the dietetic counterpart of their taste in poetry and painting.

Henri's reception was unforgettable and indeed he never forgot it. 'If I were not King of France', he said, 'I would choose to be a citizen of Venice.' He surely meant it, for no city in the world could provide so much civilized pleasure. At any rate, Henri went out of his way to help Italians—for Giordano Bruno he obtained a lecture-ship in the Collège de France—and he laid down a friendship between France and Venice which was presently to prove of great import-ance.

For passing two laws judged prejudicial to the Church and for refusing to surrender to Rome two priests accused of civil crimes, in 1605 Venice was placed under an interdict by Pope Paul V. Instead of submitting, Venetian clergy continued to say Mass and administer the sacraments, while Paolo Sarpi took up his witty and sarcastic pen to write a complete defence of the State's claim to temporal jurisdic-tion. Spain, however, prepared to help the Pope by force, and things began to look black. It was then that Venice turned to France and found an ally in Henri III's successor. With the support of the French King Venice resisted Rome for two years. In 1607, through the mediation of the French Cardinal de Joyeuse, she got the interdict lifted without repealing her two laws or being obliged to re-admit the Jesuits, who had left at the beginning of the struggle. It was generally considered a moral victory for Venice, and thereafter Rome was much less ready to ruffle the Serenissima.

With England also Venice cultivated diplomatic ties. She per-mitted Sir Henry Wotton, the English ambassador, to celebrate Protestant service in his private chapel, and to introduce what books he chose. When the Court of Rome remonstrated, the Doge replied that 'it is impossible for the Republic to search the boxes of the English ambassador, when we are absolutely certain that he is living most reserved and quietly, causing no scandal whatever.' Sarpi's

History of the Council of Trent was first published in England and when its author was stabbed through the cheek by would-be assassins in the pay of Cardinal Borghese, Wotton sent to Salisbury, for the King's notice, a portrait of the Venetian martyr with 'the late addition of his scars'.

If Venice succeeded in remaining politically independent, she was subject none the less to the general trend in Italian civilization. She too had her Academies, just as many as other cities, and there, rather than to their studies, Venetian writers repaired for agreeable discussion, to the Platonici, the Pellegrini, the Uniti, the Incruscabili, the Ricoverati, the Industriosi, the Rinati. Titian had died in 1576, Tintoretto was an old man and none of the younger painters showed equal promise. Yet creative genius was not extinct. Caution and the Index might prevent it flowering as philosophy and history, literature or the plastic arts, but there was another form it could take, where the artist was free to express his deepest feelings without fear of censorship. That form was music.

In 1501 Ottaviano Petrucci had published in Venice the first collection of polyphonic music printed from movable type. By 1523 he had issued 59 volumes of music, including reprints. Accurate and easy to read, these publications brought music into the houses of ordinary Venetians, among them rich men who could afford to hire players and singers. Music became more secular, and there began a trend away from concealed meanings and esoteric devices towards works that any sensitive person could appreciate after one or two hearings. It was a trend not unlike that from almost illegible, abbreviated handwriting to italic and cursive. It meant, in the first place, voice lines of similar character in a homogeneous tone colour, instead of dissimilar lines in contrasting timbres.

Just as the great age of Venetian painting dates from Antonello's introduction of Flemish oil technique, so the great age of Venetian music dates from the arrival of a Flemish composer, Adrian Willaert, in 1527, as choirmaster of St Mark's. Willaert brought to Venice the discipline of the contrapuntal, highly intricate Netherlands style, at that time the most advanced in Europe, which the Venetians soon developed in the direction of a more homophonic sound, with full rich chords. Finding two organs in St Mark's, Willaert began

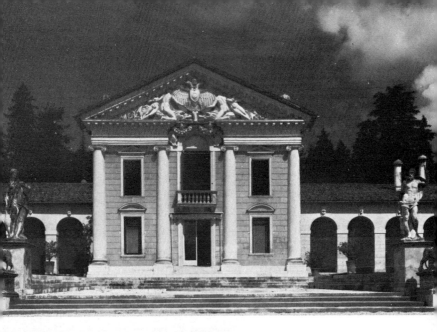

Palladio's villa at Maser, built for the brothers Barbaro. The central block in the form of a classical temple front was Palladio's most distinctive contribution to the country house; the interior is decorated with *trompe l'œil* columns and frescoes by Veronese

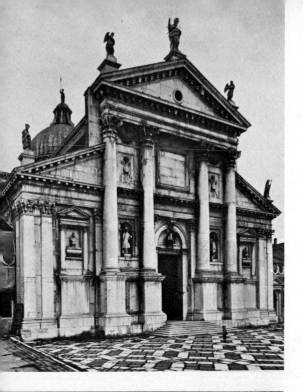

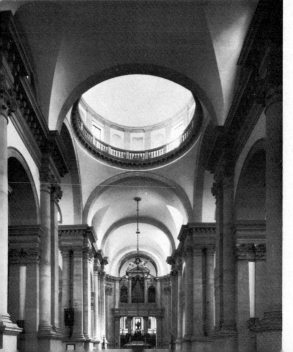

S. Giorgio Maggiore, Venice designed by Palladio. The façade is composed of two interlocking classical temple fronts; the interior has an unusually long choir where the large community of Benedictine monks could chant divine office

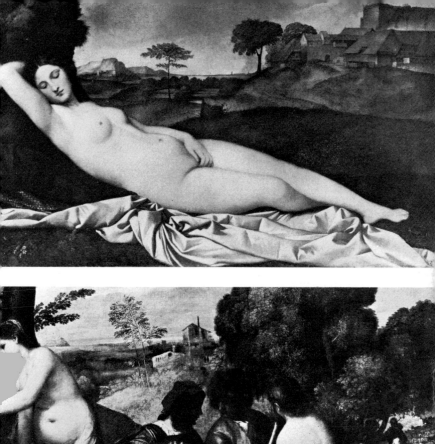

Giorgione: *Sleeping Venus*. Titian completed Giorgione's unfinished picture, adding a cupid which has since been painted over. Below, *Concert champêtre*. Arcadian pastoral poetry furnished this subject for Giorgione, who was himself a skilful performer on the lute

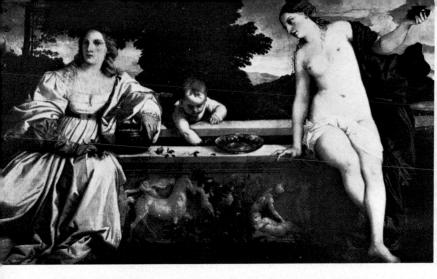

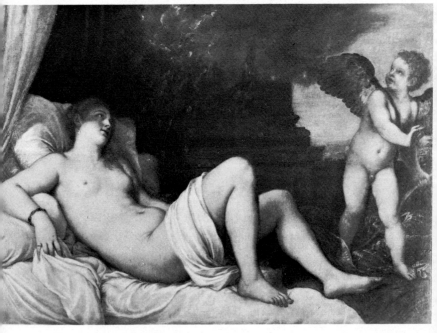

Titian. The subject of the above painting is uncertain. It probably shows Polia, heroine of a novel of the day, seated with Venus on the sarcophagus of Adonis. Below, *Danaë*. Commissioned by Duke Ottavio Farnese, the subject proved so popular that Titian painted several versions

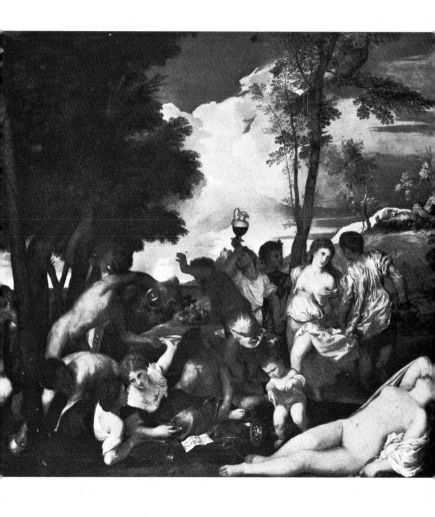

Titian's *Bacchanal* depicts revellers beside a stream of wine which, according to Philostratus the Elder, flowed on the island of Andros

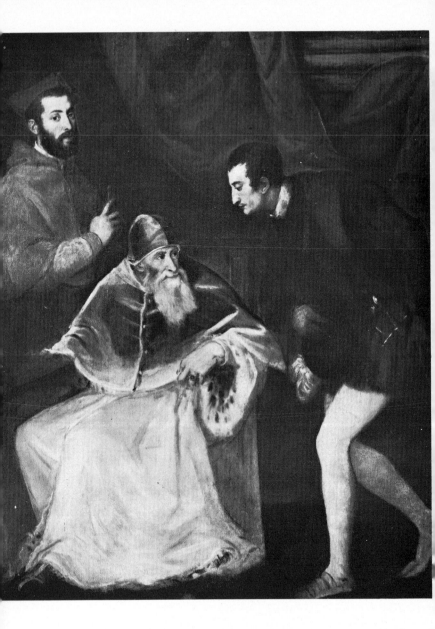

Paul III, aged seventy-seven, between his grandchildren: Alessandro Farnese, created a cardinal at fourteen, and Ottavio, who became Duke of Parma. Titian's picture, with its subtle indictment of nepotism, was soon removed from Rome to Naples

The Finding of the Body of St Mark, by Tintoretto. On the left St Mark makes known that the body being lowered from the wall-tomb is indeed his; on the right a devil in the form of smoke departs from a man possessed

Susannah and the Elders, by Tintoretto. Whereas the Florentine ideal of feminine beauty was tall and slender, Venetian artists tended to paint full-fleshed women

writing motets for two or more choruses, thus giving an impetus to antiphonal writing. For the increasing number of listeners who wanted non-religious music he introduced the madrigal—of which he is virtually the inventor—in the sense of a musical setting of a short poem with no refrain. The madrigal became one of the most popular and characteristic forms in sixteenth-century Italy; its artistry was much increased by Willaert's pupil, Andrea Gabrieli.

Andrea's nephew, Giovanni Gabrieli, greatest of these Venetian composers, was born about 1557. He continued Willaert's development of the motet, using as many as five different choruses, setting one against another, then bringing them together in tremendous climaxes such as had never before been heard. Here for the first time a sonorous balance between voices and instruments was achieved on the basis of the doubling octave. At a time when music was still predominantly vocal, Gabrieli also did much to develop music for instruments alone, thus increasing the sensuous and colourful elements at the expense of the intellectual, a trend characteristic of Venetian taste. Gabrieli began to appreciate the distinctive colour of instruments, and his *Sonata pian' e forte* is one of the first instrumental ensemble pieces to designate particular instruments for each part: a cornet and three trombones in the first orchestra, a viol and three trombones in the second. As though this were not riches enough, a native son of Venezia made the first violin, Venetian organ music was the best in Italy and, at the turn of the century, Venice also became the centre of opera.

Opera owes its first beginnings to the friendship between two Florentines: Vincenzo Galilei, a lutanist and singer who could not read Greek, and Girolamo Mei, a bespectacled Greek scholar who could not sing or play a note. Galilei belonged to the Camerata, a group of scholars dedicated to restoring the Greek drama, and he wrote to Mei, who resided in Rome, requesting information about the music used in Greek drama. After a thorough study of the Greek sources, notably Ptolemy and Aristoxenus, Mei replied that Greek music, choral as well as solo, was almost always monodic. He had never met any mention of parts, such as tenor and bass, or any account of how parts should be sung together. Mei then went on to compare modern music unfavourably with Greek. A staunch

Aristotelian, he held that music should imitate and arouse a definite emotion and so lead to catharsis. He compared the effect of counterpoint on the soul to the vain efforts of several men straining to pull down a pillar by tugging with ropes from opposite directions. He condemned 'contrary' rhythms and tempos, 'where the soprano will hardly move, while the tenor will fly and the bass will be strolling along in slippers'. Instead of communicating clearly like human beings, modern singers 'imitate the warbling and lowing of beasts'.

Mei's letters caused intense excitement among the Camerata. Galilei stated Mei's views with a wealth of historical illustration in his *Dialogo della musica antica e della moderna*, published in 1581, while the president of the Camerata, Giovanni de' Bardi, a composer of neo-Platonic masques, foresaw therapeutic possibilities in music that stirred the feelings deeply: 'We read that Pythagoras cured drunkards with music, Empedocles insane persons, and Socrates a man possessed. . . . Aulus Gellius writes that those who suffered from sciatic gout were healed with the sound of the tibia.'

It now remained to try and write monodic music. Vincenzo Galilei's first attempts were lyric: the Lamentations of Jeremiah and the lament of Count Ugolino from Dante's *Comedy*, both now lost. Galilei was, it seems, the first who composed artistic monodies, and his music followed as closely as possible the natural inflections of speech. But it was a younger member of the Camerata, Jacopo Peri, who claimed to fulfil the original intention of reviving Greek drama in the Greek manner. For the marriage of Henri IV and Marie de Médicis he wrote a festival play to music entitled *Eurydice*. In the dedication he writes: 'It has been the opinion of many persons, most excellent queen, that the ancient Greeks and Romans sang their tragedies throughout on the stage, but so noble a manner of recitation has not, that I know of, been even attempted by anyone till now; and this I thought was owing to the defect of modern music which is far inferior to ancient.'

Eurydice was performed in Florence in 1600. It is all recitative, and the words are allowed complete supremacy over the music. Peri called it a *tragedia per musica*. It is in fact the first Italian opera, although not until about 1650 did the term *opera per musica*, soon abbreviated to opera, come into use. So, in the search for Greek

recitative, Italian composers hit upon the new thing, opera. Though they did not know it, they were a long way from reproducing ancient Greek music, which by its use of quarter-tones seems to have resembled Arabian more than Western music.

Dramatic recitative simultaneously made an impact on religious music. In Rome S. Filippo Neri commissioned dramatic dialogues and *laude* for solos, choruses and groups of instruments from leading Italian poets and composers, including Palestrina, the supreme master of the unaccompanied Mass. At the end of the century dramatic recitative replaced dialogue in these works, which began to be known after the name of S. Filippo's foundation as oratorios. The first oratorio of which any account has come down to us, *La rappresentazione di anima e di corpo*, was performed in Rome in 1600. The action was staged with costumes and scenery, and the accompaniment provided from behind the stage by a double lyre, harpsichord, large guitar and two flutes. For many years there was little difference between opera and oratorio except in subject.

The composer who developed the somewhat primitive Florentine opera into an art form was Claudio Monteverdi. Born in Cremona in 1567, Monteverdi studied under Marcantonio Ingegneri, choirmaster of Cremona cathedral, before going to Mantua at the age of twenty-three as viola player and later choirmaster to Duke Vincenzo, a lively nobleman who married Marie de Médicis' sister, composed ballets and dabbled in alchemy. For the pittance of 12½ crowns a month Monteverdi supervised concerts, ballets and tournaments; he also accompanied the indefatigable duke on visits to Hungary and Flanders. In 1595 he married a Mantuan singer, Claudia Cattaneo, who bore him two sons, one of whom became a priest, the other a doctor. In his portraits Monteverdi is depicted with a long rugged head, protuberant nose, turned-up moustache and spade beard; his fingers are long and sensitive; his eyes, under conspicuously arched brows, calm and serene. A serene character is also suggested by his beautifully penned scores. Only two events seem to have disturbed his orderly, discreet life: the death of Claudia in 1607, and the imprisonment by the Inquisition of his doctor son for reading a prohibited book: he had to buy the young man's release for 100 ducats.

In 1612, when Duke Vincenzo died, Monteverdi found himself out of a job. But the following year he was appointed choirmaster at St Mark's at 300 ducats a year, later raised to 400 and again to 650. His duties included composing for religious festivals, State banquets and receptions, and the Doge's marriage with the sea. In 1632 he took minor orders. He remained in Venice until his death in 1643.

When Monteverdi was a young man, the writing of madrigals had reached a cross-roads. Monody, as developed in Florence, possessed a welcome flexibility and lifelike dramatic power; but it lacked the formal stability and harmonic richness of older vocal music based on counterpoint. It was Monteverdi's achievement wonderfully to develop the madrigal by applying to monody the lessons of the polychoral works of the Venetian school. He gave it colour and movement and, in what is called the *concertato* style, emphasized the contrast of one voice or instrument against another, while preserving a definite dramatic mood throughout. In his eight books of madrigals Monteverdi's range of emotion is unprecedentedly varied; there is hardly a text, tender or strong, sad or exuberant, that he does not succeed in matching with sound. He was humanist enough to write in a letter: 'Plato teaches that the cithara is appropriate to the town, the flute to the country, and I intend to observe this as a rule,' but he was also a bold experimenter. Into one piece, the *Combattimento di Tancredi e Clorinda*, text by Tasso, in order to suggest the galloping of horses and clash of swords he introduced the *stile concitato*, or excited style, new features of which are tremolo, pizzicato and the rapid reiteration of a single note.

In 1607 Monteverdi wrote and produced the first of his four operas: *Orfeo*. In choosing the libretto he seems to have been guided by his emotional response for later, when rejecting a script, he wrote: 'The Ariadne [his second opera] made me weep, Orpheus made me pray, but this story seems to have no purpose.' Similarly, while adopting Florentine recitative, Monteverdi gave it strong emotional colouring, and instead of writing the whole opera in recitative, provided welcome contrast with arias, duets, dances and madrigal-like choruses. These are not appendages but knit together to enhance a central dramatic effect.

Dramatic effect was also one of the reasons why Monteverdi

reorganized the musical accompaniment. In Peri's *Euridice* only a few lutes had accompanied the singers, but the *Orfeo* called for two harpsichords, two bass viols, two tenor viols, two 'little French violins', one harp, two large guitars, two small organs, two violas da gamba, four trombones, one regal, a little reed organ, two cornets, one piccolo, one clarion and three trumpets. The musicians were seated between stage and audience, in that section of the hall where the chorus danced. The Greeks had termed this a dancing place or *orchestra*, and the Greek word now came to designate the musicians. They played twenty-six independent pieces in the *Orfeo*, including an introductory number which marks the origin of the overture.

In Venice Monteverdi wrote two more operas, *Il Ritorno d'Ulisse*, and *L'Incoronazione di Poppea*, based on an episode in Tacitus, which is generally considered his masterpiece. In it Monteverdi succeeds in something that had eluded all the tragedians with their Aristotelian apparatus: the convincing portrayal of character—through melody and tone colour rather than through words. But if it was a climax, Monteverdi's *Poppea* also marks the end of an epoch. His pupil, Pier Francesco Cavalli, born in 1602, was to write forty-one operas, but treats classical subjects only for their entertaining, violent or spectacular effects. Improved stage machinery made possible ship-wrecks, sieges, thunderstorms and lightning, timely descents of the gods and all the colourful pageantry that had distinguished the reception of Henri III, while the libretto became merely an excuse for scintillating music. In painting the Venetians had borrowed Florentine geometrical principles and then steadily buried them under rich colours and dramatic light effects; so now the Venetians borrowed the Florentine principle of the importance of words, and slowly reversed it. They did so to an increasing audience. The first public opera-house opened in Venice in 1637; before long there were forty; and throughout the century Venice was to remain the operatic capital of Europe.

One last event in Venice remains to be described. It happens to con-cern a Florentine citizen residing in the Venetian Republic, and there-by brings the history of the classical revival, which began in Florence, to a fitting close. In 1591 Galileo Galilei, as we have seen, unable any

longer to bear the bigoted Aristotelianism of Pisa University, resigned his chair of mathematics. The son of the musical theorist Vincenzo Galilei, he was already known for his disturbing opinions and it says much for the Procurators that in 1592, on the advice of the mathematician Guidobaldo dal Monte, they named him to the chair of mathematics at Padua University. Galileo arrived at the age of twenty-eight, and remained there as a professor until he was forty-six. For eighteen years he had leisure for study and freedom to think as he wished. He took a Venetian girl as his mistress, and had Venetian friends in every walk of life, among them Paolo Sarpi. The sickly Servite was an authority on geometry and related subjects; he was also the first to note the contraction and expansion of the uvea in the eye. Galileo may have owed much to his conversations with Sarpi, whom he calls '*padre e maestro*'. He also enjoyed studying the latest machines in the Arsenal. On one occasion his advice was sought as to whether oars would have greater propulsive power if placed on platforms projecting from the sides of a galley. During these fruitful years he invented the thermometer and the proportional compass.

On a visit to Venice in May 1609 Galileo read the account of an instrument for enlarging distant objects invented by a Dutchman. Much intrigued, he decided to try and construct such an instrument himself. Murano led the world in the making of crystal and it is highly probable that Galileo crossed to that island in order to discuss his plans and to get the requisite glass ground. 'First,' he says, 'I prepared a tube of lead at the end of which I fitted two glass lenses, both plane on one side, while on the other one was spherically convex and the other concave. Then, placing my eye near the concave lens I perceived objects . . . three times closer and nine times larger than when seen by the naked eye alone.' With this instrument in his hand he invited friends to climb with him to the top of the campanile of St Mark's to try it out. In his diary entry for 21 August 1609 Antonio Priuli describes the historic occasion:

I went to see the marvellous and singular effects of Galileo's spyglass. It was covered with red cloth, about three quarters of a bracchio long [20 inches] and the width of a scudo [1.6 inches] . . . placing one eye to it and closing the other, each of us saw

distinctly beyond Liza Fusina and Marghera, to Chioggia, Treviso and as far as Conegliano [30 miles from Venice]. We saw the campanile, cupolas and façade of the church of Sta Giustina in Padua; we could distinguish people entering and leaving the church of S. Giacomo in Murano; visible also were persons embarking and disembarking from the ferry gondola by the Column at the beginning of the Rio de' Venieri, as well as many other really admirable details in the lagoon and the city.

Such was the astonishment, says Galileo, that even Senators bowed with age climbed the hundreds of steps a second time to peer again through the spyglass.

On 24 August Galileo presented the Venetian Government with an improved version of his instrument, nine times more powerful than the one demonstrated, explaining how valuable it would be: 'We could discover the enemy's ships more than two hours sooner than he could discover us.' Next day the Doge and his Council expressed their appreciation by confirming Galileo in his post for life, at a salary of 1000 florins. Galileo again improved his telescope, until objects appeared a thousand times larger than with the naked eye, and began a series of observations of the night sky. Galileo was not the first to point a telescope heavenwards—Thomas Harriot in England had already observed the moon—but he was the first to combine the use of a powerful instrument with great astronomical learning and imaginative genius.

Galileo's telescope showed him that the moon, instead of being a self-luminous and perfectly smooth sphere, as was thought, owed her light to reflection, while the 'spots' on the moon, about which Beatrice had discoursed to Dante, were really valleys and mountains. The Milky Way Galileo pronounced a track of countless separate stars. Near Jupiter he discovered what he first took to be four stars, but six days later he concluded that they were satellites. At first Kepler doubted the satellites' existence, 'since there would be no one to admire them', and only when he observed them himself through one of Galileo's telescopes would he accept the discovery, exclaiming, 'Vicisti Galilaee.' Galileo named the satellites the Medicean Stars, after his pupil and future patron, Cosimo de' Medici. This prompted

an urgent request from Paris, asking Galileo please to name his next stars after the King of France. Galileo was unable to oblige, but later in the century Cassini satisfied French pride on this score.

The most important of Galileo's observations were moving spots on the disc of the sun. These had been seen by Fabricius in Holland and by Scheiner in Germany, who supposed them to be small planets. But Galileo proved they were markings on the sun's disc, and from these was able to establish the rotation of the sun in about twenty-seven days. This and his observation of the rotation of the satellites round Jupiter were to lead Galileo to proclaim the truth of the heliocentric theory.

The Venetian Senators' astonishment on the campanile of St Mark's was now magnified innumerable times. Galileo himself was awestruck. 'Who', he asked, 'can set bounds to the minds of man? ... Who dares assert that he already knows all that in this universe is knowable?' From prison Campanella wrote a brilliant *Defence of Galileo*. 'We are amazed by the magnificent scene which Galileo unfolds, in which the God of wisdom and power and love brings forth his riches.' Then Campanella turns on the critics who had already begun to attack the astronomer. 'Those who believe the summation of all things is found in Aristotle and other ancient philosophers drive out faith in God. They are jealous by nature and forbid man a widening search.' 'I have shown that freedom of thought is more vigorous in Christian than in other nations. Should this be true, whoever at his own pleasure prescribes bounds and laws for human thought . . . is not only irrational and harmful, but irreligious and impious.'

The night Galileo turned his Venetian-made telescope on the moon and stars may be said in two ways to mark the end of the Renaissance. First, it changed the nature of discovery. For two centuries Italians had been advancing through study of the classical past; from now on their successors north of the Alps would find new truths and modify their picture of the world through scientific instruments such as the telescope and its counterpart, the microscope. Secondly, it marked the beginning of a new sense of time. During the Renaissance, time and the course of history were not considered to be actually generative of anything. But, as Campanella dimly saw,

Copernicus's discovery marks a definite step forward in the story of truth and man. Because it invalidated certain theories formerly held to be true, it was to lead to the theory of historical development and of a world opening out to even grander things. The resulting revolution was to have the effect of dissolving tradition and replacing an idealized classical Greece and Rome with brave new worlds as yet without a name. The gold and rose of the Venetian sunset were also the colours of dawn.

But the dawn was not yet, for Galileo had to reckon with Rome. Around 1600 Rome was a very different city from that of Julius II and Leo X. On the face of it all was well. As throughout Italy, the population had risen and now stood at 100,000. Thirty new streets had been laid out, the smartest being the long straight Via Giulia, leading up to Sansovino's church of S. Giovanni dei Fiorentini. The dome of St Peter's was complete. Sixtus V, who reigned from 1585 to 1590, built the present Vatican Library and papal apartments, restored Trajan's Column and constructed an aqueduct so that Romans no longer had to drink the filtered waters of the Tiber. But the main visible change was the number of new churches: no less than fifty-four places of worship went up in the sixteenth century.

The streets of Rome now rattled to the sound of coaches: four-wheelers open front and rear, drawn by two horses. Rome was one of the places where they were constructed. In 1581 the Duke of Bavaria ordered a specially large one, drawn by four horses, containing a small oven for baking bread and a stove for preparing meals en route. Six hundred Roman families could afford a coach; some had three or four.

There were no longer any bishops to be seen—a hundred or so had been sent back to their sees. But cardinals were much in evidence, and as rich as ever. If land is taken as yielding 3%, the capital of the sacred college in 1571 amounted to 25 million crowns. Much of their new wealth the cardinals spent on palatial villas and elaborate gardens, such as those of the Villa d'Este at Tivoli. Visiting Caprarola in 1578, Cardinal Borromeo, later a canonized saint, was stupefied and said to Farnese, 'What will Paradise be like?' adding that the money would have been better spent on the poor.

From the poor in fact much of the money had originally come. The loss of England and parts of Germany and Poland, together with religious wars in France, resulted in a heavy drop in papal revenue. This was met by increasing taxes steeply. In 1492 revenue from 'spiritual' sources had roughly equalled that from the Papal States; around 1590 the spiritual revenue was 250,427 crowns, while the Papal States contributed 1,168,488 crowns.

Even so, the Papacy's economic position remained as unsound as when Julius II became Pope. As expenditure constantly exceeded income, the Popes began to float Monti or State Loans. If it was not to be usurious, a loan must involve risk for the lender, and the contract must have the appearance of a sale. In the State Loans the Pope was considered to buy the capital of shareholders, in exchange for which he sold them shares in the Monte. Between 1526 and 1605 the Popes floated 47 State Loans. Gone were the days when they had depended on bankers in Florence: Rome was now the biggest money market of Europe. But Rome still produced nothing, and her prosperity was a bubble on a whirl of debts. By 1606 the Papacy's public debt amounted to 12 million crowns, annual revenue to only 2 million.

Rome's other perennial problem—political independence—was now solved. The Papal States had been enlarged since 1598 by the acquisition of Ferrara, Julius II's old enemy. Their integrity was guaranteed by the Spaniards, while France and Germany were no longer serious threats. Between them Rome and Spain, her treasuries stacked with American silver, governed almost the whole of Italy and preserved the peace.

Roman morals were now by and large reformed. Papal elections were no longer simoniacal; popes and cardinals no longer kept mistresses; the Curia no longer blatantly sold high offices. The decrees of the Council of Trent were being enforced. Seminaries had been set up to educate priests, who now wore black instead of any colour they liked; as we have seen, there were no more absentee bishops, nor were there any more lavish papal banquets and hunts. Much good was done by the long residence in Rome of two saints: the gay Florentine Filippo Neri, who founded the Oratory in 1575, and the Basque Ignatius of Loyola.

One positive administrative step taken by the Papacy is of more than passing significance. In 45 B.C. Julius Caesar had replaced the lunar with the solar calendar. The Julian calendar is based on the assumption that the year contains 365¼ days; in order to harmonize the calendar with the equinoxes, one more day is added every fourth year. This reckoning was too long by 11¼ minutes; by the sixteenth century the calendar year was ten days behind the sun, ten days 'slow'. Talk of replacing the Julian calendar had been going on for years, but received serious attention only when a Calabrian, Luigi Lilio, published in 1577 a project based on accurate calculations. After Lilio's death it was completed by a German Jesuit, Clavius, and put into effect by Gregory XIII in 1582. The day after the feast of St Francis Assisi, 5 October, was followed by 15 October; and henceforth century years were to be leap years only when the first two figures were divisible by four: for example, 1600 and 2000. The Gregorian calendar was accepted in Spain, Portugal and part of Italy on the same day as in Rome; in France, at the end of 1582, in Catholic Germany in 1583. Britain retained the Julian calendar until 1752, Russia until after the Revolution, with the odd result that the 'October Revolution' really took place in November.

In other ways besides the calendar it was Rome who called the tune. She had routed Lutheranism in Italy; her missionaries were winning back large parts of Germany and Poland as well as spreading the faith in America and the East. Embassies arrived with gifts for the Pope from as far afield as Japan. And her conscience was clear. No one now could point to scandalous corruption in high places, no one could say that Venus was preferred to Christ.

But that this was only one part of the picture, the bright part, can be seen as soon as we turn to look at the Popes themselves. The striking thing about them, from Pius IV, who succeeded the terrible Paul IV, to Clement VIII, whose reign marks the end of the century, is that they lack individual character. They seem not to have faces. Under their different names they are all in effect the same dry, stiff heresy-hunter: and three out of eight were in fact ex-Inquisitors. Whether it is Pius V—the protégé of Paul IV—advocating attacks upon the Huguenots in France, the Protestants in Flanders and the English crown, or Gregory XIII commissioning Vasari to decorate

the Vatican with the St Bartholomew's Massacre of 1572, considered a great triumph for the Church, the policy is unvarying: repression of heresy. These popes may have led austere lives, but they were one and all bigoted, even Clement VIII, who came of the Florentine Republican family of Aldobrandini and should have known better. It was Clement who issued a bull forbidding Italians to travel abroad without permission from the Holy Office, or to reside abroad without annually submitting a certificate of Confession and Communion.

Under Popes such as these it is not surprising that learning languished. In 1561 the excellent and conscientious Cardinal Seripando, convinced that the Index and the Inquisition would never be able to maintain the present position of the Church, to say nothing about regaining lost territory, arranged for Paolo Manuzio, head of the Aldine Press, to come to Rome in order to produce an edition of the Greek Fathers. Manuzio brought his own type from Venice, set up his press near the Fontana di Trevi and by November 1561 was ready to begin. Seripando proposed as a trial publication Pole's orthodox but liberal booklet, *De Concilio*. At once the Inquisition raised objections, and many weeks passed before the booklet could be printed. The project of publishing the Greek Fathers was so bitterly attacked that it had to be abandoned and, as Manuzio complained, scholars would still have to depend on Protestant editions. Finally Manuzio returned to Venice before his contract expired, convinced that he was wasting his time. Only in 1587 was the Vatican Press founded, by Sixtus V. It published what was to be the authoritative text of the Vulgate, but the work was done too hastily and had to be withdrawn for its many inaccuracies.

Not only was scholarship slow and faltering, but the Popes tried to keep Rome in an intellectual vacuum. Montaigne did not know whether to laugh or be angry when the Roman authorities seized his *Hours of Our Lady* because it was the Paris, not the Rome edition, and certain anti-Lutheran books by German scholars 'because in controverting heretics they specify their errors'. Latini wrote from Rome during the pontificate of Paul IV, 'Here, I imagine, no one for many years to come will dare to write except on business or to distant friends,' while Marc-Antoine de Muret, a French scholar resident in Rome, found himself forbidden to lecture on Plato, and

forbidden to consult a copy of Eunapius in the Vatican Library. 'It is my misery,' he declared, 'to watch the gradual extinction and total decay of Greek, in whose train I see the whole body of refined learning on the point of vanishing.'

It is one of the tragedies of the century that this repressive spirit gradually spread also to the Jesuit system of education. One of the largest and most imposing of the new buildings in Rome was the Collegio Romano, which St Ignatius founded in 1551 for the education of Roman boys. He and his colleagues naturally took account of prevailing curricula and theories. The best book on the subject was by Contarini's friend, Jacopo Sadoleto, published in 1533. In it he advocates study of the classics because they help to make boys aware of the goodness and moral values common to pagan and Christian. Sadoleto's theory of education is liberal, optimistic and tolerant: for example, Plato and Aristotle are accorded equal attention. Rhetoric is valued not for itself, but as a means of perfecting Christian *humanitas*.

That the first Jesuit schools were conceived in a spirit comparable to Sadoleto's can be seen from the life of one of their most gifted pupils. Matteo Ricci was born in Macerata in 1552 and educated at the Collegio Romano, where Clavius taught him mathematics. He was sent to the Far East and became the first missionary to establish a foothold in China. There he sought by ingenious methods to build a bridge between Confucianism and Christianity, just such a bridge as Sadoleto had envisaged between classical Greece and modern Rome. No one could have been more large-minded than this Italian who lived as a Chinese for twenty years, wrote books and music in Chinese, made clocks for the Emperor, explained Galileo's discoveries to Chinese astronomers, and died in Peking in 1610. Living out of reach of the Holy Office Matteo Ricci, and his fellow-missionary Roberto de' Nobili in India, another product of Jesuit education, may be called the spiritual successors of Pico della Mirandola and Marsilio Ficino.

But as the century wore on, Jesuit schools like every other Italian institution began to conform to the new mood in Rome. They continued to study classical texts, but the quickening impulses which inspired earlier days—desire for a larger and fuller life, joy in

beauty of style and thought, craving for an illimitable range of knowledge—these had largely disappeared. The stress now was placed on authority. They were not concerned to help a youth to be free to choose for himself—the choice had already been made; it was a matter rather of arming him for combat. The Jesuit Antonio Possevino, writing in 1598, puts it like this: 'Eloquence and the sciences, which priests have led as handmaids to the Rock and Citadel of God, finally become shields and bucklers in the hunt for those enemies who are bent on attacking the Church of God.'

The Jesuit Constitutions of 1583, in accordance with current practice, laid down that 'Greek and Latin authors must be expurgated of any incidents or language that can cause harm to morals.' According to the *Ratio Studiorum* of 1586, boys were first to be instructed in the humanities—grammar, rhetoric, poetry and history—before going on to more advanced subjects: 'In logic, in natural and moral philosophy, and in metaphysics the teaching of Aristotle must be followed.'

An interesting proposal was made by the Provinces of Upper Germany and the Rhine in their critique of the 1586 *Ratio*. They urged that history should receive more importance. It should be treated not just as a subsidiary of literature, but as a discipline on its own, with a special textbook, and it should be taught for one hour daily. This proposal was evidently turned down, for in the revised *Ratio* of 1591 history retains its old status. Following Quintilian, the Jesuits treated the historians as serviceable in providing certain materials for argument, illustration and parallel, and in the curriculum of their schools ancient history remained a background to classical literature. This was a great misfortune: a study of historical change might well have checked the decline into emasculated Aristotelianism. The results for Catholic Europe were to be far-reaching, for already by 1574 the Jesuits had established 125 colleges, and the number was to be multiplied during the next two centuries, until the education of talented boys in Italy as in other Catholic countries became almost synonymous with the Jesuit system.

It was against this background that Galileo came to Rome in December 1615. He had earlier been made a member of the distinguished Accademia dei Lincei and was given a warm welcome.

However, a certain Father Ferdinand Ximenes had already denounced Galileo's book on sun-spots to the Inquisition, as a result of which in February 1616 the Holy Office censured two propositions. First: The sun is the centre of the world, and altogether immovable as to local movement; second: The earth is not the centre of the world and is not immovable, but moves as a whole, also with a diurnal motion. On orders from Pope Paul V the Jesuit Cardinal Bellarmine admonished Galileo to abandon his theory, and ordered him not to hold or defend the censured propositions. For sixteen years Galileo obediently kept silence. Then in February 1632 he was to publish his *Dialogues Concerning the two Principal Systems of the World*; he was to be obliged on bended knee to recant his 'false opinion' that the sun is the centre of the world and immovable, and that the earth is not the centre of the world, and moves. Nor did he mutter, as he rose from his knees, '*Eppur si muove!*'—there is no contemporary evidence for that statement, and it would appear to be wishful thinking on the part of his eighteenth-century biographer. In this latest confrontation of Venice and Rome, it was Rome that had the last word.

The Galileo incident is famous and has a symbolic importance, but it was only one of many. We have seen Giordano Bruno go to the stake, and three years earlier a peace-loving Florentine, Francesco Pucci, was also burned for heresy in the Campo dei Fiori. Rome had indeed changed since the days of Leo X, as Tasso had in mind when he concluded a sonnet to Rome with these lines:

> *Io non colonne, archi, teatri, terme,*
> *Ormai ricerco in te: ma il sangue e l'ossa*
> *Per Cristo sparte in questa nobil terra.*

> Columns, triumphal arches, theatres, baths
> —These I ignore; I seek instead the blood
> And bones of martyrs slain in this noble land.

He meant, of course, early Christian martyrs; but in the light of the Inquisition's victims, his lines have another, more lurid meaning.

Rome, then, might vaunt herself as reformed, but for the time being she had betrayed the principles of Christian humanism, and in so doing abandoned common humanity. She prided herself on having broken with the evils of Julius II and Leo X, but in the last

resort it was the later, heresy-hunting Popes of austere life who did far more lasting harm to the Church. There was a narrowness in the air which visitors detected at once. In the city where Leo X had laughed at *Mandragola* priests were now forbidden to attend plays, while one of Rome's principal sources of wealth came from exporting those classical statues which had been the pride of earlier years. In 1500 Rome had been an international city, but in 1600 it was almost exclusively Italian. In 1500 60% of the Sacred College had been Italian, but in 1598 the figure had risen to more than 80%, and all future Popes down to the present day would be Italian. This entailed a constricted, often provincial attitude which compares unfavourably with an earlier largeness of mind. The Popes were increasingly Italian princes, out of touch with the rest of Europe. They lay lulled amid the splendid illusions of Roman baroque. So that although the pompous buildings were there, and the Holy Office enshrined in a fine new dungeoned palace, the Church was to lose very rapidly its hold on the mind of educated Europe. Though the Popes did not know it, the Papacy was weaker than it had ever been; it was in Venice, and all that Venice stood for, that the real strength lay.

Epilogue

Venice continued a free republic during the seventeenth and eighteenth centuries, continued even in decline to produce gay works of art, though these were now in a minor key, signed with such names as Vivaldi and Goldoni, Tiepolo, Canaletto and Guardi. Venice's constitution continued to be the admiration of many, including Rousseau, who made it the model for his *Social Contract*. But sound government and brave displays could no longer stem the ebbing tide of trade and it is one of history's paradoxes that Napoleon, general of the Revolution inspired by Rousseau's *Social Contract*, should have been the man to capture Venice. Later in the same year, 1797, he handed over the city to Austria. With a sure instinct Wordsworth proclaimed his grief at the extinction of the Venetian Republic, for this marked the end of true republican government in Italy, and among Italians depression yielded to despair.

The long rivalry between Rome and Venice at this point took a wider form, for the Popes aligned themselves with Austria in keeping Italy under repressive monarchical rule. Piranesi had already pictured Italy as a huge prison amid classical ruins, over which strolled monks and Austrian soldiers, and Leopardi now wrote in anguish that 'life is today a dark and awful thing.' But just as Campanella from a torture chamber had proclaimed his belief in the soaring human spirit, so now from the depths of humiliation Italians began to bestir themselves to a new revival. Curiously, it was those literary Academies which in the sixteenth century had poured out conformist poetry that now became the centres of underground resistance. By keeping alive a love of the Italian language and literature, they fostered love of Italy. They held readings of the republican historians and of Ariosto's stirring *Orlando Furioso*. They

recalled how Coluccio and Leonardo Bruni had saved Florence, and Venice's victories over the Turk. They remembered their great artists in the pages of Vasari. They were helped with money and friendship by admirers from abroad, men such as Byron and Shelley, anxious to see Italy again free and again great.

So the Risorgimento began. It was a revival largely inspired by that first revival we call the Renaissance. It found much of its impetus in the solid achievements of those two centuries which had made Italy the admiration of the world. Like the first revival, the Risorgimento sought political freedom as the essential condition for intellectual, artistic and spiritual development, and saw itself as the heir of all that was best in classical antiquity. But there is one difference. Whereas men of the Renaissance limited their horizons to the city-state, liberals of the Risorgimento sought the unification of all Italy.

Rome, still bound by the restrictive principles of the Council of Trent, could see no good in these ideas. In a striking reversal of Julius II's policy, Pope Gregory XVI even called in an Austrian army to crush a liberal rising in the Papal States. Thereafter he followed a policy of stern repression. Rome thus alienated the sympathies of liberal Italians, whose goal henceforth became not only expulsion of the Austrians, but an end to the temporal power.

The hour produced its men. Despite their black frock-coats, top hats and steel-rimmed spectacles, Daniele Manin in Venice and Camillo de Cavour in Piedmont were true successors of Pietro Aretino and Coluccio Salutati. They and their colleagues led the Italians, after many cruel reverses, up the steep slope towards independence. In the crucial year 1860 their success hung on the attitude of England, and Englishmen, who owed so much to the Italian Renaissance, were able to repay part of their debt when Lord John Russell sent his epoch-making dispatch to Turin. Her Majesty's Government, he said, would not join the other Powers in censuring Cavour's moves, but would watch 'the gratifying spectacle of a people building up the edifice of their liberties and consolidating the work of their independence.'

Italy attained independence and unity in 1870, and in the same year the Pope's sovereignty was limited to the Vatican, the Lateran

and Castel Gandolfo. The shearing of the temporal power, as many, including Contarini, had foreseen, was the best thing that could have happened to the Papacy, where very slowly the repressive features of Trent began to be reversed, and a more generous attitude to prevail. During or soon after the Second Vatican Council many of the themes dearest to the Renaissance, such as dialogue and the ecumenical movement, were to be reaffirmed, a Christian's right to follow his conscience was to be recognized, and the Index of Prohibited Books abolished.

So Italy as a whole attained that political and intellectual freedom which Florence had defended in the *quattrocento* and Venice in the *cinquecento*. With the lifting of censorship Italians began again to make original contributions to learning and science. In all this it is perhaps permissible to see, with Vico of Naples, the operation of a Providence, rectifying man's wayward tendencies, helping on those that allow him to fulfil his humanity. Once again in Italy, as a result of the Risorgimento and the example of the Renaissance, all that is best of classical antiquity is allowed to flourish within the framework of a more large-minded Christianity; once again in the Europe Italy helped to educate there are glimpses of that truth which Michelangelo had blazoned on the Sistine ceiling: man made in the image of God, open, generous and soaring, bound to his fellow men, whatever their creeds, by the divine qualities within each one.

APPENDICES
SOURCES AND NOTES
TABLES
INDEX

Italian Currencies

Rome

The *ducato di camera*, also called *fiorino camerale*, was issued from 1399 to 1581. It contained 69 12/100 grains of 24-carat gold. 100 ducats weighed 1 Roman pound (339 grams). In 1475 the ducat had been worth 10 silver carlins, but the steady devaluation of silver, owing to imports from the American mines, and the use of alloys in silver coinage meant that a ducat came to be worth 11, 12 and even 13 carlins during the second half of the century.

The *scudo d'oro in oro*, or gold crown, was issued from 1530, in imitation of the French *écu*, with which it was equal in value. The crown contained 63 16/100 grains of 22-carat gold until 1573, and 62 12/100 grains from 1573 to 1594. 100 crowns weighed 1 Roman pound.

The chief silver coin was the *giulio*. It was issued to replace the carlin from 1504 in which year it contained 74 17/100 grains of silver. 83¾ *giulii* weighed 1 Roman pound. By 1566 its composition had dwindled to 60 grains of silver, and 106 *giulii* weighed 1 Roman pound.

The *baiocco* was theoretically a tenth part of a *giulio*, but by 1537 it contained only 6 36/930 grains of silver, roughly 0.295 grams, whereas strictly it should have contained 0.333 grams. Slowly it fell out of use, though it remained a unit in accounting.

In Rome the relationship between gold and silver was, in 1500 1:11.50; in 1535 1 : 11.25; in 1600 1 : 11.66.

The purchasing power of the ducat in 1500 was roughly equivalent to that of £1 sterling today. When Reuchlin was in Rome from 1498 to 1500 he took Hebrew lessons from Obaya Sforno of Cesena, which cost him one ducat an hour; a small book such as Francesco Mancolini's *Art of the Gladiator*, of which an edition of 1000 copies was published in 1518, also cost one ducat. The purchasing power of the ducat decreased slowly but steadily during the sixteenth century.

Venice

Whereas Roman coins bore the Pope's head and, on the reverse, usually a religious scene, the Venetian ducat portrayed the doge kneeling before the Lion of St Mark, and Christ in an oval nimbus. The ducat was also known as *zecchino*: the original *zecchino*, struck in 1284, bore on the reverse the Latin legend 'Sit tibi, Christe,

datus quem tu regis iste ducatus' and the last word was retained to designate the coin and all those deriving from it.

The Venetian ducat was fractionally heavier than the Roman: 100 Venetian ducats weighed 350 grams. It was equal to 2 *soldi di grossi a oro*. Distinct from the ducat as a gold coin was a ducat of account, of which 1 ducat was equal to 124 *soldi di piccoli*. To give metallic representation to this money of account silver ducat coins were issued in 1562.

Florence

In 1501 the gold florin of Florence was equal in weight to the Venetian ducat, i.e. 3.5 grams. It was worth 140 *soldi*. It took the name *ducato* in 1531, by which date it had decreased in weight to 1.8 grams and was worth 7 *soldi*. In 1533 Alessandro de' Medici began issuing coinage in his own name, designed by Benvenuto Cellini: gold *scudi* and silver testons.

Character and an Anti-Classical Style

Mannerism is a term invented in this century to describe certain aspects of Italian *cinquecento* art which, consciously or not, are anti-classical. Among the most notable Sir Kenneth Clark has named 'flowing movements, graceful gestures, and twisted poses . . . imposed on subjects for their own sakes, irrespective of truth to appearances or probability.'

Mannerism as a concept presents two difficulties. To start with, 'anti-classical' is rather vague. It becomes less unsatisfactory if we take 'classical' in this context to mean Greek art from Phidias to Lysippus, and the kind of perspective described by Vitruvius: these were the classical elements most admired by Italians around 1500 and reached their high point in the Sistine Ceiling and Raphael's *School of Athens*. To the 'anti-classical' characteristics already mentioned we may then add: markedly unharmonious composition; rendering of subjects from an extreme angle or from the back; and, more generally, instead of economy, excess.

The second difficulty is that Mannerism is employed to describe widely different kinds of art. It designates what Vasari calls the *bella maniera* (from which the word Mannerism is derived), that smooth and elegant style which Vasari himself practised, but it is also applied to the angularities of Rosso and the twisted gyrations of Michelangelo's *Last Judgment*. The term has recently been given an even wider meaning by Dr Arnold Hauser in his book *Mannerism*, which I read after my own was written: Dr Hauser characterizes Mannerism as an aspiration to grace and beauty, a tendency to the sophisticated and affected, but also an aspiration to expressionism and spiritual depth. If, as often happens, the term 'anti-Mannerist' is also brought into play, the discussion, though stimulating, often becomes remote from the actual works of art.

Mannerism is a stylistic term and has generally been considered a purely stylistic problem. I believe it is this that has produced a plethora of abstractions and inconclusiveness. It seems to me that a more satisfactory approach would be by way of a particular artist's character, where this is known. Indeed 'anti-classical' implies intention, whether deliberate or not, and it is of the essence of the problem to examine intention. By asking of a given artist what it was in his character or circumstances that impelled him to choose unclassical features, we may be nearer understanding the phenomena which the term Mannerist is intended to describe.

I propose then to look briefly at five artists who are generally labelled Mannerist without reserve: Pontormo, Rosso Fiorentino, Michelangelo after 1520, Vasari and Tintoretto.

Of Pontormo one may say that his life was ruled by fear. He lost his father, says Vasari, when he was five, his mother when he was ten; two years later his grand-father died; one understands why 'he was so afraid of death that he would not even hear it spoken of, and avoided having to meet dead bodies.' Fear of the plague drove him to Certosa in 1522, and at Castello he worked badly because the place 'seemed much exposed to the fury of the soldiery and to other suchlike dangers.' Pontormo was also afraid of people. 'He never went to festivals or to any public gathering, so as not to be caught in the press.' He lived alone and even did his own cooking. In his house he installed a retractable wooden ladder, 'so that no one might go up to him without his wish or knowledge.' Another sign of his asocial nature: he died intestate. It was quite in character that in the lost S. Lorenzo frescoes he should have placed Christ on high, and God the Father at Christ's feet.

Perhaps the most striking features of Pontormo's art are the staring eyes that do not see or recognize: round, horrified eyes in blank faces. These are just what one would expect from a fear-ridden man. The same may be said of the twisted hands, for example in his portrait of Cosimo de' Medici, and of his sketches of worm-like nudes squirming along the ground. There is a remarkable study of a nude boy pointing an accusing finger directly at the viewer: a figure out of a nightmare. Pontormo also renders a great many figures from the back, and faces in general he depicts in summary fashion; he gives prominence to details (the pedestals and statues in *Joseph in Egypt*, the gesticulating hands in *Herod and the Magi*): these are all signs of a shrinking from direct confrontation with reality. The twisting stair-way in *Joseph in Egypt*, with no adequate means of support, is an evident symbol of Pontormo's own insecurity, later to express itself obsessively in the stairway in his own house that could be drawn up with a pulley. In short, anti-classical elements in Pontormo's work are by and large the expression of the artist's fear-bound, misanthropic character.

Pontormo's contemporary, Rosso Fiorentino, was a totally different type of man. Good-looking, with red hair and a fine presence, he was possessed by an over-weening vanity. He is known to have kept a tame ape: a well-known device for setting off fine looks and a grave manner. But as a painter Rosso was not appre-ciated, and he lived a wretched life. This gave rise to aggressiveness. Once in an Arezzo church, springing to the defence of a friend who had played a prank, he assaulted the irate priests. However, he got the worst of the scuffle and had to flee. Deeming himself 'affronted', he left Arezzo under cover of darkness, and eventually came to the French Court. Here his haughty manner went down well and he became a success. I see no reason to question Vasari's account of Rosso's suicide on the grounds that he received Christian burial: this was not unusual, and Pier Leone, Lorenzo de' Medici's physician who committed suicide, was buried in a

church. According to Vasari, Rosso was robbed of some hundreds of ducats. Rashly he accused a fellow-Florentine of the theft, but the latter was adjudged innocent and promptly issued a writ of libel. Rosso, too vain to eat his words, drank poison 'rather than be punished by others'.

Such a man, in his art, can be expected to flout accepted values and, since he considers himself a superior being, to show little interest in facial expression or character. These are just the elements we find in Rosso's remarkable *Blind Ignorance* at Fontainebleau, where blindfolded figures stumble about grotesquely. Rosso's aggressive tendencies are evident in *The Daughters of Jethro*, where naked bodies seem to burst the frame; while in one of the Fontainebleau Triumphs Rosso gives pride of place to an elephant, which dwarfs the men; he also depicts a woman mounted on a horse back to front, and Europa carried off by the Bull depicted from the rear.

Michelangelo's character and its development have been traced in the text. Here it is enough to recall that he spent an assured boyhood in the Palazzo Medici, escaped the invasion of 1494 with its tragic aftermath, and lived in the no less assured world of Julius II's Rome. Though deeply moved by Savonarola's attacks on Christian humanism, his blend of Christianity with pre-Christian ideals in the Sistine Ceiling is just what Savonarola had most angrily denounced. The Sistine marks the high-point of Michelangelo's belief in man's perfectibility. Lutheranism revived the doubts sown by Savonarola and on his return to anguished Florence these found expression in his art. The contorted statues of the Medici Chapel are battle figures, but now the battle is within. *The Last Judgment* with its gyrations and chasm-like space, and *The Conversion of St Paul*, where diagonals radiate from the spot where Paul has fallen, may be mentioned as two expressions of Michelangelo's awe before the tremendous power of God. Here and elsewhere anti-classical devices were a necessity in order to disrupt the easy world created by man's self-assurance: an artistic equivalent of the jolt produced by grace.

Michelangelo was hero-worshipped by Giorgio Vasari; as so often in such a relationship, because the older man was all the younger could never be. Vasari was a timid person living in troubled times, who clung desperately to rules and to a patron. It is typical of him that he married only because his patron at that time, Cardinal Giovanni del Monte, argued him into it. Religion was not a troublesome element in his life: he was more interested in the minutiae of a wedding reception than in the great issues raised by Luther. Because he abided by the rules Vasari believed himself to be a classical artist. But as the flabby cheeks in his self-portrait suggest, Vasari lacked virility. There is a marked feebleness about his painted figures, though he tries to hide it by piling on the props. They lunge, twist and point, but basically they are ineffective: the angel is not really restraining Abraham, his soldiers are not really scaling the walls in the *Capture of Milan*, and so, although their gestures are not exaggerated, they seem to be. Vasari, in short, may be described as anti-classical by default.

Finally, Tintoretto. His hasty temper and rugged handwriting suggest that he was not an easy man, yet he was not asocial: Ridolfi says that he counted as his friends most Venetian gentlemen of the day. Moreover he was a patriot and a generous one: he offered to paint Lepanto without a fee, saying that it was reward enough to serve the Doge, and he turned down the knighthood offered by Henri III, because he didn't want to 'enslave himself to titles'. But patriotism in a time of stress naturally produced tension, and this is evident in his civic paintings.

The other force in Tintoretto's life was religion. In old age he used to spend much time meditating in the Chiesa dell' Orto, and in discussing moral questions with clerical friends. Here again tension and doubt were in the air: we know that the problem of grace was argued more searchingly in Venice than in any other Italian city. This would have affected Tintoretto, indeed there is a marked element of trepidation in his character. On his deathbed he instructed his sons to keep his body unburied for three full days: since sick people, he said, sometimes lose consciousness and appear dead though still alive. There is fear in this remark, but also perhaps hope: an awareness of the supernatural, and of the possibility of a miraculous cure such as he had often painted.

In his religious painting it is this tremulous awareness of the supernatural that comes to the fore. The assured values of fifth-century Athens can no longer convey the facts of life: hence his relegation of the principal scene from the foreground or centre to the background; dizzying diagonals; violent contrasts of light and shadow. These anti-classical elements are all attempts to depict the supernatural battering, so to speak, at man and his assured world.

This brief survey suggests that each of the five artists adopted anti-classical devices for a different reason: Pontormo from misanthropy, Rosso from aggressive vanity, Michelangelo in order to depict the struggle between grace and nature, Vasari unconsciously through lack of vigour, and Tintoretto in order to render the supernatural. The label Mannerism blurs just such differences as these in order to emphasize certain formal similarities. But are these similarities worth emphasizing? To compare, for example, the angularity of Pontormo's *Herod and the Magi* with that of Michelangelo's Florentine *Pietà* is surely to miss the point of both works and to obscure what is most distinctive in each. That is why I have refrained from using the term Mannerism in the text.

If one were to continue this study of artistic character, one would find that the most wholehearted exponents of classicism at this period—Raphael, Giorgione, Bronzino and Titian—were all open, positive, gregarious and socially popular. They were what we would now call of an extravert type, well-adapted to reality: not for them the doubts, whether personal or religious, that troubled the five we have just observed. They were able to ride lightly over the tragic events of the age; they possessed the assurance that found a fitting correlative in fifth-century Athens. But it will not do to label them anti-Mannerists, for they were sometimes

impelled to paint in anti-classical style: Raphael, for instance, in *Fire in the Borgo*, and Bronzino in *An Allegory with Venus*.

To me the most striking feature of Italian *cinquecento* art is its parting into two markedly different currents: what I have called the serene and the troubled. Such a deep division had never occurred in Italy before, and it was a direct result of the political and spiritual crisis of the age. Some artists rode the storm, others were sucked into it through flaws or strength of character. It is this, rather than classical and anti-classical stylistic elements, which seems to me of overriding importance, and in the text I have considered artists within such a framework.

The whereabouts of works of art mentioned in the text

Giovanni Bellini	*Feast of the Gods*	National Gallery, Washington
Bronzino	*Crossing of the Red Sea*	Palazzo Vecchio, Florence
	Eleonora of Toledo	Uffizi
	Laura Battiferri	Palazzo Vecchio, Florence
	Lodovico Capponi	Frick Collection, New York
	Portrait of a Young Man	Metropolitan Museum, New York
	Ugolino Martelli	Hessische Treuhand Verwaltung, Wiesbaden
Caravaggio	*Death of the Virgin*	Louvre
	The Virgin crushing Heresy	Borghese Gallery, Rome
Carpaccio	*Presentation of Christ*	Accademia, Venice
	Two Venetian Women	Museo Correr, Venice
Danese Cattaneo	*Negress*	Metropolitan Musem, New York
Benvenuto Cellini	*Perseus*	Loggia dei Lanzi, Florence
Correggio	*Madonna of the Day*	Pinacoteca, Parma
Donatello	Marble statue of *David*	National Gallery, Washington
	St Mary Magdalen	Baptistery, Florence
Dosso Dossi	*Bacchanal*	Castel S. Angelo, Rome
Albrecht Dürer	*Adoration of the Trinity*	Kunsthistorisches Museum, Vienna
	Portrait of Oswald Krell	Alte Pinakothek, Munich
Giorgione	*Concert Champêtre*	Louvre
	Sleeping Venus	Dresden Gallery
	The Storm	Accademia, Venice
	The Three Philosophers	Kunsthistorisches Museum, Vienna
Giovanni Bologna	*Apollo*	Palazzo Vecchio, Florence
	Hercules fighting the Centaur	Palazzo Vecchio, Florence
	Mercury	Bargello, Florence

	Rape of the Sabines	Loggia dei Lanzi, Florence
	Samson and the Philistine	Victoria and Albert Museum, London
	Virtue vanquishing Vice	Bargello, Florence
Jacopino del Conte	Baptism of Christ	S. Giovanni Decollato, Rome
Michelangelo	Conversion of St Paul	Pauline Chapel, Vatican
	Crucifixion of St Peter	Pauline Chapel, Vatican
	Doni Madonna	Uffizi
	Florentine Pietà	Duomo, Florence
	Last Judgment	Sistine Chapel
	Moses	S. Pietro in Vincoli, Rome
	Pietà	St Peter's, Rome
	Prisoners	Louvre
	Sketch for Last Judgment	Bayonne Museum
	Sketch for Medici Chapel Resurrection	British Museum
Niccolò dell' Abate	Abduction of Proserpina	Louvre
	Story of Aristaeus	National Gallery, London
Parmigianino	Madonna and Child with SS. John the Baptist and Jerome	National Gallery, London
	Madonna del Collo lungo	Uffizi
	Self-portrait from a convex mirror	Kunsthistorisches Museum, Vienna
Perugino	Combat of Love and Chastity	Louvre
Piero di Cosimo	Building of a Palace	John and Mabel Ringling Museum, Sarasota, Florida
	Death of Procris	National Gallery, London
	Forest Fire	Ashmolean Museum, Oxford
	Hunting Scene	Metropolitan Museum, New York
	Misfortunes of Silenus	Fogg Art Museum, Cambridge, Mass.
	Return from the Hunt	Metropolitan Museum, New York
	Vulcan alighting in Lemnos	Wadsworth Atheneum, Hartford, Conn.
	Vulcan and Aeolus as Teachers of Mankind	National Gallery, Ottawa
Pontormo	Christ before Pilate	Certosa, near Florence
	Descent from the Cross	S. Felicità, Florence
	Joseph in Egypt	National Gallery, London
	Visitation	S. Michele, Carmignano

Primaticcio	*Ulysses and Penelope*	Museum of Art, Toledo, Ohio
Raphael	*Entombment*	Borghese Gallery, Rome
	Julius II	Pitti Gallery, Florence
	Leo X	Uffizi
	Portrait of a Cardinal	Prado
	Sistine Madonna	Dresden Gallery
	Sistine tapestry cartoons	Victoria and Albert Museum, London
	Tommaso Inghirami	Pitti
	Triumph of Galatea	Farnesina, Rome
Raphael, follower of	*Joanna of Aragon*	Louvre
Antonio Rizzo	*Eve*	Doges' Palace, Venice
Rosso Fiorentino	*Deposition*	Pinacoteca, Volterra
	Moses and the Daughters of Jethro	Uffizi
Jacopo Sansovino	*Bacchus*	Bargello
Tintoretto	*Baptism of Christ*	Scuola di San Rocco, Venice
	Finding of the Body of St Mark	Brera, Milan
	Last Supper	Scuola di San Rocco, Venice
	Liberation of Arsinoë	Dresden Gallery
	Miracle of the Slave	Accademia, Venice
	Paradise	Doges' Palace, Venice
	St Mary the Egyptian	Scuola di San Rocco, Venice
	Susannah and the Elders	Kunsthistorisches Museum, Vienna
	Translation of the Body of St Mark	Doges' Palace, Venice
Titian	*Assumption*	Accademia, Venice
	Bacchanal	Prado
	Bacchus and Ariadne	National Gallery, London
	Danaë	Museo Nazionale, Naples, and Prado
	Paul III and his Grandsons	Museo Nazionale, Naples
	Sacred and Profane Love	Borghese Gallery, Rome
	The Concert	Pitti Gallery, Florence
Vasari	*Creation of Cardinals*	Cancelleria, Rome
	Justice	Museo Nazionale, Naples
	Self-portrait	Uffizi
Veronese	*Feast in the House of Levi*	Accademia, Venice
	Last Supper	Louvre

| Leonardo da Vinci | *Mona Lisa* | Louvre |
| | *Lady with an Ermine* | Czartoryski Museum, Cracow |

Apollo Belvedere	Vatican
Daughters of Niobe	Uffizi
Laocoön	Vatican
Punishment of Dirce	Museo Nazionale, Naples
Torso del Belvedere	Vatican

Sources and Notes

DBI *Dizionario Biografico degli Italiani.* Rome 1960–
Pastor Ludwig Pastor, *History of the Popes from the close of the Middle Ages.* London 1891–1953.
Roscoe-Bossi G. Roscoe e L. Bossi, *Vita e Pontificato di Leone X.* Milan 1816–17.
Sanuto M. Sanuto. *I Diarii.* Venice 1879–1902.
Vasari G. Vasari. *Le vite de' più eccellenti pittori, scultori ed architetti.* ed. G. Milanesi. Florence 1878–85.

Chapter 1: The Awakening of Rome (pp. 19-31)
For the political structure and economy of Rome I have drawn on M. Romani, *Pellegrini e Viaggiatori nell' Economia di Roma dal XIV al XVII Secolo* (Milan 1948) and J. Delumeau, *Vie économique et sociale de Rome dans la seconde moitié du XVIe siècle* (Paris 1957-9), the latter containing copious material for the first half of the century. The Douai draper was Jacques Le Saige, author of *Les Gistes, Repaitres et Despens* . . . (Cambrai 1520), quoted by Delumeau, p. 167. Unlike some Italian towns, Rome levied no taxes on visitors.

127 editions of pocket guides, entitled 'Indulgences to be gained in the churches of Rome', were published between 1475 and 1600. Of these 48 were in Latin (only one after 1550), 46 in Italian (only six of which are earlier than 1550), and 22 German (between 1475 and 1525). After the list of indulgences come a short history of the city, notes on the Emperors, and a résumé of the Donation of Constantine. Steadily more space is given to antiquities.

For the episode of Jouffroy Bishop of Arras: Pius II, *Commentarii* (Rome 1584), Bks vii and xii. There is a translation of the *Commentaries* by F. A. Gragg and L. C. Gabel (Smith College Studies, vols. xxii, xxv, xxx, xxxv and xliii), and an English biography of the Pope: R. J. Mitchell, *The Laurels and the Tiara* (London 1962).

For Pope Nicholas, D. Giorgi, *Vita Nicolai quinti* (Rome 1742).

Flavio Biondo's career: A. Masius, *Flavio Biondo, sein leben und seine Werke* (Leipzig 1897).

Pius II's meeting with the cowherd: Bk. ix of the *Commentaries* (summer of 1462) while the classical text is Plutarch, *Life of Artaxerxes* v. 1.

For Sixtus IV and Alexander VI, Pastor iv and vi, and *The Popes*, ed. Eric John (London 1964), a useful brief guide to papal history.

Chapter 2: *Julius II* (pp. 32-55)

Bainbridge at the conclave of 1513: D. S. Chambers, *Cardinal Bainbridge* (Oxford 1965), p. 43.

Julius's character and career: Paris de Grassis, *Diarium*, ed. L. Frati (Bologna 1886) and Pastor vi, pp. 212-31. For his swearing, Sigismondo dei Conti, *Storie de' suoi tempi* (Rome 1883), II, p. 302. The nearest precedent I can find for a Pope leading an army in the field is Leo IX, who in 1054 momentarily took an active part in war against the Normans, failed completely, was captured, and died shortly after his release.

The campaign against Perugia and Bologna: Sanuto vi, and Paris de Grassis, *Diarium*. The quarrel with Venice: F. Seneca, *Venezia e Papa Giulio II* (Verona 1962).

Julius seems not to have uttered the rousing cry often ascribed to him: '*Fuori i barbari*'; tradition has simply made pithier another remark: '*Non voglio che questi barbari usurpa Italia*', in Sanuto xi, 745. The Mirandola campaign: Sanuto, January 1511, especially xi, 721-3, 729-30, 739-40, 765-7. The direct hit on Julius's billet: xi, 755; Julius sent the cannon-ball to Loreto because he had a devotion to the Holy House; he commissioned Bramante to case the house in marble.

Grapaldi's poem about Parma: Roscoe-Bossi, iv, p. 294.

Comments on Julius's wars: Michelangelo's occurs in the first quatrain of a sonnet:

> *Qua si fa elmi di calici e spade*
> *e'l sangue di Cristo si vend' a giumelle,*
> *e croce e spine son lance e rotelle;*
> *e pur da Cristo pazienzia cade!*

Erasmus's in *Moriae Enconium*, ch. 59.

For Michelangelo, the lives by Vasari, vii, pp. 135-317, and Condivi; *The Complete Works of Michelangelo*, ed. M. Salmi (London 1966) and C. de Tolnay, *Michelangelo* (Princeton 1943-60): vol. ii is devoted to the Sistine Ceiling.

Dr Edgar Wind takes a quite different view of the Ignudi. In 'Michelangelo's Prophets and Sibyls', printed in *Proceedings of the British Academy*, li (1965), he claims that the Ignudi are angels, who make visible the connection between Acts of Creation and Gifts of the Spirit. On Wind's view the emphasis of the ceiling is transferred from man's perfect body and energy to the divine order: God and His angels. This is in line with Wind's opinion that Egidio of Viterbo, General of the Augustinian Order from 1507, had a hand in the programme. Like Ficino, Egidio sought the shadow of Christianity among the ancients but unlike Ficino he believed that the union of the soul with the body was a misfortune, an unnatural condition: the body he said was '*vincula compedum terrenarum*'. Now Egidio lived an ascetic life near Viterbo and seems to have come to Rome only occasionally. In

character he is far from Julius and Michelangelo, who at this period certainly admired the human body, and I think it unlikely that he contributed to a programme that gives so much space to the body, whether angelic or human. The Ignudi, it seems to me, are much too robust to be angels, and I think the ceiling is best explained in terms of Ficino's humanism, well known in Rome and in which Michelangelo had been steeped as a youth. For Egidio, see J. W. O'Malley, *Giles of Viterbo* (Leiden 1968).

Michelangelo's rendering of the Brazen Serpent (*Numbers* xxi) is rich in classical as well as Christian allusions. The Brazen Serpent recalls Mercury's caduceus and the snakes of Aesculapius, god of healing, who had power to raise the dead. Snakes, being symbols of renovation, harmonize with the idea of a Golden Age symbolized by the Rovere oak-tree. Lastly, the treatment of the writhing figures would have reminded Romans of the recently discovered *Laocoön*.

For Bramante: C. Baroni, *Bramante* (Bergamo 1944). The most accurate surviving record of Bramante's intentions is the recently published drawing by Menicantonio de Chiarellis, in the collection of Mr Paul Mennon. This shows a later stage in the evolution of the design than that represented by the well-known medals of Caradosso and Serbaldi. P. Murray, 'Menicantonio, Du Cerceau, and the Towers of St Peter's' in *Studies in Renaissance and Baroque Art presented to Anthony Blunt* (London 1967), pp. 7-11 and pl. 6.

For Raphael, O. Fischel, *Raphael* (London 1948). The Confraternity of the Blessed Sacrament was established by a bull of Julius II dated 21 August 1508, and the Pope took the unusual step of enrolling as a *confratello*.

Paris de Grassis' comment on Julius's death: *Diarium*, quoted in Pastor vi, p. 437.

Chapter 3: *After Caesar, Augustus* (pp. 56-75)

Essential for Leo X's life and reign are the documents collected in Roscoe-Bossi. Also useful are E. Rodocanachi, *Le Pontificat de Léon X* (Paris 1931) and G. B. Picotti, *La Giovinezza di Leone X* (Milan 1928).

Leo and the poets: Roscoe-Bossi iv-x; C. Maddison, *Marcantonio Flaminio: Poet, Humanist and Reformer* (London 1965); the 'Ode to Diana', pp. 21-2. Leo welcomed Flaminio by quoting from the *Aeneid* Apollo's words on the first exploit of young Ascanius: '*Macte nova virtute, puer; sic itur ad astra.*'

'*Zographi non ars . . .*': Zacharia Ferreri, *Hymni Novi* (Rome 1523), p. xxii verso.

Leo and the theatre: F. Flamini, *Il Cinquecento* (Storia letteraria d'Italia, Milan 1902), pp. 264-319. G. Gascoigne, *Supposes*, ed. J. W. Cunliffe (London 1906).

'He left Rome without a stole . . .' Paris de Grassis, *Diarium*, January 1514, in Pastor vii, p. 162.

The elephant sent by King Emmanuel of Portugal arrived in 1514, when Leo X granted the King certain overseas territories. Roscoe-Bossi, v, pp. 7-14; Pastor vii, pp. 74-8. Capito's lines to the elephant: 'If you think . . .' Roscoe-Bossi vi, p. 182.

Cicero's statement of which Petrarch disapproved is in *Nat. D.* iii, 86: '*hoc quidem omnes mortales sic habent; . . . omnem denique commoditatem prosperitatemque vitae a dis se habere: virtutem autem nemo deo acceptam rettulit.*'

The uneasy marriage of classical and Christian concepts is well illustrated in the visual sphere by Pomponazzi's medal. It depicts the philosopher with a big Roman nose and double chin, and is inscribed *Petrus Pomponatius Mantuanus Philosophus Illustris*; the reverse is inscribed *Duplex Gloria*, evidently in allusion to his teaching and his modesty, which are depicted in the form of a pelican wounding its breast, and a lamb.

Extension of the St Peter's indulgence: *Regesta Leonis X*, ed. J. Hargenröther (Freiburg 1884–91), no. 13,053. Three weeks after Luther posted his theses at Wittenberg, Sadoleto was in touch with the Archbishop of Mainz, in connection with the efforts of a papal agent, Johannes Heitmars, who claimed to have found Livy's *De bello Macedonico*. Sadoleto told the Archbishop to pay Heitmars, on delivery of the MS, the sum of 147 ducats, '*ex pecuniis indulgentiarum*,' that is, with funds collected for rebuilding St Peter's. R. M. Douglas, *Sadoleto* (Cambridge, Mass. 1959), p. 17. Leo could be somewhat unscrupulous in the matter of MSS: he paid a dealer with the disarming name of Angelo Arcimaldo 500 ducats for the first five books of Tacitus's *Annals*, which had been stolen from the abbey of Corbie in northern France, later sending a finely bound copy of the *editio princeps* to the abbot, accompanied by a plenary indulgence for the abbey church, 'so that the theft should prove a profit, not a loss'—as indeed it would, since a plenary indulgence was very valuable.

Chapter 4: *The Challenge from Germany* (pp. 76–95)

Trissino on Germany: *Elegia Inedita ad Isabella di Mantova*, ed. T. Gnoli (Perugia 1848), pp. 16–18. The characteristics of German art are analysed in E. Panofsky, *The Life and Art of Albrecht Dürer* (Princeton 1955). Dürer's attitude to art resembles Luther's attitude to holiness, Dürer being convinced, says Panofsky, that the power of artistic creation was a 'mystery', not to be taught, not to be learned, not to be accounted for except by the grace of God and 'influences from above.' For Ulrich von Hutten, H. Holborn, *Ulrich von Hutten and the German Reformation* (New Haven 1937).

The only Italian Bibles to be published in the fifteenth century—both appeared in Venice in 1471—were compilations, not translations from the original. In the better of the two, the author, Nicolò Malermi, states in an introduction that he has 'enriched' the text with little commentaries drawn from the Fathers and other famous theologians of the Middle Ages. Significantly his work was entitled *Biblia Vulgar Historiata*.

For Luther, the 95 theses, and his early writings: *Luther's Primary Works*, ed. H. Wace and C. A. Burchheim (London 1896) and *The Reformation in its Own*

Words compiled by H. J. Hillerbrand (London 1964). Luther's description of himself as 'rough, boisterous . . .' is taken from his Preface to Melanchthon's *Commentary on Colossians*.

Separate works by Augustine (and many spurious books passed off as his) were of course circulating before the complete edition of 1506. Nor was the Pauline and Augustinian revival particular to Germany. Colet in England, Lefèvre d'Etaples in France, Contarini in Venice were among those deeply influenced by it. Luther's insistence on fear and trembling reappears in his letter to Leo X of 6 April 1520: '*Servus servorum es, et prae omnibus hominibus miserrimo et periculosissimo loco.*'

Prierias's claims for Papal authority are in *Dialogus de potestate Papae* (Rome 1518) A II.

Cajetan's learned treatise on the authority of Popes and Councils was composed in 1511 under Julius II: *De comparatione auctoritatis Papae et Concilii*, ed. V.-I. Pollet (Rome 1936). Cajetan's interview with Luther: *The Reformation in its Own Words*, pp. 63–5. It is noteworthy that Cajetan himself was unorthodox in at least one respect, for he held a view of analogy which makes it impossible to speak meaningfully of the divine wisdom, and hence leads to agnosticism. F. C. Copleston, *History of Philosophy*, iii (London 1953), pp. 338–40.

'I have begun to extract from ancient authors . . .' Letter of 9 Oct 1522 in J. Paquier, *L'Humanisme et la Réforme*: Jérôme Aléandre (Paris 1900), p. 289.

The *Capitoli* of the Oratory of Divine Love begin by saying that the society has been founded to foster divine love, that is charity. '*Et però che la carità non viene se non dal soave sgoardo de Dio, il quale non goarda se non sopra li piccioli di core, segondo quel ditto del profeta: "Super quem respiciamus nisi super humilem et trementem sermones meos"* [a mistaken quotation of *Isaiah* lxvi, 2].' The language is of a kind Luther would have welcomed. The key-note of the Oratory was humility, and priors held office for only six months, but before its effects could be felt it was disbanded by the Sack.

Adrian VI's habits and reforms: Pastor ix, ch. 3. 'His face is long and pale . . .' Sanuto xxxiii, 434–5, quoted Pastor ix, p. 65. 'All of us, prelates and clergy, have gone astray . . .' Pastor ix, p. 135.

Clement VII's character: Pastor ix, pp. 247–53. The lines from Berni's epigram are translated by E. H. Wilkins, *A History of Italian Literature* (Cambridge, Mass. 1954), p. 201, and reprinted by kind permission of the author's executors. 'You bastard of Sodom . . .' A. R. Villa, *Memorias para la historia del asalto y saco de Roma en 1527* (Madrid 1875), p. 141.

The Sack of Rome: Sanuto xlv and xlvi; Pastor ix, ch. 11. The luxury of cardinals' households reached a peak just before the Sack. Cardinal Farnese's counted 300 inmates, including an organist, carpenter, soprano, gamekeeper, carver, barber, upholsterer, embroiderer, saddler, silk weaver, apothecary, weaver of silk stockings, stable-master, book-keeper, chief cook, under-cook, pastrycook,

amanuensis, master of page-boys, master of counter-bass, butler, master mason, gardener, and so on.

Chapter 5: The Courtier's World (pp. 96-114)

Of Castiglione's *Il Libro del Cortegiano* I have used the edition by V. Cian (Florence 1947) and the English translation by R. Samber (London 1724), preferring it to Hoby's. Perhaps the best modern translation is that by C. S. Singleton (Garden City. N.Y. 1959). Bembo's *Gli Asolani* were first published in Venice in 1505 and many times reprinted. The work is included in Dionisotti's *Bembo: Prose e Rime* (Turin 1960). For treatises on love and women I have consulted F. Flamini, *Il Cinquecento* (Milan 1902), pp. 377-83. Translations from *Galateo* are from Robert Peterson's 1576 edition, pp. 6 and 8.

Opposition to marriage remained strong among many clerics. Bishop Paolo Giovio wrote to Giorgio Vasari saying that he presumed that his motive in deciding to marry was that he wished to avoid committing sin 'and contracting the French disease'. 'Remember Andrea del Sarto,' he continues, 'and his vigorous wife, who would rather have had two husbands than one! So, Messer Giorgio mio, have a Mass said of the Holy Spirit, cross yourself . . . and follow your cruel destiny.' Giovanni della Casa answers the question Should a Man Marry? in the negative, adducing the argument that a woman enjoys more leisure than a man and so feeds her sexual desire. He concludes that 'no husband has sufficient energy to extinguish or mitigate the ardour of that fire.'

Much of the material in the treatises extolling women was drawn from Christine de Pisan's *Cité des Dames* (*c.* 1404-5) or Martin le Franc's *Champion des Dames* (*c.* 1430-40). C. Fahy, 'Three Early Renaissance Treatises on Women', in *Italian Studies* xi (1956).

Love-questions similar to those quoted in the text had been debated by fashionable society in Naples during the fourteenth century, and are recorded by Boccaccio in the fifth book of his *Filocolo*. But the Provençal attitude to women declined in Naples when the Angevin dynasty disappeared.

'*La forza d'un bel viso* . . .' Michelangelo Buonarroti, *Rime*, ed. E. N. Girardi (Bari 1960), p. 133. 'Due modi . . .' *Le Rime di Vittoria Colonna*, ed. P. E. Visconti (Rome 1840), Sonnet clxxxvi, p. 346.

Tragedy: P. R. Horne, *The Tragedies of Giambattista Cinthio Giraldi* (Oxford 1962). 'It will ill become us . . .' *Galateo*, trans. R. Peterson, p. 31.

Ariosto's career: DBl iv, pp. 172-88. 'Rather than eat thrushes . . .' Satire III. His attitude to marriage: Satire V. Ariosto came to much of his material through Matteo Maria Boiardo's *Orlando Innamorato*. Whereas Boiardo's contemporary in Florence, Luigi Pulci, had burlesqued knights in armour and their claims to heroism, Boiardo in feudal Ferrara treated the *chanson de geste* seriously.

By the middle of the *cinquecento* cannon that had formerly measured 3-4 feet

had grown into 10- and 20-ft monsters drawn by teams of twenty horses. But Vannoccio Biringuccio, who wrote the first detailed treatise on the making and use of cannon, was typical of Italians in that he added urns or heads of men or animals 'to make the gun beautiful'. J. R. Hale, 'Gunpowder and the Renaissance' in *From the Renaissance to the Counter-Reformation*, ed. C. H. Carter (London 1966).

Chapter 6: *The Growth of History* (*pp.* 115–33)

I have emphasized the cyclical element in Renaissance historical thinking; to a lesser degree historians were also aware, though they often chose to forget it, that history is a linear series of events extending from Creation to the Last Judgment.

For Machiavelli's career I have used R. Ridolfi, *The Life of Niccolò Machiavelli* (London 1963). The brothel incident is described in a letter to Luigi Guicciardini, 8 December 1509, given in J. R. Hale, *The Literary Works of Machiavelli* (Oxford 1961), pp. 124–5.

The background to Machiavelli's historical writing is discussed by F. Gilbert, *Machiavelli and Guicciardini:* Politics and History in Sixteenth-Century Florence (Princeton 1965), but see the review in *Italian Studies* xxi (Cambridge 1966). Extremely valuable for Machiavelli's life and thought is C. H. Clough, *Machiavelli Researches* (Naples 1967). It is possible that Machiavelli was in Florentine service before 1498. See Clough, pp. 18–20.

The *Discourses* were published by Blado in Rome in 1531, and *The Prince* in the following year, with the explicit sanction of Clement VII. They aroused intense criticism and in 1559 the whole of Machiavelli's works were placed on the Index.

The volatility of Machiavelli's interpretation of events is well known. In *Discorsi* I, 27, for example, he censures Gianpaolo Baglione of Perugia for not slaughtering the Pope, but his original opinion about Baglione was exactly the opposite. In a letter dated 13 September 1506 he wrote, 'If he works no evil against him who has come to strip him of his State, it will be because of his good nature and humanity.'

In connection with Machiavelli's theory of a return to sources, it is noteworthy that Johannes Ludovicus Vives, a Spaniard long resident in Louvain and Bruges, sent Adrian VI a document in October 1522, calling for a Council and taking as his text the sentence of Sallust, that no Government can be maintained save only by those means by which it was established. Pastor ix, pp. 85–7.

The Taurbolium advocated by Machiavelli was not in fact an institution of the Roman Republic: it belongs to the Empire. In July 1522, in order to try to halt an epidemic, a group of Romans sacrificed a bull in the Colosseum. Sanuto xxxiii, 402.

In any discussion of Italian historians it is usual to couple Machiavelli and Francesco Guicciardini. Guicciardini played an important role in the history of sixteenth-century Italy, and he is also important as the author of the first more-

than-municipal history (though it was not he who entitled it *Storia d'Italia*). His contribution to historiography seems to be much less important, and as a theorist he is not in a class with Machiavelli.

For Vasari I have drawn on E. Rud, *Vasari's Life and Lives* (London 1964).

Francesco Patrizi (1529–97) is also known for his *Nova de universis philosophia* (Ferrara 1591), a work close in spirit to those of Bruno and Campanella. Patrizi also wrote a Utopia: *La città felice*. He was condemned by Gregory XIV for his anti-Aristotelianism. His concept of history owes much to Plato, who in the *Laws* had written, 'Our social life is the best tragedy', but held that any book about it would be a falsification.

The natives 'seem to live in that golden world . . .' Petrus Martyr Anglerius, *De orbe novo decades octo*, annotated by R. Hakluyt (Paris 1587), First Decade, Bk. ii; he is speaking of the natives of Hispaniola. It is curious that the orderly Utopias conceived by, among others, Francesco Patrizi, appeared just when evidence was mounting that natural man led a savage, disorderly life. R. Romeo, *Le scoperte americane nella coscienza italiana del cinquecento* (Milan and Naples 1954), pp. 94–102.

Piero di Cosimo's Life in Vasari iv, pp. 131–44. I am greatly indebted to the essay by E. Panofsky, 'The Early History of Man in Two Cycles of Paintings by Piero di Cosimo,' Ch. ii in *Studies in Iconology* (New York 1962). An even harsher view of primitive man appears in Piero's *Battle of Centaurs and Lapiths* in the National Gallery. As W. H. Auden puts it in 'Woods':

> Sylvan meant savage in those primal woods
> Piero di Cosimo so loved to draw . . .

Chapter 7: All Things in Movement (pp. 134–52)

General works on science: G. Sarton, *Six Wings: Men of Science in the Renaissance* (London 1958) and H. Butterfield, *The Origins of Modern Science* 1300–1800. For Leonardo da Vinci, J. P. Richter, *The Literary Works of Leonardo da Vinci*, second edition (London 1939), E. MacCurdy, *The Notebooks of Leonardo da Vinci* (New York 1958) and R. Friedenthal, *Leonardo da Vinci* (London 1959).

For the kind of questions that interested the Middle Ages, B. Lawn, *The Salernitan Questions* (Oxford 1963).

Leonardo's canal works are described in *A History of Technology*, ed. C. Singer *et al.*, III (Oxford 1957), pp. 445–9.

The general opinion is that syphilis came to Europe from America. Evidence of syphilitic lesions in North and South American bones before the arrival of Columbus has recently been accumulated to an imposing degree.

Ulrich von Hutten supposed syphilis to be transmitted by small winged worms. The edict in Aberdeen: W. P. D. Wightman, *Science and the Renaissance* (Edinburgh 1962) i, pp. 273–4.

Of Cardano's autobiography there is a translation by J. Stoner: *The Book of My*

Life (London 1931). Of Cardano's other works the one I have drawn on most is the *De rerum varietate* (Basle 1557). Cardano made his name with a provocative book, *Bad Practice in Use among Doctors*, in which he denounced 72 current modes of treatment, such as the denial of wine to the sick; whereupon Cardano's book was denounced by his fellow-doctors for 300 errors of Latin style and grammar. Cardano had to correct and reissue it.

Italian contributions to the circulation of the blood are discussed in A. Castiglioni, *A History of Medicine* (New York 1947), pp. 435–40, with quotations from the relevant passages of Realdo Colombo and Andrea Cesalpino.

For cosmological theories I have drawn on A. C. Crombie, *Augustine to Galileo*: The History of Science A.D. 400–1650 (London 1952); for Galileo his correspondence with his eldest daughter in M. A. Olney, *The Private Life of Galileo* (London 1870) and F. Sherwood Taylor, *Galileo and the Freedom of Thought* (London 1938).

Chapter 8: *The Arts* (pp. 153–75)

I have used the following editions: C. Ricci, *Correggio* (Rome 1930), S. J. Freedberg, *Parmigianino: his works in painting* (Cambridge, Mass. 1950), L. Dimier, *Le Primatice* (Paris 1928). A. Emiliani, *Il Bronzino* (Busto Arsizio 1960); F. M. Clapp, *Jacopo Carucci da Pontormo* (New Haven 1916), P. Barocchi, *Vasari pittore* (Florence 1964). Also G. Briganti, *Italian Mannerism* (London 1963).

I take Raphael's portrait of an unknown Cardinal in the Prado to represent Scaramuccia di Gianfermo Trivulzio, Bishop of Como 1508, Cardinal 1517, died 1527: see a medal of the Milanese School (G. F. Hill, *Renaissance Medals from the Samuel H. Kress Collection*, London 1967, pl. 198).

For the Medici Tombs, C. de Tolnay, *Michelangelo*, iii (Princeton 1948) and E. Panofsky, *Studies in Iconology* (New York 1962), ch. vi.

For Cellini, J. Pope-Hennessy, *Italian High Renaissance and Baroque Sculpture* (London 1963) and the *Autobiography*, trans. G. Bull (London 1956). For Giovanni Bologna I have drawn on E. Dhanens, *Jean Boulogne* (Brussels 1956), which reprints the Life by F. Baldinucci, 1688. In a letter dated 27 October 1581 Bologna is described as '*Non punto avaro, come dimostra l'esser poverissimo, et in tutto et per tutto volto alla gloria, havendon una ambitione estrema d'arrivare Michelangnolo.*'

The description of Liberality is from C. Ripa, *Iconologia* (Milan 1602). The changed meaning of *virtus*. '*Questo gentiluomo . . .*' *Trattato dell' oreficeria*, 77 in B. Cellini, *Due Trattati*, ed. G. Milanesi (Florence 1857).

My interpretation of the dog on Michelangelo's medal is hypothetical only. In describing the reception for Francesco de' Medici's bride, Vasari (viii, p. 603) says that the Tenth Car, Minerva's, was accompanied by Faith, carrying a little white dog in her arms.

For Michelangelo's later work, C. de Tolnay, *Michelangelo*, v (1960). Agnello's

report, in the Gonzaga Archives, Mantua, is given in Pastor x, p. 363. Jonah, the prophet of the Resurrection, had been depicted on the Ceiling above the altar.

Chapter 9: *The Venetian Republic (pp. 176–93)*

In the fifteenth century 'Venetian' meant either a Venetian Patrician or all living in Venice. In modern usage 'Venetian' can also mean all under the rule of Venetian Patricians, and it is in this sense that I most often employ it.

For the political and economic background I have consulted R. Cessi, *Storia della repubblica di Venezia* (Milan 1944–6), G. Luzzatto, *Storia economica di Venezia dall' XI al XVI secolo* (Venice 1961), F. Braudel, 'La vita economica di Venezia nel sec. XVI', in *La civiltà veneziana del rinascimento* (Venice 1958); two books by F. C. Lane, *Venetian Ships and Shipbuilders of the Renaissance* (Baltimore 1934) and *Venice and History* (Baltimore 1966), and A. Ventura, *Nòbiltà e popolo* (Bari 1964). The description of the Arsenal is by Pero Tafur, 1436, quoted in Lane, p. 172.

It is noteworthy that Machiavelli, who as a Florentine hated Venice, blinded himself to Venice's stable government through the centuries; by making expansion one of the criteria of success and claiming that Venice, like Sparta, could not expand, he declined to learn from either of these states.

Gaspare Contarini, an expert on the Venetian constitution, is one of those who bear witness to a relaxation of the old terror. Of the Spanish Inquisition he wrote, 'It functions with even more severity and terror than the Council of Ten *used to do*.' Orestes Ferrara, *Gasparo Contarini et ses Missions* (Paris 1956), p. 73.

For the Aldine Press I have drawn on the documents in A. Firmin-Didot, *Alde Manuce et l'Hellénisme à Venise* (Paris 1875). For Sperone Speroni, I have used the edition of his *Opere* published in Venice 1740.

For Gaspara Stampa, *Rime di Gaspara Stampa e Veronica Franco*, ed. A. Salza (Bari 1913). '*Arsi, piansi. . . .*' Sonnet xxvi, p. 18; '*Per amar molto . . .*' Sonnet cli, p. 84.

Pietro Aretino, DBI iv, pp. 89–104, *Lettere, il primo e il secondo libro*, ed. F. Flora and A. Del Vita (Milan 1960), and *Lettere scritte a Pietro Aretino*, ed. T. Landoni (Bologna 1873). It is noteworthy that correspondents, probably unconsciously, imitated his inflated language when writing to Aretino: for example, Speroni, in *Opere* v, pp. 291–6.

Terremoto del Doni Fiorentino (Rome 1556) consists of a series of letters, some to Piero himself, who is called 'Anti-Christ, Divine Wine-Jug, Venerable Gulper of roast pig-meat.' Doni objects particularly to the blasphemous tone of the Aretino cult: '*Basta che tu di' che i re e gli imperadori ti hanno tributato, come feciono i magi il Salvatore. Sì, ma esso per amore e degnamente fu presentato . . . tu scrivendo male, vivendo peggio, colle Pippe e le Nanne e sporche Cortigiane, hai le tristitie publicate.*'

Aretino's dying words are given by G. Mazzucchelli, *Vita di Pietro Aretino* (Milan 1830), p. 73.

Chapter 10: *Venetian Architecture* (pp. 194-207)

For Sansovino and his works, Vasari vii, pp. 485-531 and P. Murray, *Architecture of the Italian Renaissance* (London 1963). The move to the *terraferma* was not a wholly new phenomenon: it had begun in the fifteenth century. See A. Ventura, *Nobiltà e popolo* (Bari 1964) and the review by C. H. Clough in *Studi veneziani*, viii (1966), pp. 526-44. For Trissino, B. Morsolin, *Giangiorgio Trissino* (Vicenza 1878). For Palladio, his *Quattri Libri dell'architettura*; a facsimile of the edition of 1570 was published in Milan 1945. Palladio's career and works are discussed in R. Wittkower, *Architectural Principles in the Age of Humanism* (London 1949) and J. S. Ackerman, *Palladio* (London 1966).

Chapter 11: *Venetian Painting* (pp. 208-27)

Among general works I am indebted most to Kenneth Clark, *The Nude* (London 1956). I have used the following editions: J. Lauts, *Carpaccio* (London 1962), G. Fiocco, *Giorgione* (Bergamo 1948), H. Tietze, *Titian* (London 1950), A. Venturi *Paolo Veronese* (Milan 1928) and H. Tietze, *Tintoretto* (London 1948).

Titian's boast of making 2000 scudi from Mary Magdalen: letter from Francesco di Pietro Morosini to F. Lollino, quoted in Crowe and Cavalcaselle, *Titian: his life and times* (London 1877) i, p. 359.

In interpreting Titian's so-called *Sacred and Profane Love* I have largely followed W. Friedlaender, 'La tintura delle rose (the Sacred and Profane Love) by Titian', in *Art Bulletin*, xx (1938), pp. 320-4. However, I think Friedlaender carries too far the notion of a pagan sacrament; he fails also to note that the plant in the fore-ground is henbane, and that this points forward to the moment when Poliphilo takes Polia in his arms, and she fades as he wakes. Titian actually combines two scenes into one: the meeting with Venus at the end of Book 1 and the description of the tomb of Adonis at the beginning of Book 2, where he replaces the sardonyx statue of Venus with the living Venus.

Titian's *Bacchanal* is fully discussed in J. Walker, *Bellini and Titian at Ferrara* (London 1956). Panofsky points out that the urinating boy is borrowed from the same sarcophagus type which was one of the main sources of Michelangelo's *Children's Bacchanal*. He identifies it with a work illustrated in C. de Clarac, *Musée de sculpture antique et moderne* (Paris 1826-53) ii, p. 132, no. 38. E. Panofsky, *Studies in Iconology* (New York 1962), p. 221n.

Palma Giovane on Titian's technique: in Boschini's Preface to *Le Ricche Minere della pittura Veneziana* (Venice 1674), adapted from Tietze's translation.

For Tintoretto's life I have used C. Ridolfi, *Vita de Giacopo Robusti detto il Tintoretto* (Venice 1642).

Aretino on the view of the Grand Canal: *Il terzo libro delle lettere* (Venice 1546), p. 47.

Chapter 12: The Response to the Crisis (pp. 228-44)

Reform proposals were a tradition in Venice. For Pius II Domenici de' Domenichi drew up a memorandum in which he said that it was a mistake to go on ignoring the decrees of Constance and Basle as though they did not exist: such conduct undermined in advance the authority of every future Council. For Leo X two Venetians, Tommaso Giustiniani and Vincenzo Quirini, prepared a bold reform programme, in which they advocated a new translation of the Bible into the vernacular. They claimed that only 2% of the clergy and religious understood the Latin of the liturgical books. These were the two close friends of Contarini who entered the Camaldolese Order.

The youthful letters of Contarini from which I have quoted are published by H. Jedin, 'Contarini und Camaldoli', in *Archivio italiano per la storia della pietà*, ii (Rome 1959), pp. 61-117. For Contarini's career: F. Dittrich, *Regesten und Briefe des Cardinals Gasparo Contarini* (Braunsberg 1881) and O. Ferrara, *Gasparo Contarini et ses Missions* (Paris 1956). Contarini's report, *Consilium . . . de emendanda ecclesia* (Rome 1538), was signed by all nine members of the commission: one of the few surviving copies is in the British Museum.

Italian patristic scholarship: it is true that Italians and Greeks resident in Italy had published editions of many of the Greek Fathers, but they were slow to draw arguments from these sources. It was easier to fall back on stock works, such as the Decretals or Aquinas.

Speroni's diagnosis in the *Orazione al Re di Navarra*: *Opere* iii, p. 76.

For Trent, H. Jedin, *A History of the Council of Trent* (London 1957-); the decrees are in C-J. Hefele, *Histoire des Conciles*, IX, ii (Paris 1931). Criticism of the decrees: P. Polman, *L'Elément historique dans la controverse religieuse du XVIe siècle* (Gembloux 1932) and Hans Küng, *Structures of the Church* (London 1965).

Paul IV. See Pastor xiv, and the manuscript Life by A. Caracciolo in the British Museum: two volumes (Add. MSS. 20011-12). Carafa knew Spain at first hand, and when he instituted the Inquisition in Rome, fitted the prisons with strong locks and shackles at his own expense (I, f. 185). When he died, the Romans detached the head from his statue on the Capitoline Hill and jeeringly crowned it with a yellow hat (II, f. 187).

The attitude of Antonio Brasavola: P. R. Horne, 'Reformation and Counter Reformation at Ferrara' in *Italian Studies*, xiii (Cambridge 1958).

The history of religious intolerance: J. Lecler, *Toleration and Reformation* (London 1960). St Thomas Aquinas's views: In *IV Sentent.*, d. 13, qu. 2, art. 3, solutio.

At the time of the *Utopia* (1516) More, like Ficino, believed that perhaps the

variety of religion is willed by God, but by 1528 he could write that heresy was comparable with treason.

Chapter 13: After the Crisis (pp. 245-63)

Events described in this chapter are often referred to as the Counter-Reformation. I prefer to avoid that term, because most of the events were not directed specifically against the Reformers, and many of them happened independently of one another, not as part of a concerted campaign.

Speroni's *Apologia dei dialogi: Opere* I, p. 290.

In his Autobiography Cardano declares that he has modelled the book on Marcus Aurelius's *Meditations*. To readers of the Autobiography this is a puzzling statement, for Aurelius regarded life as 'a little bone thrown to puppies'; he was passive to events; what mattered was to have a haven within to which he could retire at will, an ever-flowing spring that could wash away the dross of life. This is miles away from Cardano's zest for life and diversity of interests. Indeed the only sentence in the Autobiography that recalls Aurelius is 'I am able like the Stoics to despise the vicissitudes of mortal existence.' The point of this sentence and, more generally, the imitation of Aurelius, become plain in the light of Cardano's clash with the Inquisition and sad last years, which however are not mentioned in the Autobiography.

According to the decree on works of art drafted by the Council of Trent on 3 and 4 December 1563, 'It shall not be permitted to display in a church or elsewhere an unusual picture (*insolitam imaginem*) without the approval of the bishop.'

The decline of Italian literature: F. Flamini, *Il Cinquecento* (Milan 1902), pp. 422-80, and J. B. Fletcher, *Literature of the Italian Renaissance* (New York 1934).

For Bruno, W. Boulting, *Giordano Bruno: his Life, Thought and Martyrdom* (London 1916) and A. Mercati, *Il sommario del processo di Giordano Bruno* (Vatican City 1942).

'It is we who are older . . .' G. Bruno, *La Cena de le Ceneri*, ed. G. Aquilecchia (Turin 1955), pp. 104-5. Peter of Blois in the twelfth century also had an inkling of intellectual development and for the same reason: because he had studied classical literature: 'However dogs may bark at me, and pigs grunt, I shall always imitate the writings of the ancients; these shall be my study, nor, while my strength lasts, shall the sun find me idle. We are like dwarfs on the shoulders of giants, by whose grace we see farther than they.' Ep. 92 in Migne, *P.L.* ccvii, col. 290.

Tommaso Campanella: the introduction to *Tutte le Opere*, a cura di Luigi Firpo, i (I Classici Mondadori 1954). *The City of the Sun* has been translated by T. W. Halliday, in H. Morley, *Ideal Commonwealths* (London 1885). 'Convien al secol nostro . . .' *Opere* i, p. 123, trans. J. A. Symonds. 'Chi più merita . . .' *Opere* i, p. 110, trans. J. A. Symonds. 'Omnipotente Dio . . .' *Opere* i, p. 145, my translation.

As a note by the author makes clear, the 'sanctuary of wisdom' is his own soul, threatened by madness.

'Ce qui est ferme . . .' J. du Bellay, *Les regrets suivis des antiquités de Rome*, Sonnet III of the *Antiquités*.

Chapter 14: *Sunset in Venice (pp. 264-88)*

Contarini's meeting with Cabot: O. Ferrara, *Gasparo Contarini et ses Missions* (Paris 1956), pp. 96-100.

For the decline of Venice: *Aspetti e Cause della Decadenza Economica Veneziana nel Secolo XVII* (Venice 1961) and C. M. Cipolla, 'The Decline of Italy: the case of a fully matured economy', in *The Economic History Review*, 2nd series, v (1952). Cipolla argues that Venice's decline was caused by the rise of England, Holland and France in the Mediterranean. Venetian textiles were of high quality and too expensive for the mass market, partly because workers were accustomed to better pay than those of northern rivals. Also important is J. C. Davis, *The Decline of the Venetian Nobility as a Ruling Class* (Baltimore 1962).

'Nuova arca di Noè . . .' Campanella, *Opere* i, p. 106.

Diplomacy: Barbaro's comprehensive account of English life and customs is printed in *Calendar of State Papers Venetian* v, pp. 338 ff. P. de Nolhac and Angelo Solerti, *Il viaggio in Italia di Enrico III* (Turin 1890). It was Agrippa d'Aubigné who described Henri III in terms of Tacitus's *mot* on Galba.

Music in Venice: D. J. Grout, *A History of Western Music* (New York 1960), G. Mei, *Letters on Ancient and Modern Music to Vincenzo Galilei and Giovanni Bardi*, ed. Claude V. Palisca (American Institute of Musicology 1960) and H. F. Redlich *Claudio Monteverdi* (London 1952).

'I went to see . . .' Cronaca di Antonio Priuli, 21 August 1609, in G. Galilei, *Opere*, xix (Florence 1907), p. 587; for further details about the telescope, Galileo's letter to Benedetto Landucci, dated Venice 29 August 1609, *idem*, x (Florence 1900), p. 253.

'Who can set bounds to the mind of man . . .' Galileo to Fr. Benedetto Castelli in Pisa, 1613.

Rome at the end of the century: P. Pecchiai, *Roma nel Cinquecento* (Bologna 1948) and J. Delumeau, *Vie Economique et Sociale de Rome dans la Seconde Moitié du XVIe Siècle* (Paris 1957-9). Since State bonds and offices brought in between five and ten per cent, new enterprises involving risks were discouraged. Sixtus V spent 76,058 crowns on raising 4 obelisks, only 62,000 on encouraging the textile industry —and this was a loan.

Seripando and the fiasco of the printing press: H. Jedin, *Papal Legate at the Council of Trent*: Cardinal Seripando (London 1947).

Montaigne's encounter with the customs: *Journal de Voyage en Italie*, vol. vii of *Oeuvres Complètes* (Paris 1928), pp. 197-8.

Revisionism extended even to art. Agostino Veneziano made the group of men writing in the lower left-hand corner of *The School of Athens* into an independent motif and replaced the numerals and characters on the tablet held by the little boy and in the book of the kneeling figure with verses from the Gospel of St Luke, thus turning the figures into Evangelists.

Sadoleto's classic work on education is the *De liberis recte instituendis*, written 1531-2, published in Venice 1533.

How far educational programmes in 1600 had fallen away from the original principles of Christian humanism may be seen by comparing them with Leonardo Bruni's programme for women's education, laid out in the form of a letter to Battista Malatesta. Women were to study (1) religion and morals as presented in Scripture, the Fathers and Greek and Roman philosophy; (2) history, because an understanding of our past helps us to foresee the future and furnishes us with a store of moral precepts; it is also easy to learn and remember; (3) oratory and poetry.

'Eloquence and the sciences . . .' A. Possevino, *Coltura degl' ingegni* (Vicenza 1598).

History and the Ratio of 1586: A. P. Farrell, *The Jesuit Code of Liberal Education* (Milwaukee 1938), pp. 247-51.

Tasso's sonnet on Rome: *Opere*, vi (Venice 1736), p. 238.

Appendix A: Italian Currencies (pp. 295-6)

H. E. Ives, *The Venetian Gold Ducat*, ed. P. Grierson (New York 1954); C. M. Cipolla, *Le avventure della lira* (Milan 1958); cf. P. Spufford, 'Coinage and currency' in *The Cambridge Economic History of Europe*, ed. M. M. Postan (Cambridge 1963) iii, pp. 576-602.

Appendix B: Character and an Anti-Classical Style (pp. 297-301)

Sir Kenneth Clark, *A Failure of Nerve*: Italian Painting 1520-1535 (Oxford 1967), from which the quotation 'flowing movements . . .' is drawn, p. 20; A. Hauser, *Mannerism* (London 1965); W. Friedlaender, *Mannerism and Anti-Mannerism in Italian Painting* (New York 1957); E. H. Gombrich, 'Mannerism: The Historiographic Background' in *Norm and Form* (London 1966).

The Popes from 1450 to 1616

Dates of reign	Name as Pope	Family Name
1447-1455	Nicholas V	Tommaso Parentucelli
1455-1458	Calixtus III	Alfonso Borgia
1458-1464	Pius II	Enea Silvio Piccolomini
1464-1471	Paul II	Pietro Barbo
1471-1484	Sixtus IV	Francesco della Rovere
1484-1492	Innocent VIII	Giovanni Battista Cibo
1492-1503	Alexander VI	Roderigo Borgia
1503	Pius III	Francesco Todeschini de' Piccolomint
1503-1513	Julius II	Giuliano della Rovere
1513-1521	Leo X	Giovanni de' Medici
1522-1523	Adrian VI	Adrian Dedal
1523-1534	Clement VII	Giulio de' Medici
1534-1549	Paul III	Alessandro Farnese
1550-1555	Julius III	Gian Maria del Monte
1555	Marcellus II	Marcello Cervini
1555-1559	Paul IV	Gianpietro Carafa
1559-1565	Pius IV	Giovanni Angelo de' Medici
1566-1572	Pius V	Antonio Ghislieri
1572-1585	Gregory XIII	Ugo Buoncompagni
1585-1590	Sixtus V	Felice Peretti
1590	Urban VII	Giambattista Castagna
1590-1591	Gregory XIV	Niccolò Sfondrato
1591	Innocent IX	Gianatonio Facchinetti
1592-1605	Clement VIII	Ippolito Aldobrandini
1605	Leo XI	Alessandro de' Medici
1605-1621	Paul V	Camillo Borghese

A Table of Dates

1529 France renounces her claims on Italy
1531 Florence becomes a Duchy
1534 Henry VIII Head of the Church in England
1535 Parmigianino, *Madonna del Collo lungo*
1536 Sansovino begins Library at Venice
1540 Society of Jesus founded
1541 Regensburg Dialogue
 Michelangelo, *Last Judgment*
1543 Nicolas Copernicus, *De revolutionibus orbium caelestium*
 Andreas Vesalius, *De humani corporis fabrica*
1545 Council of Trent (until 1563)
1546 Titian, *Paul III and his Grandsons*
1547 Benvenuto Cellini, *Perseus*
1548 Robortello's edition of Aristotle's *Poetics*
1550 Giorgio Vasari, *Lives of the Most Excellent Architects, Painters and Sculptors*
1552 Girolamo Cardano cures Archbishop Hamilton
1560 Francesco Patrizi, *Concerning History*
 Tintoretto, *Susannah and the Elders*
1563 Establishment of the Church of England
1571 Battle of Lepanto
1572 Massacre of St Bartholomew
 Giovanni Bologna, *Mercury*
1574 Venice fêtes Henri III
1581 Vincenzo Galilei, *Dialogo della musica antica e della moderna*
1582 Calendar reform by Pope Gregory XIII
1587 Claudio Monteverdi, first book of madrigals
1594 Shakespeare, *Romeo and Juliet*
1600 Jacopo Peri, *Euridice*
1602 Galileo discovers law of falling bodies
 Campanella, *The City of the Sun*
1604 Shakespeare, *Othello*
1607 Monteverdi, *Orfeo*
1609 Galileo's telescope
1612 Francis Bacon, *Novum Organum*
1613 Monteverdi appointed to San Marco
1616 Galileo censured and obliged 'not to hold nor defend' the heliocentric
 theory

Index